AHMANSON · MURPHY
FINE ARTS IMPRINT

PAINTING ON THE LEFT

PAINTING ON THE LEFT

DIEGO RIVERA, RADICAL POLITICS,
AND SAN FRANCISCO'S PUBLIC MURALS

ANTHONY W. LEE

UNIVERSITY OF CALIFORNIA PRESS
Berkeley Los Angeles London

University of California Press

Berkeley and Los Angeles, California

University of California Press, Ltd.

London, England

© 1999 by

The Regents of the University of California

Lee, Anthony W., 1960–

 Painting on the left : Diego Rivera, radical politics, and San

Francisco's public murals / Anthony W. Lee.

 p. cm.

Includes bibliographical references and index.

ISBN 0-520-21133-2 (alk. paper).—ISBN 0-520-21977-5 (pbk.: alk. paper)

 1. Rivera, Diego, 1886–1957—Political and social views. 2. Mural

painting and decoration—20th century—California—San Francisco—

Themes, motives. 3. Street art—California—San Francisco.

I. Title.

ND259.R5L44 1999 98-18740

759.972—dc21

Printed in the United States of America

9 8 7 6 5 4 3 2 1

The publisher gratefully acknowledges the generous
contribution to this book provided by The Art Book
Endowment Fund of the Associates of the University of
California Press, which is supported by a major gift from
the Ahmanson Foundation.

Publication of this book has been aided by a grant from
the Millard Meiss Publication Fund of the College Art
Association.

CONTENTS

ILLUSTRATIONS

FIGURES

ACKNOWLEDGMENTS

This book has taken a number of years to research and write, and at each point along the way, I have benefited from the kindness and hard work of many good people. I wish to thank the late Vasily Arnautoff, Phyllis Ayer, Helen Gee, Robert and Mary Fuller McChesney, the late Shirley Triest, and Masha Zakheim, all of whom welcomed me into their homes and patiently and graciously answered my questions. I thank Rick Biddenstadt, Katie Crum, Beth Garfield, Jeff Gunderson, Claudia Kishler, and Jo Ellen Roach for help with reproductions, and Deans Dennis Kratz and Michael Simpson for providing a generous subvention. Derrick Cartwright, Andrew Hemingway, Paul Karlstrom, Michael Rogin, Terry Smith, and Anne Wagner read parts or all of earlier drafts and offered good advice for improving the argument, and I tried to respond to as many of their comments as I could. Tim Clark has been supportive of this project from the very beginning. For his efforts, he was made to suffer through all of the book's earliest forms, but he responded with his usual good humor and great insight. At the University of California Press, Stephanie Fay has been a remarkably generous editor, a voice of strong support and sound reason.

The earliest portions of research were funded by an ACLS / Luce Dissertation Fellowship in American Art, and the last bits of writing by a summer stipend from the University of Texas at Dallas. I am immensely grateful for both.

A number of my colleagues, both near and far, have helped in this book in more ways than they know: Charles Bambach, Nema Blyden, Dennis Crockett, Patrick Frank, Diana Linden, Edrie Sobstyl, Jerry Soliday, Deborah Stott, Dan Wickberg, and Michael Wilson. I also wish to thank colleagues who invited me to present portions of the book as public lectures, which allowed me to think through, and

in some cases completely rewrite, the arguments: Jeffrey Abt and Nancy Locke at Wayne State University; Evelyn Lincoln at Brown University; and Annemarie Weyl-Carr at Southern Methodist University.

Finally, this book is dedicated to Catherine, Colin, Rachel, and Caroline Lee. Their loving presence is everywhere in these pages.

INTRODUCTION

San Francisco's most celebrated public murals, painted during the Great Depression by artists on the left, were politically radical works of art. Although today their politics cause no misunderstanding or outrage, in the 1930s most of the city's major patrons and critics found them politically unpalatable, and often pictorially incomprehensible. They assumed that murals had other purposes, largely decorative, and were angered when a small minority of painters thought otherwise. Sometimes they ridiculed the mural painters' radical ambitions; sometimes they simply wanted the paintings gone. "Bah ... [d]estroy the present ones," one critic wrote of the murals at Coit Tower; "[they] give one a pain in the neck."[1] The patrons who agreed arranged for a clandestine whitewashing.

But the paintings generally stayed (those at Coit Tower included), and critics and patrons took special notice of them. They puzzled over the paintings' subjects, argued over their political meanings, and contradicted the painters' desultory claims. Debates that began in artists' studios spread to the daily newspapers, art journals, the city's art schools, and corporate and civic patronage circles. The discussants, though often unfamiliar with the language of leftist politics, borrowed some of its theoretical jargon to get hold of the paintings. And sometimes the murals' subversive subjects seemed to amuse (even if they also annoyed) the critics. "Let me whisper it, lest I be overheard," one of them wrote; "the naughty boys had indulged in a little Communist propaganda."[2] This critic, at least, wanted a far less contentious role for public wall painting. What indeed did these painters think they were doing when they related their work and pictorial experiments to leftist politics?

That is the general question I pursue in this book.[3] San Francisco experienced a historical moment, peculiar and uncommon until the 1930s, when painting and

politics could have a close, explicit relationship; when art—public art, no less—could pursue socially and politically revolutionary ambitions; and when painters could think of themselves as workers who could make art part of a momentous historical transformation. I describe the social and political meanings of San Francisco's public murals in the four decades after the 1906 earthquake and fire; decipher when, how, and why the left became involved in the business of public art; and explain the particular, sometimes complex, often contradictory links between the painters' artistic and political practices. I analyze which "left" appeared in the cultural sphere and how and why a particular set of visual strategies appeared in conjunction with it. I try to understand the real network of relations between this apparently new system of visual representations and specific working classes and ethnic minorities. And I seek to provide close, sensitive readings of the three famous San Francisco murals of Diego Rivera and of others by his immediate followers and, in so doing, show how their meanings are tied to the shifting fortunes of a leftist cultural politics.

"Politics," in the chapters that follow, is meant in the usual sense: the policies, ambitions, and concerns related to governance. I am little concerned with politics when it appears in art as a vague tendency or lyrical effect, still less with it as an unconscious act or as a structuring but largely untheorized ideological point of view. The leftist mural painters I discuss were explicit about trying to make their art and politics (in the conventional sense) meet; and they worked during a time—a crisis in capitalism—when that kind of ambition seemed full of significance, portentous of dramatic change in the nature of a whole political order. The question they repeatedly asked themselves, and one I attempt to answer, was what that relationship—the dialectic of art and politics—actually meant in mural practice.

The story I tell is a chronological one. If, as the city's art critics suggested, Rivera and his followers brought new radical political meanings to their murals, the development of a public role for wall painting had prepared the way. Wall paintings first appeared in the city some fifteen years before the Great Depression, at the Panama Pacific International Exposition (PPIE). There, they immediately became "public": they were part of the effort at urban reconstruction following the 1906 earthquake, and they became a vehicle for the display of civic consciousness by corporate patrons. Local artists, spurred on by the surprising interest in the exposition murals, developed new painterly skills suited to the wall and, with the encouragement of patrons in the 1920s, put their work into dialogue with the suggestions of welfare capitalism—industry's paternalistic management of its employees' social welfare—and a new civic culture. Thus these early wall paintings, at the PPIE and elsewhere in the decade that followed, made no reference to leftist politics but instead accommodated the demands and desires of private patrons at

the most elevated levels of society. Throughout this early history "public" was (as it remained) an ideological term, referring to an imaginary social body that could be invoked as needed. Often patrons called upon it to stand fictive witness to their own ambitions. But once a public was said to exist for murals, other actors could make claims upon it.

Diego Rivera's murals permitted specific leftist painters to do just that. Rivera's arrival in the city marked the beginnings of a debate about the complex relationship between murals, the left, and the public. His first two San Francisco murals provided stunning visual evidence of a symbolic language of radical political dissent. Painters and critics saw them as models for emulation and refusal by turns, picking up some of their features and considering them in relation to new arguments about ethnic minorities and the working classes. The new art-critical term "Riveraesque" was coined, admirers and detractors alike using it as a familiar descriptive category. It signaled a certain iconography. "If a man had a shovel in his hand in a mural rather than breaking the bronco," a local administrator wrote only half-humorously, "he was modern and he was dangerous and probably radical and probably he just came from a Communist lecture by Diego Rivera."[4] Riveraesque also stood for a visual style associated with the left—a particular and often awkward approach to composition and to figures. The critic who passed judgment on the "naughty boys," for example, easily recognized the new figures and forms: "That Gargantuan Mexicano is the God of many American fresco painters, particularly those who career larboard."[5]

Immediately after Rivera's departure from San Francisco in 1931 leftist painters undertook an assortment of private mural commissions as well as working on New Deal projects funded by the Public Works of Art Project (PWAP). The Riveraesque in particular had a radical afterlife in the famous Coit Tower panels, in which artistic and political practices were closely aligned. Those murals, as I argue, represented the leftist artists' most startling moment of activism and cohesion—the moment when their work entered into meaningful dialogue with widespread working-class dissent.

During the later 1930s, when workers ostensibly made gains through federal labor legislation, leftist public wall painting received its harshest setbacks. These were partly caused by the unstable nature of the left and leftist painting. That instability was most visible when New Dealers stepped in to manage public patronage of the arts and when some artists, under the Popular Front, tried in vain to reinvigorate a slowly fading practice. But when Rivera returned to San Francisco in 1940 to paint his third and final mural in the city, the triumphant mood had clearly passed. Ideological fissures on the left created tensions and contradictions in leftist painting, bringing to the local level, where they had once been ignored,

all the fury of national and international debates. In his great *Pan American Unity* mural Rivera could only gesture toward what a politically committed mural practice might look like. The morbid events surrounding Anton Refregier's Rincon Annex murals of the mid-1940s epitomize the failure of the left to take hold of public painting and make it a medium for the organized working classes.

The dénouement in the history of leftist public murals is well known, and I will not try to shirk that history. But it is clear—or shall be at the book's conclusion—that Rivera's *Pan American Unity* and Refregier's Rincon Annex paintings made their leftist claim quite late in the day. A whole decade of determined, complex, and heated leftist cultural activity preceded them. And before that, a new interest in something called public murals had made wall painting a fertile ground for symbolic dissent. The search for an activist, alternative public art and the developing attentions of politically radical painters had their beginnings in a much less radicalized city. That is where we need to begin.

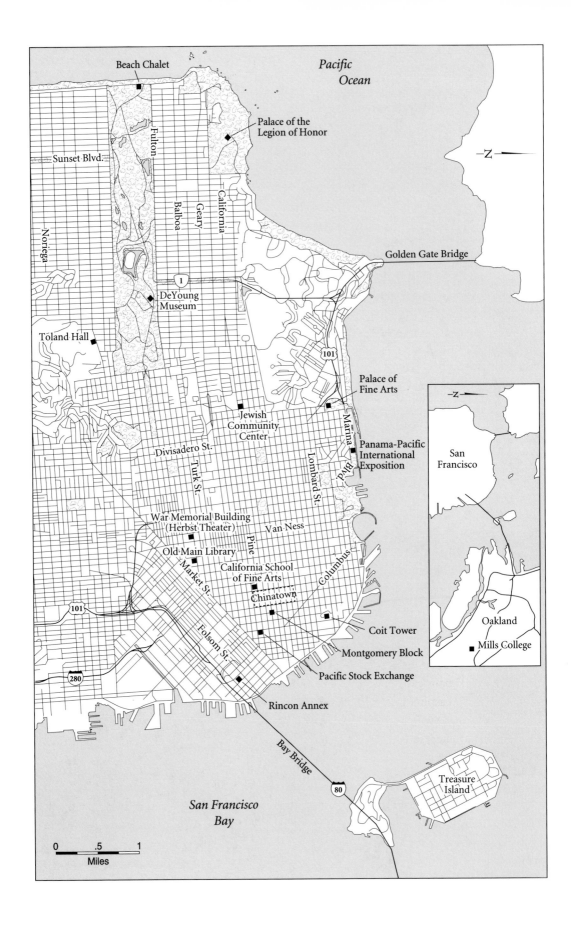

Beach Chalet

Pacific
Ocean

Palace of the
Legion of Honor

Sunset Blvd.

Fulton

California
Geary
Balboa

Noriega

Golden Gate Bridge

1

DeYoung
Museum

101

Toland Hall

Palace of
Fine Arts

Jewish
Community
Center

Marina

Divisadero St.

Panama-Pacific
International
Exposition

San
Francisco

Turk St.

Lombard St.

War Memorial Building
(Herbst Theater)

Van Ness

Old Main Library

California School
of Fine Arts

Pine

Market St.

Columbus

Chinatown

101

Folsom St.

Coit Tower

Montgomery Block

Oakland

Mills College

280

Pacific Stock Exchange

Rincon Annex

Bay Bridge

Treasure
Island

80

San Francisco
Bay

0 .5 1
Miles

WHEN MURALS BECAME PUBLIC

W e begin at the fairgrounds of the city's 1915 Panama Pacific International Exposition, or PPIE (Fig. 1.1). As its official title suggests, the exposition celebrated the opening of the Panama Canal; it also marked San Francisco's rebirth after its virtual destruction in the 1906 earthquake and fire. The fair must have been dazzling: seventy-six city blocks of triumphal arches, towers, arcades, fountains, and columns, not to mention the myriad gardens and, at one end, a huge artificial lagoon kept meticulously blue. It also included thirty-five murals of monumental size, painted on canvas. They decorated the major arches, outdoor courts, and gateways—acres of colorful forms; gigantic figures on broad, flat surfaces; dramatic gestures and glistening bodies in complex arrangements, all overhead. A visitor crossing the vast fairgrounds could, with each step, spot a painting. Because of their size and ubiquitousness, the murals were much discussed, as if they represented a new kind of art.

Records, if not recent memory, should have reminded visitors that wall paintings already existed in the city, most notably in the several dozen gaudy, opulent Barbary Coast bars and restaurants as well as in libraries, churches, and drawing rooms. But virtually all of them had been consumed by the great fire. Few, moreover, garnered the sophisticated critical attention that greeted the exposition murals.[1] These new paintings seemed to contain higher, nobler ambitions than their predecessors and aspired to be "public art." For one young critic, however, "the mural paintings as a whole [were] not so fine as either the architecture or the sculpture."[2] They seemed constricted by the exposition's decorative demands, which forced them into an ornamental role that diminished their artistic power and kept them "limited to a palette of five colors, in order that the panels should harmonize with the larger color scheme." What dreary sameness, he complained.

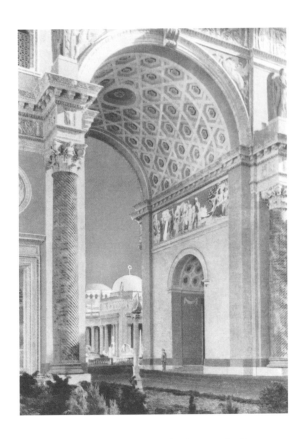

1.1 Contemporary retouched photograph of Panama Pacific International Exposition, 1915. Whereabouts unknown.

The critic was Sheldon Cheney, best known for his two books, *Primer of Modern Art* (1924) and *Expressionism in Art* (1934), and for his writings of the late 1930s that were in dialogue with those of Alfred Barr and Clement Greenberg. In 1915, however, Cheney was a virtual unknown. His was a minority opinion, and other critics countered, dismissed, or ridiculed it in their own appraisals. "Color and design impressive in a studio might, when placed beside vigorous architecture, become weak and pale," one of them wrote.[3] Thus the best murals intentionally "harmonized with the general plan of the Exposition." "All other Expositions have been almost colorless," explained another. The PPIE, in contrast, sought to achieve "absolute rightness of shade and tint" everywhere, including its murals.[4] But even in praising the murals, the critics voiced the underlying assumption that they did

not really stand on their own as forceful artistic statements. Nevertheless, whole books were given over to detailed descriptions of the mural paintings; newspapers editorialized at considerable length about them; and the many guidebooks devoted their only color reproductions to them.[5]

Though Cheney generally stood by his criticism, he must also have felt the precariousness of his stance as a dissenting critic, for he qualified it, explaining that "the most significant thing of all is the wonderfully harmonious and unified effect of the whole, that testifies so splendidly to the perfect co-operation of American architects, sculptors and painters."[6] His ideas appeared in a small, affordable guidebook published by an exposition subsidiary to explain the new paintings to their new public.

The critics' responses introduce the arguments germane to San Francisco's first public murals. A soon as the murals were identified as an ennobled public art, their suitability for that role became the focus of considerable debate. Of central concern was the issue Cheney had raised: the murals' fit with their architectural setting, their harmony, unity, and coherence vis-à-vis their surroundings. The critics well knew about the special, provocative problem of murals, which, unlike easel paintings, *belong* to a wall and its decorative environs. But they found that the murals at the PPIE *belonged* all too well; too much unity and consistency was as problematic as too little. Cheney's claim that the "dominant note artistically is *harmony*," if it reads like a description, also encapsulated his criticism.[7]

Why did it matter that the murals were, or were not, independently interesting? What issue did Cheney's art criticism address in its peculiar, hermetic way? In this chapter I suggest that the ambiguous but palpable order at the fair—the "harmonious effect" of prescribed colors and compositions in the murals—had its corollary in another order outside the fairgrounds proper. It arose from a political struggle during San Francisco's reconstruction, when specific patrons—the exposition's—sought to use large-scale painting to advance their partisan view of governance and social welfare. The murals became "public art" because of their relationship to that partisan effort, thereby beginning a decades-long accommodation of artistic and political practices. Cheney hinted at the murals' political dimension years later when he wrote of murals by Pierre Puvis de Chavannes (the French painter whose works were the apparent model for the exposition panels):

The coloring and disposition of forms both indicate a possible fear of upsetting an equilibrium attained instinctively rather than through conscious knowledge of dynamic values. There is here none of the vigor or intensity

of Orozco or Rivera. Perhaps it is Expressionism at its lowest intensity, in its most delicate manifestation—at a time when expression would seem, on its emotional side, to demand drive and strong contrast.[8]

"Low intensity" resulted when Puvis's academicism ("conscious knowledge") and "loyalty to the wall" compromised the vigor of his artistic ideas. Playing to the wall's rigid flatness meant too readily acceding to an imposed order; thus even Puvis, dead since 1898, could be indicted in the context of Progressive Era San Francisco. What murals needed was "drive and strong contrast," an energetic expression like that in the works of some radical Mexican artists.

But I anticipate a comparison that Cheney could not make in 1915, for Rivera's work, which appeared in the Bay Area some fifteen years later, could not serve as a proper foil to the public murals of the Panama Pacific International Exposition. On the fairgrounds, Cheney could only point to the new murals' unsuitability and awkwardness, his sense that they belonged to a much larger framework. The pages that follow establish how murals became "public art" precisely in attempting to mediate between the exposition where they were installed and the city outside. I look closely at the instability of this connection, the particularity and political nature of the vision, and the deeply ambivalent response.

THE EXPOSITION OF THE NEW CITY

"In the art of the Exposition," Cheney wrote,

> the great underlying theme is that of achievement. . . . So the ideas of victory, achievement, progress and aspiration are expressed again and again: in the architecture with its triumphal arches and aspiring towers; in the sculpture that brings East and West face to face, and that shows youth rising with the morning sun, eager and unafraid; and in the mural paintings that portray the march of civilization, and that tell the story of the latest and greatest of mankind's triumphs over nature.[9]

The phrase "again and again" tells the story. For if the PPIE and its murals were texts to be read, they in effect presented "again and again" the same text. Such texts gave the practicing critic little to do unless he were simply a babbling iconographer or a highly paid popularizer. (If "the writer did not pretend to a power of artistic discrimination, there would be little excuse for preparing the guide.")[10]

The exposition lasted nearly a year, from February 4, 1915, to December 4, on an artificial marina on the city's northern shore.[11] It was, like virtually every world's

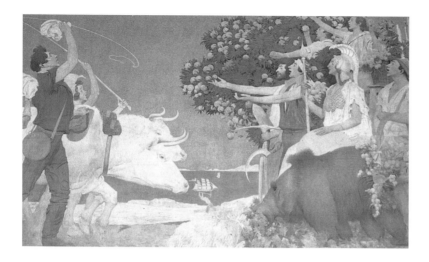

1.2 Frank du Mond, *Westward March of Civilization* (detail),
1915. Oil on canvas. San Francisco Public Library/Asian
Art Museum.

fair before, a spectacle for modern industry and technology.[12] Late-nineteenth-
and early-twentieth-century expositions generally synthesized contemporary un-
derstandings of tourism as a modern pilgrimage, used the language of progress to
promote consumerism, and interpreted capitalism as an economic system that
advanced learning and material well-being.[13] The critic, like the tourist, entered
the PPIE in search of a variety of material and intellectual wonders and knew what
kind of response was appropriate. "The Palace of Machinery holds three lessons
for the observer," wrote one: "the state of man's inventions at the present mo-
ment, the increasing displacement of coal by hydro-electric plants and liquid fu-
els, [and] . . . the changing direction of invention toward devices for human
betterment."[14]

But in the murals, meaning seemed most manifest and mechanical. In the two
long horizontal panels of Frank du Mond's *Westward March of Civilization* (one
panel is shown in Fig. 1.1, of which Fig. 1.2 is a detail), human betterment is linked
to the settlement of California, pictured as a procession of the state's historical lu-
minaries—the Franciscan monk Junipero Serra, the Spanish explorer Juan Bau-
tista de Anza, the writer Bret Harte, the painter William Keith, and others. The
painter evidently read Hubert Bancroft's *History of California* and, like that ency-
clopedic work, structured the mural as a time line from the discovery to the con-
quest, settlement, and governance of the state and the development of its cul-
ture.[15] The figures march toward the outstretched arms of Queen Califa, a newly

christened mythological figure standing for California. Her full youthful form had important local meaning, her youth signaling a long life ahead, her amplitude the economic resurgence of San Francisco itself. She is both the endpoint—the goal toward which historical momentum has tended—and the sign of a new history about to commence, the recognizable (embodied, allegorized) place where a new civilization can begin.

That kind of argument is continued in William de Leftwich Dodge's *Atlantic and Pacific* and *The Gateway of All Nations,* where the Panama Canal's opening is heralded as another step in California's history. Like du Mond, the painter makes his case with two long processions of figures. In one panel, inspirational muses lead ox-drawn wagons; in the other, cranes and dredges dig the new canal. In the first, the herculean figure Labor links Atlantic and Pacific cultures—a familiar story of European immigration and settlement in America. In the second, Neptune leads "the fleets of the world," presumably to the city's new ports.[16] Together, the panels assert San Francisco's natural and historical right to the bounty brought through the Panama Canal and link the city to the frontier West of the nineteenth-century imagination. They turn economic potential into the stuff of allegory and picture recent developments as progress—ordained and inevitable.

These paintings are not far from the typical fare of turn-of-the-century expositions, and the critics had no difficulty understanding them. ("The artist is tediously careful to make his meanings plain," Cheney wrote.)[17] If Puvis was a stylistic touchstone for the painters, so too, probably, were Emanuel Leutze, whose famous *Westward the Course of Empire Takes Its Way* shows pioneers headed toward the San Francisco Bay, and, possibly, Thomas Crawford, whose equally famous bas-relief *Progress of Civilization,* in the Capitol in Washington, uses a mix of historical and allegorical figures to make a similar case for civilization's forward march. The exposition murals resorted to conventional classical motifs and a standard academic vocabulary to represent the activities and visualize the aspirations of exposition organizers. They made legible the master narratives of the exposition.

The sheer repetition of meaning in the exposition and its murals would most likely have been read without comment had it not seemed a compensation for—or, worse, a contradiction of—the city outside. Unlike the fair, with its blocks of material splendor, the city itself hardly looked reborn. With remarkable tenacity, the official guides compared the two: the palm-lined avenues and wide fairground boulevards looked like those proposed for the new streets just outside the front gates; the fair's system of courts, promenades, and centers resembled the collection of axes radiating from San Francisco's new Civic Center; even an exhibit called Underground Chinatown in the "Zone," the exposition's amusement area, invited fairgoers to visit an ethnic enclave to witness the opium smokers, gamblers,

1.3 Perham Nahl, Poster for Panama
Pacific International Exposition, 1915.

slave girls, and hatchet murderers said to have existed in old Chinatown and res-
urrected for tourist shows in the new.[18] Only the murals could be said to have no
real corollary outside—one of the reasons for their special status. Indeed, why
else would San Francisco's Republican leadership underwrite a debated landfill on
the city's northern shore, permit the docks on the city's eastern perimeter to ex-
pand south to China Basin, or develop an expensive ferry and train system linking
the city to the northern and eastern settlements along the bay? Why would it ini-
tiate tunneling through two of the city's highest hills to open up the northeastern
and southwestern districts to residential subdivisions? Such development, the
guidebooks said, had occurred haphazardly before the earthquake and now pro-
ceeded in earnest, as if the rebuilding of the city properly vied with fair prepara-
tions. The exposition's official poster, by Perham Nahl (Fig. 1.3), leaves unclear
whether the distant skyline is that of the PPIE or the new San Francisco. Because
the herculean effort the poster depicts—to excavate and reveal—is pertinent to
both exposition and city, the picture can collapse the two wish images into one.

These emphases and promises are remarkable burdens for an exposition, already under considerable pressure because of its mission to exhibit "progress." The fair was, after all, a temporary ensemble; it was a *sign* of a much more inclusive, exhaustive reconstruction to come—an interpretation that the organizers took care to spell out for fairgoers. For this purpose they prepared the gossipy handbooks and the tourist guides already mentioned, and they erected highly visible placards at each of the main courts, major works of sculpture, and mural decorations to explain the allegorical and symbolic links between the individual works of art, the organizers' cultural expertise, industry's rationalized thinking, and San Francisco's urban development. The exposition not only signaled "progress" but also embodied it as the intellectual and material space permitted by larger enlightened efforts.

San Franciscans had rarely seen such a wealth of printed materials, most hyperbolically proclaiming and interpreting the city's recent achievements. Visitors with maps and guidebooks must have found the fair an often numbing experience. Each intellectual, cultural, or scientific display was touted for its monumental size and import. And although organizers initially worried about amassing enough works of fine art to fill the huge pavilion, "on the opening day of the Exposition it was found that the Palace of Fine Arts, far from having too little material, had too much. . . . The consequence was that a new building had to be erected." [19] It did not matter that world's fairs regularly featured such plenitude. The organizers of San Francisco's exhibition left to others the task of putting the display into perspective.

While the PPIE stood as a replete, integrated metropolis, San Francisco had hardly rebuilt with the same thoroughness or order. The major projects were less than halfway along, and while some of the city's streets resembled those of the fair, others were mere sketches for future arteries. Some major buildings stood, finished on bare lots; others were under construction; still others existed only on paper with site preparation just begun. The massive Beaux-Arts Civic Center, for example, could boast only one building completed—an auditorium finished in January 1915, the opening of the PPIE; all the other structures were barely under way. The grid system of the new city extended into the Richmond district and the new Sunset district, but in these neighborhoods, as elsewhere in the city, completed structures alternated with others just balloon framed or with large sand dunes.[20] Although elaborate plans existed to tunnel through two hillsides to lay track for a municipal railway, the bores had not yet been drilled in the hard rock.[21] Indeed, when Nahl drew his official exposition poster, his representation suggested, more accurately than he probably intended, the distance between the rudimentary con-

struction taking place outside the fairgrounds and the finished city, a fantasy imagined as an indistinct skyline.

DECORATIVE THINKING

With the actual city backdrop incomplete, exposition organizers imposed their own reading of the reconstruction—its centralization, order, and scope. The murals fit this reading not only in their sober, edifying narrative quality but also in their homogeneity of form and consistency of color, their adherence symbolically to a methodical urban arrangement. Jules Guerin, the exposition's chief of color and decoration, was certainly no stranger to large-scale decoration efforts. Born and raised in Saint Louis, he studied painting in the Paris studios of Jean-Paul Laurens and Benjamin Constant, returning afterward to New York, where he gained both a reputation as a painter of large ensembles and election to the prestigious National Academy of Design.[22] He must have been given early access to most of the fair's architectural and grounds plans, for his 1912 drawing of the exposition accurately represents its grand layout. At about the same time, he seems to have determined on an overall visual logic for the fair—a static effect produced by polychrome Venetian colors and surface patterns. He specified every detail. "I wonder how many visitors down there know," a guidebook asked, "that the very sand they walk on has been colored." The chief of color had ordered every last grain painted pink, naturally.[23] Guerin's tastes even dictated the major landscape scheme.[24] In keeping with the strong Mediterranean theme, for example, he imported old-world palms and lush flora—some 70,000 Dutch rhododendrons; 2,000 Japanese azaleas; 6,000 pansies; and 10,000 veronicas, African agapanthus, and Brazilian cineraria.[25] The colors and clustered forms of the plantings blended with the architectural details "without jar or break."[26] The ensemble produced an overall image of a prosperous Pacific coast city-state.[27]

The decorative program of the World's Columbian Exposition in Chicago some two decades before had established the visual language of a serious, culturally elevating classicism. That language was taken up enthusiastically at the PPIE because it continued the imagery already associated with reconstruction. In the new city pictured by Maynard Dixon as early as 1906 (Fig. 1.4), only weeks after the earthquake and fire, Greek temples and pavilions rise on a hillside protected by an androgynous genie. Although Dixon himself had been trained, not in the academy, but in the Wild West mold of Frederic Remington, his view of a new city in old-world garb stemmed from a myth of cultural inheritance subscribed to by a gen-

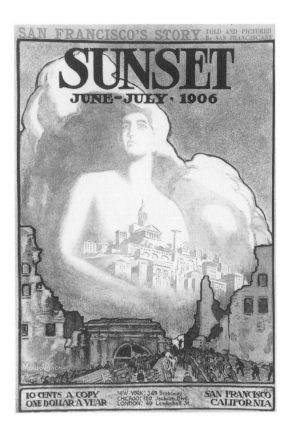

eration of city patrons (led by the fabulously wealthy Phoebe Apperson Hearst). It provided for them a morally elevating rhetorical framework for debates about reconstruction, suggesting metaphors and allegories to structure them.[28] The benefits of this vocabulary are sufficiently clear. "The whole spirit here," wrote Cheney of the exposition's architectural program, "is one of seriousness, of dignity, of permanency."[29] He did not mean this satirically, though it could well have been taken that way. At any given moment, the city *looked* temporary and disorderly—the reconstruction proceeded in starts and fits—but was given permanence and order at the fair.

In 1911 an artist named Edward Mitchell produced an official image for the fair (Fig. 1.5) that rearticulated Dixon's motifs. This time, however, the major visual elements of Dixon's work have been readjusted to represent the developments hoped for in the reconstruction. The dream city, no longer an imaginative projection, stands in the distance, more carefully articulated than in Dixon's version.

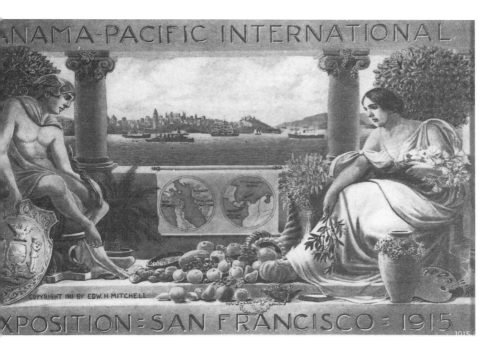

1.4 Maynard Dixon, *Hope of the City,* cover for *Sunset* magazine, 1906. Collection of the California State Library, Sacramento.

1.5 (*Above*) Edward Mitchell, *On the Road of a Thousand Wonders,* 1915. Collection of the author.

The genies, now male and female, no longer cradle the city, which has begun to take on its own energetic form; but they seem exhausted by earlier efforts. The opening of the Panama Canal and the attendant revitalization of San Francisco's economy are shown in explicit detail. The maps make the link between the canal and the city eminently clear. The rest of California—indeed, the rest of the Pacific coast and its many competing ports—is omitted. A neoclassical image of rigor and stability implied the eternal hierarchical order of economic relations for San Francisco, and the PPIE artists readily took up the suggestion.[30]

Like so much else at the fair, Guerin's mural painters were imported, primarily from New York. Seven came from Manhattan, an eighth from London, and only the ninth, Arthur Mathews, was a San Franciscan.[31] For the thirty-five "official" murals (as opposed to those commissioned by participating states and nations in individual pavilions), the chief of color outlined as early as 1912 the edifying iconographic program and consistent coloristic plan I have already noted.[32] It caused

no end of difficulty for some of the painters, and reports suggest that many had to repaint the final layer in San Francisco, after their canvases had been glued in place, under Guerin's watchful eye "to make sure that they did not conflict with one another."[33] Cheney had strong reservations about the resulting blandness of their works, and the overwhelming homogeneity of the fairgrounds—the countless blue agapanthus and veronicas, the ubiquitous pink sand, the repetitive golden domes and pearly towers—suggests why he might have been dismayed. Nothing distinguished the murals, nothing provided resistance or a counter to them. They were not so much framed by their architectural and decorative surrounds as absorbed by them.

For Cheney, the pleasures of allegorical mural painting resided in his own ironic sense of the opaque relation between the meaning of a particular painting and the exposition's grander narratives.[34] Allegory should permit—even encourage—painters to destabilize meaning. The limits imposed by the exposition's narratives and the decorative program should frame imaginative invention, not close it off. Faced with the PPIE murals' decided lack of invention, their lack of expression and expressiveness, Cheney complained about the rigor of Guerin's order, the obedience it demanded. To be compelling, allegorical painting requires slippage, the display of wit and ingenuity that belong to individual artistic performance. Painterly invention needed, in part, to work against ideology.

My description of the exposition's ideological work has edged slightly into satire, comparing, for example, the high seriousness of the paintings' arguments about progress and rebirth with the evidence of disorder and incompleteness in the city itself. Even the exposition's more sympathetic critics were tempted to lapse into a similar tone. They noted, for example, that some murals seemed not to fit the purported meanings recounted in the placards and guidebooks. Speaking of a no-longer-extant panel, one complains: "It doesn't help much to know that the middle figure, with the upraised arm, is Inspiration with Commerce at her right and Truth at her left. They might express almost any symbols that were related to beauty. And the symbolism of the groups at either end seems rather gratuitous. They might be many other things besides true hope and false hope and abundance standing beside the family."[35] The critic, who clearly had read the official written texts, practically verbatim, is dismayed at the apparent gap between word and image. Instead of giving proper form to the exposition's master texts, the murals seemed to obscure them, for the allegory was too indistinct and the figures were too generic. Truth could be Commerce; Commerce could be Truth (how the exposition committee would have relished that!). But for the viewer, the ambiguity only made the murals' edifying language seem inappropriate. What critics wanted

instead was an iconographic program more in keeping with the theme of reconstruction. Whereas the allegorical mode falsely abstracted and universalized experience, reconstruction seemed to warrant a radically contemporary particularization: "Those murals suggest what a big chance our decorators have in the themes that come out of our industrial life. They've only made a start. As mural decoration advances . . . we ought to produce men able to deal in a vigorous and imaginative way with the big spiritual and economic conceptions that are associated with our new ideals of industry." [36] The pallid scenes had little to do with the vigorous industry that required an energetic style and a progressive form of depiction.

The criticism of the exposition's murals is that of observers at most twentieth-century world's fairs, even critics in official pay. On the one hand, the paintings are asked to be texts when they would rather be paintings; on the other, the paintings' rhetoric poorly accommodates the ideals and fantasies of a modernizing society. [37] Ultimately, the murals did not connect the exposition to the city in a convincing way—or perhaps they connected it only insofar as they reflected the prescription of its organizers. A patron class was trying on an argument based on allegorical order and visual consistency, and the effort to turn ideology into painting was all too visible.

THE NEW PATRONS AND THEIR PUBLIC

What have been the keys thus far in examining the advent of murals as a public medium? First of all, we have needed to describe the specificity of place, the exposition itself, where we can reasonably describe viewers as constituting a "public" and can understand critics as endeavoring, sometimes mightily, to explain the murals to them. But second, those murals seemed to gain significant public stature only because of their relation to the debate about urban and economic renewal. They addressed an unknown body of viewers whose attentiveness to larger civic developments was nonetheless assumed. And third, we have briefly considered the conventional vocabulary of the paintings themselves—their moralizing, allegorical classicism—deeply bound up with conceptions of inherited culture and the ennobling rhetoric of reconstruction. These are among the basic coordinates of this or any social history of San Francisco's early murals. But the particular relationship between them—between physical space, the nature of the debates about governance, and the visual language of the paintings—remains volatile, made all the more so by this thing called a "public." An audience—even one so apparently disparate as the exposition's—and a public are never the same thing. The audience

is an actual body whose specific composition can be counted and distinguished from that of other audiences. The public, by contrast, is a *representation,* invoked to give an audience meaningful form; it is an imaginary body "organized and made effective."[38] Who, specifically, was served by this effort? And what was the point of conjuring this public to stand witness in the first place?

The PPIE's major beneficiaries—its organizers—were San Francisco's first "aristocrats" and their heirs. Pioneers who had capitalized on the gold rush boom, they had used their wealth in the largely unregulated climate of San Francisco politics to control the city. Their family names are legend: Spreckels, the sugar and shipping clan; Fleishhacker, the lumber and paper business family that, by the time of the earthquake, had become bankers; Crocker, the great railroad magnates; and so on.[39] Historians often see them as a disparate, competing group, but after 1906, these families joined forces to promote common commitments: to protect the private control of public services and utilities; to dismantle labor organizations, particularly the Union Labor Party; and to eradicate radical political pockets in the city's rougher neighborhoods. During reconstruction, progressive politicians began to criticize the old guard's aristocratic control and to demand reforms. Led by the iconoclast James Phelan, they succeeded in several efforts between 1911 and 1915—the years when PPIE preparations were in full swing—to gain control of public services.[40] They encouraged voters to approve a municipal railway in downtown San Francisco, for example, where the privately owned United Railroads had held a monopoly.[41] They made headway in establishing public ownership of the water supply—what would eventually become the Hetch Hetchy system (San Francisco had been served by the private Spring Valley Water Company).[42] They brought complaints against the Pacific Gas and Electric Company, with its near-monopoly of city power, and eventually secured a series of rate cuts. As a result of the Progressives' relentless criticism, the embattled aristocratic faction, united in its economic interests, acted cohesively to protect them. Several among its ranks invested heavily in private utilities and transportation companies in an effort to stave off reforms.[43]

The San Francisco Progressives' demands for public services and for political reform were not celebrated in the PPIE, for the exposition committee took a different view, enlisting the murals as exponents of their own definition of the "public good," and in so doing initiating an important link between the murals and the public. Although wall painting per se had little currency in the city—as Cheney's amnesia about earlier mural work attests—it did have meaning for this committee.[44] William H. Crocker emulated the cultural philanthropism of his uncle Edwin Bryant Crocker, who had amassed a huge collection of paintings and old master drawings during a European grand tour and bequeathed them to the art gallery in

Sacramento that bears his name. Michael de Young earned fame as a critic of theater and art (the original, principle interest of his paper, the *Chronicle*) and established an impressive collection of art and artifacts in a city museum. These men ensured that public art became an important element of an ambitious City Beautiful movement. Fleishhacker, who eventually assumed the position of parks commissioner, made that office extremely influential to those ends.[45] Indeed, the exposition organizers continually invoked wall painting as a public benefit to counter criticism and defend their own benevolence.[46]

In the exposition organizers' plans for a decorative program of murals, we witness a political investment in wall painting as a substitute for political reform. The paintings became "public" precisely when they were inserted into a debate about the scope and focus of reconstruction as envisioned in the exposition. As its president, Charles Moore, declared, the exposition was "not designed for the greater glory of individual architects, but for the enjoyment and intellectual stimulus of the people."[47] The fair's various architects and artists submerged their egos and united their efforts in "common service" for the public; and the public itself assuredly possessed the necessary sensitivity to the "co-operative idea that will not be lost." These are grand claims, but as always, the public remains a discursive category, whose existence was tied to arguments made for and against it or, as proclaimed by the PPIE's emissaries, benefits that were said to be provided for it.[48]

It did not occur to San Francisco's philanthropic exposition committee to ask actual fairgoers to ratify their projects. For them what mattered was that a public was present *in theory* to review the claims that the fair and reconstruction represented a public good. The murals' testimonial role underwrote Guerin's attitudes toward mural work. The painters he chose began their panels in New York studios with the expectation that they would not remain in San Francisco but would have an afterlife elsewhere. The finished works were shipped to the exposition as if they were large Salon canvases, given final touches to make them harmonize with each other and the fairgrounds, placed in their assigned niches, taken down when the fair had run its course, and either sent back or stored.[49] No collective judgment on them was expected, nor was their "success" scrutinized, since they were primarily fulfilling a demand from above.

These murals, called upon to link the utopia of the PPIE with San Francisco and naturalize the private control of reconstruction and civic services by insisting upon work for the public good, did so in an esoteric language that most of the fair's visitors seem not to have understood. The critics recognized that the exposition audience preferred some murals to others, but if in the aggregate the murals were to be made an official statement, viewers did not comprehend it, despite the help of placards and guidebooks.

1.6 Frank Brangwyn, *Primitive Fire*, 1915.
 Oil on canvas. War Memorial Building,
 San Francisco.

1.7 (*Opposite*) Frank Brangwyn, *Industrial
 Fire*, 1915. Oil on canvas. War Memorial
 Building, San Francisco.

We cannot recover the larger audience's "real" response to the murals, but we can gauge its force and quality by discerning how it affected the official writers in the PPIE's pay. According to the critics who observed the exposition's audience, it responded intensely to only one set of murals, by the British painter Frank Brangwyn. Brangwyn was charged to paint a series of panels for the Court of Abundance, a eulogy to fecund nature. The painter was to fill in the tall niches to suit this theme. Unlike the other official muralists, he had not studied in Paris, was not a member of the National Academy, and did not belong to Guerin's New York group.[50] A Welshman born in Belgium, he had studied primarily in England and

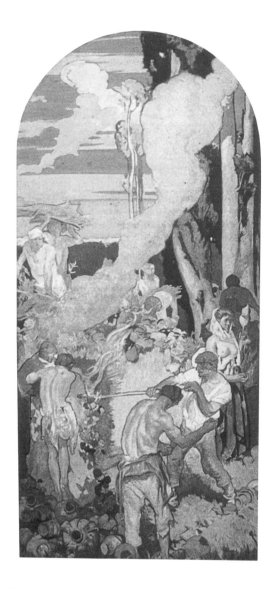

had earned a reputation as much for his etching as his painting. His strongest affiliation was with the Royal Academy in London, and he would gain a modicum of fame in later years when his murals replaced Rivera's at Rockefeller Center in New York. But in 1915 he by no means held the status of a provocateur.

Brangwyn's paintings seem to speak the fair's official language, with eight panels—two each devoted to earth, air, fire, and water—that suggest, through comparisons, the benefits of collective effort and industrial progress.[51] In Figures 1.6 and 1.7, for example, Brangwyn juxtaposes the crude processes and communal interests of *Primitive Fire* with the efficient labor and controlled blaze of *Industrial*

Fire. In the first, a community of men and women gather around a thin column of smoke, nurturing a small flame with bundles of wooden sticks and tree branches. In the second, a huge kiln fire is stoked by muscular men, producing such immense heat that the figures, even the women, can strip to the skin. Such harnessing of nature's power was an expositional commonplace.

The earliest guidebooks' discussions of the exposition's murals pay no special heed to Brangwyn's panels, describing them as they described the others. But in the guidebooks produced after the fair had opened and critics had rubbed elbows with the crowds, there is a notable change. For the critic Eugen Neuhaus

> Brangwyn's canvases are a veritable riot of color, full of animation and life. They are almost dynamic. There seems to be something going on in all of them, all the time, and one hardly knows whether it is the composition, the color, or the subject, or all three, which gives them this very profound feeling of animation. . . . Seen from a distance, their effect at first is somewhat startling, owing to their new note, not reminiscent in the very least of the work of any other . . . painter. . . . There is every indication that it gave the artist the utmost pleasure to paint them. This spirit of personal enjoyment . . . is contagious, and disarms all criticism. . . . His pictures are not intellectual in the least, and all of the people in his pictures are animals, more or less, and merely interested in having a square meal and being permitted to enjoy life in general, to the fullest extent.[52]

Whereas Cheney complained about the general blandness of the PPIE's murals, Neuhaus proclaimed Brangwyn's vitality. The figures move, the colors dance, the compositions dazzle. If other mural painters were constrained by the intellectual and narrative bases for exposition work, Brangwyn seemed simply to discard them. His work was "not intellectual in the least."

Other writers noted a similar freedom in Brangwyn's colors and figures:

> The canvases are bold, free, vast as the elements they picture. They need space. . . . Their rich reds, purples, yellows, browns, greens and indigoes are the hues of autumn skies, the falling leaves of hardwoods, the dense foliage of pines, colors of the harvest, of fruit and grapes, of flowers, and of deep waters. The men and women in them are primeval, too, of Mediterranean type, and garbed in the barbaric colors in which Southern folk express the warmth of their natures. . . . In striking contrast with the light and ethereal quality of the allegorical murals . . . these paintings are rich to the point of opulence. There is an enormous depth in them. The figures are full-rounded.

The fruits, flowers and grain hang heavily on their steams [*sic*]. The trees bear themselves solidly. The colors, laid on with strong and heavy strokes, fairly flame in the picture.[53]

The murals are so bold and colorful that the very architectural framing seems to constrain them. "They need space"; they require a different kind of viewing format. Only then will the extraordinary coloring and full-volumed figures be appreciated. As another critic proclaims:

To do justice to the great Brangwyn murals . . . one should stand under the central arch, first to the south and look eastward at the feast of color in the Primitive Water picture. Then face westward; go no nearer, and look upon the vivid wonderful line work and the master-hand in the picture Air Controlled. Then down half way to the east center of the colonnade and look toward Fire Controlled and Water Controlled; then down the north side and see Primitive Fire and the Fruits of the Earth. There is a feast of color at each turn; long distances, shadowy lights and shifting clouds and figures instinct with life. . . . In passing close to the pictures look away, because on near view they take on in some respects an air, almost grotesque, so heavy is the line, so high the color, so intense the shadows. It is a pity that it is possible for any one to be within less than twenty feet.[54]

By PPIE standards, these descriptions are veritable high-water marks of attention, and they are the only exceptions to the critics' normal language. Whereas the other official murals failed to transcend Guerin's prescriptions through inventiveness, Brangwyn's did precisely that, displaying a real painterliness. Although the writers recognized the differences and tried to express their surprise, they also grasped at ways to describe the panels when clearly their regular habits of looking and writing did not apply. The paintings did not lend themselves to either an iconographic or an allegorical reading. They are congested, too full of figures, colors, and landscape elements. They seem to lack order, hierarchy, and clarity and to refuse all the dictates of Guerin and the exposition committee. Their meanings are obscure, or at least much more obscure than the official descriptions. Narrative ambiguity and material sensuality seem important components of their powerful difference.

Neither the murals' strangeness nor the critics' failings would have mattered if the crowds had not somehow been *responding* to the artistic differences of these works. And for reasons not entirely clear to the critics, the audience was rapt. In taking stock of the larger reaction, the various writers all pointed to the murals'

figures and tried to pin down what they perceived in these works as a resistance to allegory. The result was a list of qualifying phrases—"primitive," "instinct with life," "primeval," "barbaric"—that conjured a sense of the figures' pulsing vitality and suggested, in so doing, their refusal to participate in a narrative. They remain too physical, too sensuous (see Plate 1). In insisting on the sheer materiality of bodies, the murals disallow signification. All the writers, moreover, were intensely aware of the conditions of viewing and of the intensity with which the audience examined the murals. The last of the three long excerpts I have quoted, by the writer Katherine Burke, implicitly acknowledges this awareness. Burke attempted to negotiate the viewing space, moving about the court, pitting one perception of the panels against another from a different viewpoint. Turn this way and that, she says, but stay back, at least twenty feet. And why? The second passage, by the critic Ben Macomber, addresses this problem directly. The space in which the murals hang is too cramped. It is not simply that the architecture is obtrusive but that too many people crowd the court, pushing past him and taking up space, and he cannot obtain a proper view. "People are not going in to see them as they should," he complained.[55] They got too close, causing a commotion, not following the mode of viewing prescribed by the placards. And what about the murals is so compelling? Neuhaus tries to tell us. Brangwyn "charms thousands of Exposition visitors" because his figures' vitality is "contagious."[56] Viewers "can almost feel the effort of [the woodmen's] lungs" in one panel, and in another can sense "the tang of the harvest season."[57] The crowds seemed to project themselves onto the painted figures. Taking their cue from Brangwyn's evocative handling of the "primeval" "Mediterranean type," the crowds tried to inhabit those bodies.

The reaction to Brangwyn's murals suggested to the official critics that visitors to the PPIE, particularly the local audience that stood repeatedly before the large murals, were neither completely taken in by, nor necessarily interested in, the aggrandizing material in the official panels. They seemed to have preferences, and they flocked to one set of murals over the others. The official critics tried to relate this preference to a painterly hedonism—those intense colors, the congested compositions, the nonintellectual quality of the painted surface—which seemed to separate Brangwyn's work from the others'. But we can also read their stuttering descriptions as evidence that they did not really know why the audience was so interested. Those bodies—those unidealized, coarse bodies—had something to do with the response, the critics said, for in the end, the actual audience was not interested in reading the official statements of the PPIE. The other murals, full of muscular physiques and aquiline profiles, simply failed to attract them in quite the same way.

Cheney found the murals breathtaking, and he offered the highest praise he could muster: "Ultra-learned critics will tell you that they fail as decorations, since they are interesting as individual pictures rather than as panels heightening the architectural charm. . . . It is better to accept them as pictures, forgetting the set standards by which one ordinarily judges mural painting. . . . There are no conventional figures here personifying the elements, but scenes from the life of intensely human people."[58]

The exposition committee took stock of the critical reaction and, when the fair concluded, saved du Mond's two large panels—and all of Brangwyn's. The others were given little care, and most are now badly damaged or lost. The lesson learned was an important one. One segment of San Francisco's leadership had wanted to use traditional, hackneyed academic painting to address the public, and the public responded with indifference. The palpable quality of that indifference now mattered, especially if the "public" was going to be enlisted as the beneficiary of cultural work. The public imagined for the murals proved ephemeral. The real audience had its own tastes, and if painting was to re-express specific private interests as a public good, it had better do so with greater force.

THE NEW MURALISTS

Guerin was justified in looking elsewhere for mural painters because San Francisco had so few. Only Arthur Mathews had any practical expertise, and Guerin was hesitant to employ even him. When Mathews did not appear in New York to learn the director's iconographic and stylistic guidelines for the exposition's murals ("the concert method did not appeal to him"), Guerin gave him only a small lunette to paint (Fig. 1.8), banished to a poorly lit niche in the Court of the Palms.[59] The location did not prevent the guidebook writers from seeking out the mural and lavishing attention on it, more than the piece probably deserved. Nor did it sully Mathews's reputation as a leading painter in the city. But the excess of praise pointed painfully to his status as the only local mural painter of any significance.

As Guerin well knew, San Francisco was an easel town. Its major art schools and outlying art colonies had nurtured the painting known conventionally as California Impressionism, a style of landscape painting marked by soft palettes and choppy brushwork, altogether unsuitable for the exposition's requirements. Prior to 1906 only Mathews among the city's painters had received mural commissions with any consistency, including various decorative panels at Horace Hill

1.8 Arthur Mathews, *Victorious Spirit*, 1915. Oil on canvas.
 Collection of the M. H. de Young Memorial Museum.

Library (1896) and the venerable Mechanics' Institute Library (1900).[60] After 1906 he painted murals for the private rooms of the board of directors at the Savings Union Bank (1911), the lobby at the Safe Deposit (1911), Lane Hospital Medical Library, and Children's Hospital.[61] He was chosen to paint a mural for the PPIE because of his continuing work for a patron class with a bent to derivative neo-classicism. In addition, he won great favor from the exposition committee with his proposal for the reconstruction project of a Parthenon-like structure on Nob Hill that he envisioned as a new city hall.[62] When in 1913 he was asked to submit sketches for a set of murals at the state capitol, Mathews offered a series of urban scenes in which temples rise on a hilly landscape near a shimmering bay.[63] This dreamy utopianism, with topography resembling that of San Francisco's south-eastern quadrant, certainly matched the aspirations of the PPIE committee for both the exposition and the city. For a time, Mathews was regarded as the only painter who could transform an old-world order into materials for public art.

But even in 1915 a core of younger easel painters in the city perceived Mathews as anachronistic. Although he had once been an important figure at the Mark Hopkins Art Institute, where many young artists had trained, his work and ideas had become increasingly doctrinaire.[64] For example, he advocated a tradition based on the works of Puvis de Chavannes that after 1910 he had transformed into a moribund pastoralism. In addition, he turned his attention to full-scale interior design, where his few paintings were increasingly dovetailed to his own handcrafted piano cases, tables, and upright cabinets. Guerin certainly understood and approved his thinking about an ensemble, but it could hardly have impressed the new devotees of Impressionism.

In the years immediately after the PPIE a number of younger painters vied for leadership. Two of them—Ray Boynton and Maynard Dixon—were able to attach themselves to a specific group of patrons and, because of those connections, were commissioned to produce the largest, most important murals in the Bay Area before the 1930s. The young muralists were a mismatched pair. Boynton was urbane, highly educated, one of the few staunch supporters among the younger painters of the Francophile Mathews, and well regarded as a writer and critic.[65] After studying at the Chicago Academy of Fine Arts, he came to San Francisco with a portfolio of accomplished paintings he hoped to display at the PPIE. His ambition was to make a career as a fine artist in the city. Dixon, by contrast, was largely self-taught and spent most of his early career as a commercial artist for the *Overland Monthly,* the *San Francisco Morning Call,* the *Chronicle,* and *Sunset* magazine.[66] An early photograph of him by Isabel Porter Collins shows the cowboy identity Dixon liked to affect (Fig. 1.9), hardly anyone's image of a mural painter.

It is testimony to the limited possibilities of the art scene that two such different painters held similar convictions, most apparent in their choice of company, about the paths to artistic success. Both painters sought membership in the exclusive circle of the Bohemian Club, the oldest and most prestigious men's club in the city. Unlike most turn-of-the-century social clubs, the Bohemian Club saw itself as a meeting ground for artists and the wealthy.[67] The relationship was hardly equal, and one early artist member's complaint pithily summarizes the general structure of the membership: "In the beginning, rich men were absolutely barred, unless they had something of the elements of true Bohemianism. . . . Things have changed; now the simply rich become members because it is fashionable. . . . The poor artist or literary man gets in, by hook or by crook, because he thinks he may be able to sell some of his brains to the merely rich."[68] Once admitted, both Dixon and Boynton performed the duties expected of them as artist members, painting scenery for the annual outdoor plays, illustrating the works of the writer members, donating paintings to the club's venerable collection. These were the price of patronage, and for a number of years both artists seemed content to work within the club's relatively circumscribed conditions. The connections served them well, and they were able to establish reputations as leading painters, even though neither could boast a large income from the sale of his works. Within a few years of the PPIE, however, both began to break away from this semi-indentured status, staking an independent claim in wall painting.

With Boynton and Dixon at the helm, the city's public mural movement after the PPIE developed out of the aspirations of two mutually dependent groups. The patron class, associated with both the PPIE and the Bohemian Club, had contacts with ambitious young painters, witnessed the wider interest in Brangwyn's expo-

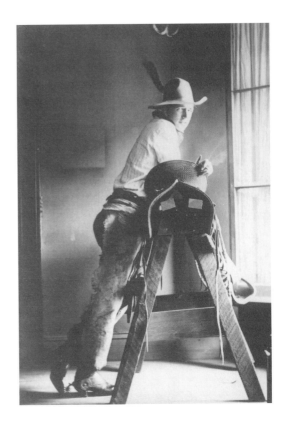

1.9 Isabel Porter Collins, *Maynard Dixon,*
ca. 1895. California Historical Society,
Isabel Porter Collins Collection,
FN-19416, San Francisco.

sition murals, and in the ensuing years commissioned periodic public-minded
displays. Young painters, led by Boynton and Dixon, recognized a void in mural
talent and saw mural painting as a means to achieve status in a developing artis-
tic community. As always, the two groups—artists and patrons—needed each
other. But because they were entering a realm in which their cultural activity
entailed testimony and promotion, they also needed the unpredictable, unstable
public to witness their efforts. The particular visual language public murals de-
veloped, however, could not have been fully anticipated from this convergence of
ambitions and needs or from the example of the PPIE.

MUSEUMS, MURALS, AND MUNICIPAL CULTURE

When Boynton and Dixon turned to mural work, they were entering new territory, since neither had ever attempted to paint anything quite so ambitious.[1] The problems were practical—the sheer difficulty of controlling a large composition, balancing a detailed handling of the surface and the need for legibility from a distance, and harmonizing the painting with an architectural frame—but, just as important, conceptual. After the exposition, painters could hardly consider murals as works for elite viewers only. Although artists worked for specific patrons whose tastes and demands had to be addressed, mural painting itself seemed to matter to those same patrons only when it was available to a broad audience and could be called public art. Boynton and Dixon approached mural painting as an art that could mediate between patrons, who paid for the work, and the public that viewed it. They had to devise a visual language to accommodate these two sets of viewers, one that could also be scrutinized for the painterly quality Cheney imagined.

These are familiar conceptual difficulties for painters, who in taking brush in hand attempt to work through "shared thoughts, points of view, alien value judgements and accents."[2] It is not entirely surprising to learn that San Francisco painters engaged in a good deal of spirited debate about the features of murals before any of them actually confronted the wall. The most ambitious painters studied earlier examples—they looked at Mathews's work, for instance. And they discussed various exposition panels, especially du Mond's and Brangwyn's. Boynton claimed to have read Cennino Cennini's fourteenth-century handbook and worked through its instructions. Perhaps most important from our point of view, by the early 1920s mural painters in San Francisco had begun to look south to the Mexican experiments, particularly Rivera's work.

Dixon was the first to take a clear, forceful stance on the attitude appropriate for a mural painter:

> A lot of dogma has been peddled around of late concerning mural painting—about significant form, volume, dynamics, golden section, space-division, space-filling and God knows what. Nothing apparently is ever said about the WALL. My own dogma, here offered, is that the wall is itself essentially an element of mural design; that since it is the wall that brings the decoration into existence (hence MURAL painting) the painter can do no less than respect it; that he should put his painting on the wall without crowding or obscuring it, planning open areas of it as integral parts of his design.[3]

The emphases are sufficiently clear. Mural painting was "decoration," and being decorative meant paying attention to the painting's two-dimensional support. Dixon rejected the theories proposed by other painters, including the popular and by then somewhat fashionable idea of "significant form," taken from Roger Fry's and Clive Bell's prescriptions for easel work, and the golden section principle, once advocated by Rivera. As Dixon saw it, the painters were searching for a set of procedures, and his own contribution was a praxis-oriented effort to establish clear guidelines in a debate that seemed to lack them. Recognizing the existence of the wall is fundamental, he says; at least this would ground the discussion in artistic practice and perhaps avoid the "shared thoughts" and "alien . . . accents."

In 1925 Dixon provided a concrete example of what he meant. In his *Metalcraft* (see Plate 2), the two-dimensional nature of the wall is indeed apparent, with bodies and spaces interlocking as in a mosaic. The rigid profiles of the main figures, the high linearity of the shield decoration, the rhythmic patterning of hair and crown—all these insist upon a calligraphic surface. The background is scumbled to produce a stucco-like, wall-like texture in the flat areas of sky and cloud. None of the major elements breaks the integrity of surface—nothing appears to move out into space or back into illusionistic depth. The large swath of red cloth, for example, is hardly modulated; the figures' positions and gestures—the squatting stance of the supplicant, for instance—do not break the crisp folds of cloth and patterns of decorative lines; the platform with its step provides no clear sense of recession or protrusion. If the pictorial elements appear to overlap, that effect remains on the surface; we can understand this—that the design's logic becomes apparent precisely when the surface is recognized—as Dixon's claim. The wall's flatness makes the mural cohere and "brings the decoration into existence."

The mural, intended as an overmantel decoration for Dixon's brother, Harry, who worked as a metalsmith, addressed the long tradition of Harry's craft. But even in this work painted for a private space, we can gauge the lingering effects of the PPIE's public murals on Dixon's sensibilities. Both *Metalcraft*'s reliance on myth and its generalized references to ancient cultures broadly evoked the exposition panels. Its frieze-like arrangement follows Guerin's prescriptions, and its major figure, the seated king, is reminiscent of Queen Califa in du Mond's *Westward March*. The strategy to put the mural in dialogue with recognizable PPIE models apparently had its proper effect, and within months of completing *Metalcraft* Dixon received a commission to fill a wall in the busy lobby of the Spring Valley Water Company. In 1926 he began another project, mural decorations for the newly opened Mark Hopkins Hotel on Nob Hill.[4]

Dixon's efforts to intervene in a debate about public murals, outline a set of practical interests, and then paint a recognizably proper mural gained notice in the mid-1920s. The appearance of a mural like *Metalcraft* had been a decade in the making, and patrons now seemed eager to support new work. Dixon proved more successful in securing commissions than most of his competitors, partly because he had intimate connections with Bohemian Club benefactors, and partly because he was able to articulate a consistent program, one linked to Guerin's ideas that also altered and emphasized them in useful ways. He also succeeded, however, as this chapter suggests, because of a new demand for public mural painting, for which his range of ideas and work seemed particularly suited. Patrons liked his insistent attention to the wall and its surface design. Furthermore, the decorative logic he ascribed to murals seemed, better than any other theoretical proposal, to fit the mediating and qualitative standards of public art.

As I argue in this chapter, public murals in 1920s San Francisco no longer needed to address the issue of reconstruction; instead, they had to find ways to address questions of city management and the concerns of an increasingly corporate San Francisco business community. The era known to historians as the decade of welfare capitalism gave new meanings to the word "public" and generated new tasks for public display. Some painters, like Dixon and Boynton, who had played absolutely no role in 1915, gained an advantage by recognizing the new social and political requirements and mapping their artistic interests onto them. This meant, to some extent, redescribing the decorative as a language appropriate to, or at least compatible with, the language of the business community that sponsored their work. That another painter, from Mexico, with entirely different pictorial and political interests, could begin to influence the course of public murals suggests, however, that the language of the new painting was not altogether convincing.

The general attitudes of working-class Progressive Era voters in San Francisco are relatively clear: they strongly suspected the power and presence of corporate industries; they felt ambivalent about noblesse oblige; they pushed for the political reform of city hall but disapproved of leftist demands to push reform into revolution; they advocated nativism and believed in equality before the law; and they saw Progressive social causes in a moral light. All these attitudes seemed to disappear soon after World War I.[5] Or perhaps I should not say disappeared, for the concerns of Progressive Era working classes were taken up and reformulated by a Republican business community, but in the process they lost their coherence as a recognizable political program of *reform.* As reshaped, they were absorbed into a conservative platform advocating business *responsibility.* Although the new business and corporate elite looked to their own interests, they also professed an ethic of efficiency, scientific management, and productivity in the name of humane capitalism.[6] Whereas in an earlier era the unions had nurtured workers' identity as a class, workers were now asked to think of themselves in the context of business and industry. They were encouraged to see businesses as families, caring for their workers and providing them economic security.

In return, the businesses demanded worker loyalty. If they promised workers they would care for their needs and be accountable to them, and if they preferred to make ad hoc improvements rather than be held answerable to social legislation, they advocated a fundamentally conservative agenda, underwritten by the logic of capital. The primary goal of San Francisco's business interests was economic expansion and the growth markets for their goods, and in the 1920s they focused on maintaining an open shop and on micromanaging the lives of their workers and shaping their material desires. In compelling rhetoric business presented its case to the workers, often drawing on the Progressive vocabulary of social concern. No need to join the labor union, so the argument often went, because big business provided job training and job security, home loans and health care. No need to worry about political reform, because reform had already taken place, and city hall, under Mayor James Rolph, was running efficiently. Workers were free to advance their material well-being through purchases.

The PPIE and its centralized decision making had put into place the mechanism to ensure the success of big business in pleading its case to the worker. The fair had elicited cooperation for a collective good, the promise of a better life after the reconstruction; and it required a temporary suspension of conflicts between business and labor for the apparent benefit of all. Furthermore, it substituted cultural advancement and the dream of material abundance for political progress or re-

form. With the stunning displays as undeniable evidence, the exposition suggested that collective activity aimed to achieve material ends, not legislative ones.

This redirection of values was not unique to San Francisco. What I have briefly outlined was part of a much larger transformation brought about by the historical developments of industrial capitalism.[7] As many others have noted, with the steep increase in urban populations; the apparent entrenchment of ethnic minorities in working-class neighborhoods; the strange, often discontinuous demands of factory and domestic life; and the remarkable availability of goods to buy, industrial capitalism helped to bring about a shift in the priorities of workers. The cultural historian Lary May calls this shift the birth of mass culture in California, in which "politics dissolved" and the "consumer ideal" was put in its place.[8] The freedom to choose was shunted from the political arena toward the marketplace for consumer goods. The conservative Mayor Rolph, for example, held office for some twenty years, with no serious challenge or, apparently, the need for one. His growing indebtedness to Fleishhacker and corporate business either did not matter or seemed eminently natural.

With the rise of mass culture, May writes, the laboring classes looked, not to the political debates about business practices that had once galvanized their activism, but "outside conventional public arenas," where they sought "the individualism and classlessness that had been the promise of democracy."[9] In this historical formulation, the growing importance of leisure as part of the rhythm of working-class life coincided with the waning of an element of public life, or at least the struggle for one. The redirection that had been decades in the making elsewhere—the wholesale shift to a consumption ethic—took place rapidly in San Francisco, thanks to the earthquake and fire and the effort to rebuild. The new modern city obscured the shape of old neighborhoods and broke down the old political relations of the city's inhabitants. Without the old working-class neighborhoods, which had been union strongholds with a tradition of violent protest, the new public sphere seemed remarkably de-politicized. Its particular uses had changed, along with its boundaries, and procedures for entry into it. What developed—what the public sphere came to be used for—is crucial to an understanding of mural art's public role. When business and industry controlled that sphere, it served to naturalize the political impotence of San Francisco's workers. Those who controlled the public sphere subsidized municipal culture and in turn asked the populace of the city to endorse their control. They promoted pro forma discussions of the appropriate expression of that culture and relied on the dailies, public assemblies, and various bond issues to limit the debate. The results are not hard to see. In 1923, for example, the city's Industrial Association reported that "three years ago over 90 per cent [of manual laborers] worked under absolutely

closed shop conditions. To-day over 85 percent work under open shop conditions." [10] San Francisco was now more properly "a metropolis of millionaires, free spenders, and fun," as one observer remarked without apparent irony,[11] than one concerned about working-class welfare, which it relegated to the private and internally managed machinery of industry, championing free play instead.

We should be wary, however, about claims that business successfully displaced the welfare of workers as a focus of civic concern, and we might look for marks of struggle and dissent, internal confusion and external resistance. An account of the growth of public mural painting and its awkward relationship to a new municipal museum culture in fact narrates something of that struggle. For the very murals offered as evidence that the masses were the beneficiaries of a citywide cultural program were called upon to ratify the existence of a municipal culture.

The intense investment in a new, conspicuously public cultural policy can be seen most clearly in some events immediately following the exposition. As soon as the fair closed, the exposition committee deeded Bernard Maybeck's Palace of Fine Arts, the fair's most highly praised structure and the city's grandest argument for a more permanent collection of paintings, to an artists' organization known as the San Francisco Art Association (SFAA).[12] The rest of the exposition's architectural gems were simply dismantled; the spectacular exhibits were boxed up and sent elsewhere. With the demand for a public collection of art, a municipal cultural program began to take shape.

In Maybeck's palace, San Franciscans had seen an array of works by contemporary and old master artists (Goya, Velázquez, Tiepolo, and Reynolds), a detailed survey of American paintings from John Singleton Copley and Benjamin West to Thomas Eakins and Winslow Homer, an entire room of Impressionist paintings, another of James McNeill Whistlers, still another of John Singer Sargents, the latest Italian Futurist canvases, works by Maurice Denis and Odilon Redon ("the new and ultra-new schools"), and so on.[13] The examples of artists' works had not been mediocre, either. "While of course, as in all such collections, there is some inferior work, the most pertinent criticism is that there are too many really notable things,"[14] one guide wrote, apparently tempted to be ironical in the face of so much good art. But the sharpest contrast came with the closing of the fairgrounds, when all the borrowed works were sent back to their original institutions. By late 1915 the cavernous palace remained as the lone vestige of a dazzling exhibition of art, with only empty hooks on walls that no longer displayed any of the great works—indeed few works of any sort. The palace's emptiness made the SFAA administrators so anxious that within days of the fair's closing, they produced letterhead for a San Francisco Museum of Art, as if to focus attention on an insti-

tution in the making rather than worry publicly that there were no paintings to speak of. The palace, however, was hardly up to the task of housing a new museum. After a year's worth of traffic, its quickly applied plaster was beginning to chip away, its mossy exterior beginning to look more pathetically wilted than grandly atmospheric, its eastern side starting to slip into the artificial lagoon.

A year later, in November 1916, with the palace continuing to deteriorate, the SFAA was still promoting its vision of a new museum to a San Francisco public. It had secured some thousand subscribers with deep pockets, held a series of traveling exhibitions at the palace (now open to the public as a museum), and boasted forty galleries' worth of art—all on temporary loan. It produced its first issue of the *San Francisco Art Association Bulletin,* promising that this slim journal would continue to appear annually and expand its coverage of the museum's still nonexistent collection. Such efforts suggest a fundamental assumption of the proponents of municipal culture—that the physical space of Maybeck's palace was more important than any collection. Although the building, with its paper-thin walls, could realistically be envisioned as only a temporary structure, the SFAA worked to transform it into a usable physical site and a focus for the debate about public culture. The *Bulletin* provided a necessary description of the building itself and made it a sign of a developing public culture. It established the boundaries for a larger public debate and gave shape to an account of municipal culture.

But while Mayor Rolph and the SFAA backers promoted new public interests, many San Franciscans were unprepared for such a dramatic shift in priorities. With attendance sparse, the palace lost between $10,000 and $14,000 annually in its first eight years of operation. An endowment for purchases did not develop because membership never expanded beyond the original thousand. In 1916 the SFAA was still pleading its case, arguing that it was indeed a "responsible body, ready, willing and able to maintain a creditable museum of Fine Arts *in this building,* free to the public and on such a scale and with an art standard so high that it may be expected to bring national if not international recognition."[15] But as late as 1922, the palace could boast few "permanent" works, and even these were mostly on long-term loan from other collections. The museum received donations from only a handful of prominent San Francisco families who had brought home from their annual European travels a limited number of old master paintings. The museum could not shake the air of amateurishness or stimulate public engagement. Its collection contained such grand objects as a silver watch from the American Revolution, complete with a provenance enumerating its various repairs. Few came to see it.

In deeding the palace to an organization it thought could be trusted to fill a new museum's walls and fulfill the palace's grand claims, the exposition commit-

tee had attempted to map an older structure of cultural relations onto the new municipal culture. The SFAA had been closely linked with the Bohemian Club in its earliest years but more recently had served as one of the few bodies outside the club in which artists could congregate.[16] In its heyday in the late nineteenth century, the SFAA held an annual exhibition, where most of its artist members sold their year's work. By 1915, however, the organization, along with its artist members, had become much more reliant on Bohemian Club funds for survival, and the prize of Maybeck's palace might have seemed a glittering one that could give it a measure of independence. In reality, however, the palace was no prize at all, for behind the scenes, members of the exposition committee moved to take control of the SFAA. The transfer of the palace proved extraordinarily easy to accomplish since a Crocker sat on either end of the negotiating table: William H. Crocker on the PPIE committee and Charles Templeton Crocker as nominal president of the SFAA. The Crockers created two highly visible committees in the SFAA with corporate members.[17] By 1916 these committees had reorganized the SFAA so that its leadership shifted from artists to patrons, who, in that familiar role, counted on the artist members to produce in the same way they always had for a parvenu class. The painters could not have been pleased, to judge by the new museum's collection, which by the mid-1920s consisted of a single, quite modest, landscape painting by the reliable Arthur Mathews.

Besides reorganizing the SFAA, the Crockers and the committees they controlled restructured the SFAA's own art school. Pedro Lemos, then director of the California School of Design (the successor to the old Mark Hopkins Art Institute) resigned so abruptly as to give rise to speculation that he had been forced out. The school's name changed to the California School of Fine Arts (CSFA), bringing it symbolically in line with the Palace of Fine Arts and the new SFAA agenda. Lemos's successor, Lee Randolph, signaled a new emphasis in the school's curriculum. An outsider to the city's art scene (he had visited San Francisco briefly in 1909 and finally settled there in 1913),[18] he had been trained as a painter in the venerable Parisian studios of Jean-Paul Laurens, Léon Bonnat, and Olivier Merson. The Bohemian Club certainly approved this conservative French connection. Randolph was frequently described as refined, aristocratic, and thoroughly Europeanized; one early chronicler characterized him as "steeped in the history of art . . . even-keeled . . . [and given] to promoting civic art life."[19] Students faced a far more rigorous schedule of classes and studio training during his tenure than previously. New teachers who claimed firsthand knowledge of Parisian developments (though they clung to late-nineteenth-century examples) stressed sketches and preliminary work, life and figure drawing, and the need to create "meticulous craftsmen"—these were the new academic emphases at the renamed CSFA.[20]

Randolph's Beaux-Arts program also included lessons in mural painting based on the work of Puvis.

This introduction of mural painting into academic training is a key moment in the history we are tracing. Prior to Randolph's tenure at CSFA, San Francisco's broadest introduction to wall painting had been the work commissioned for the exposition, which was, as we have seen, based on a general but hardly riveting classicizing model. Given the relative popularity of Brangwyn's panels, the decision to push forward with an emphasis on Puvis's approach to mural painting went against the grain. Furthermore, Puvis was taught, for the most part, at second and third hand—not by highly trained teachers who had scrutinized the works themselves. Ray Boynton, for example, was hired to teach the newly approved *buon fresco* (or true fresco) classes because he could claim to at least have *seen* a Puvis mural. With Boynton's appointment the proponents of a public culture gained an institutional means for promoting mural work. It did not even matter that Boynton was no Puvis; it did not even matter that a vaguely academic model had not much inspired the local audience. Now, young San Francisco mural painters were being produced, and their training was based on the principles of the best-known French precedents.

Well before artists could be trained in the academy to paint murals, Mayor Rolph attempted to capitalize on works from the PPIE. In 1916 he had the two panels of du Mond's *Westward March* hung in the newly completed Public Library Building, the latest of his municipal projects.[21] But the reinstallation of these panels only pointed to the still-awkward development of wall painting, the gap between patrons' desires and available materials. Du Mond's work fit poorly in the new location: long horizontal panels suited the subject of historical progress, but the library's interior had no walls that could accommodate them. The paintings had to be cropped—the rectangular panels turned into pediment-like triangles—to fit over two arched second-floor doorways, to the Reference Room and the General Reading Room. As a result of the changes, the momentum of the composition, which helped to suggest the forward lurch of civilization, was lost. San Francisco's patrons, noting the mismatch of the mural to its new site, and perhaps looking skeptically at the mayor's appropriation, commissioned no other murals for public buildings.

The failure of du Mond's rehung canvases in 1916 puts the enthusiasm for Dixon's *Metalcraft* in 1925 into better relief. In the interim the old guard turned inward, engaging artists to paint murals for private or domestic, not public, spaces. Through Bohemian Club connections, for example, Boynton received a number of private commissions for murals in San Francisco: a small work for a courtyard wall of the exclusive Hill Tolerton Print Room (1917), a large altar panel

and two smaller side panels for the Canon Kip Memorial Chapel (1919), and, perhaps most ambitious of all, a seventeen-foot-high mural in the Bohemian Club itself (1921). But these were entirely private commissions. There was no specific mention of them in the daily newspapers or art journals, and if critics like Cheney examined them, their comments did not appear in print. And it is good that they did not, since they are all poorly managed works, unevenly painted and awkwardly composed—hardly the performances to command wide interest. One can readily imagine Cheney bristling at their blandness.

Both Randolph and the major SFAA patrons understood the usefulness of wall painting to a public culture, especially after witnessing the surprising interest in Brangwyn's exposition works. Certainly each proponent of mural painting had different motives—Randolph wanted open acknowledgment of the reconstituted CSFA as well as public endorsement (even if managed and manufactured) for his academic approach; major patrons wanted the symbolic embodiments of centralized power and redirected municipal energies; and the painters themselves wanted the chance to capitalize on financial support to develop an artistic scene outside the Bohemian Club. Although murals were among the few works of art that could be commissioned at relatively low cost but could garner great publicity and wide visibility, the PPIE had suggested the difficulty of painting murals in a city where few mural painters were being trained. Randolph added the heretofore marginal studio discipline to the curriculum; his supporters, who had backed his hiring of Boynton, hunted down other painters to hire. They even began to think of training artists in the demanding, time-consuming, and expensive *buon fresco* technique, as opposed to encouraging mural painting on movable panels as at the PPIE, since there were so many new stucco and plaster walls going up in the city, their white emptiness beckoning artistic play.

Only in the mid-1920s did murals again appear in a public context. This reappearance coincided with the changed fortunes of the embattled SFAA in its attempts to establish a San Francisco Museum of Art. When in the mid-1920s the SFAA pushed through a series of bond issues to fund new museums, the proponents of murals saw an opening and proposed wall paintings as the foremost sign of municipal culture. The interests of patrons, painters, and administrators converged once again, but, as with the PPIE, conflicting ambitions lay behind that convergence. Although large-scale wall painting elicited broad support, it was also asked to subsume and resolve far more conflict about the proper roles for public painting than it had at the PPIE.

When murals began to appear in relatively large numbers in the mid-1920s, they met with a critical success they had not heretofore enjoyed. The shift had

much to do with the new readiness of local painters: they had finally begun to develop the necessary artistic and conceptual skills to try their hands at large-scale work. But in addition to the School of Fine Arts director's encouragement of rigorous training, other factors—the momentum of industrial capitalism, the "birth of mass culture," and the needs of a patron class—helped to shape the climate for murals and the public support of the arts.

PUBLIC SPACE

San Francisco in the early 1920s had become what its major corporate industrialists had wanted, a city devoted to commerce. Montgomery and Sansome Streets were hailed as the "Wall Street of the West." Their magnificent tall buildings cast deep shadows across the long business corridor, where the trading of corporate stocks reached an unprecedented scale. Downtown, major department stores and corporate branch offices sprang up side by side in an area some three miles long and a mile wide that stretched from the waterfront to Van Ness Avenue. On broad crowded boulevards retail businesses and wholesale trading boomed. Docks lined the city's northern and eastern shoreline, from the strip of filled land that had once housed the exposition to Fisherman's Wharf and all the way past China Basin. Only New York City could make larger claims about its imports and exports. Streetcars and cable cars linked wharves, banks, warehouses, and department stores. They gave evidence of the new, seemingly limitless circulation of capital.

An early 1920s photograph of the intersection of Powell and Market Streets by Gabriel Moulin (Fig. 2.1) suggests just how crowded the streets and sidewalks had become. Cable cars roll down Powell Street toward the turntable at Market Street, where passengers board for the ride uphill. The crowded picture does not necessarily represent a typical San Francisco street scene—its depiction of lively commerce suggests at least an element of boosterism. But the point is that a photographer like Moulin did not need to look hard to find crowded streets and the fast-paced downtown rhythm that exemplified corporate-style modernity. To Moulin and photographers like him who made their living picturing a new San Francisco, the city's most appropriate sites were found amid its new businesses. Another contemporaneous photograph of Market Street near Fifth Street suggests the importance of advertisements as proper subject matter for these photographers.[22] No picture of the urban scene worth its name could quite do without a busy street filled with them—flashing lights, billboards writ large, a sign for a vaudeville act next to one for a chop suey restaurant, an ad for Wobber's stationery next to another for Old Homestead Bread, a radio tower for KPO radio, an-

2.1 Gabriel Moulin, *Market and Powell Streets*, ca. 1920.
© Moulin Archives, San Francisco.

other for the Sherman and Clay Piano Company. The competing displays suggested a distinct form of modern life associated with the traffic of goods. In recording them, the photographers acknowledged consumerism in full flower.

By the early 1920s mass-produced, affordable goods filled the shelves, and the major stores, in turn, were packed daily. With competition fierce, the newspapers began to devote far more space to advertising than they ever had before. Buying and selling took place, not just downtown, but in virtually every neighborhood, many of which had a commercial strip, though none was as photogenic as down-

town. The new neighborhood stores served as landmarks for residents and strollers. "If we had started our walk down around McAlister," a writer named Jerry Flamm recounted of his Jewish neighborhood, "and then headed up Fillmore toward Sutter, making detours on the side streets, we would have covered the heart of the Fillmore district."[23] But instead of listing homes, families, synagogues, or meeting houses—the "heart" of the Jewish neighborhood—he tallies its many retail spaces: the Cat and Fiddle candy store, the Royal Ice Cream Company, Langendorf's Bakery, the Ukraine Bakery, the Jefferson Market, the New Fillmore Theatre, Peacock Confectionary, and so on.[24] Five bakeries, six theaters, markets, restaurants, clothing stores—all with prominent storefronts and street signs—these constituted the reference points of neighborhood life.

The dominant role of advertising in the visual culture of the 1920s is now a commonplace of historical thinking.[25] So is the recognition of an attendant shift in business practices that focused on social welfare. And the two are intimately linked. Large-scale employers instituted in-house programs to assure the welfare of their workers, convinced that this responsibility was theirs alone—it did not belong to government or to ethnic associations, and certainly not to labor unions. With the rise of an industrial patriarchy, the communal life of the city's workers—based on shared interests and embodied in the activities of organizations and of neighborhood ethnic groups and the kinship bonds that supported them—fell into decline. Commerce replaced community in the workers' lives.

San Francisco's streets gave material evidence of the change. By the mid-1920s the public sphere was no longer either a physical or a conceptual space for the debate of issues but a commercialized space for the display of business's prestige, prominence, and goodwill.[26] No wonder Maybeck's palace was so important, since its physical beauty could attract the notice of a citizenry more attentive to presentation than to political debate. Corporate industries used advertising to establish their authority, providing guidance (and products) for modern social and cultural life. In this climate of beneficence, the new commercial public sphere still echoed the Progressive Era's public sphere because both legitimated as worthy of "discussion" whatever came within their boundaries. But in promoting consumption and micromanaging an urban population's collective desires through advertising, business gave a curious public value to its own guidance, testimony, and anecdote and encouraged public conversation about the products business offered. In an environment of display, critical arguments focused on such topics as credibility and the rhetoric of goodwill. But to argue these subjects was to argue according to the logic of business itself.

"Spectacle" might be the aptest term for the streets, for we can say that the commercialized public sphere embodied a "spectacular society."[27] The practice

of everyday life in an urban space meant adopting, and adapting to, social practices and social relations as business interests had redefined them. The French Situationist Guy Debord writes of "urbanism" as the "seizure of the natural and human environment" by capitalism, which dominates by remaking what it has seized.[28] Perhaps Moulin's photographs of the congested downtown intersections make better sense when we understand that his sense of what constituted the urban scene had already been shaped by spectacular society.

Politicians at City Hall and the supporters of municipal culture developed an enthusiasm for bunting and parades related to the remaking of public space by business interests. The SFAA, in publishing its *Bulletin,* engaged in a similar species of boosterism. In it the museum could be displayed to the public as a collective good rather than announced as a project for discussion and debate. By the mid-1920s commercial and municipal boosterism, having taken firm hold, began to take effect. Citizens, surrounded by an "aura of good will,"[29] were primed to accept their role in subsidizing a city museum.

The issue before San Franciscans was no longer only Maybeck's Palace of Fine Arts but also another museum, the Palace of the Legion of Honor. The Legion was the pet project of Alma Spreckels, one of the prominent heirs to the great Spreckels sugar empire in California; of Herbert Fleishhacker; and of the contentious newspaper tycoon William Randolph Hearst.[30] This was a formidable trio with ample funds, a high profile, and (through Fleishhacker) control of the SFAA and the Park Commission. That a project like the Legion could be promoted in the 1920s suggests how far the public culture movement had come. Here was an opportunity to fill an embarrassing civic void—to build a museum for a collection of fine paintings, in this case, the one owned by Spreckels.[31]

Hearst did his part by applying constant pressure on the city's voters in his newspaper, the *Examiner,* and soon the art magazines added their voices. The *Argus* urged upon the public the need for a new cultural institution:

San Francisco is frequently proclaimed as an art center—but only in San Francisco. The rest of the country, artistically speaking, has for generations looked expectantly in our direction. For them, California has long been a land of aesthetic promise, but of promise deferred. That basic conditions there favor genuine artistic achievement is universally recognized. A certain freedom and happiness in life, an energy, directness, sincerity and a fine and eager enthusiasm, frank in its intensity, which characterize this unusual city were also outstanding traits in many of the world's greatest creative epochs in art . . . [but] San Francisco is not yet an important art center in appreciation, in collecting or in producing. . . . Every city of importance in the world now

has decided that a museum of the history of art is one of its most essential institutions, that no city can call itself truly civilized which does not supplement its education by constant reference to the whole range of man's greatest achievements in the realm of beauty.[32]

The argument in the *Argus*—that "every city of importance" requires a museum culture—if it was not subtle, was nonetheless effective, as were other calls for public support. In 1924 voters approved a measure providing for the subsidy and maintenance of the de Young Museum and the Palace of the Legion of Honor as civic collections, and in 1926 they voted to underwrite not only the maintenance but also the rebuilding of the rickety Palace of Fine Arts. Spreckels's and de Young's private collections thus went on stage as evidence both of the city's new status as an important art center and of its claims as a public cultural environment. The city now had three museums with diverse collections and at least a few significant works of art, all open to the public. And it would soon have public murals.

THE NEED FOR PUBLIC MURALS

The developments I have traced—the resignation and replacement of the SFAA's director and the ensuing shift in its curriculum to foster mural painting; the public subsidy of a foundering effort to establish the Palace of Fine Arts as a museum; the transfer of private collections to civic institutions for ceremonial display—are all tied to the increasingly centralized city government and the expansion of the range and depth of business's influence in the city. San Francisco's Industrial Association could celebrate an 85 percent open shop in 1923, two of the three museums gained taxpayer approval in 1924, and Dixon obtained a Spring Valley Water Company mural commission in 1925. The crudeness of the chronology should not blind us to its ideological coherence.

The job of public art in this environment was to help transform private interests into the general interest and to displace the issue of public services with that of public art. Business interests, to do this, had to elicit from the public "consent, or at least benevolent passivity."[33] Public mural painting was to be a sign of public consent to centralized control.

If the need for public murals can be explained in such terms, the form they took resists explication because of its deep contradictions. What is the look of control that masquerades as the look of consent? Or, to put the question in more familiar terms, how does mural painting take shape between the demands of patrons and the expectations of viewers? In fact, we are faced with the possibility of

an embarrassing mismatch between the elitism of public murals inspired by the works of Puvis de Chavannes and the tastes of an audience with preferences much stronger than anyone had been led to believe for the animation and color exemplified in Brangwyn's panels. Nowhere was the disjunction more apparent than in the elaborate theorizing of mural painting—from Dixon's early arguments about respect for the wall to Boynton's Puvis-based pedagogy. By the mid-1920s, these two painters' ideas (apart from their murals) had garnered enough attention and promoted enough discussion so that San Francisco's artists, critics, and patrons who belonged to the Bohemian Club began to attach to them a high level of importance. The *Argus,* when it appeared in 1927 as the city's first independent magazine devoted exclusively to art, immediately turned its editorial attention to mural theory, and Boynton's and Dixon's ideas were championed as alternative bases for public mural painting in San Francisco. But the theoretical writing generally has an anxious tone, Dixon's usual confidence notwithstanding. Here, for example, is Boynton:

> The banal tricks of oil painting have left us stammering before the wall, repeating shopworn theatrical commonplaces, making empty gestures for design . . . not knowing the difference between enrichment and display, without even the language of a design that has monumental dignity or the authority of true decoration. . . . [The mural's] problem is enrichment, the softening of rigidity, nobility of spacing, the heightened reality of [the wall's] presence. Content must submit to established formal order.[34]

The pressure to mediate underwrites Boynton's ideas. The mural painter faces an "established formal order," to which all content must submit—the brute materiality of the wall exerts its tyranny. The exposition painters had faced these problems, and as we have seen, critics like Cheney worried about them too. Painters weighed the authoritarian order of the wall and felt their own subjection to it. Boynton certainly did. He felt the undeniable pull to work within prescribed limits, and he was torn. Soften the hardness of the wall, he says, make noble its deadeningly barren spaces, and yet heighten its very presence. Make mural painting a sophisticated program of decorative enrichment, knowing full well that its fundamental job is to be mere display. Create monumental dignity and try to achieve something better than commercial theatricality; but know that any work of high quality, any "true decoration," must inevitably fit within a given order.

As Boynton and Dixon understood, murals were asked to draw attention away from themselves and to their environment, to decorate modern public spaces in which new social and political orders were being constructed and solidified. Their

designs must dovetail with the grand architectural schemes in which those orders were most legibly inscribed. The decorative logic of mural painting readily accommodated the needs of its patrons—hence the great ease with which Guerin's ideas came to permeate Dixon's and Boynton's. Painting that was essentially decorative seemed to drain off any hint of controversy and to insist on its ability to complement a municipal culture of display, without content or visual argument. When Boynton made such claims for mural painting, the critics missed his subtle irony and unproblematically concurred.

For the critics, these theoretical discussions led to a surprisingly rigid set of standards for art criticism. Despite contradictory claims in Cheney's comments on the murals at the PPIE, easel painting was judged differently from mural painting, which was scrutinized primarily for its ornamental qualities. Moreover, easel painting was considered private, individual work where idiosyncrasies were encouraged, whereas murals were communal work, accountable to the larger decorative project. In this sense, we ought to see the diverging demands on the painter as two halves of modernism: one pursued the ambitions of high modernist painting, and the other was bound by what Terry Smith calls Corporate State modernism,[35] which in the case of San Francisco demanded from the mural artist accommodation to the constraints imposed by architects and the demands made by patrons. A writer for the *Art Digest* attempted to describe this situation in less confrontational terms: "The most hopeful thing is the eagerness of artists to cooperate with architects and with manufacturers. They do not scorn to work with builders and industrialists . . . even those who heretofore have preferred the easel picture." [36] But the image of the artist as an independent producer, combining his skills with the architect and industrialist, was valid only insofar as that artist did not violate a decorative principle.

Even public mural painting that followed a decorative logic could engender an instability in the relation between ostensible purpose and actual response. The visual language of decorative murals did not necessarily inspire the public to respond enthusiastically. A set of murals that Boynton painted in 1928 for the Music Hall at Mills College in Oakland, California, suggests that instability for us.[37] "Barbaric," one observer wrote in mock horror.

Before turning to these murals, however, we can finally introduce Rivera into our account. It is perhaps appropriate that he has remained a ghostly presence in these pages, for he played a similar role in the early development of mural painting in San Francisco. His ideas began to circulate in fragmented, garbled form well before his arrival.

Rivera's influence in San Francisco was felt in three stages. First, several local

artists traveled to Mexico to study his techniques, the most prominent among them Boynton himself, who went south sometime in the mid-1920s. As wall spaces multiplied and commissions increased, Boynton understood that, despite the mastery with which he was credited at the CSFA, he required instruction from a more accomplished mural painter. On his arrival in Mexico he found Rivera at work on his massive Communist-inspired series at the Ministry of Education and the grand monumental panels at Chapingo (Fig. 2.2). The descriptions by Boynton and others aroused considerable interest among mural painters and dealers, who wanted to see the work firsthand. Their interest led to the second important contact with Rivera. A newly established gallery, the Galerie Beaux Arts, began to seek out the muralist's preparatory drawings.[38] The Beaux Arts was a cooperative venture by several young artists who belonged to the Bohemian Club and an enterprising dealer named Beatrice Judd Ryan, and its members included Boynton and Dixon. In 1926, with Boynton's help, the gallery imported and exhibited a group of Rivera's recent drawings and mural sketches, all of which excited great interest (nineteen of them sold.)[39] In the reaction to the show we can measure the distance traveled in a decade. By 1926 interest in murals was strong enough to sustain a show consisting merely of sketches of Rivera's work. But the keen interest in these drawings also produced a counterargument that championed the decorative logic that was now part of CSFA training over the obviously social realist features of Rivera's Mexican mural work. The criticism of Rivera belongs to the third stage of contact, beginning roughly in 1928, when critics went to Mexico City to assess Rivera's current projects. They helped to create concerns about Rivera well before the mural painter ever arrived in San Francisco.

The most influential of these critical accounts was that of Rudolf Hess in the *Argus,* which reproduced the Education murals for the first time in a San Francisco paper. Hess's rhetorical stance was that of the innocent abroad: he happens to be in Mexico, he says, having "no special purpose in mind, other than to see the country and its people."[40] When he turns to a detailed examination of the murals themselves, he finds them disappointing: "I had seen, from time to time, reproductions of portions of them. I scarcely know what I expected they would be, but I was not prepared to find them what they are. If they are meant to represent Mexico, it is not the country that I traversed." Not only do the murals seem misrepresentative, but they are scattered, inconsistent, and disorganized: they are "a monstruous botch—a mess of odds and ends, and mean nothing." Worst of all, they evidence a pictorial understanding at odds with the very idea of mural as decoration. Hess objected, not so much to Rivera's political views (though, ultimately, he does not agree with them) as to the inappropriateness of murals for Rivera's subject matter. That would have been better served in a series of canvases,

2.2 Diego Rivera, *The Liberated Earth with Natural Forces Controlled by Man*, 1926–27. Fresco. Chapel, Universidad Autonoma de Chapingo (Photo © Dirk Bakker).

"which, through the medium of exhibitions, would have reached and benefitted a greater number of people, not only in Mexico but throughout the world." Hess may have expressed here a more generous response to the content of the works than he actually felt (he shared none of Rivera's leftist ideas), but his comment also indicates his embrace of the division between mural and canvas work that deems the canvas more appropriate to political art. He concludes with a stinging critique, one that helped to shape the attitudes of San Francisco's more conservative patrons and critics to Rivera's public mural painting:

I should say that his predominant characteristic is a conscious showmanship. He is the P. T. Barnum of Mexico. Possessed of tremendous poise, he ap-

proaches his painting scaffold as a statesman would approach a platform from which to deliver an oration. He dominates his audience and his "stage" with the easy confidence of an experienced actor. His oration he delivers by translating it into terms of form and color, and stating it on the walls.

Hess helped to lay the groundwork for an interpretation of Rivera's work, linking it to an audience "out there," attentive to his murals. Precisely what it read in his work was unclear, but the carnivalesque P. T. Barnum allusion suggests that Rivera's audience was construed as spectators at a performance in which the political presence of the painter was inscribed.

Boynton, fresh from his experiences with Rivera, reported to Mills College with new design, compositional, and expressive ideas born from that encounter. On the one hand, he faced a group of patrons whose interest in, and use of, murals would dictate the course of his career. On the other, he began to see wider possibilities for mural painting that seemed at odds with the role these patrons expected murals to play as public art. The Mills murals were a test case for Boynton, who attempted to accommodate both his own and the patrons' desires and, perhaps more important, to garner the attention of a public that might help to shift the course of art being done in its very name.

The total wall space for the Mills murals was much larger and potentially more unwieldy than any chosen for a mural since the PPIE. The commission called for six great horizontal panels and eight smaller vertical ones on the north and south clerestory walls of a concert hall (each of the six main panels was larger than du Mond's *Westward March;* they surrounded the auditorium at the gallery level); a sixteen-by-thirty-eight-foot organ screen painted in tempera; four tiers of exposed beams and ceiling panels, covering the entire breadth and length of the auditorium; and two jutting, flat-faced screens that framed the main stage. As one critic proclaimed, the murals would be the largest west of the Mississippi.[41] The sheer size led one writer to exclaim excitedly that the project portended "an event of real significance in the history of western art." Another suggested that the murals were a sign of "California's coming pre-eminence in art."[42] Although these criticisms seem overstated, they underscore the keen attention the commission received and the eager anticipation of Boynton's pictorial and design solutions.

Boynton's murals failed to justify the excitement surrounding them or the importance prophesied for them. Boynton chose music-as-inspiration as a general theme and arranged his panels under two subthemes: on the north wall, three scenes devoted to sorrow, and on the south, three to joy. The central organ screen is a landscape, *The Golden River,* and the two corner panels are painted as illumi-

nated manuscripts, with the opening words of the Magnificat stenciled on a gold background. Despite the claims that the murals departed from anything San Franciscans had ever seen, Boynton's panels relied heavily on the lithe figural types familiar from the PPIE and the allegorical subjects common in Arthur Mathews's works. In the final panel on the north wall, for example, Boynton depicted Orpheus and Eurydice (see Plate 3), at the moment of Orpheus's fatal glance back at his lover. In Boynton's static scene the characters hardly engage each other, and they do nothing to suggest the tragic moment. In comparison with du Mond's murals, the Orpheus panel is frozen, the lyre player encompassed in airless space. In comparison with Brangwyn's, it reveals its composition too overtly, making its underlying structure too apparent. The figures assume rigid oppositional postures, the patches of earth swell up like props, the water foams like filler, crudely mediating between middle- and background. Worse, the brilliant geometric patterns on the ceilings and beams compete for attention with the figural scenes on the clerestory; the ceiling design reemphasizes the structure of the mythological panels rather than contrasts with it, and the viewer wants to read the undulating cloud and water forms as belonging to the dazzling blue and orange patterns above, dismissing the narrative altogether. The murals' unfortunate mix of pattern and figure, one contemporary concluded, was an attempt to break away from the decorative logic that ruled mural painting in the city: "Those who know the work of Boynton have expected that these murals would be interesting in treatment, forceful in character, and delightful in color. They are all this and more. Those who thought only of the present-day mural were expecting the pale, opaque-thinness and delicacy of the early Italian masters of tempera, and Puvis de Chavannes' revival of the dull daintiness of the old-time mural."[43] Boynton's work here is heralded as a harbinger. But after this writer leads readers to anticipate that she will praise the work, she has little to say, except to point to the deep colors and to remark how the "figures throughout the large mural panels are remarkably unobtrusive."[44] That relative silence, with its implicit concession that the subjects of the murals hardly warrant consideration, was tantamount to declaring Boynton's work a failure.

The awkwardness of the murals resulted from Boynton's decision to apply some of the lessons he had learned from Rivera to the logic of mural painting as it had developed in the city. What we might read as the concentration of decorative motifs on the ceiling can be related to the bright framing of Rivera's Chapingo murals (see Fig. 2.2); and it is clear that in painting the Mills murals, Boynton attempted to redo the Chapingo chapel, with its complete coverage of the wall, its strong geometric patterning on the ceiling, and its interrelated quasi-mythological subjects on the lateral panels. But whereas Rivera's figural panels stood as forceful

visual statements, intended to hold their own amid the intense decoration of the surrounds, Boynton's failed to do so. The critics' perception of the figures as inconspicuous suggests how the Chapingo-like patterning overwhelmed the mural's mythological program.

Boynton's own statements about the Mills murals suggest his awareness of the conflict between figural and decorative panels. He defended the imbalance of the room:

> The ceiling is perhaps daring, but the whole thing is daring. I have done nothing in the room timidly or half-heartedly. I have not tried to re-create any period or to copy any other ceiling or to give it any appearance of age, but I have tried to arrive at a sustained richness throughout the upper part of the room in contrast to simplicity below. . . . The ceiling grew out of the frescoes and to me the two have an integrity of design and color. . . . To this end I have avoided obvious allegory and the obviously pictorial. My aim has been to evoke dreams rather than thoughts.[45]

One could interpret Boynton's text as the application of Symbolist ideas to the figurative panels (the "dreams" rather than "thoughts"). This conceptual structure may have originated in his interest in Puvis (via Mathews). But his argument also seems compensatory, especially after he had so forcefully imported Rivera's ideas into the mural program. It was as if he had invoked Symbolist language to justify the imbalance between decorative and figural elements and to account for the resulting opacity of his side walls. Boynton probably could have said little to change critical opinions anyway.

The episode of the Mills murals suggests the difficulty of mapping Rivera's stylistic and compositional ideas onto the decorative principle. It was an attempt to "go public"—to evoke the responses of another audience—by bringing in a mural language that, critics like Hess imagined, had some galvanizing power. But there was no alternative public ready to respond, if by that we mean a group of viewers willing to stand up and speak. Part of the reason was simply that the Mills murals were hardly available for mass viewing. Painted in a concert hall on a private campus in the Oakland hills across the bay from San Francisco, Boynton's commission was circumscribed from the start. The attempt to go public only proved how little the patrons of murals had any kind of public, except a discursive one, in mind. But even if there had been a public audience receptive to a Riveraesque mural, it would scarcely have known how to respond to Riveraesque language stripped of its overt politics.

Given the ambivalent response to Rivera's works, we might wonder why he was brought to San Francisco at all. That he was suggests something of the dissatisfaction with the mural scene and its relationship to the demands of corporate patrons. Because three new patrons—William Gerstle, Timothy Pflueger, and Albert Bender—prompted a shift in the emphases of public mural painting, it is worth briefly tracing their commitments, priorities, and ambitions.

On the face of things, these three businessmen patrons seem no different from their fellow Bohemian Club members, on whom the city's painters generally depended. Gerstle owned and operated a shipping line based in San Francisco. That much of his wealth was inherited from the great Sloss and Gerstle families aligned him with the old guard (through marriage, he was even distantly related to the Fleishhackers), a connection that secured him favors and gave him power among the monied classes. When Crocker died, for example, he rose to president of the SFAA; he also served as president of the city's Chamber of Commerce.[46] Pflueger was an extraordinarily talented architect, whose firm was perhaps the only major competitor to that of Arthur Brown, Jr., the mayor's usual choice. He benefited greatly from the ambitious City Beautiful project and designed nearly all of San Francisco's most celebrated Art Deco buildings from the 1920s and 1930s. Such was his energy and growing prestige that by the mid-1920s Pflueger could move aggressively to capture some of the commissions once reserved for Brown, with a reasonable chance for success. Bender, born in Ireland, came to San Francisco as a teenager in the early 1880s. He amassed a fortune selling insurance and became an important advisor to Mayor Rolph's and the SFAA's museum administrators.

As a group, the three new patrons represented a new kind of cultural player—that mix of university learning, political savvy, industrious entrepreneurship, and liquid capital—and differed considerably from earlier patrons of mural painting. They sympathized with some of the ideals associated with California Progressivism. Although their general sympathy did not lead them to lobby for Progressive reforms in the reconstruction battles—nor did it alter Gerstle's general hostility toward waterfront unions, whose earlier strikes had directly affected his own business[47]—Rolph found it useful. It recalled his own reformist ideals (he had once run for office on a Progressive platform), and even with Fleishhacker as a powerful conservative voice in his own administration, Rolph found ways to favor the three patrons at city hall. Moreover, each man was genuinely interested in developing a new art scene in San Francisco. Unlike the Spreckels family, the Hearsts, or the de Youngs, who cared little for local artists, the new patrons involved themselves in the doings and welfare of the city's painters. The few painters from this

early period who wrote memoirs placed trust in all three. Gerstle, for example, had done much to cultivate the artists, spending considerable time at their studios and relocating his own business office closer to the Montgomery Block, or Monkey Block, the enclave where most of them lived and worked.

One painter, who recalled Gerstle with fondness, also showed familiarity with him and his day-to-day life: "He painted, himself, but he realized that he wasn't a very good painter, but he had a marvelous studio for years at 716 Montgomery Street. . . . [H]e would be at his office with Alaska Commercial in the morning, and he'd go to that studio every afternoon."[48] True, he was not a very good painter, but his vicarious pleasure in being around artists brought them tangible benefits. As president of the SFAA, he was instrumental in securing temporary teaching positions for several Montgomery Block artists at the CSFA and in securing media attention for their gallery shows.

Bender similarly befriended the more ambitious artists in the Bay Area and sustained many who were outside the Bohemian Club circle. He was one of the earliest, most reliable benefactors of an important group of San Francisco photographers, including Ansel Adams and Edward Weston. Adams's account of their first meeting suggests the figure Bender cut:

> Promptly at ten o'clock, I was ushered into Albert's office at 311 California Street. He was a partner in a leading insurance firm in the city, not large, but possessed of a remarkable clientele. His desk was a chaotic mass of letters, envelopes, postcards, books, and pamphlets: an ever-accumulating mound of memorabilia into which he could delve and immediately find whatever he sought. He greeted me warmly, talked a minute with his staff, made a phone call, then took me to a small table, pushed aside some books and periodicals, and said, "Let's look at them again." During his thorough inspection of my photographs he received at least two visitors and six phone calls, but nothing disturbed the intensity of his concentration on my work. After he finished, he looked me squarely in the eye and said, "We must do something with these photographs. How many of each can you print?"[49]

Adams describes a new kind of patron. Bender is devoted to business but sensitive to the arts; he is enormously energetic but remarkably concentrated; his busy office, which serves the city's elite, is also a space for artistic decision making. In this picture of Bender corporate-style modernity and investment in the arts intersect.

The new patrons seemed receptive to a new view of public art. (The city's artists often described Bender, for example, as an enthusiastic supporter of artis-

tic innovation, even though his tastes were never so catholic. Even so *retardataire* a photographer as Arnold Genthe, once the darling of Nob Hill, turned to Bender in the midst of the depression when his patrons began to abandon him.) [50] With the broader public's receptiveness to artistic projects and their own acquaintance with San Francisco's artists, Gerstle, Bender, and Pflueger entered the debate over public mural painting. Public art, that is, now had competing ideological and political bases. For example, the San Francisco Arts Commission was established in 1931 (led behind the scenes by Gerstle) to oversee the city's policy on the arts. It provided a municipal counterweight to cultural organizations controlled, not by the city, but by self-perpetuating boards dominated by Spreckels, Hearst, and Fleishhacker. [51] As one confidante wrote to Gerstle about the possibility of funding the arts independent of the new museums, he hoped the commission could "do a great deal to unify public opinion, and bring political pressure to bear through its united membership in the political support of art in this city." [52] The writer of this letter, E. Spencer Macky of the California School of Fine Arts, suggested that middle-class voters might well help to shift the ambitions of a municipal culture.

We have already met Bender in ghostly form, since he was Boynton's patron for the Mills project. By 1928 Bender had begun to stake out a claim in art patronage by establishing a collection at the Mills College Art Gallery. [53] With fewer resources than any of San Francisco's other major patrons, he began building that school's collection by commissioning the work of local artists and donating it to Mills, suddenly giving the gallery the most important collection of contemporary work in the Bay Area. [54] His interests included, almost from the beginning, monumental wall painting and the Mexican example. Bender and Rivera corresponded as early as 1926 about future work, with Boynton serving as a go-between, reassuring each party of the seriousness of the other's intentions. Gerstle too had contact with Rivera, the sculptor Ralph Stackpole acting as intermediary. Like Bender, Gerstle was initially unsure about Rivera's work. His account of his first viewing of it, a painting presented to him by Stackpole (Fig. 2.3), reveals the anxieties prompted by the critic Hess: [55]

> The subjects seemed to be a characterless Mexican woman and her infant.
> The woman was heavy, coarse-featured, huge-limbed, almost gross. The child
> in her lap looked like a rather large cloth doll loosely stuffed with flour. Only
> three colors had been used by the painter: a dismal brown, a washed-out
> lilac, several shades of much faded overall blue. I thought it a pretty poor
> painting and was greatly embarrassed when Stackpole gave it to me. To please
> him, I reluctantly made a place for it on a wall of my studio, where it had to
> compete with a Matisse and other works hanging there. [56]

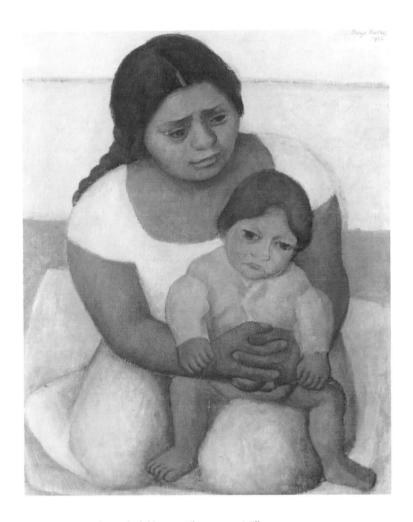

2.3 Diego Rivera, *Mother and Child*, 1926. Oil on canvas. Mills
College Art Gallery, Gift of A. S. Lavenson.

If this was hardly a propitious beginning for a patron–painter relationship, it was
a beginning nonetheless, and Boynton and Stackpole, the two Americans who
had gone to Mexico to work with Rivera, quickly became his ambassadors to the
two most generous patrons in the city.[57] Boynton and Stackpole imported Rivera's
paintings, offered them as gifts, vouched for Rivera's talent, and continually prod-
ded Gerstle and Bender to overcome the hesitations engendered by Hess's criti-
cism.[58] Apparently these efforts succeeded, for in late 1927 Bender wrote to Rivera
of a possible mural commission in San Francisco, telling Lupe Marin, Rivera's

wife, that "there will be something for him to do here" (but stretching the truth in suggesting that the city's "artists are enthusiastic about him").[59] He also asked Gerstle and Pflueger to help, the three patrons' first joint public venture. Gerstle attributed his changed opinion about Rivera's work—his conversion—to his own aesthetic sensibility, though a careful reading of his text reveals that others prodded him: "I began to feel that what I had taken for a crude daub had more power and beauty than any other of my pictures. Without having seen Rivera's murals I began to share Stackpole's excited enthusiasm. When he began to tell me of those walls in Mexico, I agreed with him that we must try to arrange for the Mexican to paint in San Francisco."[60]

The following November Rivera arrived at San Francisco's railroad station, ready to paint his first American mural.[61] There is a photograph of this event, taken by Ansel Adams, commemorating the much anticipated meeting between the painter and one of the three patrons.[62] The photograph shows the squat, dapper Bender, rigidly erect, shoulders squared, beside the towering Rivera, a bit tousled, his eyes unfocused after the long trip, his buttons barely holding the stretched vest together. The two men stand amid a crowd of tired people, including Frida Kahlo, the emissary Stackpole, and Adams's wife, Virginia. The *punctum*—the detail that pierces and unravels the photograph—is Bender's expression, full of confidence and satisfaction as he stands beside Rivera.

The decision to commission Rivera says much about the patrons' growing investment in the painter after a period of cautious contact. To understand why they eventually accepted him as the appropriate painter for a San Francisco mural requires that we expand the discussion. We need to place the patrons' investment in the context of American-Mexican politics and analyze the role Rivera played as cultural liaison to American industrialists.[63]

When Bender made contact with Rivera in 1926, cultural and political relations between Mexico and the United States were eroding.[64] Mexico's president, General Plutarco Calles, became intensely hostile to American investment in his country and threatened to expropriate American factories, mining and oil sites, and landholdings.[65] One observer has estimated the vastness of these investments in the mid-1920s: 97 percent of the mining sites, 50 percent of the oil industry, and 20 percent of the country's real estate were American-owned.[66] The American presence prevented any sustained recovery on Mexico's part after the revolution and kept the country, with its huge debts and paltry per capita income, in near-servitude to northern industrialists. Calles's threat carried more weight in 1926 than in past years because he had reputedly aligned himself, at least philosophically, with the Bolsheviks.[67] Dwight Morrow was sent into this volatile scene as the

United States' ambassador to Mexico in November 1927. His orders were familiar ones for this post: stabilize Mexican-American relations and secure U.S. industrial holdings in the country. His method, however, was unusual, for to pursue American interests, he worked with Mexico's main cultural administrator, José Vasconcelos, and courted Diego Rivera.

Morrow's unusual diplomacy is a familiar story in the critical literature, but it should be paired with Rivera's political activity during these crucial years. When Rivera rejoined the Mexican Communist Party (MCP) in 1926 after a two-year hiatus, his return was not welcomed by all its members, particularly those who had been activists under the banner of the Syndicate of Technical Workers, Painters, and Sculptors (Sindicato) when Rivera was its supposed leader. In 1924, while Rivera was at work on the first phase of his Education murals, the Sindicato's most radical members urged him to join a protest over the government's involvement in effacing the new murals in the National Preparatory School by José Clemente Orozco and David Alfaro Siqueiros. When he refused, the Party quickly expelled him. The breakup was hardly unexpected. The Sindicato group lacked cohesion, and its short life was marked by confusion, struggle, ideological antagonism over the increasing incompatibility of Stalinism and Trotskyism, and, perhaps most divisive, personality conflicts between its more famous members. As Bertram Wolfe, Rivera's biographer, has written, the "proletarian solidarity is on the surface, the rivalry and jealousy cut deeper." [68] The Sindicato's most antagonistic members were Los Tres Grandes—Rivera, Orozco, and Siqueiros—and Xavier Guerrero, a hard-line Stalinist who actively organized among the peasants. In reality, Rivera spent little time with the Sindicato, lending them his growing prestige but offering minimal leadership. [69] So when Rivera refused to take a prominent role in the 1924 protest, his dismissal was a foregone conclusion. And whereas his Sindicato comrades were continually rebuffed in their efforts to win mural commissions in the ensuing years, Rivera worked steadily on the largest projects in Mexico City.

In 1926, however, Rivera actively recommitted himself to the Mexican Communist Party, to allay concerns about his devotion and to atone for his past inaction. In the next two years he headed the Anti-Imperialist League, the National Peasant League, and the Workers' and Peasants' Bloc, each organized to carry out part of an aggressive MCP agenda—protests against American holdings and expansion in Mexico; against American intervention in Bolivia, Nicaragua, and Paraguay; and against latifundio in Mexico, the concentration in a few hands of the great landed estates. Rivera took highly publicized trips as head of the Mexican delegation to Moscow and as representative to the Moscow Peasant Congress. His artistic and political activities converged as he drew covers for *El Libertador,* the agit-

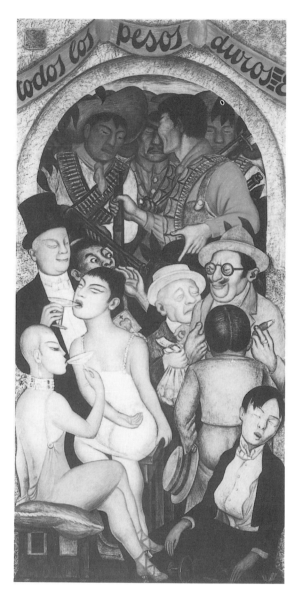

2.4 Diego Rivera, *Night of the Rich*, 1928.
Fresco. Courtyard of the Fiestas,
Ministry of Education, Mexico City.

prop journal for the Anti-Imperialist League, and had his panels from Chapingo
regularly reproduced in *El Machete* and even the *New Masses*.[70] On the walls at
the Ministry of Education Rivera caricatured American industrialists in *Night of
the Rich* (Fig. 2.4) and *Wall Street Banquet* (see Fig. 7.7), which, as San Franciscans
learned through Hess, made him the most notorious political propagandist in the

burgeoning Mexican mural movement. It is no surprise that Bender approached Rivera cautiously in these early years, when the artist was more radically active than at any time in the previous five or six.

If Bender moved slowly at first, Morrow moved aggressively.[71] Within less than a year of his arrival he had done much to ease relations between Mexico and the United States, deradicalize most of Vasconcelos's supporters, and solidify a workable relationship between corporate America and a relatively stable Mexican government.[72] One observer lamented that "coincident with [Morrow's] presence in Mexico the life went out of the revolution."[73] But Morrow could not have achieved success so quickly on the larger political field with Calles without tarnishing the appeal of the Mexican Communist Party and dismantling its most potent front organizations. He accomplished these two goals by prying loose the MCP's most important artist member; for clearly Rivera, with myriad new responsibilities and an international reputation, was the Party's leading figure in 1927. It was a sign of the artist's habitual ambivalence toward organized radicalism that within two years Morrow could so easily persuade him to reverse his position on the American presence and cooperate with the new cultural policy.

Rivera shifted his priorities largely in response to two Morrow-inspired events. The first was the famous 1928 *Mexican Art* exhibition in New York, underwritten by John D. Rockefeller, which included works by Rivera and other Sindicato members like Siqueiros, Maximo Pacheco, and Carlos Merida. The substantial attention Rivera received—which spurred his massive ego—strained his already tenuous relationship with the Sindicatos. The second event occurred a year later, in 1929, when Morrow commissioned Rivera to paint a mural for the Palace of Cortez in Cuernavaca. In the very month that Rivera accepted Morrow's commission, the Mexican Communist Party expelled him a second time.

This was the final break between Rivera and the Communists after a year of increasing disenchantment. In that time, Rivera continued to compromise his once-zealous activism by accepting more and more of Morrow's overtures and reconciling himself to the Callista regime and the administration of Pascual Ortiz Rubio that followed. In January 1929, for example, Rivera accepted election to the post of executive committee president of the Workers' and Peasants' Bloc, but in April, after the Callistas had declared the Communist Party illegal, he sought and received the government-appointed directorship of the San Carlos Academy. In May, with his fame spreading in the United States and his relationship with the former Sindicatos deteriorating, he accepted a Fine Arts Gold Medal from the American Institute of Architects, an award engineered by Morrow. By September, when it was clear that Rubio would win the presidency, he had agreed to the Cuernavaca commission. With its major spokesman absented and its very exis-

tence outlawed, the MCP had to retreat to the position of relative impotence it would remain in until 1935. In the intervening years the Callistas tightened their grip on power, and American industrialists strengthened their almost exclusive hold on Mexican resources.

In late 1929, when Rivera took pen in hand and wrote his most extended description of socially engaged painting to date, he vacillated between, on the one hand, sympathy for a generally Marxist platform and a desire to commit his energies to social and political reform and, on the other, the realization that he had just betrayed the Mexican Communist Party for his own artistic ambitions and had left the MCP to the ruthlessness of Calles.[74] The strained, overproduced quality of his writing suggests his contradictory position:

> What is it then that we really need? An art extremely pure, precise, profoundly human, and clarified as to its purpose. An art with revolution as its subject: because the principal interest in the worker's life has to be touched first. It is necessary that he find esthetic satisfaction and the highest pleasure apparelled in the essential interest of his life. . . . I searched my soul profoundly in order to see if I had the necessary qualities to attempt that kind of artistic expression in proof of my convictions, and I found that instead of possessing merely a certain amount of residue left from my previous habits and point of view, I had attained sufficient strength to be a workman among other workmen.[75]

Rivera's stance as painter-workman, plying his trade in the service of the revolution and heightening the aesthetic sensibilities of the peasant while indoctrinating him, must seem absurd for an artist about to take to the walls for Morrow and big business.

Rivera's reconciliation with American industrialists did not extend to the major aristocratic figures in San Francisco. Whereas Rockefeller and Henry Ford came to embrace him, Spreckels, Fleishhacker, and their cohorts maintained a careful distance. Much of their resistance was due to the old guard's phobic attitudes toward leftism, but it was also due to Bender's having made the first contact. He courted the mural painter before Rivera had really distanced himself from the Mexican Communist Party. If Bender in 1926 exercised caution, Morrow's entrance onto the stage in 1927 encouraged him to move rapidly. Precisely when Morrow arrived in Mexico City, in late 1927, Bender began to talk openly of a mural commission; and in mid-1928, when the *Mexican Art* exhibition in New York was in full swing, Bender firmed up a coalition with Gerstle and Pflueger.

Bender seems to have corresponded with Morrow as soon as the ambassador was appointed, and the events Morrow put into motion mirrored those initiated by Bender. As Morrow began to construct the *Mexican Art* show, for example, Bender began a similar effort in San Francisco, and in early 1928, even before the New York show, Ryan's Galerie Beaux Arts presented a collection of works by the former Sindicatos Pacheco, Orozco, Jean Charlot, and Guerrero. The *Argus* gloated as if the Beaux Arts had upstaged New York, proclaiming that the painters "are exhibiting in the United States for the first time."[76] In mid-1928, as Morrow lined up a host of wealthy patrons for Rivera in New York, Bender tapped his resources in the Bay Area. As Morrow increased the flow of good publicity about Rivera in early 1929, leading to the various awards and honors, Bender arranged a series of Rivera exhibitions up and down the California coast, from San Diego to Santa Barbara, Carmel to San Francisco. Bender became Morrow's most trusted western contact. The reverse was true as well; when Bender could not initially secure Rivera's visa, he turned to Morrow, who promptly repaid Bender's loyalty and ushered the muralist, proper documents in hand, to San Francisco.

Morrow had shown how Rivera could be used as a cultural weapon in the political field, solidifying a relationship between the United States and Mexico that would secure and extend the investments of the industrialists who employed him. San Francisco's new patrons probably intended to put Rivera to work for a similarly useful end, though they also wanted to gain popular support for his mural work in the city. We can anticipate several problems. First, 1926, the year Bender and Gerstle began to court Rivera, and 1930, the year he finally arrived, belonged to two different eras, separated emphatically by the 1929 stock market crash. General assumptions about public support before 1929 had little purchase after, for the depression caused severe hardship, and the idea of public welfare took on a new, reenergized meaning. Second, the two sets of patrons had little worry before 1929 that the public would become embroiled in artistic matters. That situation would change when other, more radical constituents of the population joined the fray in 1930–31. When Rivera left San Francisco in 1931, after he had painted two major murals and won a year's worth of publicity, it was not clear to those who initially invested in him that he had actually served his purpose. But if that was so, for others he provided a foundation from which to launch a quite different political agenda.

CHAPTER 3

ALLEGORIES OF CALIFORNIA

When he met Rivera at the train station, Bender was accompanied by a group of journalists, one of whom filed the following report on the artist:

> A jovial, big jowled "paisano," beaming behind an ever-present cigar, his clothes bulkier than his big frame, a broad-brimmed hat of distinct rural type on his curly locks, stepped off a Southern Pacific train yesterday morning, and Diego Rivera, world-famous mural artist, was here. . . . [T]he Mexican artist, belying in appearance his reputation for biting satire, piled domestically suitcase after suitcase . . . into [the] car. One looked for groceries or a canary cage to complete the "bundle" picture. . . . Quickly he proved that, despite his Dreiser-like mein and his reputation for sarcasm . . . he is "hombre muy agradable." [1]

This is a remarkable description, as much for its bald argument about ethnicity as for its zeal to give readers a quaint picture of Rivera. The writer casually enlists a range of stereotypes to describe him and finds them not only suitable but somehow insightful. The peasant Rivera is touchingly and surprisingly *of* his country, yet the rustic normality and simplicity he exudes allay concerns about his political temper. How could such a *paisano* be dangerous, so satirical, so intelligently urbane?

The controversial Rivera had finally arrived to paint a mural, one originally slated for the loggia at the California School of Fine Arts, the heart of mural training. But just months before, that commission had quickly transformed into another, a stairwell wall at the Lunch Club of the Pacific Stock Exchange, one of Pflueger's newest designs. The new commission represented a considerable shift: from an academic to a commercial space, a horizontal outdoor wall to a vertical

interior one, and, arguably, a public space (the loggia was easily accessible from the street) to a private one (the club is dozens of floors above street level). But if the mural was to embellish the exclusive walls of a lavish new building, Rivera's very presence at the train station pushed the discussion toward a public realm.

The writer attentive to the *paisano,* for example, borrowed a journalistic style reserved for covering ethnic minorities in the city. Body, gestures, clothes, and speech were all signs to be read, and each was scrutinized to confirm an attitude, instantiate difference, and argue for inferiority. With a large ethnically diverse population and a constant flow of non-English-speaking visitors in the city, San Francisco gave reporters for the big dailies ample opportunity to practice and refine the style. The light tone was the key to its effectiveness, and some San Franciscans, persuaded by the apparent good humor, might have read the Rivera article without noticing its ideological work.

But the real significance of this report is precisely its attempt at ordinariness, for Rivera could hardly qualify as just another visitor who happened to attract a horde of reporters. The early exhibition of drawings at the Galerie Beaux Arts, the criticisms by Hess, the glowing reports from the city's painters who had visited Mexico, and Bender's publicity campaign up and down the coast all produced a very public discussion of a painter about to undertake what turned out to be a very private commission. Despite Bender's considerable efforts, the discussion was generally more skeptical than enthusiastic, generating its own caustic terms to describe Rivera and his San Francisco commission.[2] He was called a political propagandist, not a painter. He was said to produce a false picture of Mexico as idyllically pre-Columbian, not a true picture of it as desperately poor. His zealous nationalism was off-putting, his leftist politics obtrusive, his interest in class imagery unsuited to mural work in a city purportedly without class divisions. His ethnic heritage was doubly problematic. If he was Mexican, he was also unlike most of his countrymen in the city, for he championed rather than downplayed ethnic difference. The discussion of him and his work built on the cynical description first offered by Hess and widened to accommodate an antiradical, racist strain.

The criticism, however, produced an unwanted effect. It provided the normative terms by which the murals could be judged, and the extent to which criticism deviated from these terms—or in the end returned to them with renewed vigor—signaled that something important had happened. The point of the next two chapters is to suggest that this something was no less than a transformation of the function of large-scale painting. A new idea for public murals began to emerge, proclaimed by a new set of actors with their own arguments about imagery and audience. Rivera's two extraordinary murals, *Allegory of California* and *Making a Fresco, Showing the Building of a City,* were at the heart of this shift.

We begin by looking at the discussion of Rivera and his work to suggest its effects in the closed, sectarian battles between the city's patrons and painters. The chapter that follows examines a wider field, where other participants staked their claims.

RIVERA, ART, AND LABOR

San Francisco's mural scene from the time of the PPIE to the stock market crash was characterized by patrons who acted in competing, collective groups; by decisions from above about the projects undertaken—and a preference for monumental work; by artists who generally worked in, around, or against the reconstituted SFAA or CSFA structures; and by extremely attentive media that determined who would win critical acclaim. Fundamental to this whole mural practice was its regional character—not surprising given the beginnings of public murals in the intensely regionalist PPIE. The practice, however, was about to be disrupted by a new fear of immigrant labor. In the newspaper account of Rivera's arrival one hears faint echoes of unease about the ethnic groups that were coming to the city seeking work. The unease would grow and would increasingly affect the city's political landscape.

The responses to Rivera's visit signal a new connection between art and labor, brought about by anxiety over the stock market crash and worries about competitive immigrant labor at a time when jobs were scarce. We can hear the resonance of those debates in the arguments of dealers and critics. In response to the Rivera commission, Constance Maynard of the *Examiner* wrote a series of articles on local art schools and the art labor force already in the city. (She named some rather marginal schools in addition to the CSFA, treating them all equally and thus inflating the number of artists purportedly available for mural work. She never mentioned how many actually professed expertise in wall painting. But Maynard outlined the schools' artistic credos—for some of them the first articulation of such principles—and listed their productive, though currently unemployed, graduates.)[3] Maynard's boosterism was augmented by the city's art dealers, who began a promotional campaign for their stables of painters that reached a climax when Beatrice Ryan, whose gallery had been the first to exhibit Rivera in the city, declared his presence a hindrance to the fostering of a local art scene.[4] By early 1930 the dealers and painters had joined together in something like a union of skilled laborers; their first act was to form a vocal public relations committee. By late summer they had begun to circulate a series of inflammatory press releases and pamphlets, accusing Gerstle and Pflueger of betraying local interests—of acting, that is, like union leaders unresponsive to the needs of the rank and file. "Is the

San Francisco Art Association dead?" the *Chronicle* and *Art Digest* asked. "Does its president have to go after Rivera to get art for our city? Is he elected for that or is he guilty of a rank betrayal of trust?"[5] A United Press dispatch made explicit what "rank betrayal" meant by reporting that the city's artists wanted "Ribera [*sic*] for Mexico City; San Francisco's best for San Francisco."[6]

Maynard's articles and the dealers' advocacy were symptomatic of a decade-long shift to a unified, if narrow, conception of municipal culture and the development of the means for a particular interest group—made up of mural painters—to negotiate a place in it by conceiving of itself as a body of nativist laborers closely linked to the culture. The city had a startlingly large pool of local talent, they said, and was producing a regional school of art based on decorative murals. The connection to labor did not arise out of any close identification with the working classes. Instead, it was asserted as a way to claim commissions for local, rather than foreign, artists, especially one whose reputation was built on mixing art and class politics. Just as important, we should note here how the city's mural scene was being reconfigured as a distinct regional school. That is, mural painters had become a laboring force working in a decorative style and needing protection to survive. The critic who declared San Francisco the "Pacific Coast Art Center" meant to suggest a strong regional identity and a host of local talent.[7] The whole argument poses obvious challenges to the ways we normally understand 1930s regional mural painting, as exemplified by the work of Thomas Hart Benton and Thomas Craven. Self-avowed regionalism in painting is as much the product of critical language as of a discernible coherent style. It generally takes shape when a threat is perceived on the horizon. But as the events leading up to Rivera's arrival suggest, it can also appear in response to local political maneuvering. An argument for regionalism in the arts developed when a struggle *in* San Francisco made it necessary.

Proponents of the new regionalism used it as a means to attack the patrons who had commissioned Rivera.[8] A caricature of Pflueger by Lucien Labaudt suggests as much (Fig. 3.1). In it, Pflueger ("Timosky Pfluegin," as he is named) is a Communist general, his tilted cap, tight lips, and stern eyes conveying his tyrannical, mean-spirited disposition. The drawing has none of the admiration evident in descriptions of Bender, for example. Instead, Pflueger is the "Farm Commissar" who doles out employment, drives his workers, and reaps the benefits. He is the Red who aligns himself with the foreign worker Rivera.

Gerstle responded officially as president of the SFAA, concluding that "this Ribera controversy [is] too silly and stupid! Why should anyone pay attention to a private mural which is to be in a private clubroom?"[9] Such an argument did nothing to lessen the local artists' outrage. Gerstle slowly lost his old status: his

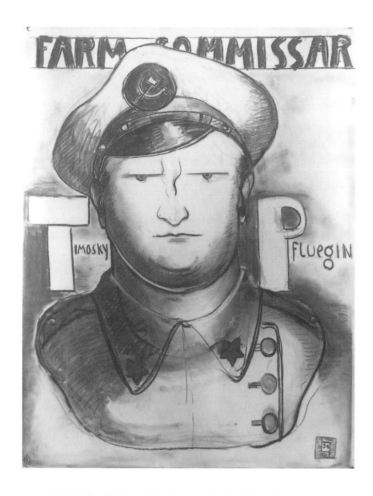

3.1 Lucien Labaudt, *Farm Commissar,* 1934. Lucien Labaudt
 Papers, Archives of American Art, Smithsonian Institution.

SFAA painters drifted away, and he was no longer the insider, haunting studios and rubbing elbows with them. Once a major force behind Ryan's gallery, by mid-1931 he had been ostracized by nearly everyone in the Montgomery Block.[10]

Gerstle, obviously, suffered from the regionalist argument, but others, like Hearst, Fleishhacker, and Spreckels, derived benefits. They were able to color the three upstart patrons as radicals who harbored leftist sympathies and fostered propagandistic, nondecorative mural painting. They tainted the reformist causes connected with the Bender group—the continual push for public services and the

regulation of private interests. This radical characterization obtained so easily in part because of a convenient amnesia on the part of the old guard, which regularly insisted on Rivera's Communist Party past, even though he had been expelled by the Mexican Communist Party in 1929 and supported by Ambassador Morrow and the backers of Mexican president Calles. The *News,* for example, reproduced a portion of Rivera's *Twilight of the Gods of the Bourgeoisie* from the Education murals beside a photograph of Gerstle.[11] The *Chronicle* printed a montage of Rivera's *Night of the Rich,* retitled *The Kiss of Judas,* and a photograph of the Lunch Club stairwell where Rivera's first San Francisco mural was to be painted.[12] Two days earlier it had reported that "through the art colony has run the rumor that Rivera will not overlook a golden chance to exercise his communistic visions in ironic lampoons, once he gets within the sacred portals of a 'capitalist' club."[13] The quotation marks around "capitalist" were meant ironically, for Pflueger's and Gerstle's sympathies were now openly questioned. Hearst made sure that the United Press picked up the scuttlebutt and broadcast the controversy up and down the coast, destroying the hospitable environment Bender had so carefully cultivated and happily proclaiming that Rivera was "not qualified on account of his communist tendencies."[14]

When the newspapers, in both editorials and reportage, discussed Rivera, they caused difficulty for the new patrons by publicly disputing their claims. But more to the point, the Red-baiting caused anxiety precisely because it threatened the constituents of liberal reform politics—that is, the city's nativist skilled working classes and the San Francisco Labor Council (SFLC). The SFLC was the remnant of a powerful umbrella organization that in the days of the radical Building Trades Council had pushed the Union Labor Party into city hall.[15] By 1930 the Labor Council, much diminished, was led by old school AFL labor leaders who had allied themselves with the Industrial Association, an organization of the city's major employers, who bonded together in an effort to eliminate the closed shop.[16] That the Labor Council's vocal resistance to Rivera's entry into the United States caused the artist some concern is evident in Bender's anxious letters.[17] The hostility of the SFLC was fanned by appeals to its anti-Communist and racist sentiments.[18] Morrow's and Bender's strategy had been to promote the cultural compatibility of Mexico and the United States to build a cultural relations policy, but San Francisco's newspapers editorialized about cultural contact only to foment fears of racial difference, and Mexican art in the various gallery and museum exhibits was treated, however illogically, as an invasion of white America by migrant workers—no small matter for the city's organized labor. In 1926, for example, large-scale growers in the San Joaquin Valley had petitioned Congress to pass leg-

islation allowing the importation of cheap Mexican labor, over the violent protests of the San Francisco Labor Council.

To read again the account of Rivera's arrival in San Francisco with an ear for its coded language is to see more clearly the rhetorical strategies. The absurd references to Rivera's "canary cage" and "bundle," the image of his car laden with suitcases and domestic knickknacks, the focus on his disheveled appearance and ragged clothes—all echoed common descriptions of Mexican migrant workers in their broken-down jalopies along the Central Valley's highways.[19] It would not be the last time that San Francisco's papers would so characterize Rivera. Throughout his stay, they emphasized the attributes and mannerisms that linked him to migrant workers, trying to attach them to him as if they carried ideological import, wrapping him tight in his ethnicity.

Feeling the full fury of criticism, the trio of patrons began to take a defensive position. Perhaps—though here one is on speculative ground—this is why they changed, late in the day, the location of the first mural Rivera would paint. Sometime in early 1929, Gerstle and Pflueger decided to switch Rivera to the Lunch Club mural commission. They asked local artists to submit sketches, and Boynton and Dixon, among others, produced detailed portfolios for the job. But in fact it was already spoken for, as the painters surely knew. As early as 1928 the *Argus* editor complained that the patrons were playing a duplicitous game:

> By far the best plan is to decide how much can be spent on a given decoration or monument and then leave to an art commission the task of appointing artists who, because of their already known work or singularly promising talent, seem to be particularly fitted for the specific work. . . . The American sculptor, the American painter who can create a true American art and leave his lasting imprint on the monuments of the country exists. He is here.[20]

The retreat to the Stock Exchange Lunch Club further signaled the futility of arguing in the public sphere. The club's cozy environs were certainly not the exclusive domain of Pflueger, Gerstle, or Bender. In fact, quite the opposite—the club boasted that its members included "all the first families of finance and a number from business."[21] But its doors were closed to the general public, and it was, to this extent, insulated from the debates about nativist labor taking place outside. Pflueger described the club's interior as an ensemble of paintings, reliefs, and sculptures, to which would now be added a large stairway mural.[22] He hired artists familiar with Rivera's methods, including Ralph Stackpole and Clifford Wight,

both of whom had assisted Rivera in Mexico.[23] Boynton and Dixon, the two most highly praised mural painters in the city, were kept out; so were those painters who adopted the Hearst position. Dixon responded angrily to his exclusion. "The stock exchange could look the world over without finding a man more inappropriate for the part than Rivera," he proclaimed. "He is a professed Communist and has publicly caricatured American financial institutions."[24] The conflicts developing in the once promising arena of public art would only become more bitter.

THE CIRCUIT OF SIGNS

The irony and Red-baiting that greeted Rivera in San Francisco prepared the Stock Exchange audience to view the mural there with an eye to controversy, especially because its subject was the "riches" of the state and its labor. Even the anonymous journalist who accompanied Bender to the train station speculated that the work would exhibit "Rivera's characteristic 'fuerte' [strong] touch."[25]

In view of such expectations, it is surprising to discover no ethnic, political, or regionalist criteria in critics' writings on the finished painting, *Allegory of California* (see Plate 4). Those who commented on the mural seemed unable to consider it in the terms generally used to discuss Rivera. Instead, critics focused on the mural as a decorative work with "flesh tones, orange, . . . accented by browns, greens, maroons, leading up to the strong blue background of the sky."[26] The vivid colors seemed to fit well in the overall ensemble: "a suave color scheme in which a warm golden yellow is predominant throughout, with many harmonious minor tones in complementary colors—ivory, brown, cool greens and blues, a little dull red, touches of copper and bronze and gun-metal. . . . Here is Unity."[27] Pflueger and Gerstle vigorously publicized the club's plan for its interior design, noting its many rich materials: ebony, pear, Philippine mahogany; copper, bronze and gold leaf; silver inlays; and a variety of striking marbles.[28] Reference to these materials was tantamount to openly declaring the decorative logic of the mural itself. Ironically, the newspapers, in their descriptions, took up the decorative emphasis with seeming delight, even though there was obvious polemic in the work.

When not recounting the colorful effects and praising the harmony of the club's interior design, early critics worked to decipher the mural's characters. Rarely did they offer full-scale readings, focusing instead on piecemeal identifications. Critics preferred to concentrate on segments and details rather than give a thoroughgoing consideration of the mural's program. They pointed to the famous gardener Luther Burbank and to James Marshall, who discovered gold at Sutter's Mill in 1848; they distinguished agricultural from forest scenes; they differentiated

miners from engineers. For a brief period the hunt for iconography prevailed, and in the press a collective picture of the mural took shape that failed to make all the disjointed elements cohere. Some interpreters suggested that the mural was about the state's fertility and productive rural energies, and one critic prepared a summary statement of this view that offered confident, if not entirely convincing, conclusions:

> The significance of the Californian mural is plain. The heroic figure of California, the mother, the giver, is dominant. She gives gold and fruit and grain. California and her riches are here for all. Without the genius of her sons, however, her riches would be dead matter. Under the earth, over the earth, and above the earth, man's will and spirit transform gold, wood, metal, into goods that are to liberate the life of man. This idea of liberation is involved in the entire fresco.[29]

The insistence that the mural's significance was plain suggests that it was precisely the reverse. The hunt for iconography petered out, and the focus shifted back to the decorative. "The fresco is like a superb tapestry," one reporter wrote; "its rich and glowing color scheme is attuned to the warm yellow of the California travertine walls which frame it."[30] "As you go up the stairs," wrote another, "you get dazzling outburst. You are startled."[31] Viewers should "bump into the colorful mural and grow with it."[32]

Should we take these criticisms as proof of Pflueger's and Gerstle's triumph? Had they succeeded in introducing Rivera into a debate about public murals? The answers cannot be unequivocal. In the short term the response to both questions is yes, for the criticisms not only indicated that the mural exceeded the critical categories available to the writers but also, as I will argue, signaled that the mural contained subjects inherently critical of corporate industry. In the long term, however, the answer is no, for the very *lack* of incisive criticism provided a space for other, more radical, attitudes to fill, transforming the murals into an unexpectedly public medium. By mid-1931, in fact, none of the major players had control of the new murals.

The criticism of *Allegory* that emerged—the fixation on the glowing colors and dazzling outbursts, the insistence on seeing the mural as an opulent facet of an architectural setting ("the happy effect of the San Francisco Stock Exchange Lunch Club"), the ambiguous iconographic readings, and the unconvincing interpretations—strained to express what was clear to all who looked at the mural.[33] That was the failure of *Allegory* to cohere in an overarching description or allegorical

structure. Consider, for example, the fullest iconographic description that appeared in the *Chronicle:*

> The mural . . . consists of a long and slender nude [on the ceiling], the Spirit of California, looking down on an heroic woman's figure of California holding in her arms symbols of the product of California's earth, forests, mines and oil wells. . . . One side of the mural is devoted to California's underearth development. The other to the fertility of the earth. The upper part is devoted to symbolization of the fertility of the earth, and shipping. . . . Figures of workers are used to depict every phase of California's history and development, among them recognizable portraits of James Marshall panning the first gold and Luther Burbank at work in his garden. Miners drilling, engineers working and youth and airplanes are depicted in the central group, while one of the outstretched hands of the figure of California is laden with California fruits.[34]

The writer was not wholly off-target in naming details, but the problem is that he ran amok in organizing them—this despite his apparent confidence in moving from side to side, apportioning figures here and there, reading themes, and spelling out symbols. When he confronted the mural's dense signs, the crisscrossing surface, and the generally ambiguous relationship between the various paired figures, all he could offer was a stuttering, weirdly syncopated, and unresolved survey.

Syncopation was built into the mural's very setting. Painted on a high wall with a steep switchback staircase before it, the mural could not be viewed whole but required that viewers consider its details step by step. Taking advantage of what looked like limitations, Rivera offered directional cues to viewers scanning and rescanning the mural: its compositional lines and angles surge upward with each step; its figures are plotted along a serpentine line; and the three stairway landings provide key points for viewing. Only at the top can viewers look back on the wall to resolve the initial impressions, and only there can they try to decipher the logic of the viewing process. The *Chronicle*'s description, which followed these cues, hinted that observers might find the mural's unity by considering, in sequence, these distinct views. (That physical and narrative movement would explain, for example, how the miners seem to migrate across the surface in the description.) But the process by which viewers were to understand the unity was left unclear.

Viewers approach the mural from the lower left. On the first flight of stairs and at the first landing they confront the pair of miners who gaze upward, directing viewers' eyes toward the hand that retracts the gray earth. Midway up the second flight of stairs viewers see a thin strip of land bifurcating the lower part of the

mural, from which rises a small, windswept eucalyptus tree. At the second landing a trio of figures, including Marshall and Burbank, form a catalogue of human postures—squatting, standing, and bent over—that arc up to the mural's center. Midway up the third flight viewers can make out the central pair more clearly: a slack-jawed boy and a square-jawed man turn obliquely toward each other. Their hands, active and passive, are poised as opposites; their expressions, one stern and the other dreamy, are contrasted; their highly individualized faces invite identification (though no early reviewer ever named them).[35] At the top of the stairs, the last group along the serpentine line comes into focus: an engineer and tool operator face each other over a blueprint, their elbows splayed, their hands grasping sharp and blunt instruments. They too are composed as opposites: bespectacled and not, bald and hatted, one face partially obscured, the other partially revealed. Overlooking the mural from behind a railing on the second floor, viewers finally confront the huge goddess figure, whose heavy shoulders mark the abrupt end of the serpentine line and whose crisp blue eyes and shimmering necklace of wheat reach across the empty space at nearly eye level. She cradles most of the figures and activities in her broad reach. Her smooth roundedness contrasts with the busy jutting lines behind her, where derricks and cranes, ships' masts, and intertwined tethered ropes form a congested picture of industry.

Such a walk-through of *Allegory* seems surprisingly simple. Enticing compositional patterns—the pairings, coordinated gestures, attention to readable props, and the body types—give a sense that each new vantage point will yield more pieces of the puzzle. But at the top of the stairs, where the mural should resolve itself into unity, it comes apart. Critics named the figures and activities, but that is all they seemed able to do. For viewers looking back from the top of the stairs, the details become kaleidoscopic fragments, seemingly unrelated, that fail to articulate the state's natural wealth—the "riches" and "fertility" the critics noted. The pathetic stump of a tree, for example, does not hint at a dense, limitless redwood forest; its cleaved surface severs the association to abundance. The tiny, overwhelmed eucalyptus does not point to the lush California countryside where these trees grow; it seems more like a miniature specimen, artificially cultivated on its own island of land. The gold for which Marshall pans had run out in California long ago, and we are left with his portrait as a sign of wealth no longer attainable. The only items potentially available are the fruits and vegetables the goddess figure offers to viewers, but she exhibits neither joy nor any other emotion in extending the bounty.

Compare the mural, for example, with a painting by Maynard Dixon (Fig. 3.2), who uses much of the same vocabulary but was far more committed than Rivera in *Allegory* to eulogizing the fertility of California. Dixon alludes to the state's gold

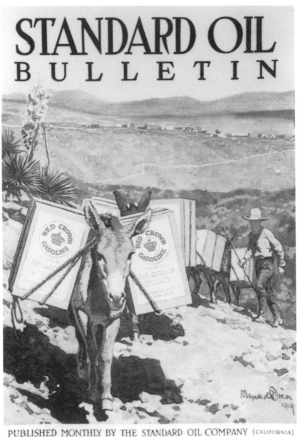

STANDARD OIL
B U L L E T I N

PUBLISHED MONTHLY BY THE STANDARD OIL COMPANY (CALIFORNIA)
SEPTEMBER 1919

3.2 Maynard Dixon, *Pack Train,* cover for *Standard Oil Bulletin,*
 1919. Collection of the California State Library, Sacramento.

rush, though what he represents is "black gold" (petroleum), pumped out of the
ground and, refined into gasoline, transported by pack mules. The image his work
conveys relates to pioneering ambition and untapped resources. The source of the
gasoline remains unseen; it comes either from the lush canyon out of which the
pack train climbs or from the distant town. Dixon's painting invites viewers to
imagine the limitless potential of the state's wealth. Whereas he represents a uni-
fied view in which the gasoline symbolizes the fertility of the earth (rather than a
threat to exhaust that fertility), Rivera presents elements of the natural world sev-

ered, isolated, or shoved aside. Whereas Dixon omits any reference to the process needed to produce gasoline from oil, Rivera suggests the depletion of resources in the tree stump and the stark industrial landscape. The figures and activities are overseen—perhaps embraced—by a goddess who, we might be tempted to say, offers her body as a sign of wealth. But we could also say that she does not seem to be performing her job very convincingly. Her strange, hulking presence, shoulders extending awkwardly from side to side, hands appearing at unlikely places, seems disjunctive—she is in the crowded field but not part of it—and her task is too visibly to turn disparate scenes of depleted wealth into a more compelling allegory of the state's fertility. Without her, would there be any such allegory? She seems to be slipped in, between foreground figures and background industry, as if somehow trying to bring them into relation. But in this middle ground the awkwardness of her body is a sign of the awkwardness of her allegorizing task, and her very presence figures an inability to wrest thematic unity from the mural's congested surface.

Or compare the mural with the most frequently praised PPIE mural, du Mond's two-panel *Westward March of Civilization* (see Fig. 1.2). It too fused together historical personalities and mythological figures. As we have seen, the panels of du Mond's mural were intended as statements of historical progress, drawing on the imagery of the state's natural resources and pioneering lore. Mounted in the Civic Center's public library, they were the city's grandest claims to large-scale painting after 1915. Du Mond's panels are full of stately rhythms and symmetry, and the figures fall neatly into the long horizontal format. In the culminating scene, the procession of historical and mythological figures reaches the allegorical Queen Califa. Whereas Rivera's huge goddess is outside the serpentine line that structures the mural (she abruptly cuts it off), du Mond's queen is the logical terminus of the long stream of figures. She is, literally and allegorically, the end point of the western march, and her upright, ennobled posture brings order and closure to the march depicted. As the terminus, she authorizes a specific thematic reading of "progress."

The criticism of du Mond's mural showed none of the awkward manner and pacing seen in the reviews of *Allegory;* it was generally crisp and confident, because critics could so easily follow the structure:

Four groups in north panel, from left to right, Emigrants setting out for the west; two workmen and a woman holding child; symbolic figure of the Call to Fortune; types of those who crossed the continent, the driver, the Preacher, the Pioneer, the Judge, the Schoolmistress, the children; youth bidding farewell to parents; in background, New England home and meeting

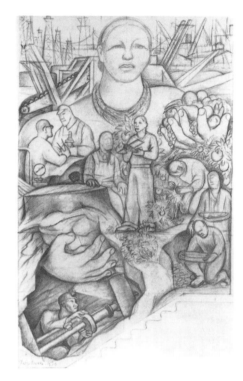

3.3　Diego Rivera, Sketch for *Allegory of California*, 1930. Pencil. San Francisco Museum of Modern Art, William Gerstle Collection.

3.4　Photograph of Diego Rivera, 1930.

place. South wall: four groups in panel, from left to right; two Spanish-American soldiers and captain with a Spanish priest, suggesting Mission period; symbolical figure "Spirit of Enlightenment"; types of immigrants, the Scientist, the Architect, the Writer Bret Harte, the Sculptor, the Painter William Keith, the Agriculturalist, the Laborer, women and children; California welcoming easterners, figures of California bear, farmer, miner, fruit pickers; orange tree, grain and fruit, symbols of state.[36]

The parade of figures pours forth, the types easily identified. None needed justification to be present, for each had some obvious bearing on the overall "march"; indeed, only the poor oxen are missing from this description. Where critics puzzled over Rivera's mix of "real" figures and the large goddess who loomed behind them, they spoke eloquently of du Mond's characters, recognizing the logic that made them compatible. One critic asked: "But how about the mixture of allegory and realism that we see in these murals . . . [d]on't you find it disturbing? Not at all. There's no reason in the world why the allegorical and the real should not go together, provided, of course, they don't grossly conflict and become absurd."[37] The points of emphasis in his description were "grossly conflict" and "become

absurd," for clearly these were murals that in his eyes did neither. For him, such failings would more appropriately have characterized *Allegory*.

The development of *Allegory* from its initial sketches shows that Rivera made alterations to achieve conflict, ambivalence, and dissolution in the mural. The first known sketch of the complete composition (Fig. 3.3) shows the serpentine line in place. A few details are noticeably different from those in the finished work: a miner is missing, the eucalyptus tree is only a small bush, one of the gold panners is kneeling rather than squatting, the figure who would become Burbank is hunched further over, the young boy's hands grip the airplane more firmly, and so on. But what is most remarkably different is the goddess figure. With long eyes slanting down, full lips, wide bridge, and tightly pulled hair, she resembles the women in Rivera's first mural at the National Preparatory School. Her head is turned slightly to the side, and she stares into the space beyond us. Her left shoulder is raised higher, making the connection between it and her raised hand more logical. In the tight space she appears to be juggling the load of figures and objects in front of her, so that the foreground subjects seem more integrally related to her.

A later full-scale drawing—this time a sinopia on the wall—can be seen in a photograph of Rivera at work (Fig. 3.4). This version caused a minor frisson in the

press. Some of the advances seem harmless enough. The identities of Marshall and Burbank are clearer, and the central pair of workman and youth are given more precise physiognomies. The goddess remains largely the same, in disposition and general facial type, as in the sketch, her left shoulder still higher than the right. But now the eyes have been widened and the hair has been draped more loosely. She appears more individualized, and some critics protested that this was a portrait image. Under an array of sketches and photographs, the *Chronicle* asked bluntly: "Who posed for 'California,' heroic figure in the Diego Rivera mural in the new San Francisco Stock Exchange Club? Are the deep eyes, the classic brows of the fresco those of Helen Wills Moody in the guise of the artist's ideal of California womanhood?"[38] Rivera's apparent choice of the prominent San Francisco tennis player as the model for "California" required an explanation because somehow her identity militated against an allegorical reading. "The figure of California," a critic argued, "is not any one individual woman but a composite, an idealized conception of the perfect type of California womanhood."[39]

Already, these early viewers of the sinopia understood the singular importance of the great looming female. Her imposing figure and momentous action (pulling back the earth to reveal the hidden riches, holding in her grasp the bounty of the state's agricultural production) set her off from other figures. She is a fulcrum around which the other figures organize. She is the single figure who asks to be interpreted, not as a historical personage, worker, or type, but as a large metaphor, her seminudity encouraging this identification. She might hold the disparate scenes together, compositionally and, just as important, allegorically. But in the sinopia Moody's identity intervened, and her bodily presence upset the balance of allegory and realism (so that they "grossly conflicted"). The insecurity of her allegorical status made it impossible for her to pin down the meanings of the other scenes. After much deliberation, Rivera obligingly changed the face, darkening the hair, broadening the eyes, tucking down the corners of the mouth, and angling the jawline and chin. "California was an abstraction," Rivera later recalled, "and should not be an identifiable likeness of anybody."[40] But as his friend and biographer Bertram Wolfe tells it, the painter "generalized the monumental face . . . that was to represent California, but it is still the generalized head of Helen Wills Moody."[41]

Rivera made three other changes in the final version. He turned the face squarely to the front. And he depressed the left shoulder, so that the left hand and fruit seem to float ambiguously in front of the body. As a result, the goddess is less securely attached to the foreground dramas and interacts more directly with the viewer. She further fragments the mural's organization and throws into question its thematic legibility, producing a work that "has admirable parts, but lacks fine

organization as a whole," as a critic observed.[42] The third addition occurred on the ceiling. Although Pflueger and Gerstle had contracted with Rivera for the stairwell wall, he convinced them to let him include the adjoining ceiling, as he would convince other patrons in years to come. His enthusiasm for the ceiling was probably due to the recent work he had done at the Salubridad y Asistencia (Health and Life) building in Mexico City in 1929. There, he painted a nude female floating overhead against a deep blue background with sun and moon symbols. He developed remarkably similar plans for the Stock Exchange (Fig. 3.5), where he extended the blue background on the major wall to the ceiling to form the "sky." His plan included floating nudes and a sun and, almost absurd, three airplanes. An early sketch (Fig. 3.6) shows the central nude stretched diagonally across the ceiling, her face virtually unrecognizable and her body extended like that of a diver in flight. The position of the second nude in the sketch is uncertain, and she competes with the airplanes for space. In the final version, however, the stretched nude's face is brought down to a more frontal position, transforming her body from that of a diver to that of a figure pantomiming a dive with outstretched arms. Her posture seems more choreographed than natural, more overproduced than smoothly harmonized. With her head tilted further down, her features are clearer, and she is recognizable as another version of the huge goddess. The second nude in the ceiling is yet another manifestation. Thus in the two ceiling goddesses the central figure assumes alternative positions. But how unstable she has become! As we climb from one landing to the next, the position of the second nude's body seems to change; it is elongated at first and then bends into a tighter L as we reach the top (Fig. 3.7). The central goddess, meant to bind the allegory together, is instead dispersed in new iterations on the ceiling.

As we ascend the stairwell, then, we follow the mural's fragmentation. *Allegory* is aiming for nonclosure, slipping away from secure meaning with every step. Its iconography was familiar, since it was gleaned from the promotional language of big business. But instead of resolving that language, the mural randomized it, splintered it. The mural left the seams between its figures and groups showing: those jagged, hard lines of the earth's crust; the bare tree stump; the crisp and isolating color complements of red against green, or yellow against green. Behind them all, the orange-hued central goddess sits in that no-man's-land between foreground figures and background machinery, refusing to unify—to get hold of— the materials on offer. The silence of the criticism speaks volumes. The mural simply surpassed the categories of looking and writing available in the city; it did not qualify as a decorative piece and did not accord with the decorative aesthetic, championed by the most vocal mural painters and active patrons, that was coalescing now into a distinct regional attitude. Although some reviewers declared that *Alle-*

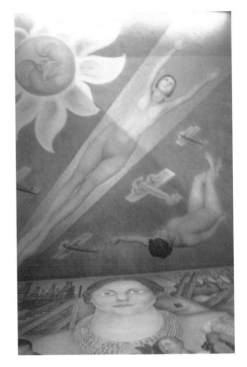

3.5 Diego Rivera, *Allegory of California* (detail of ceiling), 1931. Fresco. City Lunch Club, San Francisco.

3.6 Diego Rivera, Sketch for ceiling of *Allegory of California,* 1930. Pencil. San Francisco Museum of Modern Art, William Gerstle Collection.

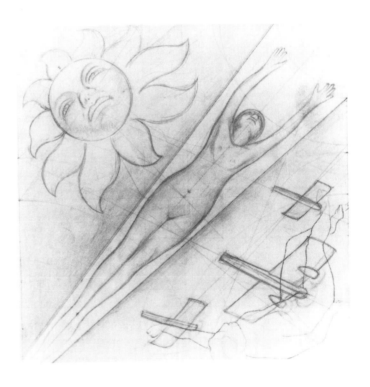

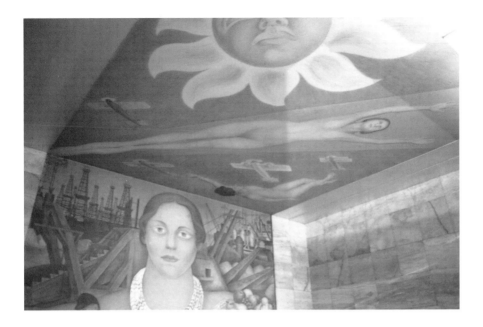

3.7 Diego Rivera, *Allegory of California* (detail of ceiling), 1931.
Fresco. City Lunch Club, San Francisco.

gory contributed to a general decorative scheme (the "happy effect" of the club), this overly persistent critical strain can be construed as a sign that the mural was far too *undecorative.* Only Dixon was able to explain the problem clearly. Speaking to a convention of architects, his brethren in the decorative enterprise, he reiterated his philosophy of murals, now with the experience of Rivera as comparison:

> [The] mural painter's first consideration . . . should be the general character and purpose of the building. . . . Second, the quality and color of surfaces and materials adjoining the proposed decoration, and the movement of the design with relation to theme; that is, its decorative value. And an admonition is needed here: Let decoration be put where it is needed, no more. To "kill" a wall or overload a room or confuse and crowd the space with decoration where it is not called for by the space contours, is not decoration at all— it is padding out or making hash of a job. The present-day dogma concerning murals is to jam the space full of something—anything.[43]

The reference to Rivera could hardly have been more pointed.

But to explain why all this really mattered—why the breakdown of criticism mattered, why the mural's insistence on fragmentation had so profound an effect, and why both responses were a sign of wider disputes—requires that we again widen the field of inquiry. We need to explore the actual meanings and characteristic representations of California, that is, the land and its well-known abundance as these were available to be allegorized. *Allegory* was painted in a space epitomizing a corporate capitalist economy, but the topic it broached was just how far the power of that economy extended.

THE CIRCUIT OF POWER

Critics made explicit the relationship between Rivera's mural and labor in rural California. They never tired of reporting on Rivera's travels through the state and his vast appetite for the daily life of the countryside. The most detailed report of Rivera's preparations for the mural took these travels into account: "He noted derricks on oil fields, the contours of factories, the colors of the countryside. He went to the mining country, dropped underground to catch the life of the miners, to get the emotion of the men at work, the emotion latent in their machines. He studied the faces of mechanics and of engineers, of Californian boys, of typical women."[44] It was probably the first time a mural painter in the Bay Area had done such research, certainly the first time a painter was applauded for it. Rivera brought together two concerns previously kept separate: an interest in the land and its activities, and an interest in its large-scale representation. The combination put *Allegory* into an artistic relationship with the only pictorial tradition that was even remotely similar—landscape painting. And that too had its own peculiar relationship both to the land in California and to the old guard patrons, as landscape painters tried to devise appropriate depictions of a land whose general purpose had less to do with its aesthetic appeal than its economic potential. It was precisely here, in the regularly displaced representation of the rural economy and its laboring force, that the mural had its most powerful effect.

In the years between the PPIE and the stock market crash, the rural regions surrounding San Francisco underwent a restructuring as extensive as that taking place in the city itself.[45] But whereas the city was often fought over by competing factions, rural lands surrounding the San Francisco Bay Area were firmly controlled by a few of the city's wealthiest citizens. Carey McWilliams conservatively estimated that 85 percent of this agricultural land was owned by "absentee landlords."[46] With few organized labor groups and a vast population of unskilled im-

migrants, the countryside had little worry about labor unrest. The city's reformers were frustrated by the wealthy landholders' control of rural California, for many of their designs for reform were thwarted by their own *lack* of control over the surrounding regions. When San Francisco needed a source of water, for example, the city's administrators had to contend with reservoir systems and pipelines outside San Francisco where the privately owned Pacific Gas and Electric Company had a monopoly. In 1925 the company took control of the Hetch Hetchy water project over the protests of San Francisco's reformers (who had proposed the public ownership of water resources), built power plants along the new water routes, and supplied the city with water at a profit.[47] Such consolidation of public utilities by privately owned companies became increasingly common—in public services, transportation, and farming. In the Santa Clara and Sacramento Valleys land holdings became increasingly concentrated, and the landscape changed as ownership shifted from the small acreage of individual farmers to the vast tracts controlled by agribusinesses that organized arable land into huge rectangular fields for cultivation and routed water in aqueducts and irrigation ditches that cut across the landscape instead of following its contours. Members of San Francisco's Commonwealth Club parceled out most of the usable land for fruit and vegetable production, bought up regions next to freshwater lakes and rivers, dammed waterways, built causeways, and redistributed water through a vast system of pipelines for drinking and irrigation. Fred Dohrmann, appointed by the club as its major strategist, lobbied for a network of asphalt roads to ship produce and canned goods. The Crockers extended railroad tracks to link more distant regions to ports and markets. By the mid-1920s, much of the land in these two valleys, and the San Joaquin and Vaca Valleys as well, had been absorbed by agribusiness. Along the coast from the Monterey Peninsula north to Half Moon Bay, canneries, ports, and shipyards were established to serve the needs of the large growers. The rural regions had become so centralized economically that in mid decade a group of urban industrialists set up a plan to coordinate activity and decision making for the entire Bay Area.[48] In one newspaper cartoon (Fig. 3.8), published just a month before the stock market crash in 1929, the "millionaire chorus," in coattails and ties, sings a tune about "industrial development," and the group is given a name with explicit neo–gold rush connotations: the "Committee of '49," suggesting how the rural economic venture was being construed. One result of centralized management in the region was the construction of several Bay Area bridges, including the Golden Gate and the Bay Bridge; another, of course, was the rebirth of the city itself. From postquake rubble it had been transformed in two decades into a full-blown metropolitan center.[49]

The development of the rural landscape gave rise to expressions of nostalgia,

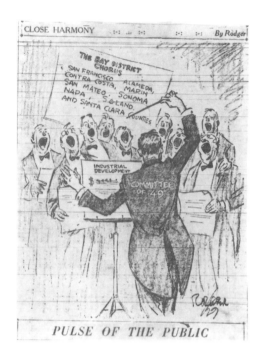

3.8　Rodger, *Close Harmony*, print for *San Francisco News*, 1929.

supported by patrons who had financed—and benefited from—the development. It is evident in a renewed focus on landscape painting after the PPIE. For example, art colonies sprouted in Monterey from 1910 to 1930, most of them with explicit ties to the Bohemian Club and the California School of Fine Arts.[50] Nearly all began to promote a style of painting that has since become known as California Impressionism. Discussions of the new painting made clear what was at stake: the metaphorical accounting for the move to organize and centralize the land. Impressionism was enlisted as part of a broadly sketched "developmental" history of California art that connected the paintings to the familiar themes of pioneers and progress. Here is one of the more eccentric examples of the effort to establish this link. It was written by the Bohemian Club painter Gottardo Piazzoni, who had been asked to pay tribute to three early California landscape painters:

> The fog was languidly retreating down the valley, leaving behind that subtle scent of summer morning. The sun was up, and from the hilltop one could see the beautiful panorama of hills and mountains extending to the sea. It was wonderful, it was magnificent, but it was not Art. It was Creation, and the inner consciousness could not be expressed, made permanent by what is

known as Art. It was too big, too immense. . . . [Then came William Keith, Thomas Hill, and Raymond Yelland] who gave so much to help form the first school of landscape painting in California, these three who in their way touched and painted that which we believe to be the essence of the California landscape. . . . For this task they came well-equipped; they had received good training in other lands, they knew their craft. This, their first knowledge, they planted in this new soil, and with love and labor cultivated.[51]

The dominant image is the painter as settler/farmer, who arrived in an Edenic land. That land was virtually unrepresentable ("Creation," not "Art") since it was too immense and unorganized. It required proper arrangement (landscape painting) and care (cultivating a stylistic and iconographic tradition) for it to yield harvest. A narrative of painterly progress is thus matched to an increasing ordering of the land. True to its link with the westward march of civilization, landscape painting found its logic in the theme of tamed nature.

Piazzoni's text, perhaps more metaphorical than most, was just one of many new narratives produced in the years after the PPIE to reconstruct a developmental history of California art.[52] They culled—from old catalogues, early reviews, periodicals, and other textual sources that had survived the earthquake and fire—whatever information they could discover on earlier landscape painters. The effort to devise an evolutionary history of California painting thus included archival research (when the field of American history itself had not fully embraced the practice), academic debate, and an effort to secure institutional sanction, which gave that effort a further measure of power as landscape painting displaced (or disguised or travestied) the actual economic activity of the rural regions. By the time Rivera arrived in San Francisco, critics could call on the resulting historical narratives and public discourse to support and interpret contemporary artistic production.[53]

Perhaps the best way to describe the displacing power of contemporary landscape paintings is to set them against the words of a critic thoroughly unsympathetic to actual developments in the rural regions. Carey McWilliams put the matter bluntly:

Travelers along the highways pass through orchards that seem literally measureless and gaze upon vast tracts of farm land stretching away on either side of the road to the distant foothills, yet, curiously enough, there seem to be no farms in the accepted sense. One looks in vain for incidents of rural life: the schoolhouse on the hilltop, the comfortable homes, the compact and easy indolence of the countryside. Where are the farmers? Where are the farm-

houses? . . . The impression gained is one of vast agricultural domains, huge orchards and garden estates, without permanent occupants.[54]

McWilliams's description certainly had a romantic cast that was typical of both New Deal and leftist rhetoric in the 1930s. He had a stake in making as sharp a contrast as he could between the new landscape and a normative picture of farming regions outside the Bay Area. Where he felt the absence of rural social life, the Impressionist painters saw the silent beauty of cultivated land. Where he saw agribusiness pervade the landscape, they saw the small farm.

This argument about a relationship between landscape painting, rural possession, and economic productivity is certainly not new.[55] Equally familiar are the means by which painted representations often come to seem proper ones, effacing one visual experience of the land in favor of another, insisting on a link between the "natural" and the represented. It often falls to critics or art historians—those who in San Francisco charted the developmental history of California landscape painting—to buttress the legitimacy of contemporary painting. But paintings cannot always effectively naturalize an ideology, whatever its institutional weight. California Impressionist paintings often suggest as much. The most exemplary canvases took as subject matter the few nonagricultural and nonindustrial spaces seemingly untouched by the precise geometries of agribusiness. But ironically, these paintings depict the ordered, controlled quality of cultivated parcels and furrowed tracts, as if the signs of corporate agriculture were embedded in the very *practice* of landscape painting.

A comparison of two paintings of the 1920s by William Clapp, *Houses along the Estuary* and *Water Scene* (see Plate 5 and Fig. 3.9), can show how landscape painters brought different compositional and brushwork strategies into play.[56] The paintings were part of a series of plein air paintings of the eastern edges of San Francisco Bay, where the salt and fresh waters meet the mouths of several rivers. Expanding industries occupied the land along the shore because it gave them easy access to both raw materials and markets. The city's Regional Plan Association counted on the fast development of such contact areas for industrial growth.[57] In the first painting, Clapp took as his subject some old houses. He narrowed the scene and limited the field of vision to a small clump of buildings in a flat foreground space. Four thin tendrils of white smoke, barely visible, rise into the sky; they are the only hint of the houses' depth. The landscape is dominated by overgrowth—the green and yellow patches climbing up the bottom third of the canvas like unmanageable vegetation. The limited field and sprawling overgrowth seem part of a strategy to signal "ruralness," characterized by clutter and disor-

3.9 William Clapp, *Water Scene,* ca. 1920–30. Oil on panel.
Collection of the Oakland Museum of California, Gift of
Mr. and Mrs. Donn Schroder.

der, in contrast to the industrial development elsewhere along the estuary. But the
disorder is stage-managed, achieved by a carefully controlled palette and brush
that disguise the considerable compositional effort. The subtle contrast of fore-
ground yellow against background blue focuses attention on the bottom third of
the canvas. The rigid horizontal and vertical brushwork, gridlike in the back-
ground, acts as a base for the heavy impasto yellows. The consistent use of verti-
cals striates the scene into readable parts — the chimney at the left; the tall, spindly
tree next to it; the thick brown arch; the running picket fence; the deep blue and

purple windows; the dark trunk on the far right. These provide the ground over which the clutter of the "natural overgrowth" can signify; the provincial quaintness of the scene is apparently authorized by the geometric framework undergirding it.

Such compositional and coloristic strategies are found in many Impressionist paintings (certain Pissarros come immediately to mind). But if we compare the painting to another in Clapp's series, we can recognize when and where the painter deemed such strategies appropriate.[58] In *Water Scene* Clapp has moved downstream, closer to the bay. The image, one of the few in which he tackled "industry" directly (he would have had a more difficult time avoiding it so close to the bay), is quite unlike his usual Impressionist productions. The task of painting industry seems to have strained Clapp's painterly habits. Whereas in *Houses along the Estuary* Clapp produces an intimate scene of small rural houses, in *Water Scene* he expands the field of vision to accommodate the larger subject. Whereas *Houses* insists on the fussy foreground shrubbery below, *Water Scene* emphasizes the vast sky above, where industrial smoke is heavy in the air and the vast space is punctuated by the scaffolding of the docks and the smoke of belching chimneys. The derricks on either side are handled with none of his characteristic rigor or the careful detail he normally accorded architectural elements. They are more obviously repoussoir elements, functioning to lead viewers deep into the painting's space.

But the ostensible focal point, a factory, hardly sustains viewers' attention. If painting industry meant expanding the field of vision and paying less attention to details, it also meant different color choices and simpler brushwork. A dark purple base is the undercoat, over which Clapp painted a sketchy field of white; purple horizontal and vertical strokes over the white describe docks, shoreline, and factory. In contrast to *Houses,* with its subtle play of complementary colors, *Water Scene* relies on crude, muddy overlapping layers. Whereas *Houses* carefully balances stiff brushwork and looser impasto, *Water Scene* more frenetically mixes and matches strokes. It seems to me that Clapp accommodated his subject—the obvious signs of industry—by transforming his usual habits, with the results visible in *Water Scene*'s compositional sprawl, limited colors, and haphazard stroke. He rarely returned to such scenes.

For a painter like Clapp, the spaces along the bay that proved most difficult to paint seemed to require that he refrain from his usual compositional and coloristic handling. He was best able to mobilize the entire logic of an Impressionist production when the subject was a scene in the interstices of the industrialized landscape. If Clapp's Impressionism was an illusory account of the rural environs, it was also, with its controlled vocabulary, a metaphor for the corporate order to be found virtually everywhere outside his chosen landscape scenes. Its rigorous struc-

turing of the empty spaces into organized strokes and dabs was a simulacrum of a real order. The overall flatness of the paintings was like a sign for the huge grids and geometric layout of the fields. The rhythmic brushwork simulated the rhythmic visual overlap of crops and roads, derricks and docks. The high tones and bright colors were like the cheerful stamp of efficiency. The homogeneous, allover handling of disparate objects was analogous to the patterning of agricultural fields in California's valleys.

The terms used to describe the typical Impressionist painting skirted these central metaphorical concerns. The landscapes "blended," "mixed," possessed a "fine harmony," their elements "melting into each other," with a "blend of shades that is gradual and melting especially in atmospheric effects." The hills were bathed in the "rich freshness of the fog"; the terrain was covered by "brooding sunshine and permeating mists"; the flora "melt into the landscape in green or gray whites and delicate pinks."[59] These descriptive phrases are characteristic of 1920s art criticism. The sense of a salient underlying scaffolding in the images was a critical commonplace in accounts of all forms of landscape painting. (Clapp characterized his own work in somewhat similar terms: "unity, contrast, harmony, variety, symmetry, rhythm, radiation, interchange, line.")[60] The critics searched for words— "melt" was a favorite—that suggested the alloverness of the painted surfaces and the tight-fitting, seamless quality of the scenes. Some of the contemporary accounts went a bit further, trying to suggest that an artificial representational order coexisted with a natural topographical order. "Here the biggest and simplest forms of man and the biggest and simplest forms of nature merge."[61] This is Dixon's description of painting—his own painterly manner could hardly be characterized as typical of California Impressionism. But it might be said that Dixon's sensitivity to the corporate origins of patronage made his understanding of the correlation between the aesthetic and industrial orders that much more acute.

Though celebrated in Bohemian Club circles, California landscape painters generally produced mediocre works. The point of my discussing them is to underscore an argument about the corporate colonization of rural spaces and its difficult yet productive relation with Impressionism. If idyllic representations of the land had their instabilities and ironies, critics failed to pursue them.

The real difficulty arose when patrons tried to make landscape painting a form of public art. In the late 1920s the longtime Bohemian Club member Piazzoni was commissioned to paint a series of panels for the walls of the second-floor lobby at the San Francisco Public Library that led to the great reading rooms where du Mond's *Westward March* hung. As might be expected with such a prominent placement, the work elicited great critical attention and anticipation, and Piazzoni

began the project enthusiastically. He had, after all, been chosen to carry the torch for the public mural movement and to build on the prestige accorded du Mond. But he was only marginally a mural painter. He had never worked in fresco, could claim no theoretical or practical knowledge of mural painting as it was being taught at the California School of Fine Arts, had studied with none of the acknowledged masters, and indeed had never painted anything so large. As his poetic text on early landscape painting suggests, he was a painter of small, moody landscapes, fit for the drawing room and gallery space; and his initial, somewhat garbled, description of the panels he planned to paint in the library says as much: "My motive would of course be 'California,' the land and the sea, the mountains and the forest, the hills and town life, in short to give an interpretation, the spirit of this great land of ours unified in a simple decorative ensemble—and whatever the forms or subject, figures or landscape, the human note to be forever present." [62] The most important element in his description is the mapping of the California landscape painting onto the decorative logic of public murals ("a simple decorative ensemble"). His project was an attempt to transform California landscape painting into public art, supported by the institutional and cultural weight accorded both to Impressionism and decorative public murals. Once again, an art whose visual concerns were bound to the interests of corporate patrons was offered to the public as a sign of a municipal culture. The difference here was the hybrid nature of Piazzoni's work and his imposition on it of the language of easel painting.

After years of work that included several full-scale mock-ups, Piazzoni's panels were finally unveiled. The painter-turned-muralist had produced a series of land and sea scenes (Fig. 3.10) hardly distinguishable from his small works on canvas, but all done on a massive scale. The strategies—a homogeneous format, uniform palette, long empty spaces, and blocky, unmodulated forms—were similar to those he used in his moody easel paintings. And like the smaller works, the library panels were governed by a familiar bluish brown hue. Their content was difficult to read from a distance, and as a result the murals looked inferior to du Mond's nearby paintings, with their heroic proportions and crisp lines. The critics who had raised expectations about the panels fell silent when they were unveiled. Piazzoni had to wait years for another mural commission, and his panels nearly slipped into obscurity.

"Nearly" is the right word, because Rivera's *Allegory* suddenly refocused attention on Piazzoni's murals. They offered a logical comparison, both painters having taken the state's natural fecundity as the subject of a mural. But because Rivera's work dwarfed Piazzoni's, the comparison could not have been more embarrassing to the landscape painter and his patrons. Piazzoni's panels invited at-

3.10 Gottardo Piazzoni, *California Symphony* (detail), 1929. Oil on canvas. San Francisco Public Library/Asian Art Museum.

tention to their artful, delicate brushwork; *Allegory* was all streaks and flat planes. The landscape and seascape series relied on subtle atmospheric effects to give unity to their scenes; Rivera's mural was all patches, abrupt edges, and harsh color contrasts. Rather than work to bring elements and forms into a tight-fitting whole, *Allegory* segmented and splayed them. Whereas Piazzoni relied on subtlety, Rivera dazzled. The comparison only made Piazzoni's failure more apparent. Landscape painting, once seen as the natural vehicle for a vision of California reborn, could not be made to work on the grand scale needed for a public building.

Allegory's subject matter touches upon the developments in the rural scene, and its details suggest the increasing economic centralization of that world. Those oil rigs and busy ports serve as background for the mining and lumber scenes. Those cranes and conveyor belts form a backdrop for the fruit and vegetables. That tiny eucalyptus tree—like a miniature landscape—was dwarfed by the surrounding hubbub of labor. The mural hinted at a circuit of capital, though its dis-

continuousness deflected attention from the links. But it did make explicit what a painting like Clapp's had generally sought to obscure—the blunt fact that the land was fully cultivated. The riches of California were not some fantasy of an Edenic, unspoiled paradise but had already been subjected to the machinery of capital. The absolute silence of critics on such a topic could not have pleased Gerstle and Pflueger more.

In March, Pflueger arranged to open the club to the public. The *Chronicle* reported that the doors were "thrown open to nonmembers [resulting in] a constant parade."[63] A day later, they were abruptly closed. It is tempting to think the "first families" stepped in.

MAKING A FRESCO, SHOWING ANOTHER PUBLIC

From the painting of murals for the 1915 PPIE to 1930, when Rivera painted his *Allegory of California,* the primary task of San Francisco's public murals was testimonial, at least from the patrons' point of view. These works provided material traces of having been painted for the public good. The question of an advanced mural practice, as first suggested by Sheldon Cheney, was generally secondary, as the California School of Fine Arts' turn to the decorative proposal would suggest. Even the moody California landscape murals of Piazzoni cannot really be considered a daring adventure in public wall painting, their failure notwithstanding, for they were rooted in a relatively unambitious approach to easel painting. But with Rivera's Stock Exchange mural, pressing questions about an appropriate contemporaneous mural vocabulary come to the fore. The questions arose from Rivera's having dispensed with the allegorical mode in his *Allegory,* and from the work's subversion of established methods for reading a mural. But if allegory was no longer workable, how might a mural painter devise an original approach to contemporary subjects? And what makes a mural legible to viewers? We can imagine some of the answers offered tenuously—about the proper meanings of symbols and signs, the links between decorative and narrative rhythms, and so on. Dixon and Boynton, as we have seen, were especially pedantic in their answers. But the point is not that definitive responses were offered but that the questions were repeatedly asked.

They were asked so often because some collective response was being anticipated. With the collapse of the stock market in 1929, the growing disgruntlement of the working classes, and especially the appearance of organized radicalism, the tasks for public murals suddenly took on new meaning. Furthermore, whereas Rivera's *Allegory* was contained in an interior stairwell of a private lunch club—

its potential allure to a wider audience thereby limited—his second mural was painted in a far more accessible space. It is certainly the case that when Gerstle and Pflueger brandished *Allegory* before their opponents, one elite gestured to another. They labeled the mural a "private" commission as a way to control the discourse about Rivera and labor, and they never alluded to or claimed a more generous public function for the mural, despite its notoriety. The second commission, in contrast, was declared a public piece from the beginning. But how "public" it was, and how involved organized leftism became in public murals, surprised even Rivera's most supportive patrons.

FROM PRIVATE TO PUBLIC

When Gerstle and Pflueger ushered Rivera onto the site of his second project, at the California School of Fine Arts, they had outbid Mexico's President Ortiz Rubio, who had wanted Rivera to return to finish the National Palace murals; they had to entice Rivera by offering him more wall space. These developments help to explain how Rivera painted the proposed mural on a high interior gallery wall instead of the more modest outdoor loggia wall that had been specified in the initial commission.[1] The grand gallery setting changed matters dramatically. The disjunctive structure and visual play in *Allegory* had been adopted and developed for the closed environs of the Stock Exchange, and the mural gained its meaning from the stairwell structure and the presumed ascent of its viewers. This relation to its environment accentuated its fragmentariness. The new mural, in contrast, was to adorn a huge open wall in a gallery where collective, even congested, viewing was not only possible but routine. Whereas *Allegory* addressed its viewers serially as they climbed the stairs, *Making a Fresco, Showing the Building of a City* (see Plate 6) asked its audience to arrange themselves together.

Gerstle and Pflueger made a quick move to start work on the CSFA mural once Rivera had completed his work at the Stock Exchange Building, and this decision to "go public" was a sign of growing confidence. The mural was indeed public. Critics were routinely invited to scrutinize the work-in-progress. If *Allegory* was shielded from view by the exclusiveness of the lunch club and the defensive posturing of Gerstle and Pflueger, *Making a Fresco* received the full onslaught of journalistic attention, as competing critics sought to outflank each other with better stories, speculation, and insider information. Even before Rivera's assistants had applied a single section of wet plaster to the wall, writers had produced long texts in the dailies describing the mural-to-be. One of the earliest, published in 1931, barely a week after *Allegory* was finished, is instructive: "Symbolic figures and

scenes representative of the creative work of followers of the arts, such as painting, sculpture, architecture, mosaics and the allied artistic industries will form the subject matter of the mural. These will be divided into approximately six main rectangles in the principal wall space with probably three smaller irregular panels reaching up into the vault of the ceiling."[2] For such an early forecast, the account was not too far off the mark, though its calculations of sections and geometry are only partly right. It has the feel of a text composed after the writer had overheard Rivera give a generic description of the mural, which he then transposed for readers to the empty wall. A month later, a writer for the *San Francisco News* filed a slightly more accurate report:

> Creative art is to be the subject of the school mural. The center panel will represent mural painters at work on their scaffolding, painting a large seated symbolical figure of a woman. To the right will be figures representing architecture both from the point of view of the draughtsman and of the actual building of a skyscraper. The left panel will represent sculpture. Central figures of the entire fresco will be two architects studying their plans.[3]

These details are closer to those of the mural itself but still only approximate. The two central figures were, in the final version, expanded to three; the large, seated woman was replaced by a large standing man; the right and left panels showed more diffuse activities. The description, however, closely matches the first known sketch for the north wall (Fig. 4.1). Here, the scaffolding is already in place, and the mural has been broken into different levels of illusion. A central figure— a woman holding fruit, very much in the manner of *Allegory*—is being painted, while on either side are scenes that suggest recession back into space along orthogonals. The central goddess in the north wall sketch suggests that *Making a Fresco* was conceived in part as a pendant to *Allegory*. The scaffolding Rivera applied to the basic vocabulary of *Allegory* might be construed as his effort to make *Allegory* "public" by painting it being painted—all this, of course, in a public space and with the self-referential title *Making a Fresco*.

It seems that the *San Francisco News* writer had somehow gotten a peek at this sketch, even though Rivera quickly abandoned it in favor of a more complicated play of figures and spaces. The stolen glance suggests that Gerstle and Pflueger made the sketch available, even though it might mislead the public, in order to fan more interest. They were exhibiting a new assurance, in light of their recent successes, that also led them to make other bold public moves. In March, for example, they invited CSFA faculty and students to the Stock Exchange to see *Allegory;* more than a hundred came, rekindling discussion of the work.[4] Another event, in

4.1 Diego Rivera, Sketch (north wall) for *Making a Fresco, Showing the Building of a City,* 1931. Pencil and ink. Private collection.

May, is worth some discussion. In that month Gerstle used his influence at SFAA to appoint Rivera to the panel of jurors for the association's annual exhibition. This move caused some of the uproar we now expect from such events, a splenetic response that had heretofore been missing in the city. "One is much inclined to suspect," one critic wrote, "that some of our artists on this jury of awards did not dare to have honest opinions of their own in the presence of the Mexican giant." [5] Rivera was accused of hanging the paintings unfairly (to the detriment of Bohemian Club painters) and of awarding prizes to those most imitative—even unintentionally caricatural—of his own work, with their rounded forms and ample figures "blown up with a bicycle pump," as one critic unsympathetically suggested. [6] Another put it more crudely:

> This the year of the great banana motif . . . the whole show at the Palace
> of the Legion of Honor is just one great big banana—the lowly, soft fruit

has wrapped its slippery skin about nearly every work in the exhibit, and "Yes, We Have No Bananas" would be a fitting theme song for the whole she-bang. . . . Bananas green, ripe and rotten—bananas for hands, arms, legs, feet, trees, rocks, and even curtains and draperies made of bananas . . . a full crop.[7]

The descriptions became ever more ludicrous.[8]

The critical humor is familiar to observers of institutionalized exhibitions, and the complaints are routine. They are certainly commonplace in writings on the French Salons during their heyday. The hanging committee is guilty of favoritism, the paintings are slavish imitations, and the prize committee is caught advocating a fashionable but desiccated version of painting. But while Paris may have been accustomed to such grumblings—in fact, may not have judged the Salon a success without them—San Franciscans were not. The annuals were normally thoroughly circumscribed affairs: owners of the local papers ran them and patronized their most celebrated artists. The critics who covered them wrote for these papers. Although the reviews had always been marked by blandness and predictability, the annual had never been the subject of such open sarcasm. The tone of the discourse on Rivera had begun to seep outward—bananas, bodies, and all.

The irony is that Rivera had very little to do with the judging and absolutely nothing to do with the hanging. But the critical momentum was such that he was forced to issue a statement defending "his" activities; he barely suppressed his anger at having to do so:

> It is not the pleasantest thing to be a member of a Jury at an Art Exhibition, because after one has given a decision one has against one the resentment of all the artists who have not taken a prize, and also the resentment of their wives, their brother-in-laws, and other relations and friends. . . . The jury has not had the [pretension] to judge the total value of the artistic personalities represented in this exhibition, still less to diminish their values, but only has wished to judge of the relative interest between the works exhibited.[9]

In speaking to the irate wives, in-laws, and relations of the artists who received no prize, Rivera in effect covered for his patrons, bearing the brunt of criticism and public displeasure for others' ambitions. Clearly he was a pawn in a larger game of cultural politics. Given his grand self-conception, the position must not have been one he enjoyed.

A newspaper report on *Making a Fresco*'s progress in May reveals the residue of ill-feeling after the SFAA exhibition:

[Rivera] affirms that the structure of the mural must grow out of itself, limited only by its relation to the space it covers and by architectural demands. It must be part of the architecture. He is no friend of what he calls "outside scaffoldings," in the sense that they are external structures, beautiful in themselves, but which, when removed, lay bare the feebleness of the buildings they covered. . . . [H]e announces that in the mural to be begun in a few days for the California School of Fine Arts, in San Francisco, he "will paint a building masked by a scaffolding upon which painters, architects and sculptors are at work. This state of construction will last as long as the wall. Then *that* beauty will endure which precedes the removal of the scaffolding." For here the scaffolding is incorporated in the design. What is true of buildings, is true of murals and of all art. Structure must be organic.[10]

There is a certain subtext to this description, no doubt echoing Rivera's own inflection as he explained the work to news-hungry reporters. He pointed to the decorative logic of San Francisco's public murals—the "relation to the space" and the "architectural demands"—which, of course, *Allegory* had followed quite ruthlessly. Murals ought to be more compliant to their surroundings, he seemed to say, lest the architecture become too feeble in comparison. He hinted, in outlining the form of the new mural in his deadpan way, that it would accommodate itself more obediently to the architectural setting. Because something of its scaffolding would remain as part of its subject matter, it would exist in happy relation with the architectural space. The description was a pointed rebuke of Pflueger, whose architectural design *Allegory* had enfeebled and whose building had been diminished in comparison. The writers were delighted to quote Rivera at length.

Publicity continued unabated. Word leaked out that both Gerstle and Pflueger had posed for portraits to be included in the mural and that Arthur Brown, Jr., Pflueger's biggest architectural rival, had also sat for a portrait sketch.[11] Rivera's assistants had posed. The painter was said to be memorializing Stackpole's current work on two monumental sculptures (Fig. 4.2) for the Stock Exchange. Rivera himself would appear in the mural, and he chose an unexpected, even uncanny, position, inscribing his own Barnum-like performance, as the critic Hess had once described it.[12] Indeed, by the time of *Making's* unveiling, an attentive San Franciscan already possessed enough information to imagine the final product, and perhaps to see the relation between Rivera and his patrons unraveling, and this observer would have looked to the mural for evidence.

The events surrounding the mural's unveiling lasted almost a week. They included a showing of nearly all the sketches: portraits of Gerstle, Brown, Pflueger, Stackpole, the architect Michael Goodman, the draftsman Albert Barrows, the

4.2 Ralph Stackpole, *Agriculture*, 1931.
Stone. Pacific Stock Exchange,
San Francisco.

painters Matthew Barnes and Clifford Wight; drafts of the first plan on the south
wall; sketches of a later plan on the north wall; thirty-one works on paper in all.
Accounts of the lavish opening suggest how befuddled the critics were by the spec-
tacle, not knowing whether to cover the mural and the drawings in their reports
or to take stock of the huge crowds milling about. Most settled on trying to dove-
tail the two; they tacked back and forth between the portraits and the identifiable
people in the room.[13] "The artist presents a rear view of himself," wrote one of
them as he observed the mural painter, "not forgetting his well known ampli-
tude."[14] Some were more satirical, like a reporter, no doubt amused by Gerstle's
and Pflueger's sudden celebrity status and grandstanding activities, who wrote the
following account: "These portraits, indeed, convey not merely acute psycholog-
ical renderings of personalities, but rise to the level of true types; we seem to have
met them many times; they are, in fact, representative facets of the American
people, and the lurking touch of gentle comicality with which Rivera has invested
them brings them all nearer to humanity and insures them against pomposity."[15]
"Against pomposity"—an ironic phrase since the two patrons had been pictured
in the papers as anything but. As Gerstle recorded in his files, when the crowd rec-
ognized him on the wall, he received a "continuous murmur of enthusiastic
praises."[16] As these examples suggest, the criticism gave voice to what was appar-

ent to nearly all viewers of the mural. In the vast gallery space, the mural asked viewers to compare its various painted figures to the flesh-and-blood people who could be found beside them, a request taken up in some form or other by every reviewer.[17] The mural called special attention to its patron figures, who were the most readily recognizable in the work, closest to viewers' eye level, and most visible in the crowd, confronting the viewer as painted subjects and hosts of the gala.

The shift in venue for Rivera's work—from a private to a public setting—marks a significant moment in the history we are uncovering, one noted in the criticism. The insistent attention to the portraits of the mural's patrons suggested that a public mural needed to retain its links with patronage, that public art in the 1930s could not quite shake the corporate support established for public art in the 1920s. Certainly the mural encouraged these critical reflexes. But the criticism also suggests something more subtle. For the patrons now competed with other subjects, as if the corporate basis for art was no longer singularly apparent. As they perused the mural's various segments and carefully identified "apposite San Franciscan personalit[ies]," for example, the critics tended to shift the terms of identification,[18] a move that had everything to do with the mural's claims for creative work—the connection between art and labor itself. Whereas Rivera pictured himself and his assistants at *work,* the postures of the three patrons make any claims about their activity ambiguous. What was their relationship to creative labor? What was their attachment to the artisans and sculptors, the draughtsmen and laborers, the muralists and Rivera? Most of all, what was their link to that huge figure that stretched the entire height of the mural? ("Gerstle represents Rivera's ideas of the American Capitalist," a critic wrote, but he did not explain whether this meant praise or condemnation.)[19]

Although Gerstle and Pflueger initially basked in the limelight, neither would have wished the comparison between himself and those shown working in the mural to be pressed too far. In June, when Rivera left San Francisco, they would fend off charges from a new group of critics—the leftist painters who began to emerge onto the city's art scene, focusing, with their radical constituents, on issues of authority, creativity, and the relation of capital to labor that *Making a Fresco* seemed to broach. The *Call Bulletin,* at one time the most liberal paper in the city and the one most often read by the city's working classes, reported Rivera's return home. If he "yawned as he stepped aboard a southbound train here today for his native Mexico. . . . there was no ennui among his patrons, for the famous mural artist departed this city in much the same sort of furor that marked his recent arrival. It all concerns the mural he did on an inside wall at the California School of Fine Arts."[20] The other papers ignored his departure, perhaps not needing to press the issue or gloat over the mess Gerstle and Pflueger

were in. It remains for us to see what had happened and how the mural, as a public piece on the subject of creative work, became embroiled in radical politics.

RADICAL PAINTERS

Boynton and Stackpole were not the only Bay Area artists who had traveled to Mexico City before Rivera came to San Francisco in late 1930. Victor Arnautoff and Bernard Zakheim had also made extended trips. Their combined sense of a public mural practice, along with that of the politically radical poet Kenneth Rexroth, helped to change the course of public murals in San Francisco, extending the meanings implicit in *Making a Fresco* and putting the mural squarely in discussions of the political left. Indeed, after Rivera's departure in June 1931, Arnautoff and Zakheim became the dominant mural painters in the city, leaving Boynton, Dixon, and Piazzoni far behind.

The two young leftists were unlike other painters who had gone to Mexico and, more generally, different from other Bay Area artists. Both were immigrants from war-torn eastern Europe, both had fought in civil wars during the new century's revolutionary uprisings, and both eventually traveled to California to pursue artistic careers. Once in the city, they felt comfortable neither in the Bohemian Club group of San Francisco artists nor under the wing of the new patrons, so that initially they merely observed the sectarian battles of the city's art scene. But the leftist sympathies that made them less attractive to patrons had the opposite effect on Rivera. Their years prior to meeting him are worth describing, for they provide a basis on which to judge their experiences with him and their cultural politics afterward.

Arnautoff was born in southern Ukraine in 1896, the descendant, as his family name would have it, of bandits ("Arnahoofs" were roving bandits in Albania).[21] During his early years, he was slated to follow in the respectable footsteps of his father, a priest in the Russian Orthodox Church. He apparently rebelled against the familial pressure, for when World War I broke out, he renounced the spiritual path and entered the Yelizavetgrad Cavalry School. His military career was checkered. Immediately after training, he joined an Italian regiment in Latvia. By 1917 he was a lieutenant in the Red Army. A year later he was named captain of the cavalry in the White Army. In 1922 he left Russia altogether and supervised the cavalry of the Manchurian warlord Chang Tso-lin.

Given such shifting allegiances, Arnautoff was probably not a dedicated Communist or someone likely to commit himself to leftist causes in the United States. But in the mid-1920s he developed new loyalties. In 1925, arriving in California on

a student visa, he attached himself almost immediately to the foreign-speaking leftist cadres in San Francisco, parts of a loose, Communist Party–dominated radical community in the Bay Area. The cadres were quite disorganized, primarily because the cells were isolated by language, but also because William Randolph Hearst and the old guard vigorously countered any radical activities through incendiary journalism and because the state's Criminal Syndicalism Act permitted the violent suppression of political dissent.[22] By day Arnautoff studied at the California School of Fine Arts; by night he channeled his energy, once dispersed, into a single aim: to develop an active, highly organized pro-Bolshevik Russian-speaking cell.

The evidence from these years is slim, but Arnautoff was apparently one of the more successful organizers. A much later account gives an approximate image of how formidable this intense and radicalized Russian must have been. He appears in a fictionalized tale as Professor Andraukov, an eccentric art teacher whose passionate reminiscences during anatomy lessons are legendary:

> Andraukov's nostrils dilated and he blew a cloud of smoke dark enough to have come from a ship; he stood in the middle of it, nearly hidden. When he emerged he began to speak. . . . "Good students," he said simply. "Listen. Now, I speak. You have come to me not to play. You have come to learn. I will teach. You will learn. Good students, each time in history that people have shame, each time in history that people hide from what they are, then in that age there is no meaning to life. There is imitation. Nothing more. There is nothing from which the little generation can learn. There is no weapon for the son to take from the hands of his father to conquer the forces of darkness and so to bring greatness to the people of earth."[23]

This kind of pedagogical moralizing, which surely found its way into his political life, apparently had its appeal. By 1929 Arnautoff had merged as a leading spokesman for the radical segments of the city's Russian colony. The moralizing also seeped into his artistic life. When during his student years he was asked to paint a mural for a downtown speakeasy, Arnautoff submitted a sketch of a police raid and the battered bodies of unarmed drinkers.[24] In 1929 Arnautoff also completed his formal studies at the CSFA. To obtain another visa, he had to spend time outside the country. That meant leaving the city's art and political scene just as he had begun to establish a place for himself and waiting some two years before being allowed to return. But in the interim he traveled, propitiously, to Mexico City and met Rivera.

Zakheim was Arnautoff's exact contemporary, born in 1896 to a Jewish family in Warsaw.[25] Like Arnautoff, Zakheim was reared in a devoutly religious family

that enrolled him in a Hasidic rabbinical school at an early age. As with Arnautoff, the family's plans seem to have backfired, and by 1913 Zakheim was estranged from both his family and the synagogue. He enrolled in the Warsaw Art Academy, an act of considerable independence, given the largely anti-Semitic bias of the school. The academic experiences must have soured him, for he was soon skipping art classes in favor of revolutionary work for Polish independence. By 1918 he had left the academy and enlisted in the army. The decision would lead Zakheim, largely untrained in military skills, to months of frontline combat, both in Poland and elsewhere, that he would later describe as "a career as a volunteer in the first World War."[26] It would also lead to a string of wartime experiences that sharpened his future enthusiasm for leftist work. (He came under the influence of Marshal Józef Piłsudski, the socialist opponent of the Bolsheviks, and was soon enlisted in guerrilla warfare; he was later imprisoned in a German camp, slated for execution, and spared, all the while professing strict adherence to the nationalist line.) His political loyalties were apparently deeply ingrained. During the fight for Polish independence, Zakheim lost most of his family, many of them activists of one sort or another, to civil war and the ensuing national fascist frenzy. By 1920, when he immigrated, Zakheim was both escaping reactionary violence and searching for a climate that would foster his socialist radicalism.

Initially he found like-minded émigrés in southern California among Yiddish-speaking Marxists and then in San Francisco among Jewish labor activists. By the mid-1920s he was running his own furniture-making business that included a self-imposed closed shop, very much against the contemporary tide of antilabor sentiment in the city. During these years he met and befriended Kenneth Rexroth, who was engaging in Communist Party debates, organizing the artists and writers of the Montgomery Block, and becoming, in the process, an important spokesman in leftist bohemia.[27] In a portrait of Rexroth by Zakheim dated 1928 (see Plate 7), we see a young bohemian—in a frumpy coat with an unmatched vest and disheveled hair—who fits contemporary descriptions of Rexroth as an intense, garrulous figure.

Together, Zakheim and Rexroth began assembling the most coherent leftist group of artists and writers the city had ever seen. They built upon the pre-1919 anarchism of Emma Goldman and Alexander Berkman, both of whom had lived in the Montgomery Block and whose anarchist *Mother Earth*–era attitudes persisted among the block's current inhabitants.[28] But in their hands Berkman's and Goldman's legacy, once identified as personal rebellion among the Montgomery Block artists, was transformed, politicized.

Zakheim was never part of the Bohemian Club or SFAA groups of artists. His 1925 watercolor of a café, *At Izzy Gomez'* (Fig. 4.3), is informative as much for the

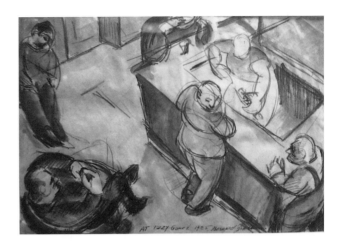

4.3 Bernard Zakheim, *At Izzy Gomez'*, 1925. Oil on canvas.
Collection of Masha Zakheim.

figures it depicts—single men looking for community—as for the place, a hang-out for marginalized painters and left-leaning intellectuals. There was never any illusion on Zakheim's part that he would break into the Bohemian Club fold or even the more liberally minded new patrons' circle. Instead, he organized the Yiddish Folkschule in the working-class Fillmore district, and under his care it became a place to display his paintings and a studio for young Jewish artists. It was also a gathering place for Yiddish-speaking Marxists and Goldman-inspired eastern European émigrés. Its mix of painting and politics became the model for the city's chapter of the John Reed Club, organized by Rexroth, the anarchist Frank Triest, and the enterprising Zakheim.[29]

With Zakheim and Arnautoff, we are witnessing the development of San Francisco's leftist painting scene. It was a decentralized scene which, despite the ties with eastern European radicalism, remained almost totally outside official Communist Party circles, nurtured instead by other organizations in the city. Zakheim's Folkschule, for example, grew out of the ethnic, rather than the national-political, identification of displaced Jewish men in the city. The leftist painting scene, moreover, was initially populated by immigrants; it arose in conjunction with ethnic cultural centers and neighborhood social spots. Zakheim's radical sense of painting, for example, was continually buttressed by the intermingling of

immigrant ethnic culture and politics in places like the Folkschule. The San Francisco scene was not unique; in other immigrant cities, like Chicago and New York, similar groupings developed. But what was unprecedented in San Francisco in the early 1930s was the bonding of the various groups. Zakheim and Arnautoff were responsible for it and, as mediator between the different cells, the faraway Rivera.

Zakheim was led to contact Rivera early in 1930 by the same outsider status and independent initiative that had prompted Arnautoff. Zakheim traveled to Mexico City, worked as a mural assistant, and met Arnautoff, with whom he forged an alliance. By the time the two artists returned to San Francisco, they could draw on a range of painterly and political experiences whose likes no artist in the city had ever seen. Their experiences in Mexico, unlike those of Boynton and Stackpole, were not colored by Rivera's growing relationship with Pflueger and Bender. When Boynton and Stackpole returned to San Francisco in the late 1920s, for example, they tried to attach themselves to the new patrons, a move that led directly to Boynton's failure at Mills and Stackpole's work at the Stock Exchange. Rivera himself seems to have treated the two sets of painters differently. He viewed Boynton and Stackpole as liaisons to Bender and Gerstle—go-betweens to be stroked and prodded, contacts necessary to securing an American commission. In Arnautoff and Zakheim he saw no such possibilities but rather a link to San Francisco's disparate Communist groups, no small matter in light of Rivera's own recent expulsion from the Mexican Communist Party. He employed Arnautoff on the National Palace and Cuernavaca projects and, as one report has it, made him "the maestro's first assistant."[30] He had Arnautoff model for a National Palace figure hanging by both hands from a tree, something we cannot imagine either the Francophile Boynton or the erudite Stackpole agreeing to do.[31] In Mexico City, when he met with the San Carlos Academy's staunch conservatives, he brought Zakheim along; the confrontation led to his expulsion from that venerable art school. Zakheim reported that he made a sketch of the meeting, which he planned to memorialize in a grand oil painting.[32] Whereas Rivera gave Stackpole and Boynton his picturesque genre scenes to pass along to Gerstle and Bender, he sent Zakheim home with a drawing from his travels to Moscow (Fig. 4.4), where he met with the Stalinist high command and sketched, among other subjects, the proletarianized Siberian railroad workers.

Arnautoff was admitted back into California in July 1931, promptly returning to the Montgomery Block. Zakheim also returned before taking a short excursion to Paris between 1931 and 1932. In these two artists the city had mural painters who were part of an emergent, coalescing radical circle that could speak directly and knowledgeably to Rivera's ideas.

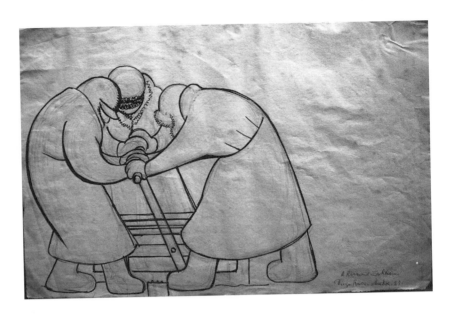

4.4 Diego Rivera, *Siberian Railroad Workers*, 1927. Pencil.
Collection of Masha Zakheim.

Looking at the CSFA mural with this radical artistic audience in mind, we can fo-
cus on elements of its subject matter that might have seemed especially pertinent
to them. An excerpt from the most detailed account of the mural gives a clue to
what these elements were:

> [Rivera] has compressed a cross section of the modern American city, engaged
> in the supreme accomplishment of this age, the building of a towering sky-
> scraper. This the muralist believes expresses both the realism and the ideal-
> ism of an ultra commercial, mechanistic and constructive era in the United
> States. Dominating the painting is a towering, heroic figure of the American
> workman. Clad in blue overalls, cap on head, he is strong, square-jawed,
> independent and intelligent. The scene itself is a familiar one—a gleaming
> red frame of structural steel, riveter high up among the steel beams, torch
> in hand, a welter of materials and men, stone cutters, welders, painters, tool
> repairers, and below builders and architects at their drawing boards and
> tables.[33]

It is not that this description is wholly accurate or convincing, in its main drift. Is the worker's expression "independent and intelligent"? Was the scene, in 1931, "a familiar one"? Did unemployed San Franciscans, with the depression beginning to look far worse than a temporary downswing, view the skyscraper as "the supreme accomplishment of this age"? Did the workman truly dominate the scene, and was he "heroic"? Although viewers gave different answers to each of these questions, we can well imagine leftist factions emphatically answering no. That the critic tried to beat them to the punch, to foreclose the possibility of debate on these very questions, testifies to his savvy. For clearly the mural raised questions about the worker and his relationship both to the creativity around him and to the patron class—not, as at the unveiling, about the individual patrons. In other words, the mural addressed the concerns of the immigrant artists, the literary intellectuals, and the rank-and-file members of a suddenly active Communist Party.

In 1930–31 the cultural arm of the San Francisco Communist Party was taking shape out of the coalescence of ethnic groups. When it required a top-down manager, Sam Darcy, a district organizer newly arrived from New York, took on the task. In Darcy, San Francisco leftists had an organizer sensitive to their radical constituents' ethnic divisions and the cultural spaces from which they drew their strongest supporters. Darcy, taking the reins from a more bookish and dogmatic bureaucrat, Emmanuel Levine, was a refreshing, energizing force. One observer noted that Darcy arrived to find "a district organization that was in complete shambles, a district-wide membership of fewer than 300, a treasury that amounted to $6, and a dispirited leadership. . . . [He had] his first contact with the membership [when he encountered] thirty or so drunks and derelicts sprawled on the floor and on a few rickety benches, sleeping peacefully and reeking of 'canned heat.'"[34] This was hardly the kind of activist CP local that a young organizer would want, but Darcy, who had been involved with the multiethnic Young Communist League in the 1920s, had learned from that experience how to organize different immigrant communities into relatively cohesive blocks.[35]

Darcy seems to have felt profound distaste for the battles between New York leftists, and under his control the Communist Party in San Francisco became much wider ranging and more inclusive than in other regions.[36] This change is evident in his working relationships with the local Socialists, Lovestoneites (the so-called right deviationists of the CP), Communist League of Struggle dissidents, and die-hard anarcho-syndicalists. It is also apparent in his relations with the more radical AFL unions and, as we will see, the waterfront unions. Darcy made more aggressive overtures to unskilled laborers in the Central Valley than any leftist organizer before him, and he began to mitigate the antagonism of skilled urban labor toward migrant agricultural workers.[37] Almost immediately, organized leftist

activity increased dramatically. The list of Darcy's early projects makes an impressive résumé for a young organizer: in 1932 he founded and edited the *Western Worker*, a weekly paper (biweekly after 1934) whose presses served several CP-operated publishing houses; in the same year he developed the Workers' School Forum on Market Street, between the Irish-dominated Mission district and the waterfront, that became the locus for weekly lectures, workshops, and art exhibitions; in April 1933 he produced the first Spanish-language articles to reach the migrant Mexicans; and in May of the same year he helped to found the Workers' Center on Fillmore Street, in the predominantly black district of town.

In early 1931, as Rivera was working on the California School of Fine Arts mural, Darcy gathered the city's leftists for a conference to develop a coherent nonsectarian program, a united front. Even Jay Lovestone's paper, the *Revolutionary Age*, normally hostile to anything remotely related to the Communist Party (Lovestone himself had been expelled from the Party for following a less rigid line), took notice of the event and applauded: "It was a real united front meeting. *But such a united front is entirely and absolutely against the official course of the Party.* What is the solution to the mystery? How is it that the California district carries on its own (correct!) line on the free speech fight directly against the official policy of the Party? Is it because the district organizer, Sam Darcy, always had his 'doubts' about the ultra-left Party line?" [38] The number of converts is hard to estimate, but at a minimum Darcy could boast some twenty thousand new supporters by June 1932 and could put CP candidates on the ballot with a reasonable expectation of their success. Some of the effects of this unconventional extra-Party unity are measurable. In late 1931, just months after the conference, Tom Mooney, the old San Francisco anarchist imprisoned for his involvement in a 1916 bombing, appealed for mass agitation to secure his release. (He had been convicted, on the basis of ambiguous evidence, for the Preparedness Day parade bombing in San Francisco, in which ten bystanders were killed.) He counted on the new nonsectarian environment to make his sweeping pleas sound other than absurd. As the *Revolutionary Age* reported, Mooney "directs his appeal to all units of the A.F. of L., to the Amalgamated Clothing Workers, to the Communist Party and all its subdivisions, to all groups who have split away from the Communist Party, to the C.P.L.A., to the Farm Labor Party, to the I.W.W., to the P.P., to the S.P., to the S.L.P. . . . From the cell where he has been buried alive for fifteen years he appeals to all working-class organizations for united action." [39]

With Arnautoff and Zakheim on the scene, Darcy developed a considerably more accommodationist attitude toward the artistic scene than existed in other districts; for instance, he did not impose Stalin's increasingly rigid agitprop demands.[40] Whereas New York painters complained about the new line in Party

discipline, San Francisco's painters were remarkably free to mix their artistic experiments, including stylistic ones, with public relations goals. Unfortunately, surviving accounts say little about this looser, more productive policy, whose flexibility and open-mindedness are surely among the most compelling, galvanizing features of this early convergence of art and radical politics. One of the few useful accounts is Rexroth's. The young poet recalls a distasteful confrontation with a Party functionary, sent to inspect the local chapter, which had been charged with lack of discipline and the sullying influence of the city's bohemians:

> He [the functionary] declared that the artist and the writer were petty bourgeois, that the intellectual was always an eater of surplus value and therefore a parasite and flunky of the bourgeoisie. . . . It didn't take much time to make mincemeat of this man. . . . As long as I was able to exert any leverage, we possessed an independence of the apparatus. We were setting up a genuine organization of intellectuals who had been radicalized by the world economic crisis, which by this time had reached California and produced wide-spread devastation, not least amongst white-collar people and intellectuals, although almost all these people were employed. What we tried to do was get a cadre which would be absolutely solid . . . a hard core.[41]

The open cultural policy accommodated writers and artists who had already developed strong, independent artistic voices—the only kind of leftist group Rexroth could ever imagine belonging to.

In addition to transforming the various language-based cultural centers into fronts for political effort, the hard-core leftist painters attempted to link the Montgomery Block to working-class districts through their artistic labors. Arnautoff and an Italian immigrant named Giacomo Patri soon began to draw for Darcy's Communist Party publications and, following the united front agenda, for labor union pamphlets.[42] Patri later collaborated on an illustrated version of *The Communist Manifesto* for workers, published by Darcy's *Western Worker*, and became the preferred artist for the waterfront unions' guidebooks.[43] By the time of the Big Strike in 1934—as we will see, a violent working-class protest—both organized labor and the CP included artists capable of producing charged visual materials. In fact, these artists were the same.

THE LEFTIST AUDIENCE AND ITS PUBLIC

It was clear to leftist artists in early 1931 that the city had no tradition of a radical visual culture for the working classes. The two most prominent union papers in

the city prior to that year, the Labor Council's *Labor Clarion* and the Building Trades Council's *Organized Labor,* had never used illustrations in its pages. Bertram Wolfe's more radical *Rank and File,* begun in 1920 as the new Communist Party rag and declaring itself "100 percent for the working class," eschewed pictures even when there were clear models: the caricatures in the *Masses,* for example, or, from the mid-1920s on, the lofty New Economic Plan (NEP) images from Stalinist Russia.[44] When Rivera painted the image of the American worker in *Making a Fresco,* he was also providing the city with its first image for and about organized labor, portraying not just any laborer but a skilled construction worker, the Building Trades Council's man, who had never before been pictured. In showing himself in the act of painting, he was also showing an originary moment, when this workman took form in his hands and revealed the skilled laborer as a body that could be painted. He is contemplating the figure as it is being completed, regarding its makeup as an image. No wonder radicals in the city closely scrutinized the mural, for among them now were sensitive, experienced artists who had worked with Rivera and who were, in 1931, attempting to find a visual vocabulary to support the new united front agenda and gain the attention of the working classes.

The new radical links and sudden formal calls for unity did not always adequately take into consideration questions crucial to the mural's leftist supporters. Was there a body of viewers who were both counterparts of, and competitors with, the city's elite? And if so, did this new audience nominate itself as the mural's *proper* audience? Or, to put it bluntly, did the working classes, as prodded by Darcy, Arnautoff, and Zakheim, claim the mural as their own, despite the presence of Pflueger and Gerstle as patrons on the wall itself? The evidence here is slim. The body of observers who came to see the mural did comprise new viewers; and radical artists had become a vocal presence in the artistic and political community. All that was needed was a simple inference: for those radicals to claim that a proper audience was now present and to point to those new bodies as confirmation. This claim was enough both to shift a public mural out of its testimonial role and to transform perceptions of Rivera's relationship to his patrons.

The San Francisco papers had always made mention of the "crowds" that gathered at the city's museums—at the opening of Alma Spreckels's Palace of the Legion of Honor, for example, or the dedication of Michael de Young's museum. But press accounts did not dwell on these viewers, who were, in effect, beside the point. As I have already noted, they were a product of argument, meant to stand witness to the designs of the city's elite and, by their reported presence, give the semblance of majority acclaim. These "crowds" changed quite abruptly in 1929, when an actual collectivity of individuals who did not normally constitute an art-

viewing audience suddenly appeared on the scene. In that year attendance at museums in San Francisco far outnumbered that at museums elsewhere in the country. The de Young alone counted nearly 1.7 million, compared with 1.6 million at the Smithsonian and 1.3 million at the New York Metropolitan.[45] The attendance can plausibly be ascribed to the huge influx of workers into the Bay Area as a result of the economic bust. They had taken over traditionally middle-class preserves: amusement parks and public pools, middle-class neighborhoods and subdivisions, parks and lakes. They were not altogether welcome.

One working-class San Franciscan realized that "the Plunge [the pool at the Fairmont Hotel] was not as public as we thought," though it is clear from his descriptions that the annoyance felt by regular patrons never deterred him from using it.[46] In the new crowds ethnic minorities were heavily represented. When the Chinese overcrowded Chinatown, for example, many of the quarter's inhabitants sought respite from the congested streets by picnicking on weekends in Golden Gate Park, whose middle-class users noticed the change: "It was as if the whole Golden Gate Park was taken over by Chinese. . . . I remember seeing people who would come over to the gate there and see all these Chinese, with that kind of startled look on their faces, and then just turn and go away." [47] Not only the Chinese but also the Italians, Mexicans, Irish, and Japanese jockeyed for leisure space and the free facilities of the park. When the *Chronicle* reported on increased attendance at the de Young, it attributed the new crowds to the museum's proximity to the picnic grounds of the park's bandstand area and the "casual strollers" who sauntered in after lunching.[48] It neglected to point out, however, the makeup of those picnickers.

If only bland newspaper commentary greeted the opening of the de Young Museum and the Legion of Honor, exhibitions in 1929 received more acerbic criticism. The paintings were very much the same—mostly works of California Impressionism—but the new audiences played a significant role in *how* the critics reviewed the art. The critic Ottorino Ronchi, for example, who reviewed a show of California landscapes at the Legion of Honor, wandered into a room of Childe Hassam paintings. As he tried to take them in, he was suddenly struck by the men and women next to him. They disrupted his normally quiet, detached viewing of the works, and he grew annoyed by their presence. He singled out a particular offender and mimicked his loud conversation:

"Yep, he's a master. See that picture—ain't it a pip?" And the big policeman led the way, pointing out this one and that, of the twenty-six paintings by Childe Hassam that are now on exhibition. . . . "See that one—ain't it keen?" he continued, "This man knows how to paint, I can tell you. All the red part of that picture is cattle—thousands of 'em. You can hear 'em bleat. An engi-

neer told me the other day that all that there land will be affected by Boulder Dam. . . . A woman told me yesterday—what was it she says?—oh! yes; they vi-brate. She's right. They buzz when you look at 'em. Ain't that cute? That bird is blue and white. Pretty little bird, ain't he! Have saw his kind many times—don't remember its name. . . . Look at that moon. You can see it like that in Marin County. He painted that in San Anselmo. . . . Go on into that other room where there's more masterpieces. I like them pictures in there, but those in that room over this way—they ain't art." [49]

In comparison with the usual tone of critical writing in the city, Ronchi's account reached a high-water mark of snide superiority. It signaled a different kind of attentiveness in gallery reviews, which would begin to enlist "crowds" as foils for more "informed" opinion. Ronchi employs this very technique:

Now that we are alone, and the art critic in belt, badge and cap has left us, we can look at Childe Hassam's works in peace. . . . The production of this prolific painter seems endless. Canvases must have poured out of his atelier like cloth from a loom. He is a one hundred per cent perfect specimen of a routine painter. . . . He is concerned only with the surfaces of life. There is nothing profound in his works and he never asks in them a question that we cannot answer. . . . The method [he uses] is an easy one and, having mastered it, Hassam has repeated it month in and month out for years. He has been digging in a gold mine but has never produced from it a real work of art.[50]

The criticism is harsh, and the critic reveals Hassam as just another hack Impressionist. But the means of conveying that verdict are striking. Ronchi ironizes the boorish policeman's wish for mimesis, his fascination with locale, and his admiration for facile technical flourishes. The true critic wants something more substantive, and though he fails to identify it, he is sure it is not what the would-be expert praises. Ronchi recognizes that another audience is scrutinizing high art and attaching to it, and their experience of it, values and qualitative standards different from his own. He disparages those new opinions and attitudes and self-consciously tries to outdistance "popular" debate by appealing to a larger, more encompassing understanding of art history, painterly skills, and comparative models. Good criticism will prove its merit by pushing beyond the provincial boundaries that hem in popular interest. If the big cop wants painting to be in dialogue with local landscape and personal experience, sophisticated opinion will have no truck with such a pandering plebeian point of view.

Where *Allegory* was off-limits to these crowds, *Making a Fresco* was on public

view, made all the more accessible by the new patrons' invitations, the generous coverage of the dailies, and the weeklong ceremonies accompanying the mural's unveiling. The reaction of these viewers is hard to gauge, but the claims for their reaction are not. The new crowds were put forward as the proper body of viewers by the leftists, since as Wolfe would claim in the first issue of the revamped Lovestoneite paper *Workers Age,* Rivera's "proletarian sympathies" were being displayed in "subjects and methods accessible to the masses."[51] Whether we believe the claim was plausible is not strictly to the point (and it is a matter of guesswork or prejudice, anyway). What matters is that the argument was made, with increasing confidence. I believe that such an argument was behind the moment in Rivera's autobiography—the most unabashed imagining of audience in a book not notable in general for its reserve—when he recalls the reaction, two years later, to the murals he did in Detroit:

> Waiving all ordinary social preliminaries, [the worker spokesman] acknowledged my presence with a nod of his head. "We are . . . workers from different factories and belonging to different political parties. Some of us are Communists, some are Trotskyites, others are plain Democrats and Republicans, and still others belong to no party at all. . . . You're reported to have said that, as long as the working class does not hold power, a proletarian art is impossible. You have further qualified this by saying that a proletarian art is feasible only so long as the class in power imposes such art upon the general population. So you have implied that only in a revolutionary society can a true revolutionary art exist. All right! But can you show me, in all these paintings of yours, a square inch of surface which does not contain a proletarian character, subject or feeling? . . . If you cannot, you must admit before all these men, that here stands a classic example of proletarian art created exclusively by you for the pleasure of the workers of this city." I looked around at the work I had done, and I conceded that the speaker was entirely right.[52]

Even the most sympathetic reader of this passage will see the danger of putting too much credence in Rivera's description. But the leftist claims were hard to contest when so many new *bodies* were present. Within days of *Making a Fresco's* unveiling, the tone of the news reports changed abruptly, as if driven in a new direction by the "crowds" and the way Rivera's work construed them. Whereas the first reports had concerned themselves with a comparison of painted and real figures, the later ones were preoccupied with the presence of the patrons in the mural. Why had they been included, and what did their relationship to Rivera mean? Various answers were volunteered: they were dupes, "sycophants," "celebrity hounds,"

"money boys," culprits, tyrants; they were the butt of socialist satire.[53] The mural painter was showing his "posterior to the existing establishment," represented by the figures below.[54] The patrons wore hats because they needed to protect their heads from his excrement.[55] Dixon summarized a common sentiment; "San Francisco got a big belly laugh," he wrote, "when Rivera, as his farewell gesture to the sycophants, painted a lot of his followers on the Art School wall facing his big behind."[56]

When Rivera left the city in 1931, Gerstle was put in the uncomfortable position of denying that the artist had ridiculed him—his denial grew all the more vehement as the leftist reading established itself. This reading—especially as it posited new viewers and viewing positions—transformed the mural and took it out of the new patrons' hands, despite their inclusion in the work (or indeed *because* of it). It separated Rivera from the new patrons, turning him back into a radical painter and putting him on the side of the disenfranchised San Franciscans who stood before that high wall. It reinterpreted Rivera's self-portrait as a mockery of those who had sought to make use of him, and it ascribed to the artist features his benefactors had worked so hard to neutralize, which many now were happy to reassert: the *fuerte* touch, the parodic eye, the Communist's satirical view of capitalists.

What elicited such a reading? Clearly something in *Making a Fresco* could sustain the claims made for it. Once again, the evidence is contained in the criticisms. "The mural is exceedingly curious," wrote the Oakland critic Florence Wieben Lehre, "in that its subject is really itself, its own creation rather than the arts and industry that are its avowed subjects. . . . In it one sees and feels a thing conceiving itself in defiance of rule, precedent and even of apparent possibility."[57] The figures of Rivera, his assistants, and the patrons interfered with the "avowed" subject. Their presence split the mural into competing parts—on the one hand, the proper subject and, on the other, the one put rudely in its place. One was destabilized by the other rather than clarified by it. Rules were broken, precedents defied. What might the rules have been? We have already encountered them, but another critic makes them explicit:

> Upon the flatter and more purely "decorative" treatment of the artisan
> [the large central worker] and the representations of his manifold activities,
> Rivera and his co-workers, the drafting office and the architects, stand out
> with bold realism, which is enhanced by each figure being a precise portrait
> of an apposite San Francisco personality. These portraits, indeed, convey not

merely acute psychological renderings of personalities, but rise to the level of true types.[58]

The bodily presence of the recognizable figures was more "real" than that of the figures in the background, who in consequence seemed more "decorative." If the identifiable figures were "true types," the others were surely something less. And if the mural focused its illusionism on the portraits, it seemed to slight realism in representing industrial activity. The figures closest to viewers standing before the mural should have been more compelling than those—the central figure especially—deeper in illusionistic space. In addition, the playacting of some of the identifiable figures—Geraldine Colby, for example, a design instructor at the CSFA, was pictured doing architectural drafting in the lower right—far from interfering with the "realism" of the foreground space, only seemed to enhance it.[59] The mural distinguishes the pantomime of Colby, and the other playactors who engage in fictitious tasks of construction, from the manifold activities of the central worker, who is also apparently engaged in construction ("coordinating the building of an American city").[60] But their jobs were not illusory; his was.

The decorative logic of public murals had once again been violated, but now in an unsettling way. The decorative element still existed, as *background,* but that background consisted wholly of the image of a laborer. The worker obeyed the old logic of San Francisco's murals: he stood in relation to the demands of the architectural surround—the "problem of enrichment, the softening of rigidity, nobility of spacing, the heightened reality of [the wall's] presence"—as Boynton had said.[61] In the postearthquake era "the worker" had been stock property in one grand ideological program after another for the city's reconstruction, above all its massive architectural projects. He was at the service of industry—its moving force.

The California School of Fine Arts mural scrambled or inverted all these roles. The "decorative" status of the worker becomes the problem, all the more so because Rivera took pains to encode him in the familiar sign language of politics. He put a hammer and sickle (perhaps originally a red star) on his left breast pocket.[62] He had him pull the crucial lever—deliberately, Michael Goodman claimed— "with his left hand (not right hand) . . . because he is a radical."[63] Although some of these details do seem loaded and the proposed readings strained, the point is that these readings were put forward with increasing confidence as time passed and the Communist Party became more of a force.

But there was something else about the mural that made these readings and rereadings plausible, and it had to do with the critics' failure to read Rivera's first

San Francisco mural—the *Allegory of California*—with its puzzling formal, compositional, and spatial qualities. A more recent observation about *Making a Fresco* suggests that such a failure continued there as well:

> Compositionally, the work comprises an arbitrary tripartite design in which no visual relationship exists between the various self-contained sections. Further, within the individual lateral sections Rivera failed to achieve a sense of compositional and visual unity. At the left, for example, there is no meaningful association, either compositional or thematic, between the Stackpole workshop and the fans and buildings above. In the architectural section to the right, the absolute lack of compositional and visual linkage between the architects and construction laborers appears even more glaringly; one design seems peremptorily tacked atop the other. In sum, then, Rivera's composition is overly rigid, even box-like, and simply fails to function as an esthetic totality. . . . Here Rivera painted a hodgepodge of his observations of industry—the exhaust fans, the construction laborers, and the machinery operated by the worker—a series of industrial images that fail to achieve any overall associative meaning.[64]

Like Rivera's first San Francisco mural, *Making a Fresco* did not cohere.

The basic organizing principles of *Allegory*—a look of compositional order that seems to lack unity; an ambiguous relation between parts, and between parts and whole; and a seemingly arbitrary deployment of figures and activities—were clearly being tried out again. The patrons wanted order and, at the very least, thematic groupings and an assembly of useful industrial props that add up. What it got was the opposite, as is apparent in one frustrated observer's complaint about "the way he put the subject together—the way he mixed up ideas and crowded everything into one narrow space . . . everything under the sun crowded into this wall space."[65] The wall is congested, but the details wander. The laborers, for example, are too scattered, their activities too loosely tied to each other. There is no logical link between the figures working on the drafting table, say, and the construction workers above them. They seem disjunctive, the weight of steel beams and girders and the open skyline rising incongruously above a wooden-ceilinged, claustrophobic workspace. The point of view continually shifts. We seem to look up at the mural, catching the undersides of wood and steel beams, peering up Geraldine Colby's dress, losing sight of feet and legs as they disappear in perspective, gazing up at clapboard ceilings and under hat brims. Yet nearly all the figures in the mural look downward, countering our gaze, making gravity a palpable force: the topmost assistants who watch plumb lines fall, the drafters who engage in detailed

tasks (accentuated by the serpentine, hunched figure of Alfred Barrows on the right), the anonymous machine operators who concentrate on gears and handles, the patrons who peruse a plan. That famous scaffolding, which compartmentalizes and regularizes the various scenes and figures, is a sham. If it looks like a structural system—holding up the scene, plotting its grid, dividing it into sections as if it were a modern industrial altarpiece with hierarchically apportioned spaces—that appearance is misleading, for no such unity obtains.

The mural's dispersing energies make studying it an exercise in continual focusing and refocusing, in shifting one's attentive gaze this way and that, following some leads, abandoning others, picking up threads of association only to discard them, searching for patterns and finding curious and compelling oddities, but always pushing on. The early reviewers never seemed to rest or to settle on a comprehensive reading, and it is therefore no surprise that at one point they began to see levels of "realism" in the mural. At least this approach would bring order and sequence:

> [Rivera] has compressed a cross section of the modem American city, engaged in the supreme accomplishment of this age, the building of a towering skyscraper. . . . The scene itself is a familiar one—a gleaming red frame of structural steel, riveter high up among the steel beams, torch in hand, a welter of materials and men, stone cutters, welders, painters, tool repairers, and below builders and architects at their drawing boards and tables.[66]

So the painters, instead of constructing the central worker, presumably paint the skyscraper; and the mural is not about building a city, or even about making a mural, but about erecting a steel-framed structure. Another early response meandered across the mural. A writer for the *Art Digest,* for example, declared that "Rivera conceived the idea of epitomizing and setting forth the inspiration which he received from viewing the activities in the arts and industries of the United States." [67] But his account of the mural moves left and right, up and down, focusing here and there without much clarity or argument:

> His conception was a picture representing a great scaffolding upon which artists were at work painting the figure of a symbolical American workman in the center. He used ingeniously the natural sub-division of the panels. These panels depict the various arts and a suggestion of industry. . . . Above, Rivera and his assistants are shown creating the symbolical workman. The artist represents a rear view of himself, not forgetting his well known amplitude. . . . The upper right gives a vista of the framework of a great skyscraper, and below is a view of a room with architectural draftsmen at work on plans.

The writer describes the mural's scenes at random, pointing to suggestions, first on this side, then on that. Ultimately, all he can do is scan, occasionally recording a specific detail (like Rivera's backside).

The slippery quality of *Making a Fresco* was the product of several decisions Rivera made between the first sketch and final mural that transformed the scaffolding from integrating structure to compartmentalizing grid. In the first fully developed plan for the south wall (Fig. 4.5), Rivera took into account a circular window and planned a nearly symmetrical composition: the horizontal beam of the scaffolding bisecting the wall to produce near halves, the illusionistic supports running on parallel tangents from the central window, six figures on each side, three in each compartment. These symmetries extended to others: the left side devoted to an urban scene, with a city profile; the right side to a rural scene, with a rolling landscape. There were clear distinctions between those figures occupying "real" space and the two symbolic figures—the urban workman and the farmer—who were being created. The second full plan (see Fig. 4.1), now for the north wall, does not need to accommodate a central window, and Rivera extends the scene vertically. The symmetry, moreover, begins to fade. The scaffolding is more complex and the compartments more irregular; the perspectival space is deeper in some places, but not in others; the two symbolic workmen (embodying the split between agriculture and industry) have become a single goddess figure, as in *Allegory,* with "industry" proliferating around her. The three central figures in the first plan—a laborer, probably an architect, and possibly a financier—have become two, and now they are clearly both (new) patrons, with a crisp hat on one figure and bowler, vest, and tie on the other.

By the final version (see Plate 6), the disassembling process has been pushed further. The binary between industry and agriculture is gone; so too is the fairly distinct difference between "real" and "painted" figures. The bodies performing "artistic" projects, for example, are now distinct from those engaged in "industrial" projects, but the relationship between them is unclear. Are the figures in overalls toward the lower left "painted," since they tend the same machinery that the large central worker grasps? If so, what do we make of the sculptor just behind, chiseling the base of Stackpole's concrete sculpture? To what project do we ascribe the figure in the upper left, hunched over and sharpening a tool? Where in illusionistic space should we place that bag, slumped and distended on the lower left, slipping outside the scaffolding but deeper in the mural's space than the worker's foot? What are the patrons contriving with the blueprint—the worker, the skyscraper, or the city—since it is now unclear which is the focus of the general activity?

This last set of questions ties together several concerns and refocuses attention

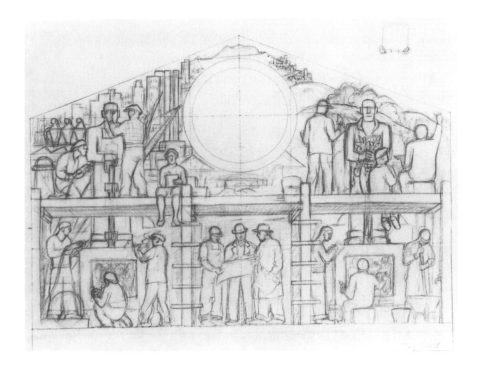

4.5 Diego Rivera, Sketch (south wall) for *Making a Fresco,*
 Showing the Building of a City, 1931. Pencil and ink. Private
 collection.

on the relationship between patrons and worker, industry and labor, progressives
and radicals. The new patrons had staked their claim to control public works and
wanted the mural to signal their municipal largesse. But it became unclear whether
Making a Fresco did its job in supporting their designs, for in it the relation be-
tween capital and labor was problematic. Look again at how Rivera depicted that
relation. The worker is continually displaced as the central focus by competing ac-
tivity and directional miscues, so that he slips from view even as he is being given
form. Consider again the rigid scaffolding that brings an illusion of order and hier-
archy to the mural. Rectangles partition the worker into component parts: head,
torso, crotch-pipe, and legs—the two patrons outside like proxies for them. He
becomes progressively obscured, even disembodied, as we move down, replaced
by objects and figures that push him farther back into space and transform him
into "decoration." The rigid ordering works not only horizontally and vertically
but also in depth, and it would seem that showing the making of a fresco—with

the scaffolding as the most visible evidence of that production—is as much an unframing device as a framing one. The tools and trappings of the painter do not bring this large figure close to us but push him away, destabilizing his image. And the worker's face—square jaw, taut lips, long cheeks, drawn eyes—is barely animate, more like that of a mannequin than that of a man. No wonder viewers offered such sterile descriptions of him: as a sign or a symbol or, worse, as background. He was not compelling enough to be called a caricature. But look again at his eyebrows: that curving, wry lift of his left brow, a flicker of animation belying the generally uncompelling countenance. Or consider the swaggering tilt of the cap, much like the fashionable angles of the patrons' hats. It seems absurd, given the head's rigidity—more wooden and unpliant than flesh and bone. The hat and brow only make the worker seem robotic—they signal their own ineffectiveness in enlivening the figure they belong to.

As the ostensible object of "painting" in the mural, the worker was given form by Gerstle's and Pflueger's public-mindedness. But his "realism" was in question—his presence as anything more than decorative background for the patrons—and he ended up as simply a representation, a figure of discourse. Like the public itself, he was a fictional effect—of political maneuvering and debate. With the crowds in attendance, it was possible to imagine a different set of aspirations for a public mural, in which the "worker" and "public" would have altogether different places.

CHAPTER **5**

REVOLUTION ON THE WALLS
AND IN THE STREETS

Less than six months after Rivera left San Francisco, he returned to the United States for a retrospective at the new Museum of Modern Art in New York. His own sense of his growing importance to painting in this country was apparently confirmed by MOMA's decision to follow up its first exhibition devoted to the work of a single artist, Henri Matisse, with one given over to Rivera's work. Some fifty-seven thousand visitors reportedly came, surpassing the number of those who had come to see Matisse. There was certainly much to see. The Rivera retrospective comprised one hundred forty-three paintings and drawings and eight portable panels, five of them re-creations of Rivera's Education Ministry and Cuernavaca murals, and the other three, new works on New York subjects. Many of the paintings had been done only in the previous several months, so that New Yorkers were getting a first chance to see not only an array of early works but also many paintings devoted to the artist's current concerns. The new works included picturesque Mexican scenes, like the 1931 canvas *The Flowered Canoe,* similar to the quaint paintings Rivera had once sent to Bender and Gerstle, but also several more pointedly political works, like the famous 1931 portable fresco *Frozen Assets,* one of his New York panels about the numbing effects of capitalism on American workers.

If Rivera believed that the exhibition gave him, as a painter of social concerns, equal standing with Matisse, who wanted art to be like "a good armchair in which to rest from physical fatigue," he was mistaken.[1] The shadow of Matisse only made it easier, in the catalogue accompanying the show, to downplay Rivera's leftist affiliations and recast the acerbic political paintings as part of a decidedly modernist oeuvre. That kind of argument is apparent in the main catalogue essay—the first such extended essay in English—by Frances Flynn Paine, who had organized the retrospective. "Diego's very spinal column is painting," she wrote, "not

politics."[2] Politically charged works, like those addressing the latifundio problem, the subject of landholdings that Rivera had treated in his Chapingo murals (see Fig. 2.2), she claimed, were part of a developmental phase of his career—"because of [the subject's] familiarity to him, he felt [it] should liberate him and give him a facility in progressing with it in much the same manner that a well-paved road facilitates the progress of an automobile."[3] And as for the apparent contract between the painter and his radical public, it was wholly fortuitous, benefiting both, though neither understood or shared the other's agenda. If the laboring classes enabled Rivera's painting in a practical way—"contact with the people and the earth of his native land had brought back again his sensitivity and his joy in painting"[4]—the laboring classes themselves "did not know him personally nor did they know his political program. . . . They know nothing of him."[5] It was as if the radical working classes had read Rivera's works according to their own peculiar political obsessions. They had misread him by consistently misreading his paintings.

Critical responses to the MOMA show, in both their praise and hesitations, generally reiterated the claims of Paine's catalogue. The most substantial review essay, by Henry McBride, appeared a month after the show closed. This remarkable text was the first to outline the history I have traced in part in the preceding chapters, that of Rivera's use to his American patrons. To substantiate his assessment of the works, McBride provided an overview of the American diplomatic mission in Mexico, pointing to Rivera's value in Morrow's campaign and—where he modulated into criticism—lamenting the muralist's continuing ill-advised service as a cultural ambassador. Morrow, McBride wrote, "had a gift for diplomacy amounting to genius . . . [Q]uick to see the significance of Rivera to Mexicans, [he realized] that by giving him a commission for the important Cuernavaca decorations [the one offered to Rivera on the eve of the Mexican Communist Party's dismantling] he could make a genuine tie between the intellectuals of the two countries."[6]

The cultural emphasis was skilled maneuvering on Morrow's part, but problems developed when American painters began actually crossing the border into Mexico and Rivera himself traveled north. The painters who sought to learn from the great muralist, according to McBride, "naturally, were enchanted [with his work] and in the first flush of excitement . . . crossed the southern frontiers in a sort of gold rush, pathetically thinking, poor dears, that art is a material thing that might be picked up in nuggets along the banks of any foreign stream."[7] As for Rivera himself, painting images in the United States, "the same thing happened to [him] when he ventured into this forbidding clime that happened to the gold-rush Americans when they went to Mexico. He came but his muse remained at home. His brain worked as usual and his hand kept its skill, but there was no ec-

stasy in it! The sense of beauty in the drama that is so moving when he speaks of episodes in his own country is chillingly absent."[8] McBride established the terms that persisted in critical assessments: Rivera's work always belonged to an argument about his *foreignness* on the American, nationalist art scene.

Paine's and McBride's texts are a matched pair. For Paine, Rivera's early achievement provided evidence of the developmental path of yet another modernist painter, whose "artistic maturity" presumably entails none of the messy politics that once enabled his art. The individual images matter less as pictorial statements arising from particular historical moments than as elements of an artistic career. The radical public notwithstanding, these works are concerned with the discipline of painting, not the subject of revolution. For McBride, Rivera's work was an autonomous modernist production, but one that was fully subject to the cultural conditions of Mexico. Instead of seeing in Rivera an opportunity for artistic cross-fertilization, Morrow used the artist as a pawn in a diplomatic game between the two countries.

In preceding chapters I have provided a framework in which Paine's and McBride's claims make rough sense. These two writers, in late 1931 and early 1932, allude to some familiar issues: Rivera is a painter whose function for important American patrons is open to question; whose on-again, off-again relationship with the Communist Party is problematic; whose appeal to American painters extends, uncomfortably, beyond painterly to political matters; whose appeal to an American audience is dangerously unclear. At stake in the MOMA retrospective was nothing less than reinterpreting the influence Rivera might have in this country, especially after his grand entrance in San Francisco. Paine and McBride agreed that he was to be regarded as a magnificent painter, who can be observed with detachment from a critical distance.

But were Paine's and McBride's arguments persuasive? One way of describing the New Deal years in San Francisco is to say that artists and patrons wrestled with the Rivera legacy and the various claims made for it. On one side were those who wished to see Rivera disappear from what was now recognized as a mural movement; on the other were those who wanted public murals to develop the transgressive qualities implicit in *Making a Fresco* and make more direct connections with a developing leftist program. And in between was a public whose interests and desires continued to be debated. Although arguments between pro- and anti-Rivera factions remained unresolved, the several inflections in the debate signaled the shifting course of New Deal public art.

We might profitably look at three distinct phases in San Francisco's 1930s murals, an approach that allows us to follow the development of Riveraesque visual language in conjunction with the fortunes of organized radicalism: the first phase,

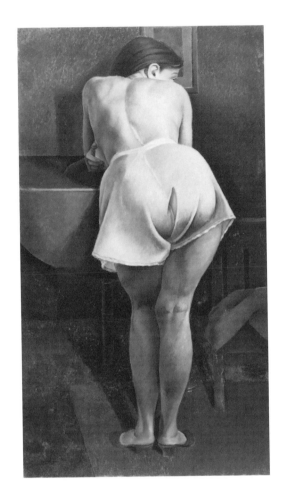

1931–33, when the city's painters, struggling to find wall space, could not carry the Rivera torch for the Communist Party; the second, 1934–35, when the federal programs began, so that both funds and walls were available, and organized radicalism had its shining moment in the city; and the third, 1935–38, to be pursued in the chapter that follows, when decisions abroad began to affect the local CP, and a radical united front began to dissolve from within.

FOLLOWING RIVERA, RIVERA'S FOLLOWING

It is testimony to Rivera's great influence in California and evidence of the close scrutiny given his work that, almost immediately, *Making a Fresco* prompted several pictorial responses. The bawdiest was Otis Oldfield's *Figure* (Fig. 5.1), which

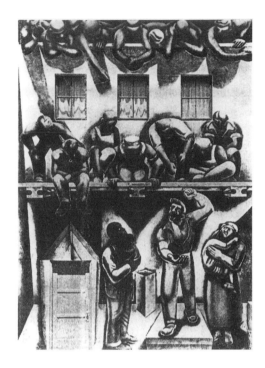

5.2 David Alfaro Siqueiros, *Workers'*
 Meeting, 1932. Cement and spray gun
 (destroyed).

appeared at the Sacramento Art Fair of 1933.[9] The painting is marked by the same
farcical attention to the body as Rivera's mural, but it conveys none of the politi-
cal overtones associated with Rivera's own backside. Another response, perhaps
more explicitly political, was that of Rivera's most outspoken Mexican Commu-
nist Party critic, Siqueiros, in his 1932 mural for another California art school, the
Chouinard School of Art in Los Angeles (Fig. 5.2). In Siqueiros's mural, *Making a
Fresco*'s scaffolding is remounted as a steel-girdered balcony where a group of
workers sit, and the industrial architecture is reconfigured as the facade of a house.
But whereas the tense, ambiguous relationship between the parts of *Making a
Fresco* gave the mural a transgressive quality, Siqueiros's mural was stabilized
around the figure of the soap-box speaker. The Chouinard mural explicitly coun-
ters the CSFA mural and states dissatisfaction with Rivera's puzzling hot-and-cold
relationship with organized leftism. In Siqueiros's image, the speaker commands
attention in part by facing forward (countering Rivera's turning away); he ad-
dresses his message to the workers on the scaffold and, implicitly, those viewing the
mural. Reading its aggressive claims, *California Arts and Architecture* dismissed the
work as an unabashed radical manifesto and fired a warning at the state's mural
painters, declaring "that the art of fresco in this country will languish until it is able
to free itself from the sorrows of Mexico and the dull red glow of Communism."[10]

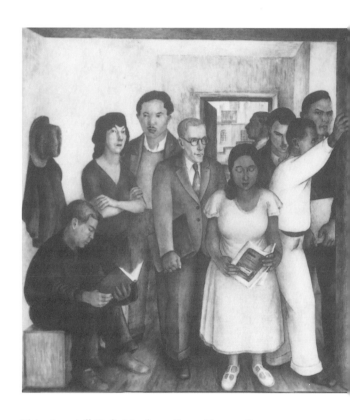

5.3 Victor Arnautoff, *Studio Mural,* 1931. Fresco (destroyed).

We are beginning to see the visual dialogue Rivera prompted—the Riveraesque language of San Francisco that I noted in the Introduction to this book. Nothing about it was codified. Painters took their cues in bits and pieces, contending with or refuting portions of Rivera's murals. The responses of Oldfield and Siqueiros, for example, took on the unstable iconographical features of the California School of Fine Arts mural and gave them stabilized, orthodox readings. What could be more conventional and conventionalizing than remaking the naughty posterior view of Rivera into the erotically charged backside of a woman? What could be more orthodox than recasting Rivera's complex construction of the working classes in *Making a Fresco* as a Communist soapbox orator haranguing a crowd of radicals? Perhaps the most important, far-reaching responses in San Francisco came from those painters who sought to grapple with questions raised by Rivera's ambiguity, both compositional and iconographic—features of the work that disturbed patrons and critics and raised the possibility of alternative meanings, al-

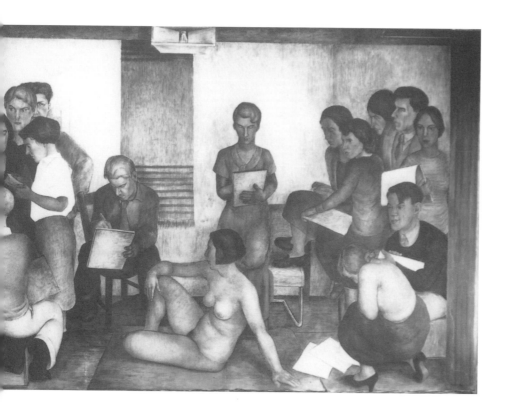

ternative publics. A radical visual dialogue developed in the gaps left by conventional readings. It should come as no surprise that the painters most responsive to the implicitly radical quality of Rivera's work were Arnautoff and Zakheim.

The transitional character of the public art scene in the early 1930s meant that Arnautoff and Zakheim could not easily pursue Rivera's example. The shift from *Allegory* to *Making a Fresco* surely marked a foundational moment of radical public art, but it was also a moment of practical reappraisal. Two pressing, recurrent problems arose: the lack of wall space when patronage was tightly controlled and the question of a coherent or, at any rate, sustained and adequately articulated agenda for cultural radicals. The works of this period suggest how difficult the task of transforming public murals would be.

In late 1931, just after Rivera left San Francisco, Arnautoff began a much-publicized (no longer extant) mural project (Fig. 5.3) on Washington Street, near the old Barbary Coast. The publicity it received—far more than the largely unknown

Arnautoff could once have expected—resulted from two related circumstances, both of which suggest the initial strategies of radical public painters.

First, Arnautoff's mural, which took shape without the consent or financial support of the city's embattled patrons, was interpreted as a provocation. The young Communist muralist simply painted on the wall of his own studio. This was hardly a brazen act in itself, but the piece powerfully transformed Arnautoff's private workspace into a public sphere. When the painter opened his studio doors, the papers had to admit that "patrons and artists thronged"[11] to see the work and found much that was familiar. In it Arnautoff invoked the biographical element of Rivera's CSFA mural, allowing the identities of his sitters—in this case, his radical painter friends—to structure a reading of the work. The papers could not resist the challenge, and their responses to Arnautoff's mural, like those to *Making a Fresco*, tacked back and forth between the figures in the mural and those before it. The small studio became a space of journalistic interest, and the mural elicited the quality of attention usually reserved for larger, more conventionally public works.

Second, the audience that came to see the mural was a mixture of conservative critics and patrons, on the one hand, and dissident artists, on the other, representing the old and new faces of public murals in an argument about their contemporary meanings. But whereas leftists viewing *Making a Fresco* had to enter (or intrude on) a school that taught conventional public art related to a corporate capitalist culture, those who came to see Arnautoff's mural had only to visit his studio, in a building just east of Chinatown, the heart of a radical leftist culture. In this Montgomery Street area Rexroth and Zakheim had begun organizing artists, and it was here that the cultural arm of the Communist Party was located. Radical viewers of the piece could be found just outside the door, in Arnautoff's abject neighborhood.

We can gauge some of the palpable anxiety the mural caused. Rumors soon circulated, for example, that Rivera himself had done a small fresco in Stackpole's studio in the Monkey Block, and however baseless such reports were, they accompanied Arnautoff's mural and linked it to the now-radicalized afterlife of Rivera.[12] In February 1932, as the mural neared completion, Arnautoff was portrayed as the torchbearer of this organized group of Communist artists. The mural had much to do with this identification. In it, Arnautoff pictured himself and his cohorts at work during a life drawing class. The painter stands to the left of the pillar, his piercing gaze meeting ours. Ranged across the room are other artists, most of whom would soon form the loose core of a leftist agitprop group.[13] Only Zakheim was missing (he was in Paris). Conspicuously absent were Stackpole, Boynton, and Dixon, though they certainly haunted the Montgomery Block. Their am-

bivalent political allegiance disqualified them from the scene. Just as Rivera's *Making a Fresco* had beckoned viewers to scrutinize both the figures in the mural and those before it, so did Arnautoff's, though the individuals in his mural, hardly household names, were clamoring for notice as a *collective* of painters, led by the confrontational Arnautoff.

Arnautoff's borrowing of notorious details from Rivera's murals must have caught the attention of some discerning viewers, giving them a troubling sense of the maestro's afterlife. On the studio wall, for example, the painter reintroduces the L-shaped nude from *Allegory*'s ceiling in his own seated nude, complete with bobbed haircut and compressed posture. And as with *Making a Fresco*'s scaffolding, he paints a trompe l'oeil post to stand in playful relation to an actual post in the room. He reworks the provocative theme of creativity, making his own studio efforts the subject of his mural. He reverses Rivera's backside view, putting his own face in full sight. The rumors that Rivera had done work in the Monkey Block perhaps obliquely acknowledged Arnautoff's pictorial indebtedness.

Arnautoff invoked Rivera's formal and compositional strategies and organized the mural around specific portraits partly to gain recognition for the new faction of radical artists and a new public art. Although he undoubtedly succeeded to some extent ("a magnificent experiment in group portraiture . . . of twenty-four prominent local artists," as one observer wrote satirically), he hardly broached the more difficult task of addressing a specific Communist Party agenda.[14] Darcy's *Western Worker,* by now up and running, did not even mention the work; and neither Arnautoff nor Rexroth tried to enlist more enthusiastic attention from the language cells since there was nothing more expansive to discuss. It seemed enough to nominate radical members of the art community, allude to Rivera's legacy, and suggest that art criticism could be forced into the heart of CP culture. And as considerable as these results may sound, they were in fact all Arnautoff seemed able to do. By the summer of 1932 the grand pictorial statement of political and artistic solidarity in his studio must have seemed a somewhat empty gesture; there were no other walls to paint, and Arnautoff's funds had ran out. He scrambled to produce a few canvases and assembled a hastily organized exhibition at a makeshift gallery on Montgomery Street. Nothing sold.[15]

At this point an old socialist, Charles Erskine Scott Wood, intervened. Wood had been a presence in the Bay Area since 1929, when he moved to a magnificent home in Los Gatos, south of the city. He had an impressive résumé as a practicing lawyer and literary radical: nearly thirty years of working for civil liberties causes in Portland, Oregon, and some of the most biting satirical contributions to the *Masses* during its heyday. In the late 1920s he published two books, *Heavenly Discourses* (1927) and *Poems from the Ranges* (1929), that established his reputa-

tion in the Bay Area. The first was a collection of dialogues between historical and religious figures about the current state of American life. These books and Wood's pedigree gave him a special status among young radicals and aspiring bohemians in the city, and his house became the site of literary and political assemblies.[16] (The usually iconoclastic Rexroth made a pilgrimage to Wood's home, and Bender was known to attend the gatherings.)[17] It is likely that Arnautoff secured the commission for his next mural through Wood's auspices; Wood had been a patron of Rivera and had trod a middle path between the Communist artists and monied, public-minded progressives. Among these progressives was the prominent physician Russell Lee. He had just built a clinic in Palo Alto whose walls needed decorating.[18] Thus Arnautoff undertook his second post-Rivera mural—four color and eight grisaille panels—in August 1932 in a small loggia of Lee's health clinic. Whereas Arnautoff might have wanted to develop the link between mural painting and leftist politics, Lee wanted images that celebrated modern medicine. Arnautoff's solution was to include radical details in a relatively banal subject— the specialties of modern medicine, an approach that did not work to the good of the paintings. A writer observed in the obstetrics panel (see Plate 8), for example, undeniable traces of Rivera's hand—the streaky brushstrokes, hard colors, thick lines, blocky figures—and stated inelegantly that Arnautoff worked "after the manner made celebrated by Rivera."[19] The Riveraesque influence also came in the emphasis on work as a worthy subject. In Arnautoff's hands, however, labor took on a schematic, almost hieratic, quality. Scenes of work that in Rivera's murals interlock in complex ways are isolated in Arnautoff's, made iconic, and marked by a certain dull legibility. And it was here, in the frank nudity and the recording of seemingly quotidian tasks, that Arnautoff sought to introduce a language of political engagement. A critic wrote of the murals that

> the air of unutterable dignity that pervades the ideal clinic has been ignored completely. . . . Victor Arnautoff, pupil of Diego Rivera, was the man called in to make the clinic look like a temple of the New Art Movement. One of his murals shows a young woman who is—er, unclothed above the waist, being examined with a stethoscope by a graybeard physician. Another reveals a male patient in a similar state of seminudity, looking as nonchalant as though a clinic held no more terrors for him than a Turkish bath! Other men and women who are decisively not hampered by too much clothing are scattered about the place looking cheerful. Other frescoes show surgeons and nurses buttoned up to the chin in medical coveralls, and wearing masks and rubber gloves, bending over unconscious patients who are entirely at their mercy.

These last preserve a nice balance with the more cheerful murals, which might tend to make a man optimistic about hospitals.[20]

The irony and mock horror of this criticism tell the story. Here were murals that tried to make the presence of bodies in commonplace labor crucial to their meanings. But against the subject Lee had imposed and the format dictated by the murals' placement, these bodies look more absurd than transgressive, more like flaccid "New Art" gestures than pictorial statements of radical political thinking. The murals, after eliciting faint disapproval, gained no further attention. Arnautoff returned to the city and painted no murals for the next year-and-a-half.

Meanwhile, Zakheim returned from Europe in autumn 1932 with a full portfolio of new work. *Café du Dôme* (Fig. 5.4) and *A Friend in Paris* (Fig. 5.5) suggest that he had strengthened his understanding of figures and expressive gestures. Like Arnautoff, he found the opportunities for mural work scarce, but in 1933 he received his first mural commission (Fig. 5.6), from the Jewish Community Center on California Street. Whereas the relatively secular working-class Folkschule had been propelled by sophisticated Marxist debate, the community center, heavily underwritten by orthodox religious thinking, served middle-class Jewish families in the Western Addition and Jordan Park districts. The differences between the two institutions seem to have mattered in Zakheim's conception of the painting, inflecting his sense of what a mural, outside the prescriptions of regular patrons for public art, ought to be: a nostalgic celebration of ethnicity.

Although Arnautoff's murals in his studio and the Palo Alto clinic received some attention, Zakheim's new work received more, the quantity of attention alone evidence that the more conservative art critical community was taking stock of the suddenly active radicals. Critics may have noted the new mural, however, with a sigh of relief, for it seemed devoid of worrisome details. Reading the criticisms, one is struck by the critics' delight in describing the community center mural, though the scene is awkwardly composed and the figure types not nearly as accomplished as those in Arnautoff's work or Zakheim's own new canvases.[21] One critic enumerated the pleasures pictured in the Jewish wedding festival for a victorious athlete and a maiden: "Jugglers so dexterous as to keep eight full glasses of wine constantly in the air without spilling a drop; drummer, fiddler and piper playing the dithyrambic chants of the Hasidim; singing maidens; hasty weddings; archers and judges, prayers and dancers, all contribute life and conviction to a finely executed picture."[22]

The critics pointed accurately to the mural's dominant features and correctly assumed its engagement with Jewish culture, with the Star of David and the Hebrew

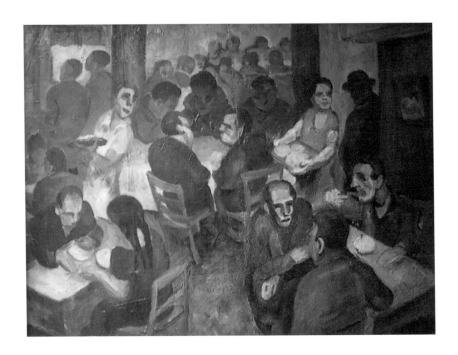

5.4 Bernard Zakheim, *Café du Dôme*, 1932. Oil on canvas.
Collection of Masha Zakheim.

text of the Song of Songs as the most visible evidence. Indeed, the scene hinges on
the central text on a post that divides it compositionally and thematically into
four related quadrants to assist viewers in reading the details of Jewish celebra-
tion. But in focusing on these elements, the critics point in quite the wrong di-
rection. For example, the conflation of subject matter and style—the jugglers'
dexterity becomes Zakheim's own—seems less than incisive. In fact the mural
suggests some of the lessons Zakheim had learned during his recent stay in Paris,
where he had observed a full range of modernist experiments. He tried them all
in a single piece: the elongated body types and unstable ground plane are remi-
niscent of those in Chagall, whose eastern European and Jewish identity would
certainly have mattered to Zakheim, as would his early focus on the Jewish sub-
culture of his native Vitebsk.[23] The wide-eyed faces and heavy brows and jowls are
reminiscent of those in Henri Le Fauconnier. The stiff abbreviated gestures have
a touch of Georges Rouault; and so on. Our task is not to enumerate one-to-one
correspondences but to suggest Zakheim's eclecticism. He mixed and matched
elements from the School of Paris of a decade earlier, borrowing and developing

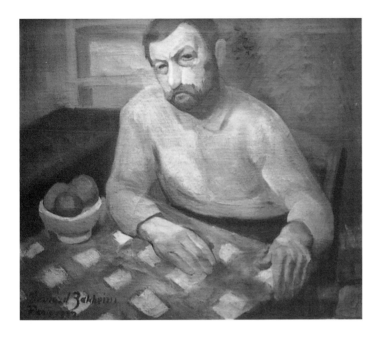

5.5 Bernard Zakheim, *A Friend in Paris,* 1932. Oil on canvas.
 Collection of Masha Zakheim.

5.6 Bernard Zakheim, *Jewish Wedding,* 1933. Fresco. Jewish
 Community Center, San Francisco.

them in a congested geometric structure picked up from Rivera. The mural is less a tight integration of these influences than an accumulation of them, for the painter seems to have had problems managing them: the background archers fade too quickly, the dancing pairs in the upper left quadrant are too abbreviated, the semicircle of figures at lower left too dominant in relation to the other scenes.

It seems clear that, like Arnautoff, Zakheim spent the first few years after Rivera's departure experimenting with new pictorial strategies. Arnautoff pared down the Riveraesque style to study its basic components of figure types and brushwork in large single-scene subjects. Zakheim experimented by grappling with the stylistic features of ambitious Parisian easel paintings and introducing them into the compositional glut characteristic of Rivera's San Francisco work. Neither artist, however, devised a way to link these experiments to leftist politics. The critical response, for example, indicates that Zakheim's gestures toward the School of Paris only made the community center mural more palatable. The two painters, however, received far more attention than one might have predicted in 1930. Because their works were now being scrutinized, the potential to transform the mural movement and put it into public dialogue with the left greatly increased. That potential came closest to being realized in 1934.

PUBLIC PATRONAGE AND RADICAL AMBITIONS

One of my concerns in this book is to demonstrate, for San Francisco at least, the inaccuracy of our received notion of "1930s public art" as issuing suddenly from an agency of the federal government and the efforts of reformist Democrats. According to this notion various New Deal art programs in 1934 began to fund and direct a nationwide mural movement—to bring art to the people, as New Dealers never tired of saying. The preceding chapters and the initial sections of this one have pointed to a local arena where several different versions of "public art" had been in practice and in contention for years, long before any New Deal programs were ever conceived. When Harry Hopkins, Holger Cahill, Edward Bruce—the major administrators of the federal projects—and their Washington staffs began to dole out mural work to local painters, they were adding money and incentive to a contest already raging, with fairly high stakes and several political inflections. The New Dealers generally laid the responsibility for decision making, daily supervision of work, and, perhaps most important, an ideological tone, squarely on the shoulders of local advisors, so that any national program filtered into the city through the practices of its own art community. Thus it might be more accurate to say that New Deal programs intensified the contest, providing the funds and

administrative apparatus that sometimes augmented, and at other times competed with, those traditionally supplied by patrons of public murals.

The New Deal's initial experimental program, the Public Works of Art Project (PWAP), began in late 1933, directed by Bruce.[24] Its relatively short life, less than a year (until June 1934), was planned from the outset, but in its time it managed to channel emergency relief funds to a remarkably large number of artists, who painted generally uncontroversial murals (except in San Francisco, as we shall see). Encouraged by its success, Roosevelt underwrote more ambitious programs, including the Section of Painting and Sculpture, also supervised by Bruce, that continued its work from October 1934 to June 1943. Funding for the Section, unlike that for the PWAP, came from the Treasury Department, and most of its projects were slated for federal buildings, primarily post offices. Unlike all the other programs, before and after, the Section prided itself on *not* being a relief project. Its artists were selected in juried competitions; it employed painters and sculptors of high repute, many of whom enjoyed relatively comfortable incomes. The only significant Section project in San Francisco was Anton Refregier's Rincon Annex murals, to which I return in my concluding chapter. Two more relief programs began in 1935, both funded by the Works Progress Administration—the Treasury Relief Art Project (TRAP) and the better-known Federal Art Project (FAP).

The FAP, directed by Cahill, had a wider range, a longer existence (until 1943), and a more profound local effect than the simultaneously run Section, one that can be directly traced to the program's purpose, to provide relief, and to its fluctuating funds. More than once Cahill defined the FAP's mission in opposition to that of the Section under Bruce, who emphasized certain (largely unclarified) notions of quality as the basis for public works. Cahill, by contrast, interpreted the FAP's program in economic rather than artistic terms. When Bay Area administrator Willis Foster developed a project, for example, he expanded the normal profile for "mural assistant": "If there was research of some sort that someone else could be put to work on, this was generally done, this just created more jobs, just as a matter of saving drudgery or just digging for the supervising artist. . . . I think in most cases the research bits were incidental."[25] Though decidedly a relief program, the FAP received only makeshift funding for its ambitious work rolls. Whereas the Section could rely on the Treasury Department to underwrite its projects, Cahill's FAP was forced to seek local funding—for wages, pigments and brushes, scaffoldings, and plaster—"to make [the project] sort of self-supporting—supported by the local municipalities."[26] That is, he relied increasingly on patrons who had previously supported public art in San Francisco.[27] (Certainly, the city was better prepared for such a vast program than locales elsewhere in the country, where New Deal machinery was put into place rather than mapped onto

the local scene. San Francisco required the importation of neither painters nor administrators.[28] The CSFA's trained mural painters, the SFAA, and new public museums, all accustomed to large-scale corporate patronage, together provided a model on which to base a nascent national arts program. According to Foster, the national director "considered this [the San Francisco region] one of the more vital areas of the program.")[29]

All these elements—the enthusiastic formation of the national projects, the diffusion of federal funds into regional spheres, the comparative vitality of the San Francisco scene—need to be weighed against the obvious worries of both painters and patrons. For painters, the New Deal represented the possibility that San Francisco's patrons, in their competition with each other, would perpetuate an existing public painting ideology as federal funds flowed through an administrative machinery now backed by the institutional weight of Washington. For some patrons, the New Deal represented the opposite possibility, that leftist painters were now suddenly offered a chance to carry out their agenda for a radical public art. Arnautoff and Zakheim, who had once had difficulty securing walls of even modest size for their work, now were offered spaces and relative freedom on a scale grander than either had ever imagined. The exasperation in Foster's voice tells the story: "For a while they were all conscious . . . if they ever saw an empty wall inside or outside a large building we'd often hear about it, they'd come and ask if they couldn't design something for it. . . . [S]ometimes [they would] go to ridiculous lengths because you'd see a theatre building maybe with a blank wall six stories high and [they would] ask for permission to paint a mural on it."[30] The most important conflict between organized radicals and one conservative set of patrons arose when competing ambitions for public murals were played out in a mural project for Coit Tower.

In late 1933, after completing the Jewish Community Center mural, Zakheim was unexpectedly invited to the home of Herbert Fleishhacker. It was the first meeting between the old guard power broker and the immigrant Communist. Fleishhacker had also invited the newly formed PWAP committee for district 15, San Francisco, whose membership underscores the fundamental conservatism of federal patronage.[31] Zakheim was the only one in attendance to leave an account of the meeting, which seemed to him like blandishment: "I just know I was called to the home of this Fleishhacker where there was exquisite wines, wonderful delicatessen. . . . So that night at Fleishhacker's house we had all these wonderful goodies to eat, after all it was Depression . . . and I was told to lead the idea that they would be going to collect the artists to come into the Coit Tower, to decorate the Coit Tower."[32] In all probability, the intent of the meeting was less to cajole than to

corral. For what is quite apparent even in Zakheim's account are the still palpable effects of Arnautoff's studio mural. The radicals, who had publicized themselves collectively, were now being gathered as a unit for a single mural project, with Zakheim (missing in that studio mural) nominated as their spokesman.

That PWAP district 15 immediately took note of the Communist presence testifies to Rivera's afterlife. But we still need to account for the events that made the cultural arm of the Communist Party so worrisome. Why, of the two possibilities suggested by federal funds, did the potential for a new, radical public art seem more likely than the continuation of the status quo? Why did the oligarchic committee not feel sufficiently in control—or rather why did it feel the need to *over-control*—the public art made in its name?

The meeting between Fleishhacker and Zakheim was prompted by two separate developments in 1933 that had encouraged the regular patrons of art to involve themselves in the mural relief movement and to choreograph its first, most ambitious project. First, the leftist cadre of bohemians centered on Montgomery Street and Telegraph Hill formed an Artists' and Writers' Union, led by Rexroth, Zakheim, and the anarchist Frank Triest. Many of the city's leading artists joined it, including some (Stackpole and Boynton) who had not professed radical tendencies before, thereby lending credence to the now familiar suspicion that Rivera's dangerous magnetism continued to exert its effect.[33] Even Dixon was drawn in by its momentum, life during the depression having grown far too dire for him to remain aloof. The union's first act was to appeal to Washington for emergency relief for its members. Zakheim recalled the exhilaration of organizing the artists, and his account still conveys his breathless excitement about the union's commitment to activism:

> [Rexroth and I] went around from studio to studio talking to each artist separately and asked questions over again. . . . The first meeting was at the Whitcomb Hotel [but] [w]e decided to call a bigger meeting at local artist Maynard Dixon's studio; sculptor Ralph Stackpole was there, and he knew someone in Washington—Edward Bruce, an artist-banker. . . . Ralph wrote him a letter, sent it off that night. . . . We made a collection of small change— less than a dollar—and sent a night letter to Washington . . . we took it to . . . the Union Telegraph office, we took it there and we sent if off to Bruce telling him that the artists are destitute, they must be provided with jobs at their own professions.[34]

That moment of solidarity is marked by expanding enthusiasm. The organizing artists move to larger quarters to accommodate more union members; they

tap the center of power; they contribute precious small change; they march collectively to the telegraph office, sending their missive to the newly empowered Edward Bruce.

Certainly Roosevelt's public proclamations displayed social concern, and his stirring promises of relief produced a climate that nurtured the Artists' and Writers' Union's enthusiasms. These were only encouraged when the letter received a quick positive reply. "In an amazing short time [four days]," Zakheim recalled, "came a telegram to the [de] Young Museum to [Walter] Heil, Dr. Heil [the museum's new director], to get the artists together and send them on a project."[35] It is one of the quirks of history that Bruce—unbeknownst to the Artists' and Writers' Union—had already begun assembling the PWAP machinery; Stackpole's letter arrived, fortuitously, just after the federal program had been approved. If the artists misinterpreted Bruce's quick response, nonetheless it gave the leftism underwriting the union legitimacy among its newer members.

The second development prompting Fleishhacker to meet with Zakheim was the artist's successful appeal to the Jewish community to commission the community center mural. The destitution of artists from the city's ethnic communities was a double curse. They were already outside the city's patronage circuit, and the depression made it unlikely that they would receive any of the crumbs tossed to painters in general. As Zakheim put it later, each artist "went to his ethnic group for support,"[36] a reasonable response given the history of San Francisco's leftist culture. But patrons feared that the ethnic cultural fronts (like Zakheim's old Yiddish Folkschule) more closely aligned with the Communist Party and populated by militant activists would begin to involve themselves in the business of public art. The threat seemed substantive, since many of the fronts had begun, since Rivera's departure, to appeal to working-class ethnic populations, attracting them with extraordinarily popular agitprop theatrical performances and several makeshift public music performances.

Very little documentation of these popular events survives, and that is filtered through the memories of the organizers themselves. But the appeal of spectacle is apparent, and the allure of a street performance can still be glimpsed in accounts like the one that follows, by Rexroth:

When I became co-secretary of the League for the Struggle of Negro Rights, we organized a Blue Blouse Troop [a group of workers/actors], which performed regularly on a flat-bed truck parked in the "free speech area" at the corner of Ellis and Fillmore Streets. It was carefully modeled on a German example. The actors all wore blue jeans and chambray shirts and moved with the semaphore motions of marionettes and spoke in a rhythmic monotone

and had been directed in rhythmic motion to a suitable record. Over half the cast were Negroes, as of course in that district was the audience. Also, sometimes I recited poetry to a jazz trio, most notably Louis Aragon's "Red Front." Early in the spring of that year [1932], we decided to do a play on the anniversary of the Paris Commune. Within a few weeks of the decision, Red Dog Haynes' brother Jack showed up with a perfect Epic Theater treatment of the whole history of the commune.[37]

What could be more ludicrous yet startling than a history of the Commune, complete with blue jeans and chambray shirts, performed for an amazed, amused, and probably rapt audience in the Fillmore?

In themselves, the plays, despite their subject matter and their unprecedented performance in the city's streets, should not have caused the regular patrons of art any great anxiety. But the depression-era spectacles seemed to have far-reaching effects. In the early 1930s, for example, the small black intellectual community in the Fillmore district underwent a perceptible shift away from the Republican Party and toward the Communists. The most dramatic realignment can be seen in the attitudes of John Pittman, editor of the *San Francisco Spokesman,* one of two black newspapers in the city.[38] In 1931 Pittman and the *Spokesman* generally supported Mayor James Rolph's policies, providing generous coverage of his appearances; a year later, having witnessed performances like the Blue Blouse Troop and their popular appeal, the paper looked more skeptically at city hall. By 1933 its editorials were relying on identifiable Communist Party jargon. And by 1934 it was fully embracing the local apparatus. The *Spokesman* folded of its own accord in 1935, after which Pittman became one of the founders and editors of the Communist *People's World.*[39]

The street performances, by invoking a relationship with radical events outside the city, suggested a choreographed leftist effort. Rexroth tells us of that larger dimension in the absurd Paris Commune play:

> With all the futile soapboxing before the factory gates, the Paris Commune play probably recruited more members for the Party than any other single activity. . . . An activity like the Paris Commune play, or the revolutionary Yiddish theater Artef, the best theater ever to originate in America, constituted dangerous foci of organizational power, like the Agricultural Workers Industrial Union, which was a source of spontaneous deviation.[40]

Black street theater and Jewish revolutionary drama—these were the instruments of radical appeal. But almost in passing, Rexroth mentions a far more disturbing

organizational power, for it was precisely the links to radical unions—like the California Agricultural Workers Industrial Union (CAWIU)—that made the performances resonate. The plays were not isolated phenomena; they seemed to belong to a much wider network of radicalism. Their crude anarchic flavor signaled a larger resistance. In 1933, for example, Sam Darcy (the Communist Party's district organizer) took control of the CAWIU and launched a series of strikes in the fields of the Central Valley, the most violent being three famous interconnected strikes at Woodville, Pixley, and Arvin, the so-called Cotton Strike.[41] Besides the general anxiety it caused in the city's press ("the atmosphere of the valley is that of a smoldering volcano," the *Examiner* reported), the rural unrest is important to this account because most of the strikers were blacks and Mexican and Filipino immigrants, and, unprecedented in California, much of the Communist leadership was nonwhite.[42]

The militant ethnic radicalism suggests a pattern of influence, and while we need not posit a concerted program on the part of the Communists to stage street performances, shift the ideology of black journalism, and foment violence in the Cotton Strike (where fear of conspirational tactics was palpable), there was enough Communist involvement in all these events to make the old patrons take steps to neutralize any potential agitprop materials. Confident claims by leftist artists about the radical audience viewing *Making a Fresco* had provoked a response precisely because they identified that audience with the disenfranchised working-class ethnic population. The increased militancy in this population in 1932–33, combined with the undeniable trace of Communist Party activity in the city's poor districts, made such identification seem entirely legitimate. The old guard, relatively quiet from 1928 to 1932, when they preferred to watch Gerstle, Pflueger, and Bender commission murals without themselves underwriting a pictorial response (Piazzoni's 1929 library murals were the one unfortunate exception), reacted aggressively in late 1933, immediately after the Cotton Strike, forming a "culture committee," led by Fleishhacker, that eventually became the PWAP committee for district 15.[43] Their primary task was to prevent the further development of any link between mural painting and leftist politics.

The Coit Tower murals constituted the largest collective project funded as part of the federal programs, not just in San Francisco but in the country. Coit Tower was hailed as "an apt place for such creative effort.... It has good, broad walls [that] need decoration, and for the most part they stand right out in fresh light where they can be seen."[44] The tower, built in 1932–33, had been designed by Henry Howard, an architect in Arthur Brown's firm. From the beginning, Fleishhacker controlled the funding, directed the construction, and determined the tower's eventual links with the PWAP, despite Heil's nominal leadership.[45] An important motivation for

him was the site, Telegraph Hill, a favorite residential area for bohemians and political radicals, second only to the Monkey Block. The move to preempt leftist culture was not lost on the artists, and they mounted a public protest.[46] Even the moderate Stackpole sent angry letters to Fleishhacker.[47] By October of 1933—the moment of the Cotton Strike—the massive 288-foot tower stood high on Telegraph Hill, as much a sign of traditional authority as a memorial to Lillie Hitchcock Coit, whose bequest to the city had been used to build it. Fleishhacker's intentions were never lost on the painters, Zakheim later naming it Fleishhacker's "last erection."[48]

The tower project had great appeal to the radicals, even if it meant that they must subject themselves to the Fleishhacker regime. The proposed wall space, totaling almost 3,700 square feet, included the circular main lobby for the tower proper, a smaller enclosed lobby, a serpentine stairway leading from the first to the second floor, a second-floor hallway, and a small room at the end of a curving walkway that leads up to the tower's highest perch.[49] The walls covered by the finished murals would constitute three-quarters of all the wall space given to murals in the state. To Arnautoff, who had conceived his studio mural as a solidarity piece for the city's leftist artists, Coit Tower represented the possibility of lavish attention for a new public art. The newspapers reflected a different emphasis, however, likening the painters to a medieval guild of anonymous craftsmen whose work served the greater glory of federal patronage.[50] A reporter observing the first moments of painting in January 1934 considered how such different ambitions and attitudes about the works might lead to some kind of pitched battle:

> Like the lion and the lamb of the millennium, violent modernists and intense conservatives have met amiably upon common ground. They have worked out plans for the interior decoration of the Coit Memorial on Telegraph Hill, the starting point for the campaign of interior beautification without even so much dissension as the memorial itself has aroused. . . . Thus the expected Battle of Telegraph Hill is at least postponed if not averted. Perhaps California sunshine, balmy climate and ocean zephyrs account in measure for the prevailing serenity. . . . [I]f there is to be internecine warfare, apparently it must wait upon the fruits of the harvest. Those who hate peace must be patient until the modernists and conservatives have looked each upon the completed works of the others, and the groups devoted to development of Culture have looked upon both.[51]

By June, Fleishhacker was leading a movement to destroy the murals, finding the work of some painters wholly unacceptable and, as we will observe, dangerous.

The contentious Zakheim came under intense fire, and his mural, along with several others, was slated for whitewashing.

To see those dangers, we need to widen our scope once again, to include the new bonds between the Communist Party and organized labor, especially the city's waterfront unions.

From 1931, when Darcy arrived in California, to early 1934, the local Communist Party and the AFL unions began to bring their policies into closer alignment. Darcy's own agenda for skilled and unskilled labor clashed with that of the national CP. (William Z. Foster, the Party's chairman, at this time advocated a narrow, inflexible approach to organized labor, largely ignoring agricultural workers and championing instead the ill-fated Trade Union Unity League [TUUL] as a separate, competing organization for revolutionary unions.[52] That is, the CP refused to work with existing AFL unions, regardless of the politics of the individual locals, and preferred to establish a competing league.) But the ideological impasse was anything but debilitating. Since Darcy worked outside the national CP program, he formulated policy on his own, often in makeshift fashion. In practice, this meant fine-tuning the united front agenda to the shifting priorities of San Francisco's labor movement. Darcy seems to have been remarkably sensitive to union demands and the workers' generally bad fortunes. Despite his seemingly authoritarian style—he was characterized as a "very strict disciplinarian [who] blows up at the slightest inefficiency"—he regularly took his cues from the leftist factions in the Bay Area, including the language cells like those represented by Arnautoff and Zakheim.[53] Thus, Darcy's united front agenda should not be construed as dogmatic; it was an adaptive strategy of a CP attentive to the shifting interests of the working classes. One of its important results was Darcy's undercutting of the local chapter of the TUUL's Marine Workers Industrial Union (MWIU) and his support of a revamped, largely untried AFL union led by Harry Bridges, self-avowedly not a member of the CP.

While Darcy was liberalizing the Communist Party, Bridges was radicalizing the waterfront and revitalizing the local International Longshoremen's Association (ILA), dormant since 1919.[54] Although Bridges is familiar to labor historians, who have written voluminously about him, a few details of his life prior to 1934 can help to establish his presence for us.[55] His meteoric rise through the rank and file is often attributed to his easy relationship with other workers, their trust in his practical thinking and competence, and their appreciation of his caustic humor. Some who emphasize these characteristics suggest that Bridges was disinclined toward theory or, worse, cloudy on leftist positions—and for these reasons never openly joined the CP. Although Bridges was not a Party Marxist, he was far from

uninformed. He had his first taste of radical politics in his native Australia, where he found working-class socialism far more appealing than the middle-class life of his parents. He took part in the 1917 Australian general strike and, in San Francisco in 1920, joined the Sailors' Union of the Pacific (SUP). When he decided that its leaders were neither as radical nor as doctrinaire as he was, he left the union for the more militant Industrial Workers of the World (IWW). But even this organization seemed to him insufficiently politicized, though he accepted many of its anarcho-syndicalist shop and strike tactics. Bridges made a productive combination of his political rigor and his acumen with the rank and file during the 1920s. Feisty and independent, he regularly confronted the shipowners' hiring hall practices and quickly gained a reputation as a highly principled, politically savvy agitator. Employers blacklisted him; longshoremen championed him.

Bridges developed his first meaningful, sustained relationship with the Communist Party in 1932–33, the period Rexroth would later link with his own Blue Blouse efforts. At this time Bridges seems to have accepted the CP line, but he also recognized its theoretical and ideological limitations for the rank and file.[56] When he revamped the International Longshoremen's Association in 1933, he sought both to blend CP tactics with demands for better wages, hours, and hiring procedures and to create a radical body of workers that was neither repressively hardline nor isolationist. In these efforts he found a sympathizer in Darcy.

Bridges and Darcy established a practical approach to working-class and leftist solidarity. Their alliance is as important to an understanding of the 1934 Big Strike as any details or behind-the-scenes negotiations between labor and capital recounted in the histories. It helps to explain how the strike gained momentum as quickly as it did, how that momentum was sustained, and how leftist artists could so readily infuse into their work at Coit Tower the concerns of the strikers.

The 1934 Big Strike is one of the key moments in the labor history of depression-era San Francisco, perhaps of the entire country, and it has deservedly received much attention.[57] For nearly three months, from May 9 to July 31, striking workers, headquartered in the city, organized into a cohesive mass up and down the Pacific coast. In July they virtually shut down all commercial activity. The strikers included not only waterfront workers—the rebellious longshoremen, teamsters, and seamen who set up the picket lines—but also municipal service workers, who quickly gained sympathy from workers in non-unionized businesses as well. The strike was remarkably widespread. During its bitterest weeks strikers controlled which restaurants could stay open (reportedly only nineteen out of some three thousand), which grocers could sell food, and which services were essential. San Francisco was held captive while labor and management waged a dramatic conflict, played out all over the city.

5.7 Jose Moya del Pino, *San Francisco Bay, North,* 1934. Oil on canvas. Coit Tower.

5.8 (*Opposite*) Otis Oldfield, *San Francisco Bay,* 1934. Oil on canvas. Coit Tower.

The Big Strike had a centripetal effect that extended beyond the actual combatants; its broad reach ensured that there were no neutral observers. For both members and nonmembers of the Communist Party among the Coit Tower mural painters and mural assistants, it brought allegiances and employment conditions into focus. From Telegraph Hill, all of them had clear sight lines to the waterfront below, where picket lines ran from one pier to the next, and between July 3 and 5 they could see the bloody hand-to-hand battles between strikers, scabs, the National Guard, and city police. When Jose Moya del Pino and Otis Oldfield painted their panels of the bay and harbor (Figs. 5.7 and 5.8), they could match the painted

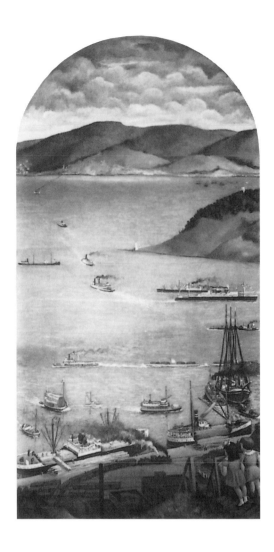

scenes to the actual views. Their decision not to include the mass of picketers was an omission of great significance, an ideological choice. Moya del Pino preferred to paint himself and Oldfield sitting on the hillside, with Oldfield sketching the scene below, as if artistic rather than political matters were more important to the scene.

Bridges's rank and file were radicalized to a point where they took to the streets en masse, with fists bared, continuing to act independent of the leadership of both the Longshoremen's Association and the AFL, which sought reconciliation with employers throughout the strike, signing contracts and pledging union obedi-

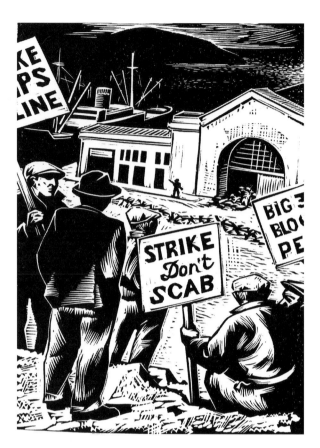

5.9　Victor Arnautoff, *Strike, Don't Scab,* 1934. Victor Arnautoff Papers, Archives of American Art, Smithsonian Institution.

5.10　(*Opposite*) Victor Arnautoff, *Bloody Thursday,* 1934. Victor Arnautoff Papers, Archives of American Art, Smithsonian Institution.

ence. The rank and file—as an anarchic but cohesive body—ignored the union chain of command and worked outside the institutionalized channels for organized labor. If ever there was a pentecostal revival of anarcho-syndicalism in the city, as some claim occurred, it flared up during these months.[58] The effect on the leftist Coit Tower artists was twofold; I describe it here briefly and expand upon it later. First, it emboldened them to ignore the Fleishhacker group formally, through their membership in the radical Artists' and Writers' Union. Second, it gave them a particular subject matter. Arnautoff and Zakheim, who had previously had difficulty choosing subjects appropriate to Darcy's ambiguous united front agenda, found one straightaway in the anarchy in the streets.

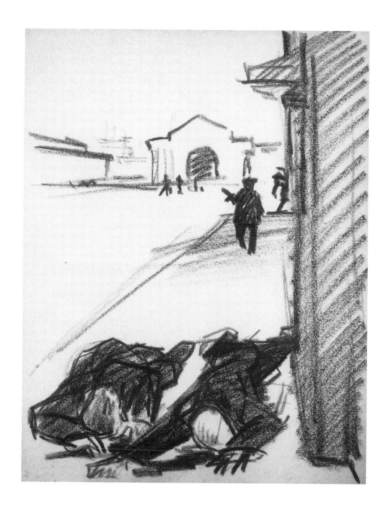

For painters who were Communist Party members the Big Strike required agit-prop, both inside and outside the tower. Outside meant graphic work, which fell primarily to several artists not involved in the Coit Tower mural project: Bits Hayden, Pele de Lappe, Giacomo Patri, and Arnautoff (Fig. 5.9).[59] Although Arnautoff was also called upon to paint Bridges's portrait, in the fantastic rush of events he never did.[60] Inside, allusions to the strike became an imperative. In addition to their artistic efforts, Communist Coit Tower painters demonstrated, marched, and, during the massive funeral procession for Howard Sperry and Nick Bordoise—the two strikers slain in the Battle of Rincon Hill (Fig. 5.10)—joined the ranks of mourning workers.[61] One sympathetic description of this funeral march

5.11 Victor Arnautoff, *Funeral March*, 1934. Victor Arnautoff Papers, Archives of American Art, Smithsonian Institution.

gives the flavor of the rhetoric Communist painters used and provides a basis for the many subsequent images of the procession (Fig. 5.11)—particularly the grim earnestness and military resolve of the workers themselves:

Slowly—barely creeping—the trucks moved out into Market Street. With slow, rhythmic steps, the giant procession followed. Faces were hard and serious. Hats were held proudly across chests. Slow-pouring like thick liquid, the great mass flowed out onto Market Street. Streetcarmen stopped their cars along the line of march and stood silently, holding their uniform caps across their chests, holding heads high and firm. Not one smile in the endless blocks of marching men. Crowds on the sidewalk, for the most part, stood

with heads erect and hats removed. Others watched the procession with fear and alarm. Here and there well-dressed businessmen from Montgomery Street stood amazed and impressed, but with their hats still on their heads. Sharp voices shot out of the line of march: "Take off your hat!" The tone of voice was extraordinary. The reaction was immediate. With quick, nervous gestures, the businessmen obeyed. Hours went by, but still the marchers poured onto Market Street, until the whole length of the street, from the Ferry Building to Valencia, was filled with silent, marching men, women, and children. Not a policeman was in sight throughout the whole enormous area. Longshoremen wearing blue armbands directed traffic and presided with an air of authority. No police badge or whistle ever received such instant respect and obedience as the calm, authoritative voices of the dock workers. Labor was burying its own.[62]

The mural program at Coit Tower was conceived by Zakheim, edited by the Heil-Fleishhacker group, and supervised by Arnautoff. Zakheim was explicit about the program: "We should deal with an overall idea on the economy . . . not so much historical as actual, what is happening right now in the United States. I suggested that and it was adopted. We were each given a certain subject. . . . And each one had his own side of a wall in which to do it."[63] The decision to enlist Zakheim as idea man may seem to have been a particularly bad one for the local PWAP in 1933–34. But the Jewish nostalgia of his only public mural would not have seemed alarming, especially in comparison with Arnautoff's studio mural. In any event, his ideas were not accepted without reformulation, and Heil's censoring hand can be felt even in Zakheim's description. On one end of events, Zakheim proposed an overall program; at the other, the painters were given walls and subject matter. In between, district 15 edited the original suggestion and, as one critic blithely observed, "outlined a scenario of ideas and arranged for the artists to work it out."[64] Zakheim had envisioned references to the dire state of the economy; district 15 revised the proposal into a collection of eminently familiar themes: California agriculture, San Francisco genre scenes, and landscapes and seascapes of the bay region.

With remarkable speed, however, individual projects began to mutate after the initial sketches had been approved, and political differences between the painters began to break down the fiction of medieval collectivity and ideological harmony. The painters who worked on the second floor were not Communist Party members; they produced scenes of leisure and entertainment, like Edith Hamlin's *Hunting in California;* figures recalling those in Greco-Roman or even Persian reliefs,

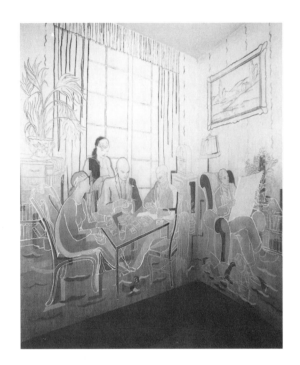

5.12 Jane Berlandina, *Home Life,* 1934. Egg tempera. Coit Tower.

5.13 (*Opposite*) William Hesthal, *Railroad and Shipping,* 1934. Fresco. Coit Tower.

like Edward Terada's *Sports;* and scenes of domestic bliss, as in Jane Berlandina's *Home Life* (Fig. 5.12). These murals show little evidence of Rivera's style in their figures, colors, or compositions, and contemporary observers were justified in calling them conservative. Only Berlandina's ventured into new territory, the influence of her teacher Raoul Dufy a strong element in her work. In the interior lobby, the works of Oldfield, Moya del Pino, and Rinaldo Cuneo were not even true fresco but oil on canvas, the panels more like the landscapes and cityscapes the three usually produced than like the murals they were surrounded by.

A stylistic comparison of the various walls suggests that the murals only thinly masked the political differences among the painters. When the political components emerged more fully during the summer, the image of the medieval guild shattered. A journalist, in a now famous passage, read the arguments in the Coit Tower murals:

Too much has already been published about the Great God Rivera's propagandic [*sic*] activities to need further repetition. Nevertheless, that Gargantuan Mexicano is the God of many American fresco painters, particularly of those who careen to larboard, so to speak. In their eagerness to follow in his

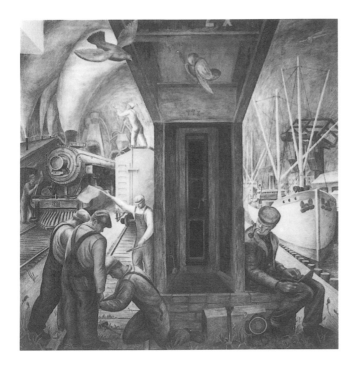

brush strokes, they not only lean over toward the extreme left, but also back-
ward. . . . [T]he Coit Tower had seen red, that is to say—let me whisper it,
lest I be overheard—the naughty boys had indulged in a little Communistic
propaganda and at the expense of the U.S. Government.[65]

Even Rivera's massive, bodily presence—that old journalistic tactic—is resur-
rected to make the charges vivid.

In some form or other, the panels painted by Communists share an attentive-
ness to the Party and union activities of Bridges and Darcy. Some journalists po-
larized the politics of the Coit Tower murals, dividing them unproblematically
into "Kid Kapital" and "Kayo Communism," as one observer put it. But this was
a crude gloss on diverse, complexly motivated leftist pictorial statements.[66] In fact
the political radicalism offered in the murals was decidedly not the version ad-
vocated by the national CP but one that had been formulated locally. This local
element can be seen quite clearly in William Hesthal's *Railroad and Shipping*
(Fig. 5.13). The panel is specific about its site: the central post is a trestle for the
Third Street Bridge that leads to China Basin, in the city's southeastern quarter.
And the (non)activity is also specific: the waterfront behind the ship crane has

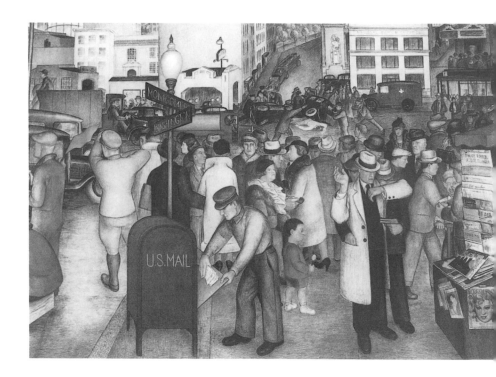

5.14 Victor Arnautoff, *City Life* (left panel), 1934. Fresco.
Coit Tower.

been interrupted in midair, the docks are virtually empty, the workers at left have
halted traffic and are pulling spikes from the tracks (one spike is held by the figure
closest to us), and the signalman has nothing to do but sit and smoke—all be-
cause of Bridges's union and the striking longshoremen. Arnautoff's *City Life*
(Figs. 5.14 and 5.15) takes a different tactic, picturing the congestion and misdirec-
tion in the streets below the tower. Violent events occur in the crowded street (a
holdup in the right foreground of the left panel, an overturned car in the back-
ground). In the right panel, the city's new leftism is evident in the presence of the
Masses and *Daily Worker* on the newsstand, and in the left panel it shows in the
reference to the Monkey Block (the Montgomery and Washington street signs)
and in the soldier waving a red flag at left, just beyond the mailbox. In *California
Industrial Scenes* (Fig. 5.16), John Langley Howard pictures the region around
Mount Shasta at the northern end of the Central Valley, the same agricultural area
where Darcy's California Agricultural Workers Industrial Union had dramatically
shifted the national CP line and his united front had produced the most coherent,

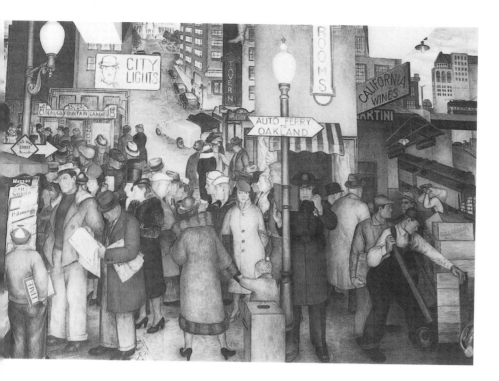

5.15 Victor Arnautoff, *City Life* (right panel), 1934. Fresco.
Coit Tower.

successful worker strikes prior to 1934.[67] In the mural, Howard provides a veri-
table CAWIU iconography. Whereas the national CP tried to separate agricultural
from industrial workers—a move that often resulted in racial segregation—Darcy
wanted to combine all workers in a multiracial militancy, as pictured at left. A
scroll (not visible in the reproduction) refers to the 1932 CAWIU Pea Strike in Half
Moon Bay, just south of San Francisco, where Mexican, Filipino, and Puerto
Rican pickers struck for wage increases and improved living and working condi-
tions.[68] On the far right, a miner reads Darcy's new radical journal, the *Western
Worker.* The Fleishhacker group wanted the whole wall whitewashed.

 Clifford Wight's painting, the most contentious, was ultimately the only one
obliterated. A description of it remains, by the critic Junius Cravens:[69]

> Over the central window [Wight] stretched a bridge, at the center of which is
> a circle containing the Blue Eagle of the NRA [National Recovery Act]. Over
> the right-hand window he stretched a segment of chain; in the circle in this

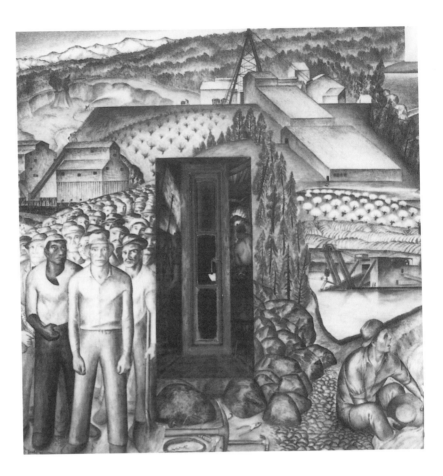

5.16 John Langley Howard, *California Industrial Scenes* (detail),
 1934. Fresco. Coit Tower.

case appears the legend, "In God We Trust"—symbolizing the American dollar, or I presume, Capitalism. Over the left-hand window he placed a section of woven cable and a circle framing a hammer, a sickle, and the legend "United Workers of the World," in short, Communism. It would seem that he considered those three issues to be important in the American scene today.[70]

Cravens interpreted this tripartite image as giving the viewer a choice between three competing social and economic systems. Such a reading seemed to be legitimized by the Artists' and Writers' Union's own defense of the panel, which posited Communism "as the principal alternative to the two other stages of social devel-

opment, the 'rugged individualism' of American capitalism and the 'New Deal' stage of the present."[71] Cravens misunderstood what was implied in the union's reading: Wight had no sympathies with the national CP line (nor had the union, for that matter) and protested on behalf of the longshoremen's union, not the marine workers'; he marched with the AFL union, not the now-marginalized Trade Union Unity League. The three symbols within circles—the dollar, the blue eagle, and the hammer and sickle—posited, not simply a choice, but a developmental process (from right to left) whose next step was already being imagined because of events on the waterfront.

In June the PWAP group's worries about the political content of the murals prompted them to close the tower,[72] which had been scheduled to open for public viewing in July. The closing only pushed the Artists' and Writers' Union into further action. Its members threw a picket around the tower like that visible below on the docks; the protest began to galvanize the members of the young union and align them publicly with the striking longshoremen. It was the second time that the Coit Tower mural painters had banded together in protest, this time with new resolve. The first protest, in February, just after the project had really gotten under way, was a response to the destruction of Rivera's Rockefeller Center mural, *Man at the Crossroads*. That mural was destroyed when Rivera's inclusion of a portrait of Lenin fomented trouble among the Rockefeller Center's political conservatives. When news of its fate reached San Francisco, the artists at work on the tower responded with a resolution and picketing.[73] It was the union artists' first such public statement of their loyalty to an alternative public painting, their first rally against the corporate substructure of conventional public art. For them the Rockefeller debacle was surely a sign of an old guard's circling its wagons. At Coit Tower, the painters responded to events in New York by encoding Rivera and the destroyed mural into their designs. In Zakheim's *Library* (see Plate 9), for example, Stackpole is shown reading a paper with headlines announcing the mural's destruction. In Ray Boynton's *Animal Force and Machine Force* (Fig. 5.17), the disembodied overseer has Rivera's eyes, as if to suggest that his ghost will haunt the new murals now that the New York panel has been desecrated. The most complex response was Stackpole's *Industries of California* (Figs. 5.18 and 5.19), which paid homage to Rivera in a scene composed along the lines of the destroyed painting. It was based, not on the semifinished mural that had elicited such reactionary resentment, but on an earlier preliminary sketch (Fig. 5.20) sent to Stackpole in 1932. (Different as this preliminary design was from the final one, it was very likely the only representation the city's artists had of the mural.)[74] Stackpole's painting preserves the horizontal format of Rivera's sketch and leaves intact the general apportioning of figures in the lower half and pipes and vats in the upper. Stackpole

5.17 Ray Boynton, *Animal Force and Machine Force,*
 1934. Fresco. Coit Tower.

5.18 (*Below*) Ralph Stackpole, *Industries of California*
 (left half), 1934. Fresco. Coit Tower (Photo: Lito).

5.19 (*Opposite*) Ralph Stackpole, *Industries of California*
 (right half), 1934. Fresco. Coit Tower (Photo: Lito).

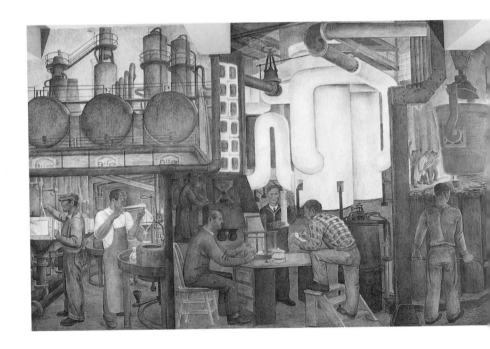

followed Rivera's compositional strategy of segmenting the mural with vertical tubes and tanks. In his panel, a chemist pours liquid into a retort; Stackpole accentuates its cylindrical form, one found prominently in Rivera's sketch. And the machinery and storage tanks in the central section look remarkably like the stamping press of the famous Detroit murals. The formal references were not lost on observers. "To my astonishment," wrote one, "Ralph Stackpole . . . was painting [like] Diego Rivera."[75]

If the first Artists' and Writers' Union protest was prompted by the disturbing events in New York, the second responded to an immediate threat of censorship. Moreover, while the first protest largely resulted in the painters' subtle revisions of their Coit Tower murals, the second prompted direct references in the paintings to the rebellion in the streets. On July 3 the *Chronicle* described Zakheim's mural as "Red Propaganda" and a "Red Plot," and complained that its various details—the reference to Rexroth on the spine of a book, the portrayal of John Langley Howard reaching for *Das Kapital,* the hint of Bridges in a headline about the "Slaughter in Australia"—referred too pointedly to events on the waterfront below.[76] The article made the larger implications of these details explicit: "The principle objection is to the mural showing a lot of emaciated intelligentsia in a reading

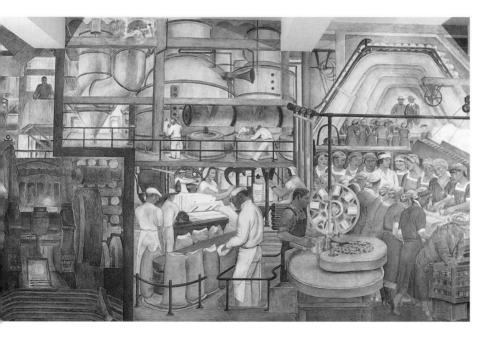

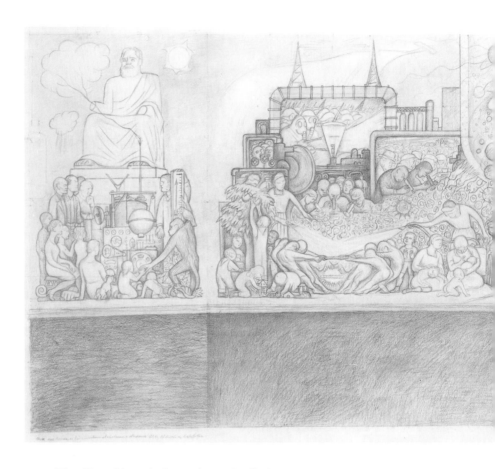

5.20 Diego Rivera, *Man at the Crossroads,* 1932. Pencil on
 brown paper. The Museum of Modern Art, New York.
 Given anonymously. (Photo: The Museum of Modern Art,
 New York).

room pursuing radical books and literature . . . Communism, if you will gentle-men; that is what certain brush wielders are . . . suspected of having portrayed overtly." The portrayal of the emaciated intelligentsia as ineffectual and bookish could hardly have been more pointed, but it was belied by events on the docks below. That day, seven hundred policemen tried to cross the picket line with cargo, only to be repelled by striking workers. The ensuing conflict lasted four hours, and the whole waterfront became a battlefield: "Bricks flew and clubs battered skulls. The police opened fire with revolvers and riot guns. Clouds of tear gas swept the picket lines and sent the men choking in retreat. Mounted police were dragged from their saddles and beaten to the pavement."[77] On July 4 the Artists' and Writers' Union called an "indignation meeting," this time to protest the prohibition

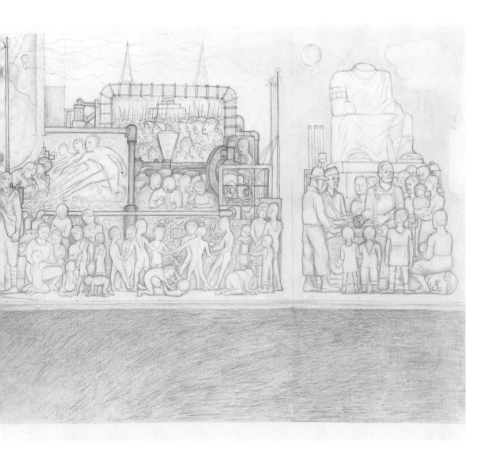

of picketing itself, because, as the police warned, "someone might throw rocks, or give signals . . . down on the entire waterfront."[78] There was great fear that the strike would spread from the docks up Telegraph Hill and beyond. Down below, the police had forced open the port, and cargo was being moved under armed escort. Fourteen freight cars were derailed by strikers, and the National Guard was put on alert. Mayor Angelo Rossi, Rolph's successor, characterized the entire waterfront conflict as a "clearly admitted plan . . . of the evil forces . . . of communism," and he worried that the malevolent energies were spreading.[79] On July 5, Bloody Thursday, a sketch of Wight's offending panel appeared in the *Examiner,* along with a detail of Zakheim's *Library.* All that morning and afternoon, phalanxes of police and strikers clashed, starting at the Embarcadero and moving up

Rincon Hill, down Steuart Street, and onto Market Street. The National Guard set up barricades on the Embarcadero, erected machine gun posts, established field kitchens, and prepared for protracted combat. During the daylong skirmishes, two were killed and hundreds wounded. On July 7, the day Coit Tower was supposed to have opened, the Bridges-Darcy coalition called for a general strike, which the delegates assembled in Eagles Hall approved unanimously. On July 9 the Fleishhacker group considered destroying the Coit Tower murals.[80] Fleishhacker himself made a last appeal to Zakheim; much later Zakheim recalled his words: "You know we are on the threshold of a war and we cannot tolerate what you have painted in the Coit Tower. Therefore if you want to play ball with us, you'll change [it]."[81] Zakheim, as he tells it, responded with typical pugnacious bluntness: "I am a hammer and sickle painter."[82] The *Examiner* sneered at the muralists' noise and at their links to the militant strikers: "If the artists were seeking excitement, they could do much better by tripping over to Russia and painting the American flag on the walls of the Kremlin. Then they would get action."[83] On the ninth, the united front of labor buried Sperry and Bordoise, and members of the Artists' and Writers' Union joined in the funeral march.[84] On July 16 the general strike began in San Francisco and Oakland, paralyzing the Bay Area. For nearly two weeks the Communist Party and the International Longshoremen's Association, in coalition, effectively ran the city, permitting certain stores to remain open and certain services to be offered in a siegelike environment. As the old guard had closed Coit Tower, now the militant strikers closed the two cities. Nothing moved in or out.

Coit Tower remained barred until October as the Big Strike and the Artists' and Writers' Union protest crumbled under the pressure of the Industrial Association and the Fleishhacker group. On the waterfront, the Industrial Association neutralized the Darcy-Bridges alliance by isolating the Communist Party, separating political radicalism from the more palatable worker demands, and containing the anarchic tendencies of the rank and file by encouraging them to return to established AFL procedures. A similar eviscerating strategy was effected at Coit Tower. The local PWAP committee, though officially defunct because the national program had ended, continued to act as a de facto body, preventing visitors, photographs, and further work for a half-year—they "clang[ed] shut" the tower, as one journalist wrote.[85] In addition to denying access, the Fleishhacker group, in describing the events of the previous months, reformulated its position—that "Kayo Communism" was at the heart of the agitation—and promoted the idea that neither the Big Strike nor the Coit Tower protests had been influenced by the CP.[86] The gist of the claim was right, for Darcy's united front policy took the local CP far from the national Communist line, and the Big Strike combined several dif-

ferent radical inflections. The group's intent in the reformulation, however, was not accuracy but the reopening of splits between various leftist positions and labor and the problematizing of the CP's presence in the International Longshoremen's Association.[87] At Coit Tower effacing the CP meant taking the high road of criticism. Radicalism was a passing fancy, so the argument went, and only the collective performance of skilled painters needed emphasis.[88] In essence this argument revived the original claim that the painters were like a medieval guild.

But the difference between February's claim and August's is instructive, for in August the tower's "guild" was said to have a spiritual leader. To the surprise of Zakheim, who proposed the mural program, and Arnautoff, who directed the daily work, Boynton was named high priest: "Most of all . . . the credit must go to Ray Boynton, who, after reading a translation of Cennino Cennini, painted his first fresco—and the first in California—in 1917. Since that time, Boynton has been a pioneer in the fresco art. He has inspired and trained many an artist to get busy on his back-yard walls, and eight out of the twenty who painted the Coit Tower frescoes are his students."[89] With Coit Tower closed to scrutiny, the murals were being reinterpreted in preparation for its eventual reopening; the old public mural argument subsumed the leftist works. They were given a lineage, traced back to the post-PPIE productions and the Dixon-Boynton debates, not to Rivera. Boynton eagerly accepted his appointment as spiritual leader. By October, he had produced his theory of murals, repeating the argument he had made a decade earlier:

The mere presentation of a number of things on a wall is not good fresco or good decoration. Pictorial themes forcefully presented are likely to be very bad fresco. In fact fresco is not a foolproof method. It reveals on a so much bigger scale, everything. Smartness becomes irritating; pedantic enumeration of things becomes dull; quaintness becomes trivial and cloying, overcrowded spaces are tiring to look at; the forceful pictorial effect is disturbing to the wall. . . . Composing is the problem . . . in the nature of spacing and movement and realization of . . . design, in the dynamic tensions of energy and repose of the whole, in a rhythm sustained with power and grandeur within the space.[90]

Dixon had once based a critique on Rivera's overcrowded scenes; Boynton did the same in responding to the work of Rivera's protégés. Their murals were too congested, too full of pictorial incident, too pedantic. They preached when they should have designed; they politicized when they should have composed. And the

grandiose pedantry, straining toward a monumental agitprop language—well, that was simply misguided.

Boynton's characterizations were partly right, and most of the avowedly leftist panels are open to the criticisms he sketched. I would stress, however, several important points implicit in Boynton's assessment. As the theoretical statement I quote above makes clear, Boynton understood Rivera's visual language of congestion and misdirection both as having a political basis and as in fact signifying that politics. Arnautoff and Zakheim, in contrast to their pictorial strategies at the Palo Alto Medical Clinic and the San Francisco Jewish Community Center, for example, seized on this particular feature of Rivera's work. The radical references operated iconographically (in details pointing to the waterfront, scenes focusing on Darcy's strikes, and images recalling urban violence). But just as important, they were stylistic (evident in the way the murals *looked,* how the various scenes were put together, how the individual figures were set against architectural elements, and especially how one tried to read the sequence of details).

Take Zakheim's *Library* once again. The painting is broken into halves by one of the gun-slit windows of Coit Tower's lobby wall. In their compositional strategies the two halves correspond roughly to Rivera's two San Francisco murals. The right side, for example, borrows the zigzagging ascending structure of *Allegory of California.* The left, by contrast, takes its horizontally layered divisions from *Making a Fresco's* scaffolding. Zakheim tries to make the two cohere in a general scene—an interior space bounded by bookshelves and organized around the activity of reading. But the mural does not fit the two neatly together, and it seems to accentuate rather than collapse the compositional differences. It operates instead on a series of forceful asymmetrical relationships. The left is all verticals and horizontals, the right, a series of claustrophobic diagonals. On the left, the figures generally face us, their bodies and faces given more distinct detail; on the right, they are generally cropped, caught in a sea of papers, checkered patterns, and the taut zigzag. Although Zakheim tried to make the background a unifying element, for viewers the incoherence of the foreground is more striking. Our eyes roam the scene, ascending with the line on the right, for example, only to end up in a compositional void bounded by flat planes and arcing lines. We follow the outstretched arms of the men in the background who reach for books, only to find most of their titles illegible. We return to the visual puns and inconsistencies—the old man at lower left who seems defined by, rather than independent of, the jutting stack of books; the weirdly incongruous staircase in the center front where one side is a series of steps and the other a sharp drop; the odd brightness on the blind man at the first table who reads a book in braille; the strange snakelike arrangement of heads on the right; the profusion of newspaper headlines angling

this way and that. We focus on the faces—Zakheim adopted the strategy introduced in Rivera's work and continued in Arnautoff's studio mural of including portraits. Again like Arnautoff, Zakheim portrayed members of the local Communist Party—Rexroth (on the ladder above), John Langley Howard, Zakheim himself (reading at the second table), and Shirley Triest (Zakheim's assistant, dressed as a boy, with a comic strip in her hand). The use of recognizable faces had become a common feature in the Coit Tower murals, and most of the union painters adopted it. But in Zakheim's hands, the portraits, like the other components, become disjunctive features, pointing viewers to details that never cohere. The mural's logic is one of randomness and disorder, tenuously contained by the overriding presence of Rivera's compositional sense.

The visual language of radicalism emphasized details and parts over narrative consistency or compositional unity. It resembled pastiche—its references applied in bits and pieces, its (dis)organization marked by "the mere presentation" of disparate figures and objects. In the language of radical murals, parataxis and metonymy rule. The critical realism of these murals was certainly not unique to the city, nor to American leftists in general. In the Russian Marxist avant-garde of the 1920s, for example, the Constructivists consolidated a political conception of art as a defamiliarizing, estranging, and ultimately renewing experience. The discontinuity of critical realism seemed to offer an arena for working-class self-emancipation, freedom from the constraining order of illusion. That the paratactic strategies in the Constructivist universe are far more exaggerated than those in the Coit Tower murals allows us to distinguish the workings of the leftist imagination in the city. I would stress that the pictorial strategies of the San Francisco painters were developed within a specific tradition of public mural painting that prized the examples at the PPIE and the legacy of Puvis. The leftist murals forced a disjunctive series of viewing positions, so that the viewer who came to them with assumptions about public painting could not see where to begin reading them. Perhaps viewers would start from the far left or right (as they were taught to do by du Mond), scan the murals (as the guidebooks suggested), look for a dominant motif, search for specific rhythms, try to make sense of the spacing. Perhaps viewers would move from side to side, step back, and then step forward again, trying to find a proper vantage point from which to resolve the subjects, their bodies moving through space as they attempted to follow a narrative with their eyes. But of course none of these gymnastics produced the desired effect. For the mural neither narrated, allegorized, nor serialized its details. It did not, in Frank Kermode's terms, ask viewers to collude with an argumentative momentum inscribed in a compositional structure.[91] It did not ask them to tease out authorial or preferred readings based on pictorial order.

The general frustration that resulted from being *unable* to stabilize a viewing position marked many responses to the leftist panels. It was voiced in many ways, but primarily in comparisons of the "balance" and "order" generally sought in murals and the "distortion" and "disorder" located in these. Viewers assessing the murals tied signs of narrative to good, uplifting painting and the "mere representation" of objects to bad. They assumed that a harmonious, modulated palette indicated traditional (corporate-sponsored) public painting and that streaking, garish colors and entangled, proliferating forms were sure signs of Communist work:

> A well-balanced work of art should uplift, enlighten and inspire, not only the educated, but the ordinary observer who knows nothing of the technique and probably cares less. Nearly every human being unconsciously craves something higher that will help him to forget the ugly disagreeable things in this life. . . . Paintings or murals which accentuate the ugly side are simply communism in art, distorted, toppling over, created to pull us down. . . . An artist must portray something besides form and color, just as an author often writes between the lines.[92]

The writer is bothered by toppling forms and spaces, the mere insistence on color. He wants something "between the lines"; he wants conjunctions and phrasings; he wants textual meaning. As another observer wrote, "If anything could be worse in color and proportion, than the murals in the Coit Tower I'd like to see it. The figures are all jammed together and too broad for their height, the colors too heavy. Murals should be delicate in touch and color, but the present ones are atrocious. . . . Bah! Destroy the present ones. The painters must be novices to display such eyesores. . . . Bah! These give one a pain in the neck."[93]

In this critical climate, viewers often neglected the iconographic content of Zakheim's mural—its overt references to Bridges's Australian radicalism, its casual display of leftist literature, its details of a Jewish-Marxist subculture—and instead discussed its overt stylistic allegiances. The very qualities of disorder and estrangement made iconographic reading difficult but, with such an equivalence between style and political meaning, almost needless.

Boynton's self-conscious distance from his union brethren and his curt remarks on the murals were symptomatic of a new sobriety imposed by the old guard. Coit Tower's closing restated the patron's traditional power, even in the age of New Deal beneficence. One by one, the less radical painters, like Stackpole, came back to the fold, recognizing the realities of their situation. Even Dixon, no close friend of the Rivera camp, saw the exodus as a betrayal.[94] The effect was to drain off the

Artists' and Writers' Union's new recruits, and within months it quietly folded.

But it would be wrong to end this chapter on a low point. The remarkable feature of 1934 was that working-class dissent created the conditions in which the leftist Coit Tower murals could be painted and read. The links between the tower and the waterfront strike were simply too dangerous to ignore. District 15 resorted to extraordinary measures—a clandestine whitewashing of one mural and a prolonged quarantine of the rest, blackened windows ("To protect the frescos from sun-stroke?" Arnautoff asked), and police barricades—in an attempt to lessen the murals' signifying power.[95] From the local PWAP's point of view, Coit Tower could not be opened until both the waterfront and the Artists' and Writers' Union were under control and the murals effectively redescribed. Public art in San Francisco had never come so far from its decorative origins.

CHAPTER 6

FEDERAL PATRONIZING

The debates surrounding the Coit Tower murals and the attempts to censor them would seem to suggest that artist members of the Communist Party successfully linked their murals, in a vivid and concrete way, to an actual moment of organized conflict. But the scope of their artistic interventions in a debate about murals never went beyond the traditional discussants of public art. The corporate patrons of public art took notice of the murals and their transgressive nature. If the anxiety and dismissiveness of criticism in the official press are evidence that the effort to develop a public art had gone awry, at least momentarily, the relative silence from the alternative press only emphasizes the failure. There are no recorded responses to the tower murals from any labor groups, no materials in any of the union periodicals (even though their illustrators included Communist artists), no editorials in Darcy's *Western Worker,* no evidence that anyone besides members of the Artists' and Writers' Union picketed at Coit Tower. The CP perhaps came closer at Coit than anywhere else to transforming public painting into a vehicle for real agitation, but whether the murals were actually effective in that way is far from certain.

We should therefore measure the effect of San Francisco's public murals against their real possibilities to foster activism. Despite the symbolic emphasis on public culture in the city, 1930s public murals could not be made to stand in for larger debates about political reform or revolution. This is not to deny the shift toward radical politics in public murals, or to undercut the avowedly leftist ambitions of most active and accomplished mural painters in the city. But it is to distinguish the artistic life of San Francisco from, say, the remarkably potent life of the French

revolutionary Salons. There, a rich symbolic language of artistic radicalism, in the form of David's resistance to academic principles, could harbor much more encompassing debates about class conflict and the system of privilege.[1] The taut dissonance and compositional strain of David's *Oath of the Horatii* could be made to stand for a whole subculture of political defiance that brought about the end of a monarchy. In San Francisco, however, although the developing vocabulary of artistic radicalism paralleled that of radical labor, the political and practical concerns of labor failed to include art.

Why the difference? The political potency of murals would seem unequivocal in light of the history traced by the preceding chapters. Indeed, it is a primary task of this book to note how public art readily and repeatedly became implicated in larger debates. First the exposition panels, then the library murals, and then Rivera's magnificent *Making a Fresco*—each hung in a nominally civic space constructed because of the expanding ambitions of a patron class. As Sheldon Cheney's heavily coded criticisms of the PPIE murals have suggested, some observers from the start linked artistic work to corporate interests and found ways to articulate the connections. Rivera's murals are a turning point in this history; they made such connections explicit. Moreover, his political and painterly gaucherie permitted radical claims to inhere in public art. Crucial changes in mural painting by 1934 suggest that it was indeed a fertile ground for symbolic dissent. Murals could no longer be regarded without attention to their discursive roles. That was their special allure and, for a time at least, their defense.

But the difference between the role of art in revolutionary France and in post-PPIE San Francisco has far more to do with the activism of Darcy and Bridges than with any feature of the murals themselves. If radicalism was to have a symbolic emphasis, it was to be found in activities in the streets—the funeral processions, outdoor dramas, and movement of bodies along the Embarcadero or into Union Square. The presence of the working class in the city's streets was as important an impetus to the symbolic debate about who could and could not assemble for collective activist ends as to the practical job of striking and forming picket lines. In this context, the Coit Tower murals were only subsidiary.

That recognition underwrote the attitudes of painters and patrons in the later 1930s. If the WPA years now seem to us a period of relative homogeneity, in the murals' iconography and style and in their general ideological tone, that impression grows out of the failure of the left to expand on the potential at Coit Tower. But that failure only partially explains the distinct motivations behind the WPA murals that followed. These can be glimpsed in the efforts of patrons and painters to reestablish a public art.

From 1935 to 1938 the mural movement in the city was funded by the several national programs begun in the fall of 1935. The various funds, however, came to the city through a common point of entry; all were channeled and managed in the Bay Area by a newly formed local body of critics, dealers, and painters that was unlike the traditional patrons of public painting or the institutional bureaucrats associated with district 15. The northern California division of the WPA's Fine Arts Project included as administrators the painter William Gaskin, the writer Willis Foster, and the gallery dealer-turned-New-Dealer Joseph Allen. But its nuts-and-bolts members were two unabashed modernists, Joseph Danysh and Glenn Wessels, who played a significant role in defining the New Deal programs. They shifted public art away from both the PWAP, which Fleishhacker controlled, and the politics of Rivera's left-leaning heirs.

From the beginning, it was unclear where this shift led. Danysh and Wessels, who had shown no interest in public murals before joining the Fine Arts Project, seemed to have no concrete vision for the program. Danysh was no newcomer to the art world, but he paid more attention to the gallery scene—he was, after Beatrice Ryan, perhaps the city's most successful dealer.[2] In the early 1930s, in the midst of the depression, he opened his first gallery in the space once occupied by Ryan's Galerie Beaux Arts. His strategy to cultivate a new Beaux-Arts was predicated on the belief that the city's most marketable artists were independent of the SFAA and the Bohemian Club. He recognized that a small circle of proven artists and an even smaller one of reliable patrons had once defined San Francisco's art scene. But the situation was changing, the brashness of Arnautoff's studio only the most visible evidence. In 1933 Danysh, in a major coup, convinced Ansel Adams, the most celebrated of the city's independent artists, to join him as partner in what became the Adams-Danysh Gallery (later, the Danysh Gallery). With Adams as intermediary, he became one of the dealers for the remarkable Group f.64 photographers, including Adams, Edward Weston, Imogen Cunningham, and Sonya Noskowiak.[3] Within a few years, he had climbed to the top of the dealer hierarchy with little help from traditional institutions.

In addition to playing an entrepreneurial role, identifying and showing the city's finest artists, Danysh worked as art critic for the *Argonaut,* which published the most influential newspaper criticism of art in San Francisco after the *Argus* folded. The dual role of dealer and critic was unprecedented in the city, and we can measure some of the power Danysh's status afforded him. In the early 1930s, for example, he founded a short-lived but much-discussed Salon des Refusés to compete against the SFAA annual—a remarkably bold undertaking by any mea-

sure. This exhibition and the frisson it generated served to publicize the painters he favored and to mark him as a formidable player in the cultural scene. By mid-1934 even Walter Heil, the director of the de Young Museum, began to court Danysh, having come to see the brash young critic-dealer as an important ally, a fast-rising power who remained outside the sectarian battles.[4] So by 1935, when the WPA began to hunt for local administrators, Danysh was able to launch himself into an even more powerful independent position. With an impressive résumé that included work with the city's nationally famous photographers, experience in organizing glittering citywide exhibitions, and evidence of friendly relations with the city's most important museums, he won the post easily. Just as important from the point of view of Harry Hopkins and Holger Cahill, the WPA's national directors, Danysh represented a position outside the Fleishhacker orbit and was blessedly removed from the Coit Tower turmoil that had ensnared Heil and PWAP's district 15.

Wessels was a young painter and, like Danysh, a formidable art critic.[5] Born in South Africa into a family of modest means, he came to the Bay Area early in the century and began a career as a graphic artist for the *Call Bulletin.* In the 1920s he alternated between teaching at the California College of Arts and Crafts in the East Bay and working as a scab on the docks and in the oil fields. His enthusiasm for scab work is revealing, for his anti-union, antiradical stance was evident even before organized labor and the Communist Party became a truculent presence in the early 1930s. He recalled having had "a toothbrush moustache and a hard derby hat, the tough appearance which the strikebreakers cultivated in order to protect themselves, because when you stepped off the pier you were very apt to be attacked by people. So you swaggered and threw out your chest, tipped the derby down over one eye and scowled as well as you could."[6] By the early 1930s he had become the critic for the *Fortnightly,* another new arts magazine whose largest boast was that it had been the first periodical to present Hans Hofmann to the Bay Area. After Danysh left the *Argonaut,* Wessels became the critic there as well, and in the two posts provided what sometimes seemed a diverse critical discourse that in fact represented a singular sensibility. No writer since the aged Eugen Neuhaus had so dominated art criticism. Danysh very quickly sought him as an ally.

Wessels's reviews are among the most insightful of their time, and he almost single-handedly put the *Fortnightly* on a competitive footing with other journals. His emphasis was decidedly Eurocentric. He prided himself on his "internationalist" perspective on art—which meant that he focused on developments in France and Germany rather than Mexico. The most biting criticism Wessels could level at a local painter, Dorothy Wagner, for example, was to declare that "one realizes that Rivera has come but not entirely gone when encountering Dorothy Wagner's

work."[7] That level of acerbic understatement was Wessels's forte, and he was copied, mimicked, and sometimes parodied. But he conveyed his opinions clearly: Rivera was the contaminating seed, Hofmann, the city's true artistic savior. The swaggering scab-turned-art-critic Wessels was instrumental in bringing Hofmann's brand of abstract expressionism to San Francisco at the moment when Rivera's legacy seemed most entrenched. He translated Hofmann's writings, published them regularly in the *Fortnightly,* became his interpreter and guide during a much-publicized tour of the United States in 1930, and successfully urged local dealers to show and local patrons to buy the German's difficult works. Given the largely conventional tastes of the city's monied classes, Wessels's and Hofmann's success in securing relatively generous patronage and in shifting the focus to abstract painting was remarkable. It also testifies to the young critic's convictions and connections. In contrast to the lavish attention he gave Hofmann's work, Wessels found little to praise in other exhibitions of the early 1930s—he noted of a traveling show of children's paintings that they were unlike the "pretentious, the sententious, the rambunctious, the plagiarizing weaklings who fill our nursling museums with tripe."[8] He meant the Riveraesque painters.

Wessels's admiration of Hofmann won him favor in the eyes of new museum administrators in the city, including Heil, who had emigrated from Germany in 1933, and Alfred Neumeyer, who had come from Berlin in 1935, whom Bender handpicked to direct the Mills College Art Gallery. With the appointment of Neumeyer and Heil and the publication of Wessels's art criticism, attention shifted to paintings coming out of France and Germany. Neumeyer, for example, arranged shows of the works of Picasso, Rouault, Matisse, Paul Klee, Marc Chagall, and Wassily Kandinsky, among others. He got hold of the most significant traveling exhibition of Van Gogh in the country to date and managed to acquire visiting lectureships for Oskar Kokoschka and László Moholy-Nagy—all within five years of assuming the directorship.[9] These events, which introduced twentieth-century European painting to the Bay Area, were followed in 1939 by the massive fine arts display at the Golden Gate International Exposition (also orchestrated in part by Heil and Neumeyer). For these Europeans, Wessels was the only critic of sensitivity in the city, and they combined to support him as a chief WPA bureaucrat.

If the WPA under Danysh and Wessels was far more attuned to the language of European modernism than to that of San Francisco public murals, for which it was now nominally responsible, the city's corporate patrons (who would eventually fund much of the WPA work) and its leftist painters (who were most in need of welfare) continued to harbor vastly different—competing—beliefs about the value of public art. Danysh and Wessels understood the close relation between dealers and critics in San Francisco, and they were able to map its structure onto the WPA

apparatus and in the process to displace the previous political ambitions for public murals. They defended their handling of the projects in print, tapped various patrons, lobbied, promoted, dealt, and haggled. The local WPA operated much like Danysh's gallery, and Danysh, as a singularly positioned entrepreneur, reaped the benefits.

The mapping of a commercial structure onto the WPA permitted an important critical shift. Murals and mural projects in San Francisco were now compared to small-scale canvases and the unveilings to gallery exhibitions. The mural painters themselves were regarded as studio painters who had to be reoriented to the new federal patronage. Wessels saw the task of the WPA as one of "trying to break down the line that I think has been drawn by the artists themselves to some degree. Artists have a tendency to run off into art colonies and to dress differently and to establish different sets of values and to separate themselves from the social body and I think this has been bad for them." [10] This description may have been accurate for the sequestered Monterey landscape painters and the Danysh gallery stable, but it had little to do with the collective work of the radical Coit Tower painters. The conflation of traditional and radical artists might have been predicted, given the enthusiasms and expertise of the two administrators. And ultimately the comparison of the mural projects to the gallery scene allowed a new conception of public murals to develop. It directly linked large-scale murals and small-scale canvases in a much more direct way than had regularly been permitted in the city, so that the standards of judgment for canvases could be applied to murals.

This, to repeat, was a significant transformation. Hitherto one of the most consistent features of San Francisco public painting had been the rigid distinction between the visual demands of murals and of easel work. Because of it mural painters had developed a logic for their work, and critics had applied to it criteria that differed from those for easel paintings. (Even the California School of Fine Arts carved out space in the curriculum for the new discipline.) Because leftist painters developed their approach to mural painting in a relatively insulated environment, they could employ heavily charged aesthetic innovations in a recognizable vocabulary of artistic expression. Under the influence of Danysh and Wessels, however, the city's murals were scrutinized against the myriad new canvases from Europe, making a stylistic norm moot. Furthermore, given the aesthetic bent of both men, this scrutiny worked against wall paintings. The standards by which San Francisco murals were once praised—design considerations and adherence to the architectural framework—came to be denigrated as insufficiently complex. Mural painters who had once thought murals properly made up of large figural elements and regular compositional rhythms (Boynton had made this claim as recently as 1934, after the completion of the Coit Tower murals) now seemed woefully naive,

quaintly but annoyingly provincial, and insufficiently ambitious. It was no large step for Danysh and Wessels to regard murals as forms of commercial art, as in fact they did in promoting the WPA murals. Wessels argued that the mural painting "is an elevated form of commercial art. You are working for a community, and you have to paint to an average taste of some sort that will be received. You can't introduce too many novelties, too much mysterious stuff, too much individual technique because it simply will not be accepted." [11] Murals are not ambitious artistic statements, nor do they attempt "novelty" (of style or iconography). Instead they make their appeal to "average taste," which is shaped by commercial advertising. Wessels's comments seem calculated to orchestrate the demise of leftist critical realism and its paratactic visual strategies.

Even though most of the city's mural painters disagreed, Wessels's views went unchallenged because they dovetailed with Holger Cahill's agenda for the WPA Federal Art Project. For the New Dealers in Washington, the mural commissions were relief projects, whose principal task was to put unemployed, often unskilled, bodies to work. Danysh and Wessels cited these destitute laborers when they denigrated public painting, maintaining, despite the many accomplished mural painters who worked in San Francisco, that most were barely competent—because they did not need to be—and that the hired assistants were inexperienced. Neumeyer, when asked to assess public painting's new ambitions and subject matter, declared:

> What terrible spiritual poverty must we confess to our successors if we believe that American life means nothing but canned food production or the banking business! I do not believe that such poverty is really found in the hearts of our artists, but there is now a certain routine or fashion of painting which deprives the artist of an original conception of his task. . . . Let us remember the fresco dreams of Hans von Marees in the museums of Munich and Berlin, or even Puvis de Chavannes' frescoes in Marseilles and Paris, which have a deeper truth than the so-called realistic truth of many of our American paintings. [12]

But Danysh and Wessels neither expected nor encouraged a Puvis revival. Let the WPA painters produce glorified advertisements for canned food or banking, Neumeyer's reservations about quality, imagination, and innovation notwithstanding. Let the attention of Europe and its artists fall elsewhere.

The new ideology of public painting downplayed the once worrisome presence of radicalism in art, to which the two directors were unsympathetic. [13] (As Wessels remarked: "You'd have thought that overnight all the San Francisco artists' models had all developed big feet, and that the San Francisco artists all had overnight be-

come Mexican peasants. It was just as phony as a costume party!"[14] Or as Danysh commented, in a passage I have already quoted in my Introduction: "If a man had a shovel in his hand in a mural rather than breaking the bronco, he was modern and he was dangerous and probably radical and probably he just came from a Communist lecture by Diego Rivera.")[15] As murals were identified with commercial art, a visual vocabulary developed to compete with that of Riveraesque works. In style, for example, it avoided the congested, overblown aggressiveness of the Communist painters. Zakheim's Coit Tower work was to be rejected, specifically "the way he mixed up ideas and crowded everything into one narrow space."[16] The style Danysh favored was characterized by clarity, legibility, strong compositional rhythms, and a logical arrangement of figures. The gist is clear. The range of meaning was to be closed down, and ambiguity to be avoided. Murals were to create a stable subject position for the viewer, not a dislocating one. What the WPA administrators truly wanted was the conventional PPIE work all over again, but now under the aegis of the New Deal.

In effect the WPA's Federal Art Project put in place a surveillance and control system along with its relief effort. This development suggests yet another significant inversion of the decorative logic developed for public painting in San Francisco. Boynton and Dixon in the late 1920s had elaborated on the decorative to carve out a space for public painting, and Rivera in 1931 had parodied the decorative to bring murals into the orbit of radical politics. After 1935 the WPA administrators subsumed the decorative in arguments for the relation between commercial art and their relief projects, thereby stabilizing the public language of the federally sponsored murals. Wessels and Danysh, in other words, quickly learned to occupy their posts.

AN OVERDETERMINED MURALISM

I want to avoid turning the WPA murals into the mere material form of a centralized ideology. No free play, no possibility of painterly excess, no potential for counterdiscourse—these are the risks of an overdetermined muralism, along with utter banality. Between 1935 and 1938, if most of the city's federally funded murals showed the acceptance of precisely these constraints, that acceptance was not achieved without moments of stress.[17]

One of the most ambitious projects, Lucien Labaudt's *San Francisco Life* at the Beach Chalet, is worth scrutinizing in some detail to determine the imaginative latitude permitted by a dominant regime. *San Francisco Life,* painted in fresco on three walls of a long dining room, was, like the Beach Chalet itself, devoted to

middle-class leisure. Willis Polk designed the building, which was constructed at public expense and opened as a municipal restaurant in 1925.[18] One of Mayor Rolph's beautification projects, the chalet joined other nearby structures at the western edge of the city that were meant for public entertainment, including the Fleishhacker zoo and pool, the Sutro baths, and Golden Gate Park (and eventually the amusement park called Playland). In early 1929, before the stock market crash, the Great Highway was laid at the chalet's front door, giving access to it to the residents of the towns sprouting on the peninsula and opening it to tourist traffic.

Labaudt began the murals in 1936, well after the stock market crash had inhibited most such traffic, and he seems to have taken the ironic possibilities of the subject of leisure as his material. He painted four scenes, each organized around a San Francisco tourist location: the beach (Fig. 6.1), Golden Gate Park (see Plate 10), Fisherman's Wharf (see Plate 11), and the Marina. Each manifests the clarity and rhythm prescribed by Danysh and Wessels. The figure groupings, for example, fall into neat triangles; the discrete scenes stay within legible borders; the perspective of individual panels remains more or less orthodox; the background spaces and foreground events remain distinct. If the Communists had once used their murals as an occasion to depict each other, Labaudt did the same, including his own friends in the art scene with a certain comic verve. The park scene, for example, has three groups of figures.[19] On the left is the artists' group that includes Beatrice Judd Ryan (of Galerie Beaux Arts fame), Ben Cunningham (one of the conservative Coit Tower painters), and E. Spencer Macky (director of the CSFA). In the central administrator's group around a park bench, Labaudt shows Danysh (with a Vandyke beard), Gaskin (with his arm crossed over his knee), Phil Sears (a local WPA officeworker, leaning against the back of the bench), and the aged John McLaren (with a white moustache). In the background, just to the right of Danysh, we glimpse the tower of the de Young Museum, which is echoed on the south wall by the Palace of the Legion of Honor. Just to the right of the long park scene, a group of Bohemian Club members get ready for a tennis match.

Along with these figures arranged around the park bench Labaudt portrayed patrons and arts administrators—including not only the WPA bureaucrats and Ryan but also members of the Bohemian Club and officials from the de Young Museum and the Legion of Honor. He repeated the pattern in other scenes, the strategy on each wall being to gather notables at leisure. In fact, Labaudt included *all* the important agents of power in the current art scene. Was he simply pandering, hedging his bets during a time of deep economic depression? If so, he managed nonetheless to suggest an ironic view of those he portrayed. Leisure scenes in general must have seemed a trifle absurd, or at least forced, during the difficult years 1936–37. He depicted Danysh on a white horse ("in shining armor [from] Came-

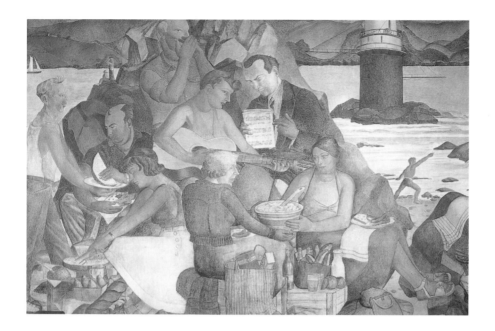

6.1 Lucien Labaudt, *Beach Scenes,* 1936–37. Fresco. Beach
Chalet, San Francisco (Photo: Lito).

lot," Danysh would later say), satirizing the WPA's argument linking welfare and
relief.[20] Mixing upstart New Dealers with members of the venerable Bohemian
Club, if not comic, was certainly unprecedented. Moreover, the careful plotting
and naive clarity of the scenes suggest caricature, underscored by the lavish cos-
tuming and playacting of the figures.

But Labaudt's Beach Chalet murals, despite their ironies, met the WPA's visual
prescriptions; and their humor, though directed at the subject of patronage—
clearly a topic with resonance after Rivera—was hardly transgressive. This reserve
can be readily seen if the panels are compared to Labaudt's previous mural work.
At Coit Tower, Labaudt had painted on the long walls of the stairway that winds
from the first to the second floor, representing the ascent of Powell Street, which
he filled with recognizable portraits. The crowd in *Powell Street* includes the Coit
Tower painters, Arnautoff, Maxine Albro, and Parker Hall, all leftist sympathiz-
ers; the recent (and momentary) Communist Party convert Stackpole; and some
of the more conservative painters, like Oldfield, Moya del Pino, and Cuneo. These
artists mixed with the PWAP New Dealers Edward Bruce and Forbes Watson and
rubbed elbows with infamous characters like the old socialist C. E. S. Wood

6.2 Lucien Labaudt, *Powell Street* (detail, C. E. S. Wood), 1934. Fresco. Coit Tower.

6.3 (*Below*) Lucien Labaudt, *Powell Street* (detail, Eleanor Roosevelt), 1934. Fresco. Coit Tower.

6.4 (*Opposite*) Lucien Labaudt, *Powell Street* (view from top), 1934. Fresco. Coit Tower (Photo: Lito).

(Fig. 6.2). Conspicuously missing were members of Fleishhacker's group—the ostensible patrons of the piece—their absence made all the more apparent by the inclusion of the federal PWAP administrators and, even more notable, Eleanor Roosevelt (Fig. 6.3). But more important than the mural's diverse portraits was its innovative structure. Using the geometry of the stairwell (who would not have worried about Rivera's *Allegory* as a precedent?), Labaudt had his figures jostle up and down Powell Street (Fig. 6.4). They seem almost to tumble down the stairs, running up the backs of other figures, spilling onto the street in seeming chaos. There was no punctuation in the headlong flight of figures; there were no stable points to stop the rush of the eye. Rather than cohere, *Powell Street,* like a vortex, spirals endlessly down. In the mural's tower context, above the waterfront, the implications of its composition were not lost. The street where patrons and artists jostled in a singularly congested space brought uncomfortably together during the Big Strike a microcosm of the city's population.

The stairway at Coit was the most radically charged painting Labaudt would ever produce. Although in comparison with Zakheim's, Howard's, or Wight's panels it made no outright statement of political leftism (and Labaudt was certainly no activist), nevertheless its inflections leaned left. When the painter's work began to turn away from the chaotic stairway at Coit Tower, a critic could pro-

claim with a sigh of relief that he had finally "forgotten all about his radical leanings."[21] The Beach Chalet only confirmed his return to the fold. Its rigorous symmetry and compositional concision, its playful but unabashed kowtowing, its scenes of relaxed pleasure and unproblematic display of the city's entertainment spots, its purposeful omission of any Artists' Union painters—all these run counter to the visual language of his Coit Tower mural. To ensure the proper reception for his new work, Labaudt, never much given to writing, undertook an explanation of his murals:

> The State is now the Patron, and so it was in all great Periods. The Artists did not make the Periods. The Periods made them. . . . An Art period has always started with a fixed program. Be it as in the past; the will of a Pharaoh which created the Egyptian era; the religious fervor that created the Gothic; or the State and Church which made the Renaissance. . . . When these programs [*sic*] ceased, stagnation took place[,] hence decadence.[22]

These fawning words could not have appeased Wessels and Danysh more.

In 1937, just after the murals were unveiled, Labaudt was rewarded for his renewed loyalty. His painting *W2* (Fig. 6.5) was purchased for the city and characterized enthusiastically as "entirely modern, without eccentricity."[23] The awkward word "eccentricity" hinted at Labaudt's temporary lapse into radicalism. He could now be trusted to depict the contemporary scene without referring to the distasteful events of recent years. *W2*, like the north wall at the Beach Chalet (see Plate 11), depicts the waterfront that only a year-and-a-half earlier had been the site of such violent confrontation. Neither image hints at the turmoil: in one, beyond a quiet dock, boats steam in and out of port, and in the other (virtually the same pier), the Bay Bridge looms in the background and a railroad freight car stands declaratively upright. The dock is the place where travelers set off to sea and a fisherman off to the bay, where a sailor comes in for shore leave, and a longshoreman returns to work.

The responses to Labaudt's Beach Chalet murals manifest the new critical sensibility, as if critics wished to replace recent influences on public murals with a more palatable pedigree: "The painting of Labaudt is like a living composition on this coast [i.e., side] of the Atlantic, of the fine traits of French painting. Through his works one perceives again Watteau, Chardin, Courbet, Delacroix, Manet, and Cézanne. The work of Labaudt is also a composite of the whole evolution of modern art. It is a condensation of all the experience of fifty years of painting in the great movement of contemporary art."[24] The overproduced praise and the litany of canonical European influences signaled this substitution. It hardly mattered whether the murals actually lived up to the ancestry proposed for them.

6.5 Lucien Labaudt, *W2*, 1935. Oil on canvas. Whereabouts
unknown.

THE AFTERLIFE OF RADICAL PAINTING

In this climate, the radicals could do little to influence the public use of murals. The impediments to their efforts erected by Danysh and Wessels and the erosion of the discourse about public murals, however, were only part of the story. The rest has more to do with the rank-and-file unity that had provided the conditions for the transgressiveness of the Coit Tower murals. After all, the language of Labaudt's panels bears far more resemblance to that of the Riveraesque murals than to that of the early PPIE murals, du Mond's *Westward March,* or Piazzoni's mural landscapes. But Labaudt's panels could not elicit an alternative reading, even against the grain of Labaudt's intent, because of a gap that had developed between the various leftist factions.

The remarkable coherence the left had achieved began to dissipate in 1934, in large part because of the campaign waged against the Darcy-Bridges alliance. During the long months of the 1934 strike the Industrial Association had tried to pry Bridges's International Longshoremen's Association loose from the more conservative International Seamen's Union and the Teamsters, primarily by identifying and splintering the radical constituencies. The Industrial Association pictured for the public an isolated leadership of Reds trying to starve the city in the name of revolution, *for revolution's sake.*[25] By the end of July the Darcy-Bridges alliance began to crack.[26] To keep from being deported, Bridges disavowed his links to the Communist Party, preventing any undisputed articulation of a united front agenda. During the AFL-CIO debates of the mid-1930s, when organizers began to rethink the role and scope of unionization, he supported affiliation with the more conservative skilled-labor AFL; Darcy, under the national CP, had to favor the CIO.

One sign that leftism was disintegrating appeared in 1935, the initial year of relief efforts by the WPA's Federal Art Project. During the mayoral campaign, the leftists officially supported the United Labor Party against the incumbent, Angelo Rossi, and his allies. United Labor's candidates should have been compelling choices to radical voters: Redfern Mason, a renegade journalist who was chair of the city's Newspaper Guild; Anita Whitney, a founding member of the Communist Party; and George Anderson, a lawyer who earned CP members' respect when he defended strikers during the Red raids of 1934. United Labor's platform resonated with united front issues: full unionization of all San Francisco industries, repeal of the oppressive criminal syndicalism laws, release of the convicted bomber Tom Mooney, discarding the hated Blue Book and the hiring practices it represented, and so on. But days before the election, some United Labor officials put Rossi at the head of their ticket, proclaiming that "union labor is not endorsing any Communists for office."[27] The polls showed the rifts: Rossi beat Mason by a nearly ten-to-one margin, winning several of the solidly working-class districts and halting the advances in union support Darcy had won just a year earlier.

Besides these developments in the city, events on the national and international scene from 1935 to 1938 split the city's leftists even further. In the summer of 1935 Stalin called for the Popular Front—his attempt at ideological compatibility with various liberal and left-leaning positions. The shift ordered by the Seventh Comintern Congress brought the local CP back under a liberalized national line, and Darcy's unique position—as head of a popular front *avant la lettre*—was much harder to sustain. Earl Browder, the Party's national chair, became the major spokesman for its new agenda of nonsectarianism, and his tenure was marked by increasing support of New Deal legislation. In San Francisco, however, the CP seemed more hard-line than it had been at the moment of Darcy and Bridges's al-

liance. The local CP's appeal quickly diminished under the Popular Front, and many members moved into the liberal wing of the Democratic Party. By 1938, when California elected the Democrat Culbert Olson as governor, the CP had lost much of its membership.[28]

The second major international event was the Moscow Trials, beginning in 1936, which put Trotsky under Stalinist censure. Trotskyites, Lovestoneites, and Stalinists who had worked relatively closely in the city could no longer do so after the trials. The effects on the local scene were devastating. As one artist member recalled: "We used to be able to talk together and get things done. We even got PG & E [the Pacific Gas and Electric Company] to maintain utilities for the poor in cold weather because we put up such a fuss. But after the Trials, we didn't have enough agreement. We didn't even talk to each other." [29]

For the city's radical writers and artists, the rifts that had begun to close in 1931–34 began to open again. Rexroth dissolved his links with the Party, renounced all support of Darcy, and began to pull others with him. Among them were the most anarchic members of the Party, including Frank Triest, the tireless activist who had worked to sustain the local John Reed Club and the Artists' and Writers' Union,[30] and many new members of the union who, under Rexroth's influence, came to see Darcy as anti-Trotsky, anticulture, and antiart. The Stalinist terror in the Comintern and the blatant display of authoritarianism at the Moscow Trials bolstered Rexroth's claims. The CP under Darcy had promoted itself as nonsectarian and free of party-line rigor, but the Comintern's erratic behavior made Darcy's calls for a united front seem like a masquerade for Stalinist totalitarianism.

Arnautoff and Zakheim remained Party members but on that account encountered much difficulty securing commissions for public murals. The right saw them as revolutionary zealots who had shown their true colors at Coit Tower; the left opposition saw them as blind Stalinists who could not see past their passionate allegiance to an indefensible center; and Danysh and Wessels regarded them as stubbornly clinging to an unsustainable vision of public painting now being eradicated by federal patronage.

The conflicted quality of radical painting can best be seen in Zakheim's largest mural series, *The Story of California Medicine*. Between 1936 and 1938 at Toland Hall on the University of California at San Francisco medical campus, Zakheim painted a series of panels—some 700 square feet of wall space—in an amphitheater. The project was initially a public commission offered by Chauncey Leake, a prominent physician at the medical school, who gave Zakheim a relatively free hand in formulating the mural program.[31] Disburdened of pressure from Danysh and Wessels, Zakheim, still the committed Stalinist, explored the leftist claim on public

6.6 Bernard Zakheim, *English Explorers,* 1936–38. Fresco.
University of California at San Francisco.

murals, and his series was perhaps the most direct expression of public art under
the new Popular Front Communist Party.[32] Many of its features are carryovers. If
Labaudt's Beach Chalet murals for the WPA's Federal Art Project are peopled with
full-bodied figures and crisply delineated forms, Zakheim's Toland Hall murals
comprise grotesque faces and angular body types (Fig. 6.6). Whereas Laubaudt
produced a set of panels measured by their legibility and caricatural clarity, Zak-
heim obfuscated at every turn, cluttering his panels with convulsive figures and
fragmenting spaces (Fig. 6.7), following, with a new determination, the familiar
leftist critical realist strategies.

There is indeed a continuity between Zakheim's Coit Tower panel (see Plate 9)
and the Toland Hall murals, which extend the explicit gaucherie of *Library* to a
new level. The angular faces and limbs of the Coit Tower figures tend toward car-
icature; those in the Toland Hall mural push toward the grotesque. Whereas the
bodies at Coit Tower struggle against the binary structure and weave in and out of
its diagonals, the Toland Hall figures push up against the tops and sides and burst
out across the surfaces, straining and overflowing borders and repoussoir ele-
ments. Whereas the compositional focus of *Library* continually shifts across the
axis of the window slits, the focus of *Story* works in a double movement, each
panel gesturing left and right at the same time. *Story* strives to be a panoramic as
well as a disjunctive performance, taking the potentially spasmodic structure of
parataxis to monumental dimensions.

But the basis of Zakheim's push toward the extreme possibilities suggested by
Library is more orthodox, even conservative, at least in relation to Stalinist radi-
calism. For Zakheim was very clearly coming under the influence of José Clemente

6.7 Bernard Zakheim, *Pioneer Doctors,* 1936–38. Fresco.
 University of California at San Francisco.

Orozco, the painter who, in Zakheim's eyes, began to seem a more logical model
than Rivera for a committed Stalinist. When Zakheim met Orozco in 1936 at the
First American Artists' Congress—as he was organizing the medical school mu-
rals program—the Mexican had just completed his major controversial murals
in the Baker Library at Dartmouth College (Fig. 6.8). There, he produced a series
of panels devoted, as his biographer Alma Reed proclaimed, to "an epic interpre-
tation of civilization on the American continent,"[33] in twenty-four scenes, each
centered on a representative moment of North American civilization, from the
Aztecs to "Modern Industrial Man." The narrative was not grounded in deep his-
torical research but was based on a general, somewhat conventional Marxist
understanding of history. The various scenes moved dialectically back and forth
between the "corrupt orders of man" and the "actions of a divinely inspired sac-
rificial hero."[34] The Baker Library murals undoubtedly provided Zakheim with a
formal model as well. Orozco's panels are characterized by elongated figures and
a composition in which adjoining scenes spill over into each other and figures
overlap. As in the Toland Hall murals, many of the faces are grotesque, the activi-
ties savage, and the violence excessive. The shift from Rivera to Orozco as model
signaled Zakheim's own political investment, for of the two Mexicans, Orozco
seemed the mural painter most actively trying to give pictorial form to an ortho-
dox Marxist theory of history.[35]

 This last achievement meant much to Zakheim. As he wrote, the Toland Hall
series followed a specific program "to use as subject the history of medicine in the
state of California. . . . As to the subject, I did not pick only the beautiful or heroic
parts of history, because the contrast of good and bad constitutes the dramatic

6.8 José Clemente Orozco, *The Epic of American Civilization:
 The Departure of Quetzalcoatl* (panel 7), 1932–34. Fresco.
 Commissioned by the Trustees of Dartmouth College,
 Hanover, New Hampshire.

quality of narrative." [36] He adopted the inspired heroes and corrupt orders of the Baker Library murals as part of his own program. But there is now tension between the congested, overwrought scenes and the pedantic orthodoxy of ideas. Potentially, that is, the excess of the Toland Hall murals ran counter to Zakheim's new narrative needs. The drama of good and evil is played out over ten scenes, each based on individual passages from Henry Harris's new history, *California Medical Story* (1932). The series begins with an Indian (Fig. 6.9) who reaches out to greet the morning sun,[37] his back to the viewer. His gesture—arms flung open—is like a directional cue, and the rest of the panels spread out laterally, curving from the back of the amphitheater and continuing across the flat front wall. The murals unfold chronologically, accompanied by informational scrolls, well-placed placards with iconographic details, and narrative cues. To the Indian's right, for example, are scenes from southern California medical history: a shamanistic ceremony; the Portola Expedition, whose members suffered from scurvy (1789); the trapper James Ohio Pattie, who introduced a vaccination against smallpox during the great 1828 San Diego epidemic; and the physicians of old Los Angeles in the mid to late nineteenth century. To his left are scenes from northern California medical history: Sir Francis Drake presiding over an autopsy; Indians offering medic-

6.9 Bernard Zakheim, *English Explorers* (detail), 1936–38. Fresco.
 University of California at San Francisco (Photo: Lito).

inal herbs to Junipero Serra; Don Pablo Soler attending an Indian who has been
disemboweled; the trapper Peg-Leg Smith, who is performing the act of self-
amputation that gave him his name; and the rough-and-ready physicians of the
gold rush period. On the front wall are images devoted specifically to San Francisco
and the University of California medical school's history, including the stormy
careers of Beverly Cole and Hugh Toland, who opened the first medical schools
in the 1860s and after whom two buildings on campus were named. The central
episode (see Plate 12) is the Sponge Case of 1856 that pitted Cole against Toland
(they face off over the dead body of James King of William, the publisher of the
San Francisco Bulletin), generating accusation and counteraccusation over King
of William's fatal surgery and, ultimately, over the competency of each.[38]

 This litany of biographical details and the representation of obscure events
might easily be read as Zakheim's claim to epic historical thinking, especially af-
ter he had met Orozco. But these elements must also be seen in light of the ap-
parently new emphasis on history. The murals fit into an explicitly programmatic
argument about class conflict and the superexploited races and peoples. Like the
Baker Library murals, they give form to Stalin's dialectical materialism.[39] Across
the ten panels, the story of medicine is marked by the aggressive colonizing of the

6.10 Bernard Zakheim, *Science*, 1936–38. Fresco. University of
California at San Francisco.

state, the subjugation of Native Americans, and the continued exploitation of the
laboring classes.[40] The central Indian, from whose open arms the historical pa-
rade unfolds, is a figure of pathos. The medical achievements, the notable physi-
cians, the life-saving vaccines and famous surgeries pictured in the amphitheater
are set against the brutality of exploration, settlement, and expansion. A narrative
of medical progress coexists with a more troubling counternarrative of corrupt
regress. The tension crops up between the scenes, undermining the glorification
of events and personalities. In the Sponge Case panel, for example, the scenes ra-
diate from a central point where a large plague rat sits, its contaminating presence
setting the tone for the histories proliferating around it: Toland's and Cole's charges
of incompetence against each other and the careerism implied in the accusations;
the bodies of dead Chinese workers to the immediate left; the distressed woman
at the right who sits in a Barbary Coast hovel; the figure of the quack Albert Abrams,
at the far left, who attends an unsuspecting patient with one of his cure-all ma-

chines. In the adjoining mural, the science panel (Fig. 6.10), Zakheim shows a generator with wheels and belts. It runs on ball bearings on which are inscribed the names Galileo, Newton, Lavoisier, Einstein, Roentgen, Pasteur, Hegel, and Darwin; it is an engine born of centuries of scientific knowledge. But it spins out of control, serving military, not humane needs, its products bombs and poisonous gases, its victims the defenseless.

For Zakheim, radical painting under the sign of the Popular Front seemed to require a massive narrative history, so different from Rivera's San Francisco murals or the panels at Coit Tower. Few knew anything about the history of California medicine, and the painter himself had to research it in Harris's book and elsewhere to tease out its contradictions and omissions.[41] It is tempting to find the intensity of that research written in the contorted spaces and exhausting narrative of the murals. If the grating and confrontational elements of his *Library* at Coit Tower could be directly linked to the Darcy-Bridges alliance and events on the waterfront, the dogmatism of his *Story of California Medicine* is sealed off in its own frenetic but bookish preserve. Whereas *Library* defamiliarizes viewers with contemporary references, *Story* preaches to them with unfamiliar ones. The difference is rooted in the artist's coherent vision of a public for his *Library* mural and the absence of such a vision for the murals at Toland. *Story* seeks to articulate a Stalinist position during the moment of a disintegrating leftism. The ponderous quality of the Toland Hall murals and the names, dates, and inscriptions are signs that Zakheim is soapboxing. His underlying assumption in this approach, however, is that a radical Communist audience no longer exists for what he has to say, and he must therefore spell out his message historically and argue for it thoroughly.

In Zakheim's hands, the grating Orozcoesque style which he emulated was diluted and deflated. Whereas Orozco organized his narrative around particular stress points, usually a key figure (the sacrificial hero), Zakheim dispersed his story across the long horizontal surface, in which his figures read as fragmented ciphers. Orozco provided moments of thematic and visual intensity, while Zakheim relied on placards to relate obscure details. Observers could not avoid the overwrought quality of the murals. In 1937, just after their first public showing, Ray Boynton gave his assessment: "Mr. Zakheim might very honestly be called a proletarian artist and it would be a distinction and real classification. . . . There is genuine imaginative sincerity in [his work] which makes it forceful even tho it is sometimes crude in execution. His designs achieve a real relation to his ideas."[42] What Boynton tried to suggest diplomatically—the crude style, pedantic tone, overblown narrative, and strained design—the critic H. L. Dungan put bluntly:

The frescoes are as complicated as a set of viscera to the lay mind. . . . Our California fresco artists, when they face a blank wall, seem to feel that they must tell a whole story of creation, forgetting that that has already been done simply and better than they can ever hope to do. Perhaps, if they set themselves to the task of telling one tale well, the world at large will think more of their art. But the artist thinks nothing of what the world thinks of his art, so there we are again in this endless confusion.[43]

History painting could not be made to work on such a grand scale, especially when the artist's intent was to try to fill an evacuated leftist field.

We have traveled far from the moment of radical unity in 1934 and the murals of painters who tried to participate in it. After that singular year, the organized working classes were never again so powerfully invoked as a proper public for federally sponsored mural painting in San Francisco. When Danysh and Wessels spoke about the public (which was not often), they referred fleetingly to it as the beneficiary of New Deal art. The projects, Danysh declared, would "secure for the public outstanding examples of contemporary American art."[44] But that was all he was willing to say, and the public remained, at best, a representation; at worst, Danysh's argument was a conscious repression of the city's militant working classes.

This is admittedly a grim picture of the New Deal's major relief program on a microlevel. The local WPA spoke the language of culture but dismissed the painters it employed and the works they produced as barely artistic; its officials emphasized the link between commercial art and relief, thereby managing the iconographic programs of the artists it hired; it invoked public welfare when bargaining for continued funding; it made grand claims for a broadly democratic and popular art that only tangentially embraced those Americans who suffered most during the depression. I make no claims of my own here to expose or indict the federal public art program. Long ago, in 1936, Meyer Schapiro clearly understood the "public uses of art" when he described the federally funded programs.[45] The public art projects, he argued, were essentially propaganda for a reactionary regime. Their practical value had little to do with addressing the structural economic problems of life during the depression.

The left really had little hope of transforming federally sponsored public murals into an activist medium. The link between murals and leftism had dissolved by 1940. By the time of Pearl Harbor, there was no such thing as an alternative language for wall painting, and the United States' entry into the war—the intensely nationalistic fervor it engendered and the imagery it required—sealed the fate of

a subversive minority. But even before that, it is abundantly clear that the San Francisco left, wracked by contradiction and internal dissension, was in no position to counter the tide of New Deal statism; and the mural painters were prey to larger organizational, ideological, and international rifts. We have already seen the signs of the splintering, particularly in the local responses to the Moscow Trials and the Popular Front. In the sectarian debates that followed, disagreement over important issues degenerated into interest-group conflicts.

Throughout these debates, most of the committed Communist mural painters maintained a belief that external forces prevented them from producing a more compelling, or at least more politically productive, pictorial language. The Fleishhacker group had clamped down on dissent; the followers of Darcy and Bridges had chosen another terrain for symbolic transgression; the WPA had tempered the arts program; the Comintern's puzzling decisions had fragmented the mural painters as well as their potential audience. It would be left, ironically, to Rivera to suggest in murals the debilitating internal problems and a deep retrograde fantasy that troubled the leftist mural painters.

CHAPTER 7

ARTISTS, UNITE!

The most important issue those divisive sectarian debates brought to light may have been precisely the radical use of the organized working classes. That is, they brought into question what the left had always casually invoked, an identification with the city's laboring population. Darcy's united front had given the illusion of coherence among disparate working-class factions and had shown the Communist Party's ability to tap into them. But with the CP in disrepute and the left in ideological confusion and practical dissolution, mural painters recognized that this identification with labor might be completely imaginary, a mere register of cultural desire. And if that were the case, what would become of the possibilities for a radical public art? In a great ironic twist, Rivera, who helped to make possible a leftist proposal for San Francisco public murals, painted a mural that articulated that final horror, the real distance from the working classes.

Rivera's return came as something of a surprise. His supporters had held out little hope of it despite his ghostly presence in the city during the 1930s and the correspondence he maintained with local painters and patrons.[1] Given the current status of public murals, the New Dealers were not eager to see him paint. In 1940, however, the situation changed dramatically. During the second of the two ill-fated years of the city's Golden Gate International Exposition the old painter became the focus of the exposition's massive Art-in-Action pavilion, where he painted a monumental ten-panel mural, entitled *Pan American Unity* (Fig. 7.1), allowing the fair's visitors to observe him at work. In the display of the painter himself on his scaffold before a disparate audience, the likenesses to *Making a Fresco* must have been uncanny, and the echoes of that mural's richly particularized moment must have resounded. What political and cultural strands had

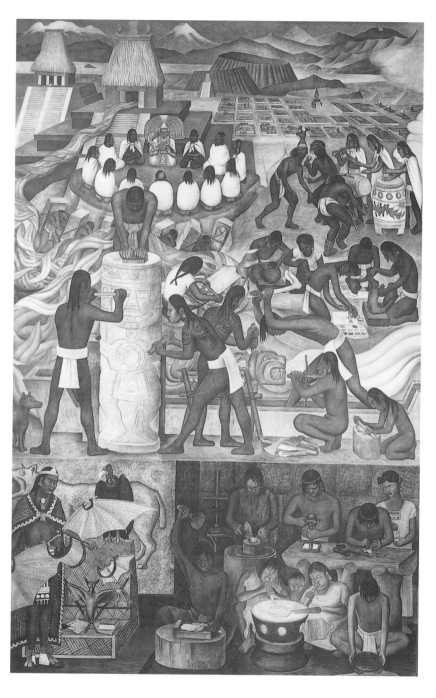

7.1 (*Above and following pages*) Diego Rivera, *Pan American Unity*
 (10 panels), 1940. Fresco. City College of San Francisco © 1999.

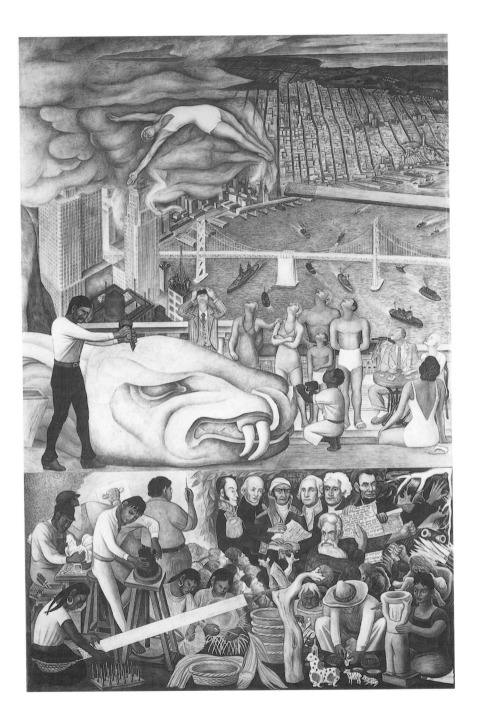

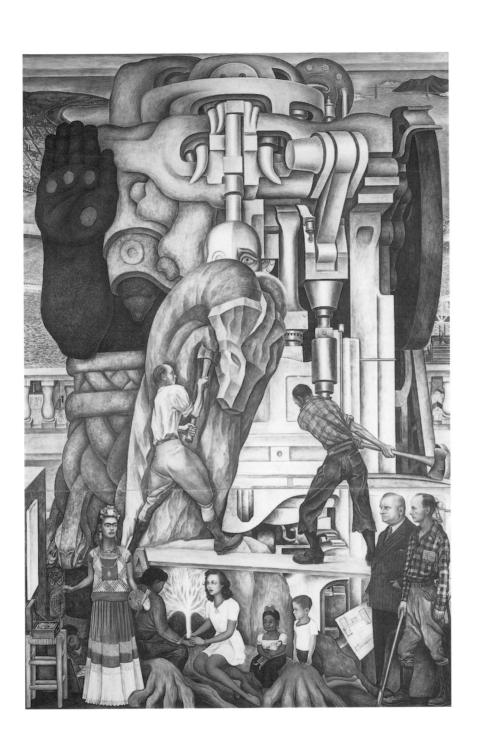

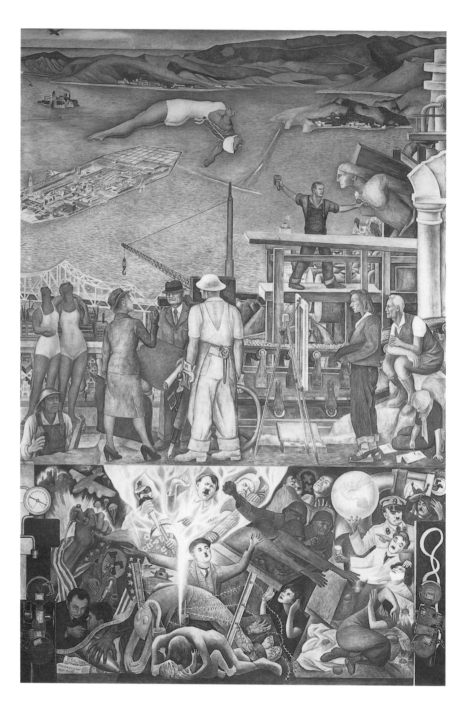

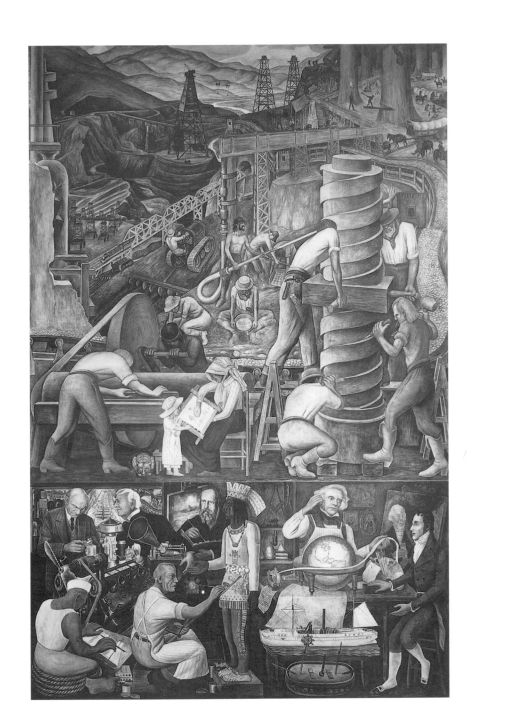

combined to bring Rivera back to San Francisco? And how did he come to paint again on such a grand scale?

THE ISLAND FANTASY

The Golden Gate International Exposition (GGIE) was planned during the early New Deal years to follow up on the PPIE two decades earlier. The new exposition would occupy a mile-long artificial island in San Francisco Bay, linked to San Francisco and Oakland by the new Bay Bridge.[2] With a hundred new buildings and transportation facilities, the GGIE's express purpose was to lay the architectural framework for a new international airport (which was never built) and to expand the city's commercial links along the Pacific Rim—to make the city a "Western Empire in every sense of the term," as a booster put it.[3] But as before, this fair had a local importance, to regenerate an economy hit hard by the depression. And like the earlier fair, the 1939 exposition became the locus of competing interests and a battleground for control of the metropolitan Bay Area.[4] Two major differences between the fairs are worth noting, however. First, the New Deal's equation of cultural pursuits and relief cast a shadow over GGIE preparations, including ambitions for mural work; and second, labor, often recalcitrant in such a massive undertaking, presented no difficulties at all. This second difference may be somewhat surprising given the parallel history traced in this book and the generally prolabor attitudes conventionally attributed to FDR. But as has been implicit from the beginning, labor, when organized, could also be corralled, its aggressive behavior channeled. Moreover, as the labor historian David Brody has said, Roosevelt hardly understood the attitudes (trade unionist or more militant) underwriting labor's demands, and he neither formulated nor advocated policies to meet them.[5] Instead, the Wagner Act, his most acclaimed legislation in support of unionization, contained a fundamentally conservative base—collective bargaining—that stimulated workers to organize but deflated any wider political ambitions. In San Francisco, the act helped to neutralize the anarchic, pentecostal fervor that, as in 1934, sometimes moved labor toward leftist politics.[6]

Timothy Pflueger was singularly placed to control the GGIE: as an architect, he knew how to capitalize on federal building contracts; as a patron of the arts, he worked with Danysh and Wessels and was funding many of their WPA projects; as a longtime builder, he was savvy about the city's construction unions. By the time engineers had begun full-time preparations for the fair, he had positioned himself as a force behind most of the exposition's grand architectural schemes. In

November 1937, when the Treasure Island site was dedicated with a symbolic shoveling of soil, he happily held the spade.[7]

What is worth remarking in Pflueger's rise is the means by which he attempted to expand his power. Believing in the claims represented by public culture, he named himself the GGIE's director of fine arts, taking not only the responsibility for murals and the fine arts exhibition but also the job held by Jules Guerin, the PPIE's chief of color, to organize a unified program of decorations. He designed the most important structures—the Federal, California, and San Francisco Buildings—and the most visible court, the central Court of Pacifica. He brought in the aged John McLaren, the former parks supervisor who had designed the PPIE landscape, to transform a cold, windy island into a tropical paradise; and he choreographed the whole ensemble as the "Pageant of the Pacific." This "Coloniale Moderne," with palm trees lining the walks and towers, made to look like elephants, piercing the sky, was erected to stimulate the economy, its vast tropical image ready for the tourists' consumption.[8]

But Pflueger's ambitions are most easily discerned and measured in the fine arts exhibit. During the fair's first season, in 1939, he imported a dazzling display of canonical works: Botticelli's *Birth of Venus,* Raphael's *Madonna of the Chair,* Mantegna's *St. George,* Tintoretto's *St. Augustine Healing the Plague-Stricken,* Verrocchio's *David with the Head of Goliath,* and others. An even more glittering display of works by French and Italian modernists included Matisse, Picasso, Georges Braque, André Derain, Fernand Léger, and Pierre Bonnard. The paintings occupied a cavernous space, some 9,000 square feet, that was to become an aviation hangar after the fair (one reason for Pflueger's special interest), and the whole art exhibition was hailed as the "greatest . . . ever held in the U.S."[9] The judgment was not inaccurate. The total value of the painting section alone was placed conservatively at $40 million, far exceeding the combined value of all the shows ever held west of the Mississippi. The visual spectacle given to the eight thousand or so who visited the Fine Arts Building each day probably surpassed that of any art museum or gallery they had experienced, certainly in San Francisco.[10]

Despite the visitors who crowded the Fine Arts Building, the first year proved a miserable failure. Many San Franciscans could not afford the ferry ride or bus trip to Treasure Island; others who came could not afford the various amusements. The anticipated tourists from out of state never appeared, going to the New York World's Fair instead or simply staying put. The plans for the airport fell apart, and the GGIE looked more like an outgrowth of the previous ten years of destitution than a promise of the recovery to come. Worse, as the fair drew to a

close and the GGIE committee determined to open for another year (for "Fun in the Forties"), the massive fine arts display suddenly had to be returned to Europe.

The abrupt dismantling of the art exhibition has been attributed rather vaguely to "the war in Europe,"[11] but this explanation alone has never been convincing. The paintings' return might more plausibly be attributed to a combination of ambivalence on the part of European curators in countries now at war and Pflueger's development of a new strategy. In late 1939, he closed the European masters' exhibition in favor of an Art-in-Action event that he hoped would draw visitors to watch the drama of art being made in the cavernous hangar and to witness creative genius at work. Artists invited to participate were drawn from a list of local painters and sculptors. The key to the event's success, however, was the presence of a centerpiece artist, the familiar and controversial Rivera.

Pflueger's determination to enlist Rivera was aided by other factors that need to be described in some detail: the new status of the city's leftist painters and their own diminishing investment in public painting in 1940, and Rivera's shifting priorities, which prompted him to accept the Art-in-Action invitation and colored his ambitions for the mural work he agreed to do.

First of all, although to reemploy Rivera might have seemed to run the risk of reenergizing radical painters, in truth, there was little to fear. I have already described the heavy-handed program of Danysh and Wessels and the dissolution of organized radicalism. Another development in mid decade further helped to loosen the leftist claim on public murals: the shift from wall painting to easel work. It came about because of the San Francisco Museum of Art, the latest development in that old debate over the afterlife of Maybeck's Palace of Fine Arts.

In 1931 Mayor James Rolph laid the cornerstone for the War Memorial Building across Van Ness Avenue from San Francisco's City Hall, and within four years it housed the new city museum, in the making since 1916.[12] Because its director and curator, Grace Morley, looked to local talent, her tenure there is important to our narrative; it gave the onetime Coit Tower muralists immediate access to wider patronage.[13] Once the San Francisco Museum of Art (SFMA) was established, for example, its exhibitions included the easel works of Arnautoff, Hesthal, Zakheim, Albro, Boynton, and others. The money earned from these shows was never much, but at the museum the leftist artists were shielded from Danysh and Wessels and given new license to invest in easel work. By the end of her first year Morley had hung seventy shows, advocated modernist and social realist work in sophisticated but readable prose, made important contacts with the likes of Michael and Sarah Stein (who had just settled in Palo Alto, already enjoyed a considerable local reputation, and would soon augment the museum's collection), and began a program of arts education. In 1936 she organized a Decorative Arts Exhibit for local

artisans, the first show of its kind in the city, and began a regular stream of alternative exhibitions. One tangible result was that Morley's stable of artists, artisans, and designers, who were already accustomed to public performances, could sustain Art-in-Action in 1940. This eventuality put Morley at the center of Pflueger's new ambitions.

Morley and the new museum gave seasoned leftist painters an outlet that made the loss of murals less devastating and the resistance to agitprop in the public sphere less frustrating. After 1936 Arnautoff, for example, never undertook another mural project in the city and began to rely on his easel production.[14] With his smaller canvases he tried to reinvigorate painting with radical overtones and transform the SFMA into the new public sphere for artistic dissent.[15] His paintings of the later 1930s—*Fisherman at a Quayside* (Fig. 7.2) is a fair example—were often pictorially understated, especially in comparison with his *City Life* at Coit Tower. In *Fisherman,* the lingering history of the docks is a subtext for a relatively quiet American scene subject. This was one of a number of waterfront paintings sympathetic to the isolated fishermen and longshoremen, and its pathos—its careful regard for the man's solitary work—came to typify much of his own work during the 1940s.[16] Zakheim, too, took to the easel, but he made the move less easily. After completing the grand amphitheater at Toland Hall at the University of California's medical school campus, he continued to paint as if before a wall, often with mixed results. In 1939–40, he undertook a five-panel series devoted to Jewish heroes of the American Revolution (Fig. 7.3), the first sustained easel work he had done since 1933. These were his worst paintings yet, lacking all compositional control or even the fierce crudity of his Toland Hall panels. The figures are cramped, the gestures melodramatic, the faces pared down to blunt, comical features. These paintings assembled motifs from his previous work—the appeal to Jewish subculture, the narrative emphasis, the high dogma and obscure histories—but the squat figures and claustrophobic spaces suggest how a mural language could resist being transferred to the easel.

As a result of the changes in the artists' work, however, Pflueger thought he could take a risk. Where once the Communist Party had members who were competent muralists with old links to Rivera, when the Mexican returned in 1940, it had painter members who were preoccupied with small pieces.

What Pflueger was not counting on was the emergence of another group of much younger radical and inexperienced artists who had not yet come to Morley's attention. This group, unlike the first generation of Communist painters, included some Asian-Americans, two of whom—Mine Okubo and Peter Lowe—formed Rivera's staff at the GGIE.[17]

7.2 Victor Arnautoff, *Fisher-*
 man at a Quayside, 1938.
 Oil on canvas. Private
 collection (Photo: San
 Francisco Art Institute).

7.3 (*Opposite, above*)
 Bernard Zakheim,
 A Committee of Jewish
 Patriots, 1940. Oil on
 canvas. Collection of
 Masha Zakheim
 (Photo: Lito).

7.4 (*Opposite, below*)
 Contemporary photo-
 graph of the Chinese
 Revolutionary Artists'
 Club, n.d. Whereabouts
 unknown.

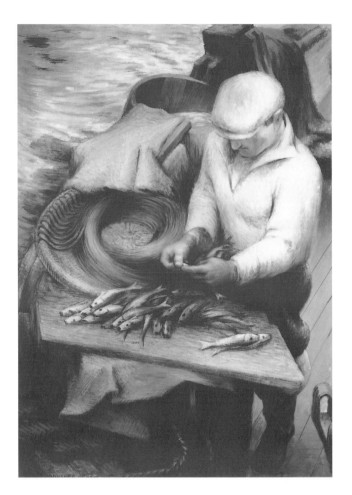

The history of Asian-American painters in California, especially as it relates to radical politics, needs further uncovering.[18] The largest obstacle is the obscure trail these painters left; the archives preserve only tantalizing hints of their activities. Still, there is enough to piece together the tradition of radicalism out of which both Okubo and Lowe emerged. It began in 1926 with Yun Gee and the Chinese Revolutionary Artists' Club, based in San Francisco's Chinatown.[19] A photograph of Gee and the club's members survives (Fig. 7.4), showing Gee (at the left with a pipe) instructing five young Chinese men. The sketches and small canvases tacked on the walls suggest the vaguely cubist attempts by club members. (Gee would soon develop his theory of Diamondism, derived from Orphism—a version of cubism that emphasized color and lyricism—probably intending his formulations for practice within these very walls.)[20]

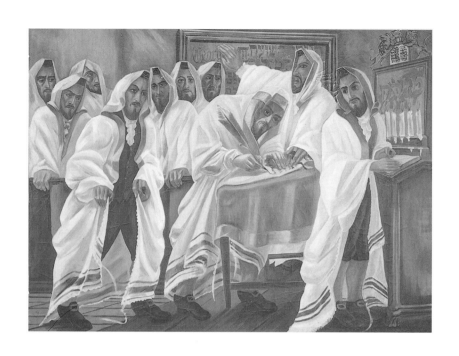

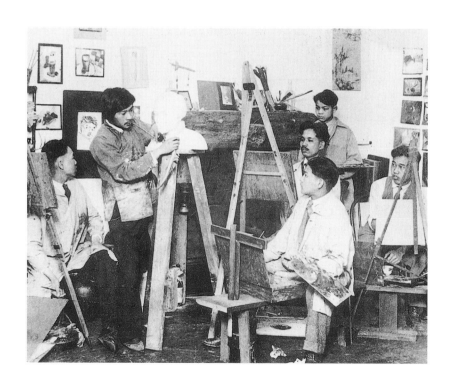

The club was important for several reasons. Not the least among them was the daring it took for Chinese men to gather during an intensely racist moment in the city's history, when the "bachelor societies" of Chinatown were subjected to surveillance.[21] More important, it was also a "revolutionary" club, freely mixing art and politics and attempting to relate the modernist painterly experiments to a new political agenda. Rexroth played a crucial role in this effort, helping to theorize the club's nascent ideas and shift members toward the Communist Party. He was apparently a frequent guest at the club in the late 1920s, during his most enthusiastic period of organizing. One of the few written statements that remains of Gee's early ideas obliquely hints at the interconnections of cutting-edge art and progressive politics but makes no mention of the CP:

> The strongest hope for reviving a once great but now jaded and worn art lies with those painters who are making a serious endeavor to combine the old with the new. The aim of this school is not to cultivate merely an art of compromise, nor a safe, middle-of-the-road art, but to create an art that is vital and alive that will contribute to the development of Chinese painting technique. This is no easy task. But, since the republic is young and art is long, time will be an ally in the successful development of the new style.[22]

Art's life is bound to the Chinese revolution, drawing vitality from the dreams for a new republic's political future. For Gee, a recent immigrant, the club's aims referenced events on mainland China, and members considered recent and challenging Western art in relation to new nationalist ideas in the East. In this the club resembled other, now obscure, groups in Chinatown that emerged from 1926 to 1928: the Kung Yu Club (1926), the San Francisco Chinese Students Club (1927), the Grand Revolutionary Alliance of Chinese Workers and Peasants (1927), and the Chinese Workers Club (1928).[23] All were politicized and torn between mainland concerns and American priorities. But after Gee left San Francisco in 1927 for Paris, the club turned squarely to the local Communist Party, no doubt prompted by Rexroth and Arnautoff, who was only a hundred feet from Chinatown in his Montgomery Block studio. Arnautoff's early devotion to mural work must also have been passed along, for when Rivera arrived in 1930, the club members already regarded the great muralist as a painter to be reckoned with. Sometime in late 1930 or early 1931 they invited Rivera to speak at their tiny studio in the heart of Chinatown.[24] But even after his visit, Yun Gee's Revolutionary Artists' Club did not become a full-blown Communist organization. The club's mixture of painting and radical politics, though ambiguous—not to say confused—was nonetheless rela-

tively productive, and the club itself provided a center for newer, more aggressively political members.

Rexroth helped to sustain the agenda of the local Communist Party in the Chinese-American art circle, and until his own faith lapsed, he was regularly able to persuade its members to support Darcy's united front. Rexroth also had some success with Japanese writers in San Francisco, primarily because they were linked with Japan's CP and had already articulated an agenda for local work. As he tells it:

> Inasmuch as the Japanese military government cropped the Japanese Community Party, or rather mowed it like a lawn, the reserve echelons of the leadership were usually based in California, and unlike most representatives of foreign parties, they mixed freely with the Japanese-American membership. . . . I became a sort of English-language adviser to these people and helped them put out their little mimeographed paper *Rodo Shinbun.* We met in the back of a tempura parlor frequented by agricultural workers from the Sacramento–San Joaquin Valley and went over the English-language supplement word for word.[25]

One aim of *Rodo Shinbun,* to create cohesion among the migrant farmers, matched that of Darcy's ambitious multiethnic militancy, certainly in the way John Langley Howard imagined it at Coit with his *California Industrial Scenes* (see Fig. 5.16).

The Moscow Trials of the mid-1930s, along with the splintering of the united front on the waterfront, strained the tenuous relations between the local Communist Party and Asian-American activists. Most Nisei and Sensei, for example, drifted away. In addition, Japan's aggression in mainland China made it harder for the two ethnic groups to join in California. But those who remained Communists were hard-liners, held together by Stalin's policy of the Popular Front and the new orientation of the CIO. *Rodo Shinbun,* for example, changed its name to *Doho* in 1937 and became far more loyal to the Comintern. Thus activism continued, and in February 1938 the Chinese Ladies Garment Workers' Union, Local 108, was established in San Francisco's Chinatown. This momentous occasion—a rupture in Chinatown's history rather than a culmination—required a radical break from the family and village structure of sweatshops and replaced long-standing immigrant and clan ties with a politicized labor community that questioned the patriarchal order. One of the local's leaders was Peter Lowe.

Lowe and Okubo were born in southern California—Lowe in Los Angeles, Okubo in Riverside. Lowe developed an intense commitment to the Communist

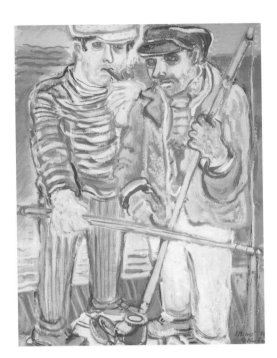

7.5 Mine Okubo, *Two Fishermen*, 1940.
Gouache. The Oakland Museum
of California.

Party when he resettled in San Francisco sometime in the mid-1930s. Evidence from these years is murky, though Lowe probably first met politicized painters among the remnants of the Chinese Revolutionary Artists' Club, through whom he became embroiled in Chinatown's art and labor politics.[26] His early experiences in San Francisco's Chinatown seemed to have transformed him into a hardline Stalinist, in particular his cementing of a close friendship with the painters Robert McChesney and Herman Volz, both committed Party members who had recently come to town.[27] As many Coit Tower artists left Darcy's camp—some had been only temporary members in the first place—the apparatus was reinvigorated with young new recruits. Ironically, their relative anonymity and ethnic identities made them palatable to Danysh and Wessels and, through them, to the Pacific Rim visionary Pflueger. No doubt their race fit Pflueger's fantasies of the Pageant of the Pacific and Art-in-Action.

Okubo arrived at the GGIE by a different route. She came (the child of a poor immigrant family) to study at the University of California at Berkeley.[28] As she experienced university life, she also engaged in physical labor, financing her edu-

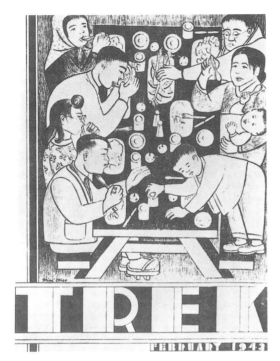

7.6 Mine Okubo, Cover for *Trek*
magazine, 1943.

cation by working as a seamstress, a domestic, and a seasonal worker in agricul-
ture.[29] As a field-worker she first encountered organized labor and the Commu-
nist Party in 1936–37, when the ethnic agricultural unions and Darcy's California
Agricultural Workers Industrial Union began to orient themselves to the CIO,
and when *Rodo Shinbun* and *Doho* were making incursions into Japanese and
Japanese-American migrant cultures.[30] Although Okubo was never affiliated with
the left—and she was certainly not a hard-liner like Lowe—her experiences seem
to have had a profound impact on her and to have put her in the company of po-
liticized artists. "My schooling," she would later say, "has always been outside the
classroom."[31]

Okubo's paintings from this early period are more like sketches than complete
pictorial statements, but their subjects are telling. Those of paintings like *Funeral
Procession* and *Two Fishermen* (Fig. 7.5) were hardly neutral choices in the years
immediately after the Big Strike. By 1943 her work had changed dramatically. In
covers she produced for *Trek* (Fig. 7.6), the literary magazine of the Topaz Reloca-
tion Camp where she was interned, her images became more complex, her com-

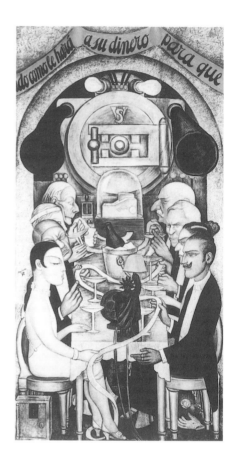

7.7 Diego Rivera, *Wall Street Banquet,* 1928. Fresco. Courtyard of the Fiestas, Ministry of Education, Mexico City.

positions more compressed, her figures more substantial, and her tone more biting. Her cover image for the February 1943 issue, showing a Japanese family at table, makes overt reference to a familiar image from Mexico City (Fig. 7.7). The family at her dinner table, however, is the ironic reverse of the American rich at Rivera's table, the simple plates and saucers the meager equivalents to the champagne and ticker tape. Between 1940 and 1943 stood Okubo's experience with Rivera.

MURALIST ON THE MARGINS

While Pflueger was moving toward the Art-in-Action alternative to the exhibition of European art with the group of younger painters on hand, Rivera was moving in that same direction, but with different motivations and from a distinctly dif-

ferent place on the artistic and political spectrum. From 1936 to 1940 Rivera painted no murals. His last before this period was the Hotel Reforma's *Burlesque of Mexican Folklore and Politics* (Fig. 7.8), perhaps the most caustic gibe at Mexican popular cultural representations that he would ever paint. Soldiers were transformed into pigs, Zapatistas into donkeys, farmers into cows, workers into sheep. The folklorists were "dessicated urban types whose imbecile pretensions were satirized by asses' ears sprouting from their heads."[32] The bright, colorful ethnic dress was carnivalesque, like badly contrived costumes for an equally bad masquerade. The garish profusion was epitomized by circus tents in the background, and "La Gran Victoria" on a building facade underscored the satiric tone of the panels. For Rivera, who had always treated images of nativist culture with a strategic ingenuousness, *Burlesque* was an opportunity to unmask cultural forms and to show them as hackneyed. His patrons, the Pani family, claimed that he had parodied and caricatured when he should have engaged seriously with cultural materials.[33]

The four-year hiatus in mural work was the longest in Rivera's public life as a mural painter. More than once he expressed anxiety about ever being able to paint on a large scale again. He dismissed opinions that he had lost his powers; and he fairly bristled at the insinuation that his political flip-flops made him suspect. He preferred a different, much easier, but unconvincing excuse: "Following the affair of the Hotel Reforma, poor health kept me from painting murals for several years. . . . During these years of bad health, I became passionately absorbed by a less exacting artistic activity—making spot sketches evolved into drawings and water colors. More important, they stimulated me to observe more closely than ever before the life of my countrymen."[34] The humble spot sketches were transformed into a huge number of genre scenes and picturesque landscapes, easily Rivera's most substantial output to date of these subjects. They were reminiscent of the paintings Rivera had sent to Bender and Gerstle in the late 1920s, except that many were done in pastels and charcoal—quickly produced and just as quickly sold. He certainly needed the income he produced in this way. In 1936 the Sindicato de los Talleres Graficos, the graphic workers' union, began a collective project in Mexico City, and while Orozco undertook three major mural commissions in Guadalajara from 1936 to 1939, nobody seemed interested in Rivera's services.[35] For the first time since returning from Paris as a young man, Rivera needed to rely solely on the income he could earn with small works.

If Rivera had no major Mexican patrons (*Burlesque* sealed that fate), he was doubly marginal in relation to the Comintern. Its previous suspicions of him had been confirmed by his behavior in the mid to late 1930s. In 1936, for example, Rivera joined the Trotskyite Fourth International Communist League and later that year brazenly extended an invitation to Trotsky to live under his protection in

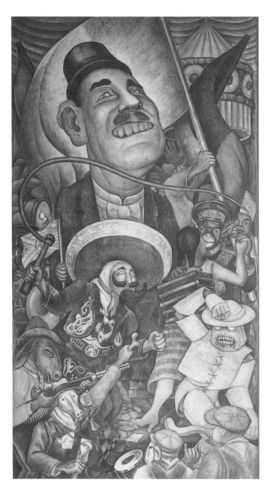 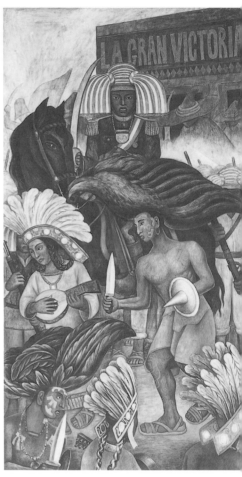

Mexico City. The offer came during a heated moment, in the midst of the Moscow Trials, where Trotsky was charged with both treason and conspiring with Hitler. In January 1937 the Trotskys arrived and effectively transformed Rivera's house into a military fortress, targeted by Stalinist henchmen. In 1938 André Breton traveled to Mexico. During the next several months, under heavy guard, Breton, Trotsky, and Rivera formulated the famous essay "Towards a Free Revolutionary Art."[36] Although it was clear even then that the text was largely Trotsky's, with Breton and Rivera simply lending their signatures, Rivera's complicity was an unforgivable act of anti-Stalinism. The Comintern's suspicions of him were con-

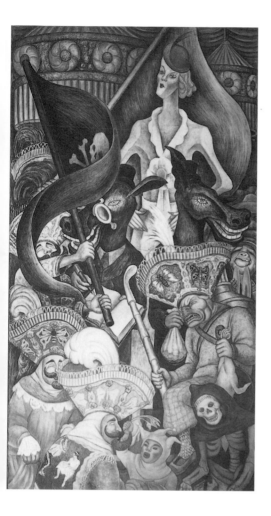

7.8 Diego Rivera, *A Burlesque of Mexican Folklore*
 and Politics (3 of 4 panels), 1936. Fresco.
 Mexico City, Museo del Palacio de Bellas Artes
 (Photo © Dirk Bakker).

firmed later that year when he delivered a paper to a General Workers Congress, condemning Stalin's behind-the-scenes work in the Spanish Civil War.

In 1939, the year before Trotsky was murdered, Rivera publicly broke with him, a move generally interpreted as a sign of Rivera's shift away from the Fourth International line and the beginnings of his reconversion to Stalinism.[37] But Rivera's allegiances underwent a period of fluctuation and instability in 1939–40. His disavowal of Trotsky was neither forthright nor complete. In fact, the break was

probably more performance than substance: the two men continued to maintain close relations and remained ideologically compatible. But Trotsky was too firmly entrenched in the international Communist arena, a major drawback for Rivera in the xenophobic Mexican political scene. Rivera's fears were confirmed in August 1939 when, with Hitler's and Stalin's agreement to the Molotov-Ribbentrop Pact, the Mexican Communists fell into confusion as well as disrepute.

Shortly after the public break, Rivera founded the Revolutionary Party of Workers and Peasants (PROC) in an effort to launch himself back into the center of Mexican politics, apart from any official Communist faction. In the presidential election he supported the controversial candidate from Nuevo León, Juan Almazán, a former general. Almazán was hardly a peasants' and workers' candidate, for he was backed by a diverse coalition that included staunchly antilabor and anti-Communist factions.[38] But formally severed from Trotsky, the Fourth International, and the Comintern, Rivera and his party could speak for Almazán. The attempt to deceive was ineffective. One San Francisco journalist who tried to interview Almazán reported being told that first he must "see Mr. Diego Rivera who knows better than anybody else about our program and our activities and who will also put you in touch with Leon Trotsky."[39] Rivera could not escape his links to the old Russian revolutionary. All for naught, as it turned out. Almazán's candidacy was doomed by an ineffective campaign strategy and the ragged coalition of conflicting interest groups that supported him. The vote reported was 2.26 million to 129,000 against him.[40]

Publicly, Trotsky regarded the break with Rivera as a loss of "moral solidarity" between them.[41] Privately, he had misgivings about Rivera's tactics, presciently summarizing their disastrous result for the artist: "Diego's break with us would signify not only a heavy blow to the 4th International, but—I am afraid to say—it would mean the moral death of Diego himself. Apart from the 4th International and its sympathizers I doubt whether he would be able to find a milieu of understanding and sympathy not only as an artist but as a revolutionary."[42]

Trotsky pinpointed the nature of Rivera's new political life: the desire for revolutionary, Marxist politics set against a self-imposed, institutional void. Rivera would not reconvert to Stalinism for many years, and in the interim he was without a party and, furthermore, without the artistic and political supporters he had once enjoyed.

Rivera as we approach the GGIE is a painter losing his public influence, a leftist marginalized by most of the important factions. Indeed, only Wolfe and the remnants of the Lovestoneites remained reliable supporters in the United States, and even they had reservations. Rivera's behavior contributed to his growing isolation. Working behind closed doors, escorted by armed guards, sealed off from

Mexico City by a new perimeter wall around his house, Rivera was a garrisoned artist. This modus vivendi contrasted markedly with the public life he had led. The problems he attributed to ill health were increasingly worries about his safety. In 1937 at the Restaurant Acapulco in Mexico City, four *pistoleros* drew their weapons on him. As Wolfe tells it, only Frida Kahlo's bravery saved him; she put herself between the gunmen and Rivera and wailed.[43] The commotion scared off the would-be assassins but did not assuage their enmity. In May 1940 Siqueiros led an assassination attempt on Trotsky. It failed, but Rivera, feeling threatened, went into hiding.

When Pflueger traveled to Mexico City in the spring of 1940 to invite Rivera back to San Francisco, he met the painter at a most propitious moment. In the arena of Mexican politics Rivera was a self-declared Almazánist with an uncomfortable antilabor agenda. On the international leftist stage he had recently broken with Trotsky, perhaps the only major leftist who championed his work. Behind his perimeter wall, he continued to be targeted by Stalinists for harboring a treasonous criminal. His artistic skills were called into question; his major competitors were at work on grand projects; and he had received no major commission in years. He greeted Pflueger enthusiastically and by June was back in San Francisco.

PAN AMERICAN UNITY

The commissioning of Rivera faced strong opposition on several fronts. The criticisms are by this point practically routine. Rivera's radicalism was in question, his price tag too high, and his showmanship clownish; his opportunism left a trail of betrayed artists and friends.[44] The critics, however, now included his own protégés, led by Arnautoff and the regional unit of the American Artists' Union, Local 88.[45] The reasons for this apparent disloyalty to a mentor had far more to do with the divisions between Stalinists and Trotskyites I have been describing than with the complaints highlighted in the press.

Local 88 was the newest of the city's radical artists' collectives, an outgrowth of the Artists' and Writers' Union (the major activist organization at Coit Tower, which itself had developed from the local John Reed Club of 1931). But unlike the earlier groups that had followed an explicitly regional agenda, Local 88 emerged at a time when the program of San Francisco's divided left had taken on an increasingly national and international flavor. For example, Zakheim returned to San Francisco from the First American Artists' Congress, which met in 1936 in New York, with a renewed sense of communal activism fostered by the Popular Front platform, and he soon began efforts to establish the local. But artistic radicalism

proved problematic to this new regional unit because of Stalin's increasing ideological shifts. Local 88's half-hearted objection to Rivera was only the most obvious sign of its uncertainty in following a party line.[46] Rivera represented a left opposition with an apparent antilabor intent that was now being given an opportunity to lay claim to public art. As far as Local 88 was concerned, the commissioning of Rivera was tantamount to giving the enemy (the supporter of Almazán and Trotsky) the opportunity to express his viewpoint in the exposition's grandest commission.

But this was not the only difficulty facing Local 88. By the time Rivera set foot in San Francisco, the national Communist Party had fragmented even further. In February 1940 the art historian Meyer Schapiro began a movement in the Popular Front's Artists' Congress to challenge the Stalinists and the contradiction of their antifascist platform, given Stalin's shocking pact with Hitler.[47] Schapiro's group constituted yet another instance of opposition to the Communist Party from the left, but this time with much greater force because of the emphasis on the Comintern's conceptual impasse about fascism. Between February and June, the debates led the hard-liners to a strange but predictable position. Those advocating the Stalinist line were forced to bracket ideological questions about fascism and to insist upon the exclusive priority of "cultural matters." In practice, the most ardent Stalinists were ludicrously unable to articulate the function of socially engaged art at the same time that they were fearful of Rivera's doing precisely that in his new San Francisco mural. In June the self-censoring split the congress, and the more vocal dissidents formed the Federation of Modern Painters and Sculptors. From June to December 1940, during the months Rivera worked on *Pan American Unity*, the federation, led by Schapiro, openly debated art's relationship to politics, outside the Comintern's restrictive influence. The congress's remaining members could not and did not engage in this dialogue, cornered into the culture argument instead. The organization never recovered. By the next meeting, in 1941, the number of members had dwindled to only a few, and the call for a principled antifascism must have seemed absurd. By April 1942, after two years of waning influence, the congress quietly folded.[48]

Like many other regional affiliates, Local 88 remained loyal to the Communist Party and worked feverishly with the CIO. But a leftist cultural politics in San Francisco differed from that on the national scene in that Rivera was present at the GGIE. The predicament of the city's Communists became more difficult in August 1940. In that month the Spanish Stalinist Ramón Mercader assassinated Trotsky, and San Francisco Communists began to fear for Rivera's safety. Not only was the murder a crude display of Stalin's realpolitik, but it also further height-

ened concerns about the Hitler-Stalin pact and the fascist overtones of the Comintern's new cultural agenda. And if there was anxious silence on those concerns, Rivera forced them into open debate in an interview published in September:

> Communist revolution leads only to totalitarian dictatorship. That has been proven wherever a Communist revolution has occurred, in Italy, in Germany and in Russia. The theories may point one way, but the practical results in the test tube of history point another way, and it is the fact that counts. The princip[al] difference between the dictatorships is this—Mussolini has executed 2,000 and jailed 40,000; Hitler has executed a million and imprisoned three million. Stalin, according to his own published figures, has killed off 2,700,000, jailed 6,000,000, and records the death of 5,000,000 peasants.[49]

The numerical claims were not far off the mark, and the gist was clear to the Party and its remaining artist members, who were now, to some degree, Rivera's bodyguards. The question of commitment crystallized with particular force: how could one maintain a Marxist affiliation while rejecting questionable policies of the Comintern and the discredited Fourth International? How could one remain an engaged leftist without an institutional connection? These questions, as we have seen, were gnawing at the painter in 1939–40.

And thus it happened in the fall of 1940 that Rivera could claim, uncharacteristically, that "democracy is the only way."[50] If he made the claim in a moment of whimsy, the irony nonetheless is that this position was one of the few Rivera *could* occupy in the radical political climate of late 1940, given his own recent behavior. In public discourse nearly all the formalized leftist positions were closed to him as defensible options.

Along with many other leftists, Arnautoff stayed away from Art-in-Action to avoid the question of public murals when it was clearly so problematic for San Francisco's radicals. Pflueger was unconcerned about this response on the part of the city's most accomplished mural painters. He preferred to envision Art-in-Action as the spectacle sketched by Esther Bruton (Fig. 7.9). In her drawing the well-dressed crowd mills about; new paintings fill the walls; artists and artisans work busily behind railings as in a three-ring circus; Rivera and his crew, on a scaffold in the background, paint a Picassoesque woman and guitar. And, floating overhead, the spirit of Pflueger presides, angelic, Asianized, with the ears of a Buddhist saint.

These preliminaries to *Pan American Unity* provide some insight into the conditions and political forces at work when Rivera developed his ideas and put brush

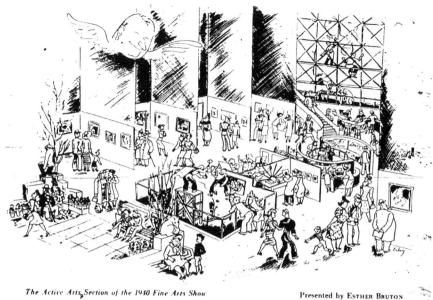

The Active Arts Section of the 1940 Fine Arts Show Presented by ESTHER BRUTON

7.9 Esther Bruton, *Fine Arts in the 1940 Fair,* print for *San
Francisco Art Association Bulletin,* 1940.

to wall. What form, in art, could a debate about the fortunes of organized leftism
take? And how might Rivera represent leftist discourse in a time of crisis and dis-
solution in the somewhat incongruous, if not ludicrous, context of a spectacle for
advanced capitalism, the "Pageant of the Pacific"?

We might expect whatever artistic meditation he produced to require a pano-
ramic, inclusive, almost excessive vision to handle its subject adequately. And in-
deed, in its sheer size, *Pan American Unity* (see Fig. 7.1) fits the bill. The mural is
massive, much larger than any single scene Rivera had ever done or would do. But
it is conceived as a whole, quite unlike his other, partitioned, monumental mu-
rals. Because of the potentially disjunctive composition of such a large scene and
the several panels that constitute it, the mural was susceptible to disjointedness
and lack of focus. But in this work, Rivera countered the critical realist language
he had introduced into San Francisco with *Allegory of California* and *Making a
Fresco* and attempted a series of clear thematic and compositional links. The mural,
he stated, "is the representation of the union of the technical and industrial ge-
nius of North America and the artistic and creative genius of South America."[51]

He offered a longer explanation in autumn 1940 as the painting proceeded amid the debates initiated by Schapiro's group:

It is about the marriage of the artistic expression of the North and of the South on this continent, that is all. I believe in order to make an American art, a real American art, this will be necessary, this blending of the art of the Indian, the Mexican, the Eskimo, with the kind of urge which makes the machine, the invention in the material side of life, which is also an artistic urge, the same urge primarily but in a different form of expression. . . . In the center of my mural there is a large figure—on one side it has the neck of Quetzalcoatl[,] elements from the Mexican Goddess of Earth and the God of Water. On the other side the figure is made of machinery, the machine which makes fenders and parts for airplanes. On one side of this figure there is the northern culture, on the other the southern art, the art of emotions. People are working on this figure, artists of North and South, Mexican and North American. . . . From the South comes the plumed serpent, from the North the conveyor belt.[52]

This is hardly an explicit representation of the state of organized leftism. But we can sense the pointed refusals even in Rivera's grand claims about North and South. "That is all," he declares, as if anticipating questions from those not quite satisfied with what he offers.

Iconographically, *Pan American Unity* retells *Making a Fresco*. It pairs art making as an activity with industrial work, drawing out the links by tabulating artist and worker types, southern and northern sensibilities. Unlike the California School of Fine Arts mural, however, *Pan American Unity* distinguishes between its dialectical elements, dividing its space in two and hinging the composition on the central hybrid figure. The symmetrical structure is meant to be read laterally, so that viewers cross-reference the figures and activities of the southern artistic panels, at left, with those of northern industry, at right.[53] In the upper left register, for example, Indians sculpt an upright Toltecan column; in the upper right, workers carve a cork-screw wine press. In the lower left, Netzahualcoyotl, the Aztec poet king of Texcoco, brandishes the wings that represent imaginative transport; in the lower right, Robert Fulton points to his steamboat as the industrial version of such wings. The far left background shows the high plateau of Mexico City, the site of ancient religious rituals; the far right is the hill country around Mount Lassen, the site of recent industrial development.

The bilateral structure facilitates the comparison of ancient and modern cultures and, as it pushes inward, of contemporary cultures. The Mexican peasant sculptor Mardonio Magana, in the second panel from the left, is paired with Frank Lloyd Wright, seated in the fourth panel. Frida Kahlo, at center, holds a palette and brushes and begins work on a primed canvas; opposite her are the aged Pflueger, holding plans for a new junior college library, and Dudley Carter, architect and woodcutter, with a long ax. And on two of the lower panels (second and fourth from left) Rivera compares himself to Charlie Chaplin and the mural painter's traditional fresco practice to the actor-director's technological one: both work at their crafts and both portray major political, military figures.[54]

These thematic and compositional similarities on the cross-referenced panels have their moments of dysfunction or dark humor—usually embodied in grim statements about the viability of southern culture in the face of northern developments. The Mexican peasants in the lower panel, second from the left, for example, produce primitive woodcarvings, tourist-trade sculptures, and baskets—items for the roadside stand or ethnic bazaars of the exposition itself. (The Pageant of the Pacific offered its share of ethnic entertainment and native commodities.) The outstretched arms and lassoed neck of the anthropomorphized tree set the panel's tone as the tree pulls against the demand for folkloric production and the hackneying of indigenous culture for mass consumption. In a reversal of roles, the American folk artist paints a cigar store Indian in the lower right panel, transforming the native into a stock commodity, immobilizing the stoic figure as an artistic cliché. Just above, on industrial Mount Lassen, the Native American, brought to life, strains to turn a crank. This scene clearly hints at slave labor, and, in opposition to the scenes of Native American culture at far left, suggests how industry requires the habitual exploitation of an indigenous workforce.

But the mural establishes its disturbing comparisons in a pervasively celebratory context. Behind the basket-making peasants, for example, are portraits of national heroes—Simon Bolívar, Miguel Hidalgo y Costilla, José Maria Morelos y Pavón, George Washington, Thomas Jefferson, and Abraham Lincoln—who stand before the "Liberty Tree." That tree is paired with the "Tree of Hope," young and iridescent, in the hands of Rivera and the actress Paulette Goddard (Chaplin's co-star). In fact, the images of southern oppression are not simply set against these grander statements but are nearly subsumed by them. For it is in the brilliantly colored passages that the mural's tone is set, permitting Rivera to underscore the compatibility of North and South, technology and artistic invention, and, further, to insist upon continuity across time and space. The Indian workshop, for example, or the prayer gathering of the Aztecan priest and disciples, the Yaqui deer dancers and musicians, the "genius artists" Robert Fulton and Samuel

Morse, who were both painters and inventors—all these, Rivera would later claim, exemplified those who were "artists" almost unconsciously, and who therefore shared a common bond that was transhistorical and transcultural. "It is so easy for them to make art," he said, "because they do not know that they are artists and that art is something apart from life."[55]

In the center background is San Francisco Bay, with the city at left, and Treasure Island at right. The background is the space of the present where, at the GGIE, the marriage between artists and workers of the two cultures can take place, where in fact Rivera himself was giving it form. That marriage is visualized in the central panel in four-fold form: in the hybrid Coatlicue (half-mechanical, half-organic), in the wooden ram that is being carved by the two figures representing Carter (who actually hewed the sculpture in front of Rivera's Art-in-Action mural, bringing the northern and southern artists into visual relation), in the erotic relations between Rivera and Goddard (and the more innocent one between the brown and white children), and in the figures of artists and patron.[56] In his GGIE mural Rivera conjoined industry and art and linked them to sexuality and patronage.

What is more notable, however, because it is new to Rivera's work, is the emphasis on *place*—on the exposition itself as a space for a unifying vision. The mural that represents Pan-American unity also encodes its operation; it is, like the exposition itself, the "major device for thematizing persons, objects, or places [by] grouping [them] around . . . a proper name."[57] That was an exposition's job—to connect architecture and statuary, new technology and the fine arts, festive and intellectual pursuits with one dominant ideology. Rivera's mural directs us to see the exposition from above, from the imaginary vantage point of its benefactors, where the connections are most legible and the GGIE is most coherent, where it becomes a single spectacle.[58] Against the dream from above, however, is a practice from below, where individuals actually inhabit and negotiate the fairgrounds—a "spatial practice," as Michel de Certeau describes that activity.[59] Indeed, the mural occludes the bird's-eye view of the exposition with an array of figures in the foreground who engage in disparate, sometimes comical, behaviors. What can be more ludicrous than the synchronized swan divers leaping into the crowds? What can be more startling than the embrace of the lesbian couple in the fourth panel from left, transfixed by the erotic form of one of the arching divers? They have turned the place of the exposition into a space for individual experiences that take only partial notice of the GGIE's express claims—or perhaps none at all.

And is not the mural itself a spatial practice? Rivera transformed Art-in-Action into his own performance, making the very wall on which he painted a metaphorical (and in the case of Carter, actual) representation of the creative work taking

place below. But in the mural he has subverted the purity of Pflueger's fantasy and transformed art making into a cross-cultural enterprise. Indeed, he has given ironic form to the criticisms of his own presence—of the southern artist imposing on northern climes, contaminating art with his outlandish clowning.

Pan American Unity does not tackle the more difficult question of leftism in any direct way (despite the presence of Rivera's own Communist assistants), preferring to deal with art and the exposition instead. It does broach the subject of leftism and fascism obliquely, however, in comparing mural painting with film and Rivera with Chaplin. The delicate subject is addressed in the Hitler panel (see Plate 13), which alludes to Chaplin's new 1940 film, *The Great Dictator.* In that film Chaplin stepped out of his familiar tramp persona and into the double role of Adenoid Hynkel (Adolph Hitler) and an anonymous Jewish barber. Intertwining the life stories of these characters, Chaplin contrasts Hynkel's absurd, egomaniacal reach for power with the barber's more modest ambitions for romance and community. But the barber, mistakenly identified as Hynkel, is suddenly given power to control the fascist military machine of Tomainia (Germany). The climax of the film is the barber's monologue, aimed as much at the movie's audience as at the fictional Tomainian army, which he now heads; and critics have rightly pointed to this segment as Chaplin's stepping out of his fictional roles to appeal directly, passionately, to his Hollywood fans. "More than machinery," he exclaims, "we need humanity . . . [not] machine men with machine minds and machine hearts." And in phrasing that sounds like Rivera's, he pleads for solidarity: "In the name of democracy, let us all unite."

Rivera represents several moments from *The Great Dictator.* On the right, for example, the Jewish barber shaves the face of his romantic partner, Hannah (played by Goddard), a scene in which Hannah is transformed from a plain girl to a glamorous beauty. The humor of the scene lies in the barber's determination that Hannah needs male grooming, whereupon he lathers her face with shaving cream and sets to work with his razor. Behind the barber Hynkel grasps a globe that shows the North and South American continents. In the movie Hynkel's zeal for conquest takes on pathological dimensions in this scene, as he fondles and tosses his globe like a plaything. To the left of the globe Hynkel confronts his rival, the Bacterian dictator Benzino Napoloni (Mussolini), with whom he competes for attention, control over pageantry and decorum, legitimate authority, and so on. They each plan to invade the country of Austerlich, a fictional nation that represents their rivalry as well as a real European state. In the foreground, Tomainian soldiers "stone" Hannah, who shields her head. In the film, this scene suggests the soldiers' brutality but also their relative impotence; with tomatoes

their only weapons, they humiliate their victim rather than harm her physically. Rivera, in emphasizing the absurdity of each character, stays true to the tone of Chaplin's film and its mockery of Hitler and Mussolini. The film turns on moments of the masquerade in which the characters are unmasked as performers: Hynkel shows himself, not a frightening dictator, but a pathetic child who cannot rise above sibling rivalry; the bullying Tomainians are revealed as soldiers without weapons; even the barber is not who he appears to be, since he grooms a woman as if she were a man and ultimately can be mistaken for a military dictator. Fascism, the film suggests, is a performance undertaken by inept men.

Chaplin's direct plea, which breaks the fictional framework of the film, was for Rivera both its most pertinent and its most difficult element. The "real" Chaplin intervenes in the fictional tale to deliver its "message." [60] The climactic contrast between Chaplin's masquerade and his singular intervention in his antifascist persona secures the "directness" and "sincerity" of the appeal. The film signals a principled antifascism when its fictional structure is least stable, a strategy Rivera tried to replicate in the mural. On the far right of the Hitler panel, for example, a film projector sits outside the masquerade scenes, suggesting that they are produced and that they accrue meaning within a larger system, outside the filmic details. But when we look for a moment of interjected candor, we scarcely find it. The painted scenes from *The Great Dictator* instead are set against the vaporous, ghostly figures of Hitler, Mussolini, and Stalin (in a passage of the mural not taken from the movie); details from Edward G. Robinson's *Confessions of a Nazi Spy*, at left; the familiar tramp character of Chaplin, at center; and an anonymous mother and child slumped at bottom. Rivera's images play against representations, each hinting at the continuation of masquerade and eliding the problem of sincerity.

Rivera's pictorial identification with Chaplin suggests the painter's doubts that he could achieve the directness the actor had engineered: the moment of candor and authenticity, inserted into a fictional fabric, that stands as evidence of plainspeaking. Without question Rivera achieved a grand, even spectacular, vision in the mural, but he gave it a self-parodying, self-mocking tone. Those swan-diving women, high above Treasure Island, are plainly absurd. The bathers and fashionable couples on the balustraded balcony gawk—probably like the Art-in-Action audience itself. The congestion in the panels reached a new extreme that only drew more attention to the intense performance of the painter on his scaffold. And yet the panels strain to fit together. The seams between them remain, palimpsestically, and the movement from one panel to the next is far more awkward than fluid, despite the explicit cross-referencing and compositional rhymings. The shifts from claustrophobic lower panels to deeply recessed upper ones draw attention to a discontinuous focus. The system of orthogonals, so strongly felt in

the upper left, is brought to an abrupt halt by the bay scene and city landscape. It was as if the painter, despite considerable effort, could not bring coherence to this performance.

Antifascism was the language for unity, but it could not be spoken frankly, for it also referred to the conceptual impasse the radicals faced and pointed to the lack of formal leftist positions. So antifascism had to be displaced into the language of Art-in-Action. And the strain of that displacement is written across the mural itself—in its brilliant, massive, thoroughly glutted performance. The debate about fascism that impels the celebratory mode cannot be named as the rationale for a cultural marriage. It underwrites the fragile stability of the mural, where the overwrought jigsaw puzzle of scenes seems always on the verge of collapse, always about to give up the grand fiction in favor of an interjected statement of belief. The leftist antifascist claim remains wedged between the spaces of representation, a present absence, unarticulated yet essential.

And what of the "public"? The distance between the imagined alternative activist public and the actual viewing audience could not have become more obvious during the fair. And the public disappeared altogether in late 1940 as Rivera, working steadily, took nearly half a year to complete the mural, painting on into December, several months after the GGIE had closed. After September, he had to work in an empty, cold hangar, with only a waffle iron for heat, as one chronicler would have us believe, and Art-in-Action and its milling, admiring crowds just a memory.[61] The oddly assorted, hopelessly radicalized assistants were his only company. Where once Pflueger had imagined Rivera the headliner for a spectacle of art making, the mural in its final days turned out to be a rather private performance, with the Stalinists its spectators. When *Pan American Unity* was completed, Pflueger opened the hangar for a single day on which, reportedly, some ten thousand saw it.[62] But overall the mural generated little critical discussion and no debate. After the one-day showing *Pan American Unity* was packed up, destined for yet another of Pflueger's new projects, the San Francisco Junior College Library (now part of the City College of San Francisco), then being built.[63] But it did not reach this site and was never shown to working-class San Franciscans, who could not afford the fare to Treasure Island though they had always been invoked as the proper audience for a leftist public mural. *Pan American Unity* was reinstalled for view only in 1961.[64]

The circumstances surrounding the mural's viewing only underscore the problematic embrace of the public by leftist artists. The left had always identified itself with the working classes, the urban and rural poor, and organized labor. Its claims on this audience gained power and legitimacy when the actual viewers of its murals could be described in heterogeneous terms, when some of its members could

be marked as different from the usual crowd in museums and galleries, and when various groups in whose name the left spoke stood up and demanded space in the bourgeois public sphere. The 1940 GGIE and Art-in-Action proved as embarrassing to the leftist artists as to Pflueger. The events revealed quite painfully that their relationship to this public was, at best, imaginary. With the possible and hardly unequivocal exception of 1934, it had always been so.

And perhaps *Pan American Unity* was the final acknowledgment of this grim fact. The fiction of the public "out there" was harder to maintain as the empty hangar grew colder. With the Communist artists on the scaffolding, the mural's argument for artistic unity was a call for leftist solidarity, with only the pretense that the public constituted the work's proper audience. Rivera certainly avoided becoming embroiled in the debates between the various left-leaning camps, as is apparent in the mural's self-imposed limits: its dream for contact between North and South America avoided the messy affairs of Europe and the uncomfortable position of both Stalinists and Trotskyites in 1940. The conflict on the Continent is almost left outside the picture (in fact, almost left outside the Pacific fantasy of the GGIE). The specter of war was not completely hidden, but it had to be included with delicacy. These self-imposed limits on radical expression had more to do with the left's theoretical difficulties than with the imagined response of disgruntled GGIE tourists. Leftist constituencies could not agree on a position against fascism. Public art and radical politics could not meet directly, and in an awkward displacement, culture was shunted to an isolated realm and forced to speak metaphorically about political alliances as artistic marriage. High on the Art-in-Action scaffolding, in the empty dreamworld of the GGIE, Rivera, surrounded by young radicals, must have understood the irony of his situation. Yet he tried to fashion a statement about solidarity through the contorted spectacle of art making. The details of the mural suggest he was well aware of the strangeness of that intent and the fabrication of his own performance.

CHAPTER 8

LABOR AND LOSS

In the preceding chapters I have suggested that politically radical murals thrived on the artists' sense of a like-minded public and their arguments about its makeup. The possibility for art to express the radicals' dissent, however, disappeared when the United States entered World War II. The intense nationalism that drove the American war machine and a strong sense of shared effort made dissent suspect, however it was expressed. The pressure for political conformity and orthodoxy that prevailed during the war continued into the 1950s with congressional committees hunting down Communists. The fate of radical public mural painting was sealed.

While that sometimes hysterical conservatism spelled mural painting's doom, the city's art scene had its own share of significant transformations. In 1941 Bender died; in 1946, Pflueger. Fleishhacker lived until 1957, but with his chief rivals gone, he no longer needed to display his authority overtly; and as Zakheim had once prophesied, Coit Tower remained his last great claim. Other major patrons turned their attention to the easel works that Morley had tirelessly championed, a development that suited the consistently European bent of Heil and Neumeyer. In 1945, under a new director, the California School of Fine Arts became a haven for ambitious modernist experimentation.[1] David Park and Hassel Smith joined the faculty. In 1946 Elmer Bischoff and Clyfford Still were hired, followed soon after by Mark Rothko. The training in mural painting, important during Randolph's tenure—it had indeed produced a coterie of young, talented muralists—was dropped from the curriculum. In the new academic climate Rivera's *Making a Fresco* was often the object of scorn, not because of its leftist politics but simply because it represented a whole generation of social realist painting. Douglas MacAgy, the CSFA's ardent champion of abstract painting, had it covered as a gesture to that generation's passing.[2] Zakheim and Arnautoff found no further outlets for their mural

ambitions, and the new emphasis on the painterly made their modest, tentative easel works seem outmoded. Without the stabilizing force of a political role for art, Zakheim floundered and disappeared from the artistic landscape. Arnautoff, despite his success as a teacher, could not make art and politics connect in a forthright, or at least compelling and productive, way. He eventually gave up teaching, returned to the Soviet Union, and during the Cold War took up a career as a Soviet Social Realist painter. By the mid-1940s all the institutional, artistic, and political ingredients that had helped to make public wall painting vital, complex, and productive had evaporated.

Now, it can be argued that one last mural project, undertaken after the war, indicates that leftist mural painting in San Francisco retained some potency. Between 1946 and 1948 the radical artist Anton Refregier painted a twenty-seven-panel series for the Rincon Annex Post Office. He had a long record of work on the left and adhered strictly to the Comintern's shifting policies.[3] Like Zakheim in his Toland Hall murals, he meant to paint a narrative to give pictorial form to a Marxist theory of history. But to suggest that a radical public mural, even with such a program, could exist *outside* its possible uses in a radical political culture is to contradict much of the argument of this book. Leftist mural painting thrived on the possibility of pushing the working classes away from trade unionism to revolutionary politics. It sought to shift the meaning of public by painting for an actual agitated working class, and it fostered a visual language that could be said to demand and inhere in radical viewing positions. Immediately after World War II Refregier's project could claim to do none of these.

The painter's original program consisted of scenes from the 1939 WPA historical guide to San Francisco. The panels, arranged chronologically, lined two long hallways, beginning with a Native American scene and ending with the contemporary panel *Building the Golden Gate.* Panels between focused on key figures and dramatic moments in the text. As was typical of Treasury Section commissions, Refregier was required to document the progress of his work in photographs, first of his sinopia designs, which provided evidence that he was following the plan laid out in his initial sketches; and then of the finished work, so that he could secure payment.[4] In addition, the photographic documentation and the postmaster's reports became subject to inspection by interest groups, which continually measured the content of the murals against the "preferred" readings of the WPA text.

Refregier's structural and ideological alterations were readily apparent under such a system of surveillance. Thus in mid-1947, panel 14, *Importation of Chinese Labor* (Fig. 8.1), came under fire from the Chamber of Commerce and the Employers' Association (the revamped Industrial Association). The scene in its present form shows picketers in the 1860s: six men carrying torches and a placard

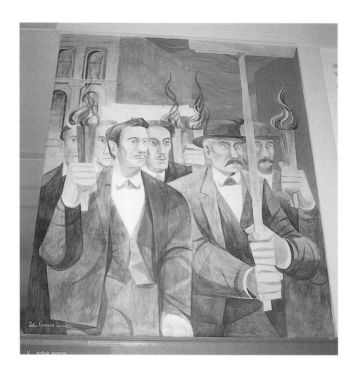

8.1 Anton Refregier, *Importation of Chinese Labor,* 1946–48.
Fresco. Rincon Annex, San Francisco.

protesting the Central Pacific Railroad's notorious importation of coolie labor.
Originally, however, Refregier had painted it to read, "Ship Caulker's Union Won
an Eight Hour Day in 1865," a message echoed in a placard behind it announcing
a similar success on the part of "the gas fitters—1873." In July, the mural painter
received a letter complaining that "the subject matter on the signs or placards is
considered controversial. Please delete this feature." [5] In mid-1947 a Communist's
praise of union victories could only be regarded with suspicion. The Taft-Hartley
Act had just been passed, outlawing the Communist Party's presence in trade
unionism. Section 9 of the act was pointedly aimed at the Communists, as op-
posed to the ragged Socialists or any of the other generally leftist groups still op-
erating in the country, and it served as a prelude to eliminating any Stalinist influ-
ence from collective bargaining. Refregier edited the offending panel, sending a
sketch of the new design to Washington with a contentious note agreeing to omit
"any reference to anything that is of benefit to the American people," by which he
meant the sign's statement of union triumph. [6] The edited version, however, still

seemed to imply the original design, as if the new planes of red and blue and the clipped placards indicated the declarations that had been painted out. In 1948 the AFL protested the revised panel and its potentially race-baiting title. The original panel had commemorated organized labor's successes; in the final version that intent was undercut by the presence of coolies, who, historically, had been the object of organized labor's fury.[7]

Interest groups continued to protest various panels of the Rincon Annex murals. Panel 22, *The Cultural Life of San Francisco,* originally contained books whose covers bore the names C. E. S. Wood and Mike Quin—one an iconoclastic socialist, the other a propagandist for Bridges and Darcy.[8] The Hearst papers protested, and Refregier had to paint them out. Panel 10, *1846: California Becomes an Independent Republic,* was cited for its abuse of the Mexican flag, which originally appeared trampled, with the new state "bear" flag triumphant. The Mexican ambassador complained, and Refregier transformed the flag into a neutral white.[9] Panel 6, *The Mission,* was criticized for its picture of Spanish conquest, with haggard Indians being preached to by "a huge-bellied, Rabelaisian monk."[10] The Native Sons of Americanism protested, and Refregier was obliged to thin him.[11] Panel 21, *Sand Lot Riots,* was condemned for its portrayal of white abuse of immigrant Chinese. The panel was redescribed (unconvincingly) as a eulogy to Frank Roney, the nineteenth-century Irish immigrant who opposed that mistreatment.[12] The detractors came from different quarters: the American Legion, the Associated Farmers, the Daughters of the American Revolution, the Society of Western Artists, the South of Market Boys Association, and so on. As the months passed in 1947–48, the Rincon Annex lobby must have been a strange sight. Some panels were covered with thick censoring muslin, drawing attention to the materials covered; other panels were open to assessment. Refregier and his assistant, Robert McChesney, had to move the scaffolding back and forth, depending on which panel had come under fire and required revision. On some workdays the two men painted as jeering crowds looked on, making the tall scaffolding a precarious perch. By mid-1948 Refregier could not work into the evening as had been his wont; the large crowds that gathered threatened his safety.[13]

One debate among many can serve as a postscript and testimony to the transformed use value of Refregier's murals. In the spring of 1948 the Veterans of Foreign Wars called attention to panel 26, *Maritime and General Strike* (see Plate 14).[14] If even an allusion to the Big Strike was problematic, Refregier's handling of the subject only exacerbated the difficulty, for he misrepresented its critical details. The panel shows three stages of the 1934 events. On the left, a waterfront boss points to one of the clamoring job seekers. His left arm disappears behind a partition, reappearing on the other side, secretly accepting a bribe from a job seeker. In the

center, a labor organizer (possibly Bridges himself) speaks, pointing to the system of graft and exploitation. On the right, three groomed men attend the funeral service for Sperry and Bordoise, the two slain strikers of Bloody Thursday. The movement from left to right in the panel suggests a sequence from prestrike complaints to increasing momentum for labor unity to some successful outcome (note the "Strike Won" caption of the accompanying newspaper). That narrative of success plays against the actual course of events, which was well known. The irony is thickest in the scene at right: the strike in fact was lost. "Americanism" (the big flag in the background) was invoked to critique the alliance of Communists supporting the Bridges-Darcy alliance, and the funeral procession comprised a phalanx of laborers, as pictured by Arnautoff (see Fig. 5.11), not the likes of the fashionable trio of executives.

Refregier's critics could not explicitly challenge his misrepresentation of the Big Strike, for in the panel's fiction, the strike is won by adherence to the Industrial Association's "Americanism." To critique it was to admit to the lie.[15] The criticisms were displaced onto other subjects, and the veterans' organization, for example, objected to the appearance of its own insignia on one of the strikers' white caps. As a result of the complaints panel 26 was covered in muslin for three months while Refregier continued his steady painting down the deep hallway at Rincon Annex, amid other half-finished panels and censoring screens. But the history under this particular muslin became the object of long debate and picketing, as if the veil could not adequately conceal the sordid details or lessen the scrutiny.

Like the inflammatory murals in Coit Tower, panel 26 hinted strongly at a link to labor unrest. If the Big Strike was inflected by Communism, however, the decidedly different tenor of organized labor's drama in 1948 only puts into relief the gap between panel 26 and labor's activities, between a public art and the dream of a radicalized working class. The year 1948 was marked by another waterfront struggle in which, once again, Bridges led a huge rank and file into a prolonged strike. Under the International Longshoremen's and Warehousemen's Union (ILWU), the strike lasted ninety-five days and froze cargo shipments throughout the Bay Area, transforming the docks into a bottleneck of stacked crates and rows of fully laden ships.[16] Though it never became a general strike, the waterfront unrest disrupted the local economy with enough force to cause the revamped Employers' Association, after three difficult months, to negotiate an unfavorable peace. From 1934 to 1946 there had been continual strikes up and down the California coast; one historian counts some thirteen hundred local work stoppages alone.[17] But the 1948 strike proved different in its intensity and duration; it was perhaps closer than any other strike or stoppage to the massive display of working-class solidarity in 1934.

But by 1948 the longshoremen did not need the Communist Party. Whereas Darcy and Bridges in 1934 had energized the longshoremen (organized labor in the 1930s absolutely required the threat of revolution just to reach the bargaining table), the ILWU in 1948 relied on the collective bargaining structure created by the New Deal and the long battles of the AFL and CIO. It now bargained from a position of relative strength. The strike was fought primarily over the Employers' Association's desire to take control of hiring practices and break the closed shop. In 1934 the longshoremen's association had bid for precisely those powers. In 1948, unable to mobilize armed resistance and forced to the negotiating table by the New Deal's National Labor Relations Board, the shipowners had to concede, suffering heavy losses they could not recoup. They not only lost the bid for the open shop and hiring hall but also had to submit to an embarrassing 10 percent wage increase as well.[18]

With the double problem of a weak Communist Party and an independently strong ILWU, Refregier could not easily convince detractors that his murals spoke on labor's behalf. He certainly tried, and through the efforts of his young assistant, McChesney—the young Stalinist who had befriended Peter Lowe—Refregier mounted support for his grievances against the censor in the guise of the Labour and Arts Committee, organized by McChesney and made up of the ILWU, the Marine Cooks and Stewards, and a newly formed Artists' Guild. In May 1948 the committee formed a picket around Rincon Annex (who could not have remembered Coit Tower?); in June and July it passed resolutions against the Washington bureaucrats' censorship. But the support was insufficient and unconvincing. The picketers consisted mostly of Artists' Guild members, and the waterfront unions remained largely offstage.[19] It was clear that although the ILWU lent its institutional weight, it was not particularly interested in the Rincon dispute, certainly not prepared to move actively in Refregier's support. McChesney tried to invoke the union's presence before the censors anyway. In a letter to Washington, he declared that censoring the murals was "bad politics" because "San Francisco is a good 'union-town.'"[20] But the ploy to link the conservatives' censorship of the mural with the Employers' Association's battles against the ILWU did not work.

Whereas Refregier and McChesney wanted to see parallels in painter versus reactionaries, and ILWU versus employers, the ILWU was interested in publicity. Precisely when *Maritime and General Strike* came under fire from the veterans, the union entered the Rincon Annex debates, seeing a means of bringing the new strike into the public sphere as an echo of the 1934 Big Strike. In fact, the union cared little for any of the other debates about the murals—about the fat monk or the Mexican flag—and when it was clear that the employers posed no real threat to the union, it simply left the Labour and Arts Committee to its own weightless

ambitions.[21] Refregier was soon revising his panels in compliance with orders from above.[22]

In appraising the Rincon Annex murals I have focused almost exclusively on iconography. In this, I have followed contemporary critics. Elsewhere in this book, however, I have stressed that San Francisco's public murals can be scrutinized for style and composition and, furthermore, that departures from the recognized idiom of public painting—especially those related to legibility—might bear on the political element of a mural and help us read it more incisively. I have argued that particular audiences repeatedly took notice of the subversive pictorial strategies. Sometimes they were angered by them, and I have tried to suggest where in the surviving literature we might glimpse that anger. At times, anxiety cropped up in the form of repeated omissions, weird staccato descriptions, or oddly dismissive assessments. At other times, it manifested itself as a thorough bewilderment of critics before the large painted walls; all they could do was resort to bland or hackneyed praise. And at other times still, especially with Zakheim's murals, it registered as a distaste for the crudity and seeming amateurishness of the work. Were there any such responses to Refregier's murals?

There were not, and this answer has bearing on one of the main lines of my inquiry. The radical public of left-leaning murals could be conjured in part because the murals' style could be interpreted as recalcitrant, as pushing the murals outside the boundaries of conventional pictorial order. The apparent ease with which viewers assessed and digested the disjunctive stylistic features of Refregier's leftist panels—the blocky forms and careening perspectives, the caricatured faces and truncated bodies, the garish colors and abbreviated spaces—suggests that we have reached the end of a certain moment of public painting in San Francisco. The critical attention came primarily from conservative quarters, and their political misgivings were most often voiced, confidently, as complaints about the panels' deviations from the agreed-upon program.[23] How, then, do we regard the various interest groups' responses to the Rincon Annex murals? How do we interpret their readings and the rhetoric of their dissent, especially as these relate to the paratactic, metonymic strategies that had once animated leftist public murals? In nominating different panels for scrutiny, the interest groups underscore a view of the mural program less as an overall project, a developing historical narrative, than as a series of discrete, sometimes disjunctive, scenes. Each interest group articulated its argument by pointing to individual scenes and their specific details. Like other interest groups, the International Longshoremen's and Warehousemen's Union had a stake in a representation of the Big Strike and that panel's value in a contemporary labor struggle. Could we not say that this piecemeal identification

constitutes a synecdochic compensation, fixing on a part as a way to take stock of and organize the convulsive whole? After all, the fuss by reactionaries over individual panels was a way to protest the perceived radicalism of Refregier himself and the leftist intent behind the murals. As one dissenting group remarked, "The fight against communism is not merely a fight against enemy guns and bullets and tanks but against enemy ideals and ideas. This makes the display of the Refregier murals in a Government building little short of treason."[24] Or as another put it, looking down the deep lobby, they were "definitely subversive and designed to spread Communist propaganda and tend to promote racial hatred and class warfare."[25]

In the context of public painting in San Francisco, the ability to read synecdochically had been conditioned by the practice of looking at murals since the first arrival of Rivera. It was he who splintered murals into unwieldy components and beckoned attention to pictorial (dis)unity. Under the proddings of Communist artists, incoherence, along with narrative and compositional breakdown, had been put into productive tension with the threat of radical activism. In the two decades that followed, with repeated practice, San Franciscans had learned how to look at left-leaning murals, how to recognize what a subversive mural looked like. On some level at least, those attentive to public murals—conservatives, reactionaries, liberal reformists, and, yes, even some leftists—learned to scan a mural's formal codes without puzzling over pictorial unity. They could sit comfortably, or at least temporarily, in its various and often destabilized subject positions. Confronted with the iconoclasm of Refregier's "history," viewers understood how to enlist certain visual skills in reading all twenty-nine panels and how to express their larger misgivings in bits and pieces. In the late 1940s, in an atmosphere of fanatical anti-Communism, without the challenge of leftist mobilization, and without even the mediating presence of a politically progressive middle ground, conservatives could mobilize the ability to read by parts, and thus to condemn the whole, against the one leftist painter who remained.

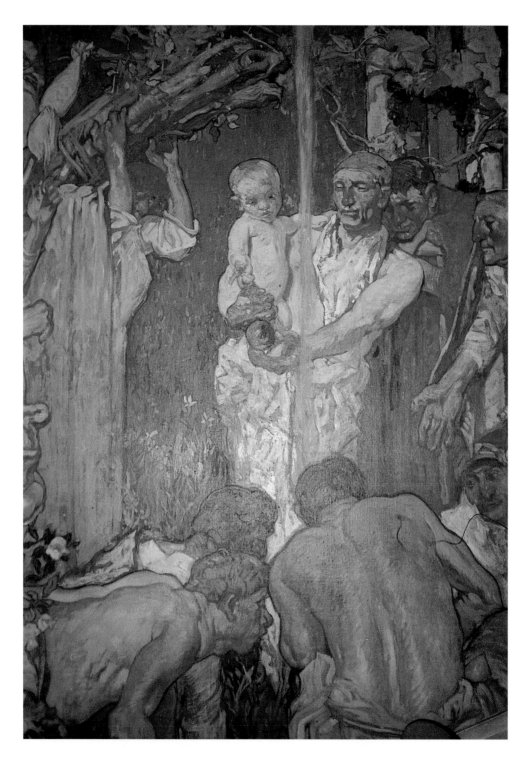

1 Frank Brangwyn, *Primitive Fire* (detail), 1915. Oil on canvas.
War Memorial Building, San Francisco.

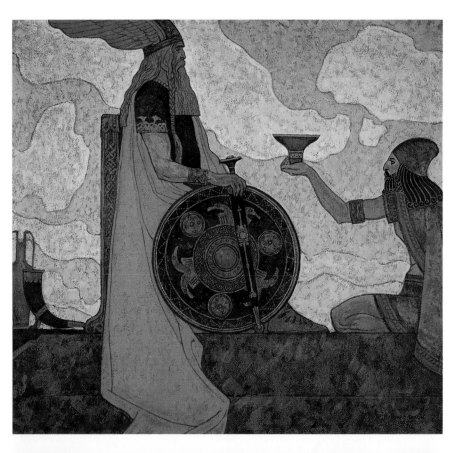

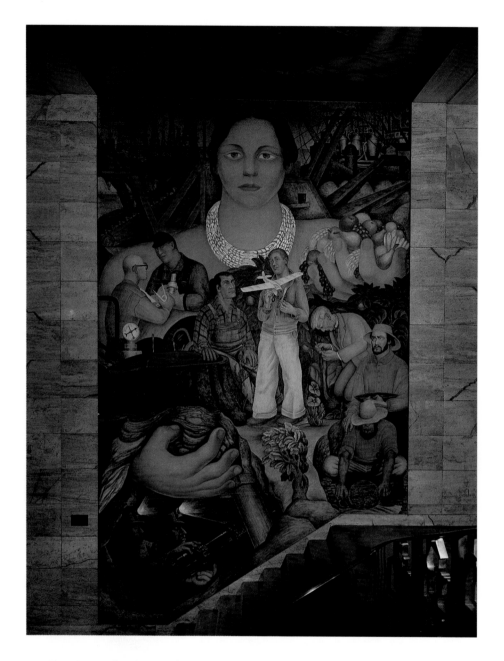

2 (*Opposite, top of page*) Maynard Dixon, *Metalcraft*, 1925. Oil
 on canvas. Collection of the Oakland Museum of California,
 Gift of Florence Dixon in memory of Harry Dixon and his
 son Dudley Dixon.

3 (*Opposite*) Ray Boynton, *Memory Recalling the Dead*, 1928.
 Fresco. Music Hall, Mills College.

4 (*Above*) Diego Rivera, *Allegory of California*, 1931. Fresco.
 City Lunch Club, San Francisco (Photo © Dirk Bakker).

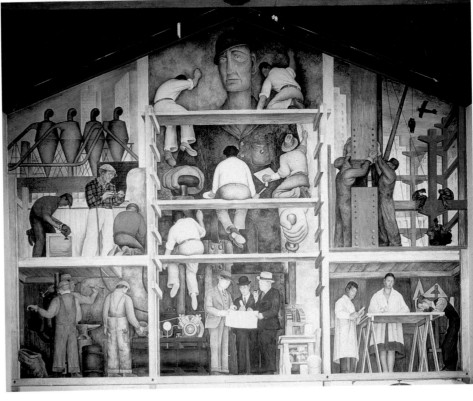

5 (*Opposite, top of page*) William Clapp, *Houses along the
 Estuary*, n.d. Oil on panel. Collection of the Oakland
 Museum of California, Gift of Donn Schroder.

6 (*Opposite*) Diego Rivera, *Making a Fresco, Showing the
 Building of a City*, 1931. Fresco. San Francisco Art Institute
 (Photo: David Wakeley).

7 (*Above*) Bernard Zakheim, *Kenneth Rexroth*, 1928. Oil on
 canvas. Collection of Masha Zakheim.

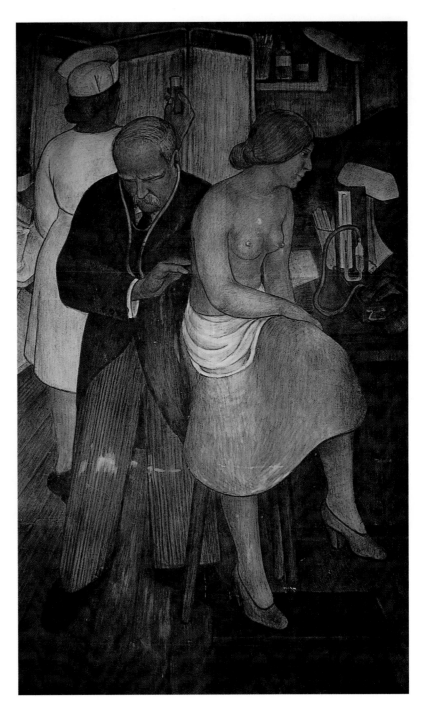

8 Victor Arnautoff, *Obstetrics,* 1932. Fresco. Palo Alto Medical
Clinic.

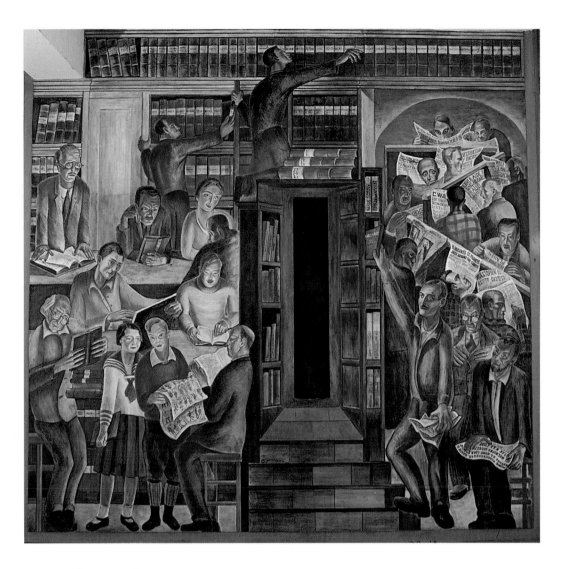

9 Bernard Zakheim, *Library*, 1934. Fresco. Coit Tower,
San Francisco (Photo: Lito).

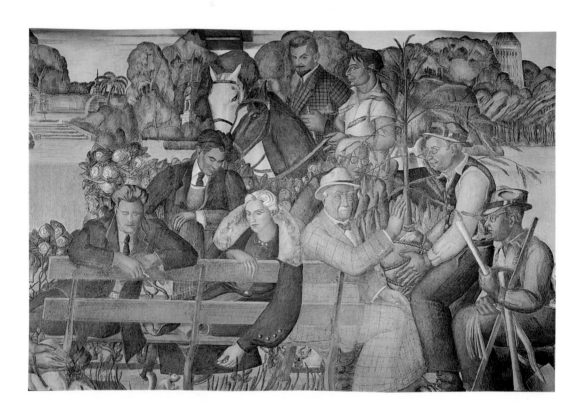

10 Lucien Labaudt, *Park Scenes*, 1936–37. Fresco. Beac Chalet,
 San Francisco (Photo: Lito).

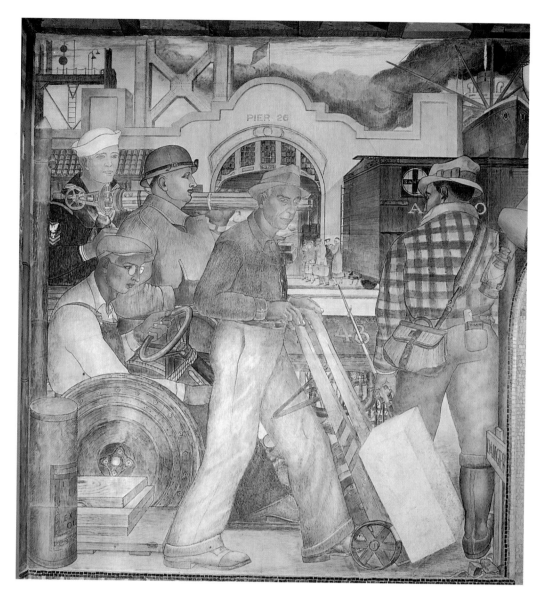

11 Lucien Labaudt, *Fisherman's Wharf Scenes,* 1936–37. Fresco.
Beach Chalet, San Francisco (Photo: Lito).

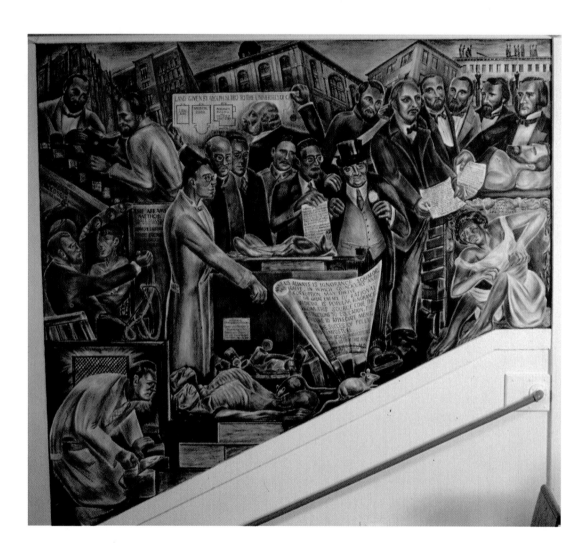

12 Bernard Zakheim, *San Francisco Medical History*, 1936–38.
Fresco. University of California at San Francisco.

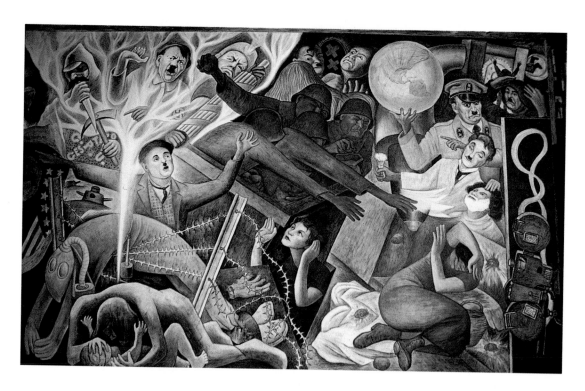

13 Diego Rivera, *Pan American Unity* (detail), 1940. Fresco.
City College of San Francisco © 1999.

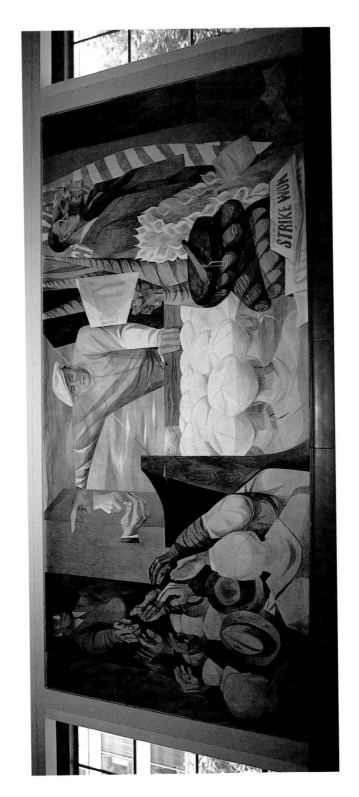

14　Anton Refregier, *Maritime and General Strike*, 1946–48. Fresco. Rincon Annex, San Francisco.

NOTES

The notes include references to materials in several archives, listed below. I was very fortunate to conduct interviews with some of the mural painters who worked on the 1930s projects and their descendants. Information on these interviews is not listed immediately below but is given in full in the notes. Unless otherwise indicated, the interview records, transcripts, and tapes are in my possession.

AAA Archives of American Art
BANC Bancroft Library, University of California at Berkeley
CHS California Historical Society, San Francisco
CSL California Room, California State Library, Sacramento
JAB Joseph A. Baird, Jr. Collection, University of California at Davis
LAR Labor Archives and Research Center, San Francisco
MILLS Heller Rare Book Room and Mills College Art Gallery Archives, Oakland
OAK Archives of California Art, Oakland Art Museum
SFAI San Francisco Art Institute Archives
SFPL San Francisco Public Library Archives

INTRODUCTION

1. A. C. Boudreau, "Shakes Head at Coit Murals," *San Francisco Chronicle,* August 30, 1935.
2. Junius Cravens, *San Francisco News,* July 7, 1934.
3. Although this book differs from earlier studies of 1930s American murals in its distinct scope, I wish to acknowledge the sweeping national surveys. They give scholarly space to public murals, and they make possible our current attentiveness to the *differences* among public murals—their regional, not national, political inflections; their diachronic, not synchronic, readings. The broader surveys include Richard McKinzie, *The New Deal for Artists* (Princeton, N.J., 1973); Francis O'Connor, *Federal Art Patronage, 1933–1943* (College Park, Md., 1966); Belisario Contreras, *Traditional and Innovation in New Deal Art* (Lewisburg, Pa., 1983); and Marlene Park and Gerald Markowitz, *Democratic Vistas: Post Office Murals and Public Art in the New Deal* (Philadelphia, 1984). I cite additional surveys in the notes that follow.

4. Joseph Danysh, "When Art Was Fun and Fabulous," *City of San Francisco* 10, no. 30 (1976), 21, LAR.

5. Cravens (as in note 2).

CHAPTER ONE

1. Two important exceptions for the critics were Arthur Mathews (discussed later in this chapter) and Domenico Tojetti, perhaps the best known mural painter/decorator for the restaurateurs. With his sons, Tojetti had a decorating business in the city for some two decades. See "Signor Dominico [*sic*] Tojetti," *California Art Research* (San Francisco, 1937), 3:24 – 41; the biographical folder "Domenico Tojetti," CSL; and the biographical folder "Domenico Tojetti," JAB. Though his work was applauded, it was never given extensive coverage; see, for an example of early attention to his work, the *San Francisco Call,* March 29, 1892.

2. Sheldon Cheney, *Art-Lover's Guide to the Exposition* (Berkeley, Calif., 1915), 11 (for the quotations that follow as well).

3. John Barry, *City of Domes* (San Francisco, 1915), 18.

4. Ben Macomber, *The Jewel City* (San Francisco, 1915), 36 – 39.

5. Even a partial list of official, semiofficial, and unofficial guidebooks would be long, and it would probably not include many pamphlets that survive in name only. In addition to the guides already listed in the notes above, see Katherine Burke, *Storied Walls of the Exposition* (San Francisco, 1915); Arthur Clark, *The Significance of the Paintings of the Exposition* (San Francisco, 1915); Juliet James, *Palaces and Courts of the Exposition* (San Francisco, 1915); Minnie McCullagh, *The Jewel City* (San Francisco, 1915); Stella Perry, *The Sculpture and Murals of the Panama-Pacific International Exposition* (San Francisco, 1915); and *Splendors of the Panama-Pacific International Exposition* (San Francisco, 1915). The most influential synthetic guides are both by Eugen Neuhaus: *Art of the Exposition* (San Francisco, 1915) and *Galleries of the Exposition* (San Francisco, 1915). All of the books listed here (except for the limited edition *Splendors*) were widely available in the city. Many other publications that aimed at a larger audience outside the state included some information about the paintings. The most characteristic was a new periodical edited by E. J. Wickson, *California Magazine,* published in San Francisco beginning in 1915.

6. Cheney, *Art-Lover's Guide* (as in note 2), 7.

7. Ibid.

8. Sheldon Cheney, *Expressionism in Art* (New York, 1934), 291–92.

9. Cheney, *Art-Lover's Guide,* 7.

10. Ibid., 6.

11. The standard account of the PPIE is the five-volume work by Frank Morton Todd, *The Story of the Exposition* (New York, 1921).

12. The study of international expositions has undergone something of a renaissance. An incisive, brief essay is Michael Wilson, "Consuming History: The Nation, the Past, and the Commodity at l'Exposition Universelle de 1900," in *American Journal of Semiotics* 8, no. 4 (1991), 131–54. For useful discussions of the PPIE, see Robert Rydell, *All the World's a Fair: Visions of Empire at America's International Expositions, 1876 –1916* (Chicago, 1984); and Burton Benedict, *The Anthropology of World's Fairs* (Berkeley and Los Angeles, 1983).

13. The notion of world's fairs as capitalist pilgrimage sites was first offered by Walter Benjamin, *Charles Baudelaire: A Lyric Poet in the Era of High Capitalism,* trans. Harry Zohn (London, 1983), 165.

14. Macomber (as in note 4), 149.

15. Du Mond had trained in Paris. Prior to his work at the PPIE, he had been a teacher at the Art Students League in New York and played a part in East Coast academic circles, as evidenced by his election to the National Academy in 1906. His Parisian connections and membership in the academy also gained him a seat on the PPIE Jury of Awards. Materials on du Mond's years in San Francisco are slim. See Brother Cornelius, *Keith: Old Master of California* (Fresno, Calif., 1956), 562; and *Art in California: A Survey of American Art with Special Reference to California Painting, Sculpture, and Architecture Past and Present, Particularly As Those Arts Were Represented at the Panama-Pacific International Exposition* (San Francisco, 1916), 131.

16. Macomber, 46.

17. Cheney, *Art-Lover's Guide,* 41.

18. See my "Picturing San Francisco's Chinatown: The Photo Albums of Arnold Genthe," in *Visual Resources* 12, no. 2 (1996), 107–34.

19. Barry (as in note 3), 28.

20. The grid structure and centralization were updated features of an old urban design plan, the Burnham Plan, that had appeared prior to the earthquake. See Judd Kahn, *Imperial San Francisco: Politics and Planning in an American City, 1897–1906* (Lincoln, Nebr., 1979).

21. For the projects, see William Issel and Robert Cherny, *San Francisco, 1865–1932: Politics, Power, and Urban Development* (Berkeley and Los Angeles, 1986), 170–76; and Anthony Perles, *The People's Railway* (Glendale, Calif., 1981).

22. Guerin's biography can be pieced together from the following: *American Art Annual* (New York, 1933); Edan Hughes, *Artists in California, 1786–1940* (Ann Arbor, Mich., 1986), 190; and Eugen Neuhaus, *The History and Ideals of American Art* (Stanford, Calif., 1931).

23. Barry (as in note 3), 31.

24. "Division of Works," *Panama Pacific International Exposition* (San Francisco, 1915), 96–100. John McLaren, the longtime superintendent of Golden Gate Park, was named PPIE landscape director.

25. See, for example, Barry (as in note 3), 11.

26. Macomber (as in note 4), 27.

27. On the old-world flavor, see Gray Brechin, "San Francisco: The City Beautiful," in *Visionary San Francisco,* ed. Paolo Polledri (San Francisco, 1990), 40–61.

28. The metaphorical power of the rhetoric can be felt as late as the 1920s, when civic leaders still promoted a utopian vision of San Francisco, though their ambitions had grown much broader. As one architect declared, with no apparent humor or sense of self-parody:

> I have seen a vision and I want you to see it with me. It is not a dream, but rather a project conceived in unity, found on fact and buttressed by strong arguments. In my mind's eye, I have seen on the summit of Yerba Buena Island [in San Francisco Bay east of the city] a very beautiful white marble building. It is not massive, it has neither gilded dome nor tall tower. It has nothing of the appearance of a castle or citadel. On the contrary it has the characteristics and beauty of both the Acropolis at Athens and the Lincoln Memorial at Washington. There are broad easy steps leading down to convenient monumental landings at the water's edge. . . . That temple-like structure crowning the summit is the assembly hall of the Federation of the Boroughs of San Francisco Bay.

Stephen Child, transcript of a speech given to the Commonwealth Club, *Architect and Engineer* (September–October 1927).

29. Cheney, *Art-Lover's Guide* (as in note 2), 9.

30. My discussion of the exposition-as-city reproduces a critical amnesia that the fair itself sought to effect—about *who,* in fact, built both. Labor unions, working-class organizations,

and ethnic groups had long dominated the construction scene, helping to divide the city along class and racial lines. In contrast to the rigorous classicism of the exposition, the look of the old city seemed to reflect its mix of classes and ethnic groups. Streets were laid out ad hoc; clapboard houses sprouted in makeshift disorder; immigrant ethnic neighborhoods grew precariously on the flanks of the city's steep hills. Dixon, no fan of the old congestion, pictured a hierarchical, seemingly unified hill city marked by a pointed refusal of heterogeneity. The image was appropriate in that the PPIE represented a temporary erasure of sectarianism that the old city had fostered. To construct it, San Francisco's notoriously activist workers were brought under centralized control, the populations of its huge ethnically segregated neighborhoods were channeled into the collective effort, and its contentious unions, whose membership included virtually all the skilled construction trades in the city, effectively corralled. (See Michael Kazin, *Barons of Labor: The San Francisco Building Trades and Union Power in the Progressive Era* [Urbana, Ill., 1987]; and Ralph Giannini, "San Francisco: Labor's City, 1900–1910," Ph.D. diss., University of Florida, 1975.) Between 1906 and 1915, the city's business class organized political machines and resorted to aggressive union-busting and open-shop tactics. San Francisco, once the most highly organized labor town in the country, by World War I was one of the least.

The labor unions held enough sway in working-class districts so that their cultural agendas could not simply be ignored. As a result, a surprising number of cultural institutions arose to benefit the working class, the most famous the so-called Mechanics Institute. (See, for example, the institute's own published materials collected in "Mechanics Institute: Exhibition Catalogues," JAB.) In such institutions the fine arts first came before the public eye in yearly exhibitions full of genre and landscape paintings. After the earthquake, as middle-class voters offset labor, the influence of the unions waned, and the cultural organizations shifted their focus. The Mechanics Institute, for example, limited the use of its exhibition rooms and library by the working classes by 1910.

31. The mural painters were Frank du Mond, William de Leftwich Dodge, Milton Bancroft, Robert Reid, Charles Holloway, Childe Hassam, Arthur Mathews, Frank Brangwyn, and Edward Simmons.

32. "Division of Works," *Panama Pacific International Exposition* (as in note 24), 97. For a longer description of Guerin's overall decorative plan, see Macomber (as in note 4), 36–41.

33. Barry (as in note 3), 18.

34. As Paul de Man writes, the allegorical mode "designates primarily a distance in relation to its own origin, and, renouncing the nostalgia and the desire to coincide, it establishes its language in the void." See his "Rhetoric of Temporality," in *Blindness and Insight* (Minneapolis, Minn., 1983), 207.

35. Barry, 45.

36. Ibid., 50.

37. The concerns about reconstruction were not limited strictly to the city but also included the larger Bay Area; see Mel Scott, *The San Francisco Bay Area: A Metropolis in Perspective* (Berkeley and Los Angeles, 1959), 149–68.

38. John Dewey, *The Public and Its Problems* (New York, 1927), 35.

39. Many of the studies devoted to these families are informative but gossipy; others are uncompromisingly celebratory. The best, though they are quirky and unapologetically adulatory, are Hubert Bancroft's two seven-volume works, *History of California* (1886–90) and *Chronicles of the Builders* (1891–92).

40. Issel and Cherny (as in note 21), 165–93.

41. Morley Segal, "James Rolph, Jr., and the Early Days of the San Francisco Municipal Railway," *California Historical Society Quarterly* 43 (1964), 3–18.

42. Elmo Richardson, "The Struggle for the Valley: California's Hetch Hetchy Controversy,

1905–1913," *California Historical Society Quarterly* 38 (1959), 249–58.

43. The two Fleishhacker brothers took control of the Great Western Electric Power Company in 1915, and William Crocker, Patrick Calhoun, and Michael de Young joined to defeat proposals to buy out other privately held railway systems with public funds. Herbert Fleishhacker ingratiated himself with James Rolph, the city's longtime mayor, by bankrolling many of his business investments, which by the late 1920s amounted to more than a million dollars; the relationship was a source of great frustration to reformers, especially when Herbert Fleishhacker became Rolph's major political adviser in the years after the PPIE. See Issel and Cherny (as in note 21), 180.

44. The most prominent members of the exposition committee were William Crocker, heir to the massive Crocker fortune, president of a national bank, and director of the recently founded Pacific Telephone and Telegraph; Charles Fee, manager of the Southern Pacific; John Britton, vice-president of Pacific Gas and Electric; William Bourn, president of the Spring Valley Water Company; and Michael de Young, Charles de Young, and George Cameron of the *Chronicle* newspaper.

45. The City Beautiful movement was yet another manifestation of California improvement schemes. See Kevin Starr, *Americans and the California Dream, 1850–1915* (Oxford, 1973), 288–306.

46. Barry (as in note 3), 17.

47. Quoted in Starr, 305, as is the quotation from the poet Edwin Markham that follows.

48. Thomas Crow, *Painters and Public Life in Eighteenth-Century Paris* (New Haven, Conn., 1985), 5.

49. The technique of marouflage, in which a canvas was glued to a hard support, was typical of exposition murals at this time.

50. A short, useful biographical sketch of Brangwyn can be found in Peter and Linda Murray, *A Dictionary of Art and Artists* (Harmondsworth, England, 1969), 57–58. The standard biography is still the adulatory Rodney Brangwyn, *Brangwyn* (London, 1978).

51. As of this writing, the panels hang in the Herbst Theater in the old War Memorial Building in San Francisco.

52. Neuhaus, *Art of the Exposition* (as in note 5), 65–66.

53. Macomber (as in note 4), 67–71.

54. Burke (as in note 5), 72.

55. Macomber, 68.

56. Neuhaus, *Art of the Exposition*, 64.

57. Ibid., 66; and Perry (as in note 5), 172.

58. Cheney, *Art-Lover's Guide* (as in note 2), 19–21.

59. Todd, *The Story of the Exposition* (as in note 11), 351.

60. Harvey Jones, *Mathews: Masterpieces of the California Decorative Style* (Oakland, Calif., 1985), 50–53.

61. The Savings Union Bank panel is, to my knowledge, untitled; the Safe Deposit mural was called *St. Francis;* the Lane Hospital mural was called *Health and Arts;* the Children's Hospital mural is presumed lost.

62. Mathews's opinions appeared most frequently in his self-published journal, *Philopolis,* collected in BANC. On its tone, see Bruno Giberti, "Loving the City: *Philopolis* and the Reconstruction of San Francisco, 1906–1915," paper presented at the California American Studies Association Conference, San Diego, Calif., 1994.

63. The mural was completed and installed in 1914 in the rotunda of the state capitol. See Jones (as in note 60), 52.

64. The best biography of Mathews can be found in Jones, but see also George West,

"Secluded S.F. Artist Revealed as State's Leading Mural Painter," *San Francisco Call-Post,* March 28, 1925.

65. The only biography of Boynton is the brief "Ray Boynton," *California Art Research,* vol. 9 (San Francisco, 1937). Other information can be found in an unpublished manuscript, "Ray Boynton," MILLS. Boynton's obvious regard for Mathews is evidenced by his own article, "Arthur F. Mathews, Institute Gold Medalist in Painting, 1923," *Journal of the American Institute of Architects* 11 (1923), 131–33.

66. The best biography is Donald Hagerty, *Desert Dreams: The Art and Life of Maynard Dixon* (Layton, Utah, 1993); but see also Wesley Burnside, *Maynard Dixon: Artist of the West* (Provo, Utah, 1974).

67. The best information about the Bohemian Club is its own multivolume chronicle, Robert Fletcher, ed., *The Annals of the Bohemian Club* (San Francisco, 1898–1972). Information about its artist members is not collected in any single volume, but a useful source is a manuscript by Fletcher, "Memorandum of Artists" (1906–7), JAB. The best critical study of the club covers its later years, though its argument is certainly applicable to earlier years: G. William Domhoff, *The Bohemian Grove and Other Retreats: A Study in Ruling-Class Cohesiveness* (New York, 1974). In addition, see my "Chinatown and the *Flâneur* in Old San Francisco," *Journal of the American Studies Association of Texas* 26 (October 1995), 36–54.

68. "Early Bohemia," n.p., n.d., CHS. This anonymous pamphlet surely dates to around 1890–1906.

CHAPTER TWO

1. The singular exception might be Dixon's work on the so-called Baldwin murals (1912), four oil-on-canvas panels, each forty-eight inches high. See Donald Hagerty, *Desert Dreams: The Art and Life of Maynard Dixon* (Layton, Utah, 1993), 67–74.

2. Mikhail Bakhtin, *The Dialogic Imagination* (Austin, Tex., 1981), 276.

3. Dixon, as recorded in Hagerty, 130. Dixon initially wrote his statement in an undated letter, now in the Maynard Dixon Papers, Collection of John Dixon.

4. Dixon executed the Mark Hopkins Hotel murals with the painter Frank Van Sloun in the Room of the Dons. See Hagerty, 145–51.

5. There is a huge body of material concerned with Progressive Era California. I have relied on George Mowry, *The California Progressives* (Berkeley and Los Angeles, 1951); Martin Schiesl, *The Politics of Efficiency: Municipal Administration and Reform in America, 1880–1920* (Berkeley and Los Angeles, 1977); and especially the collection of essays in William Deverell and Tom Sitton, eds., *California Progressivism Revisited* (Berkeley and Los Angeles, 1994).

6. For a brief account of this transformation in the San Francisco scenario, see William Issel and Robert Cherny, *San Francisco, 1865–1932: Politics, Power, and Urban Development* (Berkeley and Los Angeles, 1986), 165–99.

7. The best study of this entire phenomenon is Lizabeth Cohen, *Making a New Deal: Industrial Workers in Chicago, 1919–1939* (Cambridge, England, 1990).

8. Lary May, *Screening Out the Past: The Birth of Mass Culture and the Motion Picture Industry* (New York, 1980).

9. Ibid., 235.

10. Robert Dunn, *The Americanization of Labor: The Employers' Offensive against the Trade Unions* (New York, 1927), 49.

11. Felix Riesenberg, *Golden Gate: The Story of San Francisco Harbor* (New York, 1940), 304.

12. John Trask, "The Influence of the World's Fair on the Development of Art," *Art and Progress* 6 (1915), 113–17. On the struggle to develop the palace into a museum, see Jackson Dodge, "Patrons and Collectors: B. Albert Bender and the Early Years of the San Francisco Museum of Art," in *From Exposition to Exposition: Progressive and Conservative Northern California Painting, 1915–1939,* ed. Joseph Baird, Jr. (Sacramento, Calif., 1981), 41–44.

13. Sheldon Cheney, *Art-Lover's Guide to the Exposition* (Berkeley, Calif., 1915), 92.

14. Ben Macomber, *The Jewel City* (San Francisco, 1915), 108.

15. SFAA, letter to PPIE, (1916), "Panama-Pacific International Exposition" file, SFAI. My emphasis. The letter is partially reprinted in Dodge (as in note 12), 42.

16. There is no adequate history of the SFAA, but see the following: John Walter, "The San Francisco Art Association," *Art in California* (San Francisco, 1916); *Artist-Teachers and Pupils: San Francisco Art Association and California School of Design: The First Fifty Years, 1871–1921* (San Francisco, 1971); and the brief essay by Paul Karlstrom, "Creeping Towards Modernism, 1871–1945," *San Francisco Art Institute: Illustrious History, 1871–Present* (San Francisco, 1996), 7–10. Other primary information can be found in the exhibition catalogues of the SFAA and in the *Review of Art,* a journal published by the Mark Hopkins Art Institute between 1899 and 1904. These are collected, irregularly, at CHS, JAB, OAK, and SFAI.

17. A museum board included the two Crockers and the city hall architect Arthur Brown, Jr.; the two Crockers also founded and sat on a fund-raising committee whose other notable member was Fleishhacker.

18. The only biography is "Lee Randolph," *California Art Research* 15 (San Francisco, 1937).

19. Ibid., 1.

20. The quoted phrase is from one of the school's brochures and became more famously the basis for future resentment when the school became a haven for abstract expressionism. See Richard Cándida Smith, *Utopia and Dissent: Art, Poetry, and Politics in California* (Berkeley and Los Angeles, 1995), 92.

21. See the official description of the panels in the brochure printed for the library opening, *Public Library Building, erected Nineteen Hundred and Sixteen* (1916), SFPL.

22. See, for example, Tom Moulin, *San Francisco: Creation of a City* (Millbrae, Calif., 1978), 57.

23. Jerry Flamm, *Good Life in Hard Times: San Francisco's Twenties and Thirties* (San Francisco, 1978), 74.

24. Detailed in ibid., 75–83.

25. Stuart and Elizabeth Ewen, *Channels of Desire* (Minneapolis, Minn., 1992); and Roland Marchand, *Advertising the American Dream: Making Way for Modernity, 1920–1940* (Berkeley and Los Angeles, 1985).

26. This formulation is close to that of Jürgen Habermas in his *Structural Transformation of the Public Sphere,* trans. Thomas Burger (Cambridge, Mass., 1991), esp. 200–201.

27. The phrase is Guy Debord's in his *Society of the Spectacle* (Detroit, Mich., 1977).

28. Ibid., 169; Debord's emphasis. The number here refers not to a page, but to a sequence of paragraphs.

29. Habermas (as in note 26), 201.

30. See Joseph Baird, Jr., "The California Palace of the Legion of Honor: A Short History," unpublished manuscript, JAB.

31. The de Young and Legion of Honor museums were never fully complementary, and there was evidently an intense rivalry between Spreckels and de Young (dating back before the turn of the century). The Legion was defended as a museum that would house Alma Spreckels's vast collection of French painting, tapestries, porcelain, crystal, and sculpture, including perhaps the most significant body of Rodin's work outside of France, and (a defense less publi-

cized) one that would compensate for the de Young Museum in Golden Gate Park, which had been tentatively deeded to the city and was dedicated (from Spreckels's point of view) to all things non-French. (In fact, the de Young Museum happily mixed fine art with picks and pans from the city's gold rush era.) For a lively and informative essay on the early rivalry between the two museums, see Stephen Birmingham, *California Rich* (New York, 1980), 80–93.

32. Arthur Upham Pope, "A Museum Program for San Francisco," *Argus* 2, no. 6 (1928), 1, 3.

33. Habermas (as in note 26), 200.

34. Ray Boynton, "The True Nature of Mural Painting," *Argus* 2, no. 4 (1928), 1–3.

35. Terry Smith, *Making the Modern: Industry, Art, and Design in America* (Chicago, 1993).

36. Peyton Boswell, "California," *Art Digest* 4, no. 19 (1930), 3–4.

37. Godfrey De Berniere, "Mural Art As Seen by Ray Boynton," *California Arts and Architecture* (December 1932), 21.

38. The best concise description of the gallery and its related club is Beatrice Judd Ryan, "The Club Beaux Arts: Three Years of Growth," n.p., n.d., JAB. Ryan presents the best history in her unpublished reminiscences "The Bridge between Then and Now," 20–45, BANC.

39. Ryan, "The Bridge between Then and Now," 27.

40. Rudolf Hess, "The Tragedy of Rivera," *Argus* 4, no. 1 (1928), 1–2. The quotations that follow are from this essay.

41. Jehanne Bietry-Salinger, "The Boynton Murals at Mills College," *Argus* 3, no. 3 (1928), 4, 13.

42. See Arthur Millier, "Frescoes at Mills College," *Los Angeles Times*, June 17, 1928; and "Boynton Murals for Mills College Thrill California Critics," *Art Digest* (June 1928), 3.

43. Rose V. S. Berry, "Mills College Murals Are Distinctive," *San Francisco Chronicle*, May 27, 1928, D7.

44. Ibid.

45. Boynton, letter to President Reinhardt, July 3, 1928, MILLS.

46. Mel Scott, *The San Francisco Bay Area: A Metropolis in Perspective* (Berkeley and Los Angeles, 1959), 136.

47. See, especially, William Gerstle's anti-union rhetoric in "President's Annual Report," *Sixty-first Annual Report of the Chamber of Commerce of San Francisco* (San Francisco, 1910), 17–18.

48. Ruth Cravath and Dorothy Cravath, "Two San Francisco Artists and Their Contemporaries, 1920–1975," an oral history conducted in 1977, Regional Oral History Office, University of California, Berkeley, 1977, 74.

49. *Ansel Adams: An Autobiography* (Boston, 1985), 81–82.

50. See, for example, Arnold Genthe, letter to Albert Bender, February 26, 1936, MILLS.

51. Issel and Cherny (as in note 6), 114–16.

52. E. Spencer Macky, letter to William Gerstle, April 29, 1931, SFAI.

53. The Mills College Art Gallery directors' correspondence in the 1930s suggests ambivalence toward Bender. On the one hand, they are enthusiastic about having so reliable a donor; on the other, they are vexed that the gallery has become a storage closet for Bender and angered that his untutored tastes have dictated the collection. Read the barely hidden subtext in Roi Patridge, letters to Albert Bender, April 27, 1933, and February 1, 1934, MILLS.

54. Bender regularly gave a flat one hundred dollars to a painter to commission a work; if the work that resulted did not seem to have earned the money, the painter was less likely to enjoy further patronage. Although Bender's method angered artists, many of them accepted his terms and produced works of considerable value. See, as a fairly typical example, the complaints registered in Ruth Cravath and Dorothy Cravath, "Two San Francisco Artists" (as in note 48), 2.

55. Gerstle never named the painting, though it is probably *Mother and Child* (1926), now at Mills.

56. Gerstle, quoted in Bertram Wolfe, *The Fabulous Life of Diego Rivera* (New York, 1969), 280.

57. Boynton and Stackpole may well have traveled to Mexico under Rivera's auspices, through the journal *Mexican Folkways*. See Lee Randolph, letter to Francis Toor, March 3, 1927, SFAI.

58. The early correspondence between Rivera and Bender gives a good idea of the maneuvering and momentum that finally brought Rivera to San Francisco. In the summer of 1926, under pressure from Boynton and Stackpole, Bender purchased a Rivera painting, sight unseen, for much more than his customary $100 (he paid Rivera $750) to make an initial impression on the painter. Bender was apparently not pleased with the arrangement, however, and in the fall, Stackpole wrote asking Rivera to send him a photograph of the painting for Bender, as evidence of his good faith (Ralph Stackpole, letter to Diego Rivera, September 26, 1926, BANC). The letter apparently mollified the patron, at least temporarily. Damage to the finished canvas in transit caused anxiety on both ends, but it was quickly assuaged by Boynton, who promised to touch up the damage (Diego Rivera, letter to Albert Bender, August 25, 1926, MILLS). To help smooth over any misunderstandings, Bender, in the fall, sent Rivera an Aldo Hiroshige print, which Rivera accepted warmly (Diego Rivera, letter to Albert Bender, October 5, 1926, MILLS). And Rivera wrote immediately to Stackpole, urging him to act on his behalf to secure Bender's confidence (Diego Rivera, letter to Ralph Stackpole, October 1926, BANC). There followed a flurry of letters between Rivera and Stackpole, the latter charged with negotiating prices and currying favor for the former (see Diego Rivera, letters to Ralph Stackpole, October 13, 1926; December 15, 1926; and December 24, 1926, BANC). In early 1927, Rivera sent more pictures to Stackpole to sell, apparently with good success (Diego Rivera, letter to Ralph Stackpole, February 8, 1927, BANC). By the fall the mural painter had shipped Bender four new paintings; Rivera encouraged Bender to sell them but knew he would now probably purchase them himself (Diego Rivera, letter to Albert Bender, October 6, 1927, MILLS).

59. Albert Bender, letter to Guadalupe Marin, November 29, 1927, MILLS. For an example of the response to Bender's first mention of the mural, see Paul O'Higgins, letter to Albert Bender, December 9, 1927, MILLS. Rivera often had his American assistants write to Bender to assure him of his reliability. When Rivera himself finally responded, it was with an unusual, suggestive reference to his recent political battles: "It will give me great pleasure to go to San Francisco—since one of my principal motives for returning [from the Soviet Union] was to [see] all of you, and to paint the mural. I am anxious to hear from you regarding this project" (Diego Rivera, letter to Albert Bender, June 18, 1928, MILLS). His return to Mexico from the Soviet Union actually had little to do with an impending San Francisco project. He had become increasingly ostracized by a disappointed Stalinist faction in the Communist Party and was being pressured by the Mexican government to finish his long overdue Ministry of Education murals.

60. Gerstle, quoted in Wolfe, *The Fabulous Life of Diego Rivera* (as in note 56), 281.

61. An interesting correspondence precedes Rivera's arrival. The mural painter did not write much during 1928 (and even afterward he often asked others to write for him). His silence caused some anxiety, and Bender wrote to him in early 1929: "We have been looking for you in San Francisco for a long time. No one seems to know the reasons why you have not come here, but whenever you come you will be most cordially welcome" (Albert Bender, letter to Diego Rivera, February 18, 1929, MILLS). Bender sought out other American patrons for Rivera's smaller canvases (see, for example, Albert Bender, letter to Diego Rivera, March 13, 1929, MILLS). To help Rivera plan for the commission, Bender obtained exact dimensions for the

wall space to be painted—details that had not been determined until he made a request for them (see Gerstle's request for information about the CSFA wall space, Minutes from SFAA Board of Directors, January 15, 1929 to November 20, 1930, 6, SFAI). In response to the request the secretary to the SFAA Board wrote to Gottardo Piazzoni (May 22, 1929, SFAI) because this Bohemian Club painter apparently knew more about the "location, character of the wall, area, and space" than anyone else. Bender also made his first, unsuccessful, attempt to secure a visa for Rivera (SFAA, telegram to James Phelan, June 19, 1929, MILLS). And he sought to alleviate Rivera's concerns about the commission, writing somewhat cautiously in June 1929: "I am still looking forward to your visit to San Francisco, and am doing my best to help in removing the labor opposition to your coming, but I am unable at present to say whether or not I have made any progress" (Albert Bender, letter to Diego Rivera, June 20, 1929, MILLS). Rivera often fell into silence, and in August 1929 Bender wrote, exasperated: "I have not heard from you for several weeks and do not know if you received my letter, in which I told you what had been previously done in your behalf" (Albert Bender, letter to Diego Rivera, August 13, 1929, MILLS). In early 1930 Rivera wrote Stackpole, telling him his plans to travel to the city and his hopes for the mural, but he did not bother to give the same information to Bender or Gerstle until later (Diego Rivera, letter to Ralph Stackpole, May 3, 1930, BANC).

62. The photograph exists in negative form, Albert Bender papers, MILLS. A related photograph appears in Adams (as in note 49), 197.

63. I am indebted to Alicia Azuela for her ideas in the following section. See especially her forthcoming study, portions of which were presented in her paper "Diego Rivera: A Good Will Cultural Ambassador," presented at the College Art Association meeting, Chicago, 1992. See also James Oles, *South of the Border: Mexico in the American Imagination, 1914–1947* (Washington, D.C., 1993).

64. My account in the text is a thumbnail sketch. The materials on the relationship between the United States and Mexico during the revolutionary years are vast. Some useful works are Mark Gilderhus, *Diplomacy and Revolution* (Tucson, Ariz., 1977); and Robert Freeman Smith, *The United States and Revolutionary Nationalism in Mexico, 1916–1932* (Chicago, 1972).

65. This was a continuing theme in Mexican-American relations. See, for example, Lorenzo Meyer, *Mexico and the United States in the Oil Controversy, 1917–1942* (Austin, Tex., 1977).

66. Smith (as in note 64), 21.

67. James Horn, "U.S. Diplomacy and the 'Specter of Bolshevism' in Mexico, 1924–1927," *Americas* 32 (1975), 31–45.

68. Wolfe, *The Fabulous Life of Diego Rivera* (as in note 56), 164.

69. Ibid., 225–39.

70. See, for example, *New Masses,* March 1927.

71. The new ambassador's work with President Calles involved several related steps, accomplished with remarkable speed. The first was to convince the American government and major industrialists to suspend Mexico's payment on its debt, at least until the national economy improved. The second was to improve Calles's public image, particularly among the Mexican peasants, who suffered under his oppressive rule; this improvement primarily involved softening Calles's hostility toward Catholicism (Edward Berbusse, "The Unofficial Intervention of the United States in Mexico's Religious Crisis, 1926–1930," *Americas* 23 [1966], 28–62). The third was to control the 1929 election, imposing a Callista puppet even when Vasconcelos won the popular vote. Mexico in the early 1930s would fall under the nominal presidency of Pascual Ortiz Rubio, an unabashed Callista with strong ties to American industry.

My reading of Morrow's work in Mexico risks reproducing what has commonly been held about the U.S. intervention—that Mexico itself was in no position to counter American interests. For a complementary and authoritative account of the unstable, shifting alliances between

Mexico's revolutionaries and Rivera's relationship to them, see David Craven, *Diego Rivera as Epic Modernist* (New York, 1997), 53–99.

72. Robert Freeman Smith, "The Morrow Mission and the International Committee of Bankers on Mexico: The Interaction of Finance Diplomacy and the New Mexican Elite," *Journal of Latin American Studies* 1 (1969), 149–66.

73. Eyler Simpson, quoted in Anita Brenner, *The Wind That Swept Mexico: The History of the Mexican Revolution of 1910–1942* (Austin, Tex., 1971; originally published in 1943), 86.

74. It should be noted that the 1929 election produced a generation of young activists who worked against Ortiz Rubio and eventually experienced some political success. See Roderic Camp, "La campana presidencial de 1929 y el liderazgo politico en Mexico," *Historia Mexicana* (1977), 231–59.

75. Diego Rivera, "The Revolution in Painting," *Creative Art* 4 (1929), 29–30.

76. The exhibition was held in January 1928. Reviews were favorable, including the one from which I quote: *Argus* 2, no. 4 (1928), 3.

CHAPTER THREE

1. "Rivera Arrives in San Francisco to Paint Stock Exchange Murals," *San Francisco Chronicle,* November 11, 1930, 13.

2. See, for example, the tone developed in the *Chronicle*'s criticisms: November 11, 1926; October 9, 1927; January 12, 1930; September 25, 26, and 27, 1930; October 2 and 21, 1930; November 9, 11, 15, 19, and 23, 1930.

3. Constance Maynard, "Local Art Schools Hold High Repute," *San Francisco Examiner,* November 23, 1930, 10E.

4. Ryan's comments, which appeared frequently in the *Oakland Tribune,* were later reprinted in national journals. The most famous passage reads as follows: "It is too bad we can't have our own men do this type of work. We have any number of Californians who are capable of doing fine murals. We should aim at developing local talent rather than going abroad for our art. Ribera's style will enrich the community, surely, but so would that of many California muralists." (See, for example, "Seeing Red," *Art Digest* 5, no. 2 [1930], 8.)

5. "New Broadside in Artist War," *San Francisco Chronicle,* September 27, 1930; reprinted in "Seeing Red," 8.

6. United Press dispatch, September 23, 1930; reprinted in "Seeing Red," 8; and in Bertram Wolfe, *The Fabulous Life of Diego Rivera* (New York, 1969), 285.

7. Nadia Lavrova, "San Francisco Pacific Coast Art Center," *San Francisco Examiner,* November 23, 1930, 11E.

8. For Pflueger's response, see Elisabeth Fuentes Rojas de Cadena, "Three San Francisco Murals of Diego Rivera: A Documentary and Artistic History," master's thesis, University of California at Davis, 1980, 7–9.

9. "Seeing Red" (as in note 4), 8.

10. Beatrice Ryan, "The Bridge between Then and Now," unpublished manuscript, 45, BANC.

11. *San Francisco News,* September 26, 1930; see also Wolfe, *The Fabulous Life of Diego Rivera* (as in note 6), 286, for a longer account.

12. See *San Francisco Chronicle,* September 25, 1930.

13. "Artists Fight on Employing Mexican 'Red,'" *San Francisco Chronicle,* September 24, 1930.

14. United Press titled the article "Opposition of United States Artists to Diego Rivera" and wired it September 23, 1930.

15. On the history of the SFLC, see Jules Tygiel, "Workingmen in San Francisco, 1880–1901," Ph.D. diss., University of California at Los Angeles, 1977; John Alan Lawrence, "Behind the Palaces: The Working Class and the Labor Movement in San Francisco, 1877–1901," Ph.D. diss., University of California at Berkeley, 1979. On the SFLC's populist platform, perhaps its most important feature for the city's voters, see Daniel Walters, "Populism in California, 1889–1900," Ph.D. diss., University of California at Berkeley, 1952. On the SFLC's work in major political events, see Walton Bean, *Boss Ruef's San Francisco: The Story of the Union Labor Party, Big Business, and the Graft Prosecution* (Berkeley, Calif., 1952).

16. Its most prominent figure was the aged Andrew Furuseth, president of the International Seamen's Union, who in just a few years would denounce the 1934 Big Strike (discussed in Chapter 5) and back the city's industrialists at the expense of his own rank and file. See Bruce Nelson, *Workers on the Waterfront: Seamen, Longshoremen, and Unionism in the 1930s* (Urbana, Ill., 1990), 153–55.

17. See also the SFAA's urgent telegram to Phelan, June 19, 1929, MILLS. The relevant passage reads as follows: ARE INFORMED LOCAL LABOR COUNCIL WILL MAKE EFFORTS TO PREVENT DIEGO RIVERA SECURING VISA FOR ENTRY TO UNITED STATES ON ACCOUNT OF HIS ANTI-AMERICAN ACTIVITIES AND RADICAL POLITICAL VIEWS.

18. On the roots of racism in the city, see Alexander Saxton, *The Indispensable Enemy: Labor and the Anti-Chinese Movement in California* (Berkeley and Los Angeles, 1971).

19. See, for example, the description in *Pacific Rural Press,* December 17, 1927, quoted by Carey McWilliams, *Factories in the Field* (Boston, 1939), 126.

20. J. B. S. [Jehanne Bietry Salinger], "Competitive Bidding Evil," *Argus* 2, no. 4 (1928), 2.

21. See "Notes on the Art and Decoration of the Stock Exchange Club," n.d., City Lunch Club files.

22. In the shift to the Lunch Club, Pflueger enlisted Gerstle and two allies, Milton Bremer and William Hendrickson, for an ad hoc mural committee and developed the interior design with the artist-designer Michael Goodman. For a partial description of the whole design, see Laurance Hurlburt, *The Mexican Muralists in the United States* (Albuquerque, N.Mex., 1989), 98–109.

23. The artists Pflueger hired included Stackpole, Wight, Adaline Kent Howard, Ruth Cravath, and Robert Howard (bas-reliefs); Michael Goodman and Harry Dixon (metalwork); and, eventually, Otis Oldfield (stained glass) and Stackpole again (the exterior monumental sculptures).

24. As recorded in Wolfe (as in note 6), 285. Dixon's comments were carried by the United Press, September 23, 1930.

25. "Rivera Arrives in San Francisco to Paint Stock Exchange Murals" (as in note 1), 13.

26. Harris C. Allen, "Art to the Rescue of Tired Business Men," *California Arts and Architecture* (December 1931), 32–33. The Matissean allusion in the article's title ("What I dream of is an art . . . which might be for every mental worker, be he businessman or writer . . . something like a good armchair in which to rest from physical fatigue," Matisse had famously written) was no surprise. Matisse's and Rivera's work had been shown at New York's Museum of Modern Art, its first solo exhibitions.

27. Ibid., 32–33.

28. On these features, see "Luncheon Club Stock Exchange, San Francisco, California," *American Architect* (July 1932); R. Sexton, "An Unusual Use of Metals," *Metalcraft* (February 1932); Carleton Winslow, "The Stock Exchange Luncheon Club, San Francisco," *Architect and Engineer* (December 1931).

29. Emily Joseph, "Rivera Murals in San Francisco," *Creative Art* (May 1931), 333–37.

30. Allen (as in note 26), 32.

31. John D. Barry, "Characteristics of Rivera," *Stained Glass Association of America Bulletin* (Chicago) 26 (1931), 248.

32. Michael Goodman interview, recorded in Fuentes Rojas de Cadena (as in note 8), 19.

33. Allen (as in note 26), 32.

34. "Rivera Mural Given Initial Club Showing," *San Francisco Chronicle,* March 15, 1931.

35. Hurlburt (as in note 22), 102, for example, has identified the boy as Peter Stackpole, son of Rivera's supporter Ralph Stackpole, and the man as Victor Arnautoff (see my discussion in Chapter 4).

36. John Barry, *The City of Domes* (San Francisco, 1915), 112.

37. Ibid., 56.

38. "Helen Wills Moody Ideal California Type, Says Rivera," *San Francisco Chronicle,* May 17, 1931.

39. Ibid., 4.

40. Diego Rivera, *My Art, My Life* (New York, 1960), 176.

41. Wolfe (as in note 6), 290.

42. Frank Jewett Mather, Jr., "Rivera's American Murals," *Saturday Review of Literature,* May 19, 1934.

43. As recorded in Wesley Burnside, *Maynard Dixon: Artist of the West* (Provo, Utah, 1974), 84. Burnside does not date Dixon's remarks, though it is likely that Dixon delivered his talk in mid-1931, just before he left San Francisco.

44. Joseph (as in note 29), 337.

45. The literature on the restructuring of rural California between 1915 and 1930 is vast, but see especially Cletus Daniel, *Bitter Harvest: A History of California Farmworkers, 1870–1941* (Berkeley and Los Angeles, 1982); and Linda Majka and Theo Majka, *Farm Workers, Agribusiness, and the State* (Philadelphia, 1982). One of the earliest studies is still one of the best: McWilliams, *Factories in the Field* (as in note 19).

46. McWilliams, ibid., 146.

47. General information about this conflict can be found in Ray Taylor, *Hetch Hetchy: The Story of San Francisco's Struggle to Provide a Water Supply for Her Future Needs* (San Francisco, 1927).

48. It was formally called the Regional Plan Association (RPA) but also known by a number of other, less formal, titles (and some less exalted). On the RPA, see Mel Scott, *The San Francisco Bay Area: A Metropolis in Perspective* (Berkeley and Los Angeles, 1959), 186–201; and also the material in "Regional Plan Association, Inc., of San Francisco Bay Counties," BANC. For the RPA statement of intent, see Harland Bartholomew, *The San Francisco Bay Region: A Statement Concerning the Nature and Importance of a Plan for Future Growth* (San Francisco, 1925).

49. Scott, 234–38.

50. On the introduction of Impressionism at the PPIE and its relationship to the outlying colonies, see *Impressionism, The California View: Paintings, 1890–1930* (Oakland, Calif., 1981). Much good material on the links between the Monterey and San Francisco art scenes can be found in the files for "E. Charlton Fortune," OAK. Because of her connections with Ryan's Beaux Arts gallery and the CSFA, Fortune was perhaps the most important figure—institutionally at least—between 1910 and 1930 for the art colonies. See also Susan Landauer, *California Impressionists* (Irvine, Calif., 1996).

51. Gottardo Piazzoni, "Three Pioneer Artists," *Argus* 3, no. 6 (1928), 1, 15.

52. Characteristic examples include *Art in California* (San Francisco, 1916); Eugen Neuhaus,

Painters, Pictures, and the People (San Francisco, 1918); Emile Pissis, "Art in California: Reminiscences" (manuscript, 1920), OAK; and Arthur Millier, "Growth of Art in California," in *Land of Homes*, ed. Frank Taylor (Los Angeles, 1929), 311–41. Materials on individual painters are gathered in the series of biographies undertaken by the Works Progress Administration (WPA), entitled *California Art Research*, 20 vols. (San Francisco, 1936–37).

53. Links between patrons and academics were remarkably explicit. See, for example, the correspondence between Eugen Neuhaus, the critic and art historian, and Carl Rhodin, the chairman of the Commonwealth Club, "Commonwealth Club" folder, BANC.

54. McWilliams (as in note 19), 4.

55. This section is indebted to T. J. Clark's "Environs of Paris" chapter in his *Painting of Modern Life* (New York, 1985). For a somewhat similar argument about the relationship between painting and the enclosure movement in England, see Ann Bermingham, *Landscape and Ideology: The English Rustic Tradition, 1740–1860* (Berkeley and Los Angeles, 1986).

56. William Henry Clapp arrived in the Bay Area in 1916. He was European trained (and claimed to have attended virtually all the important Salons in the early 1900s, including the famous 1905 Salon d'Automne, where the Fauves made their debut), and fostered Impressionist painting during the 1920s. His paintings were well regarded, and he had important institutional links: he was the founder and director of the Oakland Art Gallery, beginning in 1919; he served as a juror for virtually every important annual exhibition between the early 1920s and early 1930s; he wrote long, poetic treatises on painting. The best materials on Clapp can be found in Nancy Boas, *The Society of Six* (Berkeley and Los Angeles, 1997), and *Society of Six* (Oakland, Calif., 1972). For early attitudes toward Clapp, see "New Colony for Dreamers in Oakland," *San Francisco Examiner*, January 9, 1925; and "Oakland Man Chosen Head of Art Society," *Oakland Tribune*, August 4, 1928.

57. See Bartholomew (as in note 48).

58. There is little evidence of exactly when Clapp painted these canvases. It is known only that the entire project was undertaken during the 1920s.

59. The quotations, from Ruth Westphal, ed., *Plein Air Painters of California: The North* (Irvine, Calif., 1986), describe works by the following painters: Xavier Martinez (101), Bruce Nelson (127), Theodore Wores (177), and Giuseppe Cadenasso (51).

60. From the Manifesto for the Society of Six, reprinted in Boas (as in note 56), 97–99.

61. Maynard Dixon, quoted in Ruth Pielkovo, "Dixon, Painter of the West," *International Studio* 78 (1924), 466.

62. Gottardo Piazzoni, letter to Albert Bender, January 3, 1928, MILLS.

63. "Rivera Mural Given Initial Club Showing" (as in note 34), 9.

CHAPTER FOUR

1. On the original wall space and speculation on Rivera's proposal for it, see Minutes from the SFAA Board of Directors, January 15, 1929, to November 20, 1930, 6, SFAI.

2. "Rivera Will Paint Mural at Art School," *San Francisco Chronicle*, February 20, 1931.

3. "Diego Rivera Wants to Stay in City by the Golden Gate," *San Francisco News*, March 5, 1931.

4. Edward Clark, Jr., letter to CSFA, March 10, 1931, SFAI.

5. Morton Sontheimer, "Banana Motif Rules in Art, Says Critic," *San Francisco News*, May 6, 1931.

6. Arthur Millier, "In Los Angeles Galleries," *Argus* 2, no. 6 (1928), 8.

7. Charles Duncan, quoted in Sontheimer (as in note 5).

8. Morton Sontheimer, "'Art?' Scoffs Officer, 'Not That Collection of Sausages, Fat Women, and—Omelettes!'" *San Francisco News*, May 8, 1931. See also Maynard Dixon, "Art Show Best Laugh in Year, Says Dixon," *San Francisco News*, May 11, 1931.

9. "Interview written by Diego Rivera for the *San Francisco Daily News*, May the sixth, 1931," SFAI. The interview was the basis for a press release.

10. Emily Joseph, "Rivera Murals in San Francisco," *Creative Art* (May 1931), 337; emphasis in original.

11. Brown's inclusion caused considerable anxiety for his rival Pflueger, who responded with letters insisting on his contributions to the girders that framed the mural. See, for example, his letter to E. Spencer Macky, July 9, 1931, SFAI.

12. Ruth Cravath and Dorothy Cravath, "Two San Francisco Artists," an oral history conducted in 1977, Regional Oral History Office, University of California, Berkeley, 1977, 73, BANC.

13. "Rivera Limns Industries in Great Fresco," unidentified clipping in vertical files at both SFAI and SFPL.

14. "Diego Rivera Paints a Novel Theme for San Francisco Art School," *Art Digest* 5, no. 20 (1931), 3–4.

15. "The New Rivera Frescoes in San Francisco," *London Studio* 3 (1932), 239.

16. "Gerstle Reception," SFAI.

17. In addition to the criticisms of the mural I have already cited, others can be found in *Wasp*, August 7, 1931; *Emanu-El*, August 7, 1931; *San Francisco Call-Bulletin*, August 7, 1931; *San Francisco News*, August 7, 1931; *Berkeley Gazette*, August 9, 1931; *Oakland Tribune*, August 9, 1931; *San Francisco Chronicle*, August 9, 1931; *Jewish Journal*, August 12, 1931; *American Magazine of Art*, August 28, 1931; *Art Digest*, September 1, 1931; *San Franciscan*, September 1, 1931; *Pencil Points*, September 8, 1931; and *Creative Art*, January 1932.

18. "The New Rivera Frescoes in San Francisco" (as in note 15), 239.

19. "Rivera Limns Industries in Great Fresco" (as in note 13).

20. "Diego Leaves S.F. in Furore [*sic*]," *San Francisco Call-Bulletin*, June 4, 1931.

21. Although there is no comprehensive biography of Arnautoff, his unpublished autobiography has recently been translated: V. M. Arnautoff, "A Life Renewed." I draw my account from several sources: "Victor Arnautoff," *California Art Research* 20, part 1 (San Francisco, 1937); "Victor Arnautoff" folder, OAK; "Victor Arnautoff" folder, JAB; "Victor Arnautoff" folder, MILLS; and Vasily Arnautoff, interview by author, San Francisco, June 10, 1994.

22. On the early character of these Communist Party cells, see Ralph Shaffer, "Formation of the California Communist Labor Party," *Pacific Historical Review* 36, no. 1 (1967), 59–78.

23. Evan Connell, Jr., "The Anatomy Lesson," *New World Writing* (New York, 1953), 251–52.

24. He did not win the commission. I believe the sketch no longer exists. A narrative of these events can be found in the transcript of Jacob Arnautoff, son of Victor Arnautoff, interview by Lewis Ferbrache (?), March 23, 1970, OAK.

25. The date of Zakheim's birth was at one time documented as 1898, but I am told by his daughter, Masha Zakheim, that this is erroneous. I have patched together the account of Zakheim's pre-1930 years that follows from different sources, including "Bernard Zakheim," *California Art Research* 20, part 2 (San Francisco, 1937), 32–52; Bernard Baruch Zakheim, interview by Lewis Ferbrache, San Francisco, 1964, OAK; "Bernard Zakheim" folder, JAB; "Bernard Zakheim" folder, MILLS; and Masha Zakheim, interview by author, San Francisco, June 30, 1994.

26. Recorded in Zakheim, interview by Ferbrache, ibid., 1.

27. The best (admittedly biased) account of Kenneth Rexroth during these years is his own book *An Autobiographical Novel*, rev. ed. (New York, 1991), 369–404.

28. Ibid., 369. On Goldman and Berkman, see Alice Wexler, *Emma Goldman in America*

(Boston, 1984). Berkman's greatest influence in the city occurred around 1916, when he edited the famous anarchist journal *Blast;* Goldman gave a well-attended lecture series in the summer of 1916 in the throes of the Mooney-Billings trials, in which socialists were convicted of planting a bomb and killing bystanders during San Francisco's Preparedness Day parade. Her influence also derives from this time. On the afterlife of both Goldman's and Berkman's anarchism in the city, see Richard Frost, *The Mooney Case* (Stanford, Calif., 1968).

29. Linda Hamalian, *A Life of Kenneth Rexroth* (New York, 1991), 67; Hamalian does not mention Zakheim, though it is clear that Rexroth's activities in the Fillmore paralleled Zakheim's.

30. "Radical Artist, Victor Arnautoff, 1896–1979, Dies in Russia," *Community Muralists' Newsletter* (Fall 1979), 3, LAR.

31. Jacob Arnautoff (as in note 24), 5.

32. "Mexican Market," *San Francisco Call-Bulletin,* June 21, 1930.

33. "Rivera Limns Industries in Great Fresco" (as in note 13).

34. Cletus Daniel, *Bitter Harvest: A History of California Farmworkers, 1870–1941* (Berkeley and Los Angeles, 1982), 132.

35. Theodore Draper, *The Roots of American Communism* (New York, 1957), 343–44, 450 n. 33.

36. On Darcy's differences with the New York Communist Party, see Bruce Nelson, *Workers on the Waterfront: Seamen, Longshoremen, and Unionism in the 1930s* (Urbana, Ill., 1990), 108–9. For a more trenchant view of Darcy (and his "exile" to California), see Harvey Klehr, *The Heyday of American Communism* (New York, 1984), 33–35.

37. See especially his glowing report about organizing workers in the fields in Sam Darcy, "Not Reliance on Spontaneity but Organization Is Needed," *Party Organizer* 4, nos. 8–9 (1931), 23. See also Daniel (as in note 34), 133–35.

38. "The 'New Turn' in California," *Revolutionary Age* 2, no. 16 (1931), 3. Emphasis in original.

39. "Unite the Forces of Labor to Free Tom Mooney," *Revolutionary Age* 2, no. 40 (1931), 1.

40. Stalin's demands were announced in two new series, "Quotations from Lenin" and "Lenin's Teachings About the Party," included in the pages of the *Party Organizer*. See, as a characteristic example of the statements in these series about bourgeois (and artistic) individualism, 4, no. 6 (1931), 21–32.

41. Rexroth (as in note 27), 419–20. Rexroth did not see eye to eye with Darcy and was, in fact, openly suspicious of Darcy's work with writers and artists. I take this as symptomatic of Rexroth's huge appetite for control of the Communist Party, which Darcy kept in his own hands. (See my discussions in the chapter that follows.)

42. Besides the more famous Arnautoff, one should also include the less well-known Giacomo Patri in any account of Communist Party graphic production. Born in 1898, he immigrated to San Francisco in 1916; founded the Vitrus Club in the Italian North Beach district in 1917, devoted to theater and art exhibitions; trained at the CSFA and soon gained mural commissions for North Beach restaurants ("even though I knew nothing of mural painting"); became the major graphic artist for the local CP and, ironically enough, for the *Call-Bulletin* and the *Chronicle* after 1937; and taught at the CP-run California Labor School. See the "Giacomo Patri" file, LAR; see also the exhibition catalogue *Giacomo Patri Retrospective, 1930–1978* (San Francisco, 1982), LAR (from which the quotation on mural painting is taken).

43. See, for example, *Organize Now* (n.p. [International Longshoremen's and Warehousemen's Union], n.d.); *Behind the Waterfront: History of Warehousemen's Union, Local 6* (San Francisco, n.d.); *Twelve Thousand Men Who Are the Marine Cooks and Stewards* (San Francisco, n.d.); *How to Organize the Job* (San Francisco, n.d.); *San Francisco Harbor for Ships and Men* (San Francisco, n.d.); all LAR.

44. *Rank and File,* May 1, 1920.

45. "Attendance at Museum Here Largest in U.S.," *San Francisco Chronicle,* June 28, 1931, 8D.

46. Jerry Flamm, *Good Life in Hard Times: San Francisco's Twenties and Thirties* (San Francisco, 1978), 106.

47. Victor Wong, "Childhood 1930s," *Ting/The Caldron,* ed. Nick Harvey (San Francisco, 1970), 23–24.

48. "Attendance at Museum Here Largest in the U.S." (as in note 45), 8D.

49. Ottorino Ronchi, "A Guide to Hassam," *Argus* 4, no. 5 (1929), 4.

50. Ibid., 4.

51. "Diego Rivera at the John Reed Club," *Workers Age* 1, no. 1 (1932), 2.

52. Diego Rivera, *My Art, My Life* (New York, 1960), 197–98.

53. Donald Hagerty, *Desert Dreams: The Art and Life of Maynard Dixon* (Layton, Utah, 1993), 169.

54. Michael Goodman, quoted in Elisabeth Fuentes Rojas de Cadena, "Three San Francisco Murals of Diego Rivera: A Documentary and Artistic History," master's thesis, University of California at Davis, 1980, 49.

55. Phyllis Ayer, interview by author, San Francisco, June 11, 1994.

56. Many of the criticisms can be found in materials associated with the painter Dixon, whose links with both the leftists and Bohemian Club patrons made him uniquely qualified to observe the Rivera debate. See, for example, Dixon's biography in the WPA-funded *California Art Research* 8 (San Francisco, 1937), 70.

57. Florence Wieben (Lehre), *Oakland Tribune,* August 9, 1931.

58. "The New Rivera Frescoes in San Francisco" (as in note 15), 239.

59. There is some debate about the identity of this female figure. She has also been identified as Marion Simpson, though the grounds for this claim are not clear. See *Diego Rivera: A Retrospective* (New York, 1986), 285. My identification of the woman as Geraldine Colby is taken from Sotheby's auction catalogue, which listed the sketches for these portraits: *Fine Nineteenth and Twentieth Century American and European Paintings* (Los Angeles, 1979). In any event, neither Simpson nor Colby was an architect or draughter.

60. *Diego Rivera: A Retrospective,* ibid., 285.

61. Ray Boynton, "The True Nature of Mural Painting," *Argus* 2, no. 4 (1928), 1–3.

62. There are competing claims about the insignia. The first is that the original insignia was a red star and that the current hammer and sickle was painted much later, probably during the frenzy during the hearings of the House Un-American Activities Committee (HUAC); this view is advanced by Lucienne Bloch and Steve Dimitroff, Rivera's assistants in later projects ("A Red Star for Diego Rivera," *San Francisco Examiner,* December 4, 1986). The second is that the hammer and sickle was original but was immediately covered by a red star; this reading is forwarded by Laurance Hurlburt, *The Mexican Muralists in the United States* (Albuquerque, N.Mex., 1989), 274, n. 53. Neither argument is firmly corroborated.

63. Michael Goodman interview, recorded in Fuentes Rojas de Cadena (as in note 54), 49.

64. Hurlburt (as in note 62), 122.

65. Fragments from Joseph Danysh, unpublished autobiography, reprinted in "When Art Was Fun and Fabulous," *City of San Francisco* 10, no. 30 (1976), 21, LAR; these fragments do not appear in his more complete, though still unfinished, manuscript "Federal Art: A Memoir of the Thirties," OAK.

66. "Rivera Limns Industries in Great Fresco" (as in note 13).

67. "Diego Rivera Paints a Novel Theme for San Francisco Art School" (as in note 14), 3–4.

1. Henri Matisse, "Notes d'un peintre," *La Grande Revue* 25 (December 1908), 731–45. My translation is from Herschel Chipp, *Theories of Modern Art* (Berkeley and Los Angeles, 1968), 135.

2. Frances Flynn Paine, *Diego Rivera* (New York, 1931), 35.

3. Ibid., 29.

4. Ibid., 22.

5. Ibid., 30.

6. Henry McBride, "The Palette Knife," *Creative Art* 10, no. 2 (1932), 93.

7. Ibid., 93.

8. Ibid., 95.

9. Oldfield's own relationship with Rivera was complex. As one of the tenuously established local painters, he had initially been openly suspicious of the Stock Exchange commission and joined the unlikely group made up of the painters Dixon and Frank Van Sloun and the critic Rudolf Hess in voicing his dissent. But during Rivera's stay, Oldfield's estimation of the mural painter began to change. He served as Rivera's translator, became part of the festive entourage at Rivera's various social engagements in the city, and benefited from the huge publicity attending the mural painter's visit. For a brief discussion of the effects of Rivera's social engagements on local painters, see my "Another View of Chinatown: Yun Gee and the Revolutionary Chinese Artists' Club," in *Reclaiming San Francisco*, ed. James Brook, Nancy Peters, and Chris Carlsson (San Francisco, 1998), 163–82.

10. *California Arts and Architecture* 42, no. 1 (1932), 2.

11. "New Arnautoff Mural Shows S.F. Artists in Studio Work," *San Francisco Chronicle*, February 27, 1932.

12. Rivera probably did some painting in Stackpole's studio—several memoirs mention that he did—but probably not a mural. See, for example, Ruth Cravath and Dorothy Cravath, "Two San Francisco Artists and Their Contemporaries, 1920–1975," an oral history conducted in 1977, Regional Oral History Office, University of California, Berkeley, 1977, 8, BANC.

13. The artists Arnautoff portrayed included Giacomo Patri, Adaline Kent, Maxine Albro, Ruth Cravath, Helen Forbes, Dorothy Wagner, Suey Wong, and Parker Hall. Their devotion to the radical left underpinnings of agitprop varied considerably, though each was in some way strongly influenced by Rivera's work.

14. *San Francisco Examiner*, February 15, 1932; quoted in "Victor Arnautoff," *California Art Research* 20, part 1 (San Francisco, 1937), 112.

15. "Radical Group Will Exhibit," *San Francisco Chronicle*, July 12, 1931.

16. See Lawrence Ferlinghetti and Nancy Peters, *Literary San Francisco* (San Francisco, 1980), 139.

17. Linda Hamalian, *A Life of Kenneth Rexroth* (New York, 1991), 47–48.

18. The records at the Palo Alto Clinic, though scant, hint that the Lee-Wood-Arnautoff relationship had connections with Stanford University. See, for example, an article by Henry Lanz, *Palo Alto Times*, August 31, 1932. Lanz, a professor of Slavic languages at Stanford, knew Arnautoff and Lee and defended the clinic murals from their detractors. In 1943 Arnautoff accepted a permanent position on the faculty at Stanford.

19. "Paintings of Seminudes in Clinic Stir Palo Alto," *San Francisco Chronicle*, August 21, 1932, 14.

20. Ibid.

21. See, for example, *San Francisco Call-Bulletin*, July 15, 1933; and *San Francisco Examiner*, July 23, 1933, both recorded in "Bernard Zakheim," *California Art Research* 20, part 2, 58–59.

22. Joseph Danysh, *Argonaut,* August 4, 1933, recorded in ibid., 60.

23. Zakheim claimed that during his European travels he had executed a fresco in Hungary devoted to "Jews in Poland," the very subject a precedent for the Jewish Community Center work. Though there is no reason to doubt the existence of this fresco, I have found no evidence of it. See "Bernard Zakheim" (as in note 21), 56.

24. The best concise description of the New Deal programs is still William Leuchtenburg, *Franklin D. Roosevelt and the New Deal* (New York, 1963). For programs pertaining specifically to mural projects, see Francis O'Connor, *Federal Art Patronage: 1933–1943* (College Park, Md., 1966), and *Federal Support for the Visual Arts: The New Deal and Now* (Greenwich, Conn., 1971); Marlene Park and Gerald Markowitz, *Democratic Vistas: Post Office Murals and Public Art in the New Deal* (Philadelphia, 1984); and Barbara Melosh, *Engendering Culture: Manhood and Womanhood in New Deal Public Art and Culture* (Washington, D.C., 1991). The best recent critical study is Jonathan Harris, *Federal Art and National Culture: The Politics of Identity in New Deal America* (Cambridge, England, 1995). In the 1970s the federal government undertook a massive project to inventory public art works from the New Deal era. The northern California accounting was undertaken by Joseph Baird, and copies of his notes can be found in "California: WPA Fine Arts Inventory," JAB.

25. Willis Foster, interview by Lewis Ferbrache, Berkeley, Calif., 1964–65, 16, BANC.

26. Glenn Wessels, interview by Lewis Ferbrache, Berkeley, Calif., 1964–65, tape 3, 20, BANC.

27. As Willis Foster recalled, two patrons, Pflueger and Brown, regularly volunteered, for familiar reasons: "The architects and the public officials were glad to cooperate because if they were to use work of this sort [murals] they were given an actual percentage increase in the [federally funded or municipally funded] construction budget for the building to cover the art work . . . [and they shaped] the type of audience or influence that the completed work was apt to have." Interview by Ferbrache (as in note 25), 9–10.

28. As Karal Ann Marling and others have shown, the emplacement of New Deal machinery was not always happy. Friction between rural bureaucrats and painters hired from out of town often resulted in clashes over whole iconographic programs. See her *Wall-to-Wall America: A Cultural History of Post-Office Murals in the Great Depression* (Minneapolis, Minn., 1982).

29. Foster, interview by Ferbrache (as in note 25), 3.

30. Ibid., 17.

31. The committee for district 15 comprised Walt Heil, the new director of the de Young Museum; Thomas Carr Howe, assistant director of the Legion of Honor Museum; Charles Stafford Duncan, an artist member of the Bohemian Club; and Harold Mack, a stock broker who was also a club member. The advisory board for district 15 consisted of Charles Templeton Crocker; Mrs. Lewis Hobart, wife of the Bohemian Club architect; Edgar Walter, an old student of Arthur Mathews's and a longtime CSFA sculptor; and the architect Arthur Brown, Jr., whom San Francisco's Mayor Rolph engaged to design Civic Center buildings.

32. Bernard Baruch Zakheim, interview by Lewis Ferbrache, Oakland, Calif., 1964, 4, 6, BANC.

33. Hamalian (as in note 17), 78, 390, n. 17. See also Lester Ferris, "Interview with Kenneth Rexroth," in *Between Two Wars,* ed. Richard Bigus (San Francisco, 1982).

34. I have patched together this quotation from two Zakheim sources that refer to the same moment: Zakheim, interview by Ferbrache (as in note 32), 2–3; and Masha Zakheim Jewett, *Coit Tower, San Francisco: Its History and Art* (San Francisco, 1983), 32.

35. Zakheim, interview by Ferbrache (as in note 32), 3.

36. Ibid., 3–4.

37. Kenneth Rexroth, *An Autobiographical Novel* (New York, 1991), 442–43.

38. Albert Broussard, *Black San Francisco: The Struggle for Racial Equality in the West, 1900 – 1954* (Lawrence, Kans., 1993), 98 – 105.

39. *San Francisco Spokesman,* May 29, 1935.

40. Rexroth (as in note 37), 442 – 43.

41. Cletus Daniel, *Bitter Harvest: A History of California Farmworkers, 1870 – 1941* (Berkeley and Los Angeles, 1982), 167 – 221.

42. *San Francisco Examiner,* October 9, 1933. The best documentary evidence for the Cotton Strike can be found in Paul Taylor, *On the Ground in the Thirties* (Salt Lake City, Utah, 1983), 17 – 158.

43. The Fleishhacker group was never officially identified but was nonetheless a coherent body based on Bohemian Club connections. See especially the materials for 1933 in the folders "Bohemian Club" and "de Young Museum," JAB. The group was largely intact prior to Bruce's official telegram instructing Heil to form district 15's committee; see Edward Bruce, telegram to Walter Heil, December 10, 1933, AAA.

44. "Artists Work for CWA in Coit Tower," *San Francisco Chronicle,* February 11, 1934.

45. Meant to eulogize Lillie Hitchcock Coit, a prominent benefactor of the city who had bequeathed funds for a project, the tower was quickly subsumed under the city beautification agenda. Using the Coit bequest as a pretext, Fleishhacker selected a ramshackle area of Telegraph Hill as the site for a memorial Coit herself had never wanted. Fleishhacker's interest in the tower was partly financial. It was built with 5,000 barrels of cement and 3,200 cubic yards of concrete purchased from Fleishhacker's own Portland Cement Association. To ensure that such a vast quantity was required, Fleishhacker had chosen Arthur Brown's architectural office to design the tower. Gertrude Atherton, a member of the commission managing Coit's bequest, recalled the fate of competing design proposals: "None was adequate in my opinion nor in that of Mrs. Musante — the only other woman on the Commission — but the model of the tower by the eminent architect Arthur Brown met with the final approval of the men. Mrs. Musante and I protested in vain . . . and after days of wrangling the males of the Commission went into a huddle and emerged with the dictum that they were for the Coit Tower, and that was that" (Gertrude Atherton, *My San Francisco: A Wayward Biography* [Indianapolis, Ind., 1946], 30).

46. See the unidentified clipping, "Memorial Row Up Tuesday," in the Ralph Stackpole Papers, BANC.

47. See, for example, Ralph Stackpole, letter to Herbert Fleishhacker, April 30, 1932, BANC.

48. Recorded in Jewett (as in note 34), 32.

49. For the details of costs, space, payments, and so forth, see ibid., 42.

50. See, for example, Nadia Lavrova, "Forty-six Artists and One Palette," *Christian Science Monitor,* August 8, 1934.

51. "All Serene as Local CWA Art Plan Starts," *San Francisco Chronicle,* January 11, 1934.

52. Harvey Klehr, *The Heyday of American Communism* (New York, 1984), 38 – 48.

53. Caroline Decker, as quoted in Bruce Nelson, *Workers on the Waterfront: Seamen, Longshoremen, and Unionism in the 1930s* (Urbana, Ill., 1990), 109.

54. Nelson, ibid., 52, 106.

55. The most comprehensive study of Bridges is Charles Larrowe, *Harry Bridges: The Rise and Fall of Radical Labor in the United States* (New York, 1972).

56. Interview with Harry Bridges, recorded in Theodore Dreiser, "The Story of Harry Bridges," *Friday,* October 4, 1940, 6 – 7.

57. Two early contrasting accounts still provide some of the best insight into the strike: Paul Eliel, *The Waterfront and General Strikes, San Francisco 1934: A Brief History* (San Francisco, 1934); and Mike Quin, *The Big Strike* (Olema, Calif., 1949). Eliel represented the employers' Industrial Association; Quin was a Communist and Bridges's advocate. See also the important

article by Sam Darcy, "The San Francisco General Strike," *Communist* 13 (October 1934), 985–1004; and Nelson (as in note 53), 127–55.

58. Nelson used the term "pentecostal era" in combination with "Syndicalist Renaissance" (ibid., 103–88).

59. Most of these graphic materials, especially the pamphlets, now exist in name only. References to them are scattered in the files at LAR and in Mitchell Slobodek, *A Selective Bibliography of California Labor History* (Los Angeles, 1964). I have, however, found prints and pamphlets at Bolerium Books, San Francisco, which specialized in works on labor. See, for example, International Longshoremen's Association Local 38–79, *The Maritime Crisis: What It Is, and What It Isn't,* 2d ed. (San Francisco, 1936).

60. Vasily Arnautoff, interview by author, San Francisco, June 10, 1994.

61. Hamalian (as in note 17), 82; and my interview with Vasily Arnautoff.

62. Quin (as in note 57), 128–29.

63. Zakheim, interview by Ferbrache (as in note 32), 7.

64. John Barry, "Ways of the World in Coit Tower," *San Francisco News,* June 23, 1934.

65. Junius Cravens, *San Francisco News,* July 7, 1934.

66. Arthur Caylor, *San Francisco News,* July 10, 1934.

67. Daniel (as in note 41), 128.

68. They lost the strike. See *Western Worker,* June 15, 1932, 5.

69. Evelyn Seeley, "A Frescoed Tower Clangs Shut Amid Gasps," *Literary Digest,* August 25, 1934, 24.

70. Cravens (as in note 65).

71. "Art Commission Head Replies to Coit Tower Artists' Complaint," *San Francisco Chronicle,* July 4, 1934.

72. Heil, by mid-1934, was having misgivings about seeming to be Fleishhacker's puppet on the district committee. Letters and telegrams to Forbes Watson suggest his ambivalence (see, for example, Walter Heil, telegram to Forbes Watson, June 2, 1934, AAA). Spreckels, in response to Heil's wavering, began an unsuccessful campaign to have him removed from his post at the de Young. (Although Spreckels did not succeed, the carnage would be great: relations between the two museums were severely strained, another director for the Legion of Honor was hired, and art critics who did not publicly denigrate Heil were pressured to resign.) See Glenn Wessels, "Education of an Artist," an oral history conducted in 1967, Regional Oral History Office, University of California, Berkeley, 179, BANC.

73. "Destruction of Rivera Mural in N.Y. Termed 'Murder' and 'Capitalism Couldn't Take It' Declares Steffens," *San Francisco News,* February 14, 1934.

74. "Diego has been riding rough-shod over the hardest-boiled bunch of architects in the world. They started by insisting that fresco was out of the question and that the decoration must be in black and white. Not one brush stroke could be added in the building itself on account of the labor-unions and as regards the subject, 'Man at the Crossroads,' the solution of all social problems was to [be] found through intelligent direction of Capitalism. After the suave Diego had got through with them, his decoration is to be in color and in fresco[;] as regards the subject I am enclosing a copy of Diego's synopsis of his decoration. And he has them all licking his boots. I was afraid that his sketches would not be approved by the Rockefellers but Mrs. J. D. Jr. said that he didn't give Communism *enough* importance and asked him to include a portrait of Lenin." Clifford Wight (?), letter to Ralph Stackpole, December 2, 1932, BANC.

75. John D. Barry, "Ways of the World" (as in note 64).

76. "Murals on Coit Shaft Hint Plot For Red Cause," *San Francisco Chronicle,* July 3, 1934. The quotation that follows in the text is also from this source.

77. Quin (as in note 57), 104.

78. Seeley (as in note 69), 24.

79. "Complete Text of Rossi July 4 Speech," *San Francisco Chronicle*, July 5, 1934.

80. Helen Dunning, "Art and Politics," *San Francisco News*, July 10, 1934.

81. Zakheim, interview by Ferbrache (as in note 32), 16.

82. Ibid., 9.

83. *San Francisco Examiner*, July 9, 1934.

84. At least its most important members did, including Arnautoff and Zakheim. See my interview with Vasily Arnautoff (as in note 60) and with Shirley Triest, San Rafael, Calif., May 29, 1994.

85. Seeley (as in note 69), 24.

86. Tully Nettleton, "Communists in American Strikes," *Christian Science Monitor*, August 8, 1934, 6.

87. The strategy had long-term effects. The Darcy-Bridges link was never resolved, and the ambiguous link between the Communist Party and the International Longshoremen's Association resurfaced over and over again. See Estolv Ward, *Harry Bridges on Trial* (New York, 1940).

88. Seeley (as in note 69), 24.

89. Ibid. The writer did not get her facts right: Boynton did not paint the first California fresco in 1917 (Domenico Tojetti probably did in the 1880s); and there were twenty-six master painters at Coit Towers (not twenty), nineteen assistant painters, and two plasterers. As for the claim that Boynton taught eight of the muralists, the number is probably higher, though records at the CSFA are not conclusive.

90. Ray Boynton, "Walls and Composition," *San Francisco Art Association Bulletin* 1, no. 6 (1934), 2.

91. Frank Kermode, "Secrets and Narrative Sequence," in *On Narrative*, ed. W. J. T. Mitchell (Chicago, 1981), 83.

92. Gay Betts, "Ruskin Saw Beauty in Stagnant Pool," *San Francisco Chronicle*, September 9, 1935.

93. L. S. Bingam, "Does Not Approve Coit Murals," *San Francisco Chronicle*, August 23, 1935.

94. Edith Hamlin, interview by Donald Hagerty, Davis, Calif., 1981, 28, BANC.

95. Victor Arnautoff, "A Vital Question," *San Francisco Art Association Bulletin* 1, no. 5 (1934), 1.

CHAPTER 6

1. See Thomas Crow, *Painters and Public Life in Eighteenth-Century Paris* (New Haven, Conn., 1985), 211–54, and "The *Oath of the Horatii* in 1785: Painting and Pre-Revolutionary Radicalism in France," *Art History* 1 (December 1978), 424–71.

2. There is no biography of Danysh. The account that follows is drawn from several sources: Danysh's unfinished, unpublished autobiography, "Federal Art: A Memoir of the Thirties," OAK; Bernard Baruch Zakheim, interview by Lewis Ferbrache, Oakland, Calif., 1964, OAK; Glenn Wessels, "Education of an Artist," an oral history conducted in 1967, Regional Oral History Office, University of California, Berkeley, 1967, BANC; and Shirley Triest, interview by author, San Rafael, Calif., May 29, 1994.

3. On the group, see Therese Thau Heyman, ed., *Seeing Straight: The f.64 Revolution in Photography* (Oakland, Calif., 1994).

4. See, for example, the description of their friendship in Danysh, "Federal Art" (as in note 2), chapter 5, n.p.

5. Wessels left some important records, useful in constructing a biography: his own "Education of an Artist" (as in note 2); Glenn Wessels, interview by Lewis Ferbrache, Berkeley, Calif., 1964–65, BANC; and Wessels's own vast writings as an art critic and art teacher. There is also useful bibliographic information in the biographical files at CSL.

6. Wessels, "Education of an Artist" (as in note 2), 52.

7. Glenn Wessels, "The Visual Arts," *Fortnightly* 1, no. 3 (1931), 24.

8. Ibid., no. 9 (1932), 23.

9. Materials on these shows and others and several important lecture series can be found in the binders for Mills College Art Gallery History (1935–40), MILLS. Lyonel Feininger and Oskar Kokoschka taught in 1936, László Moholy-Nagy in 1940. The so-called Van Gogh festival took place in 1936; Picasso, Rouault, Klee, Chagall, Kandinsky, Matisse, Giorgio de Chirico, and Emil Nolde had shows in 1937; and Ernst Barlach and Karl Schmidt-Rottluff had shows in 1938.

10. Wessels, interview by Ferbrache (as in note 5), tape 3, 5–6.

11. Wessels, "Education of an Artist" (as in note 2), 209–10.

12. Alfred Neumeyer, "Modern American Fresco: The Overemphasis on Realism," *San Francisco Chronicle,* February 6, 1938.

13. See, as the most direct example of his attitudes, Willis Foster, "The Case of Communism," *Fortnightly* 1, no. 2 (1931), 8.

14. Wessels, "Education of an Artist" (as in note 2), 191.

15. Joseph Danysh, "When Art Was Fun and Fabulous," *City of San Francisco* 10, no. 30 (1976), 21, LAR.

16. Ralph Chesse (a painter and assistant at Coit Tower), in ibid., 21–22.

17. Other important murals and mural projects produced under the WPA's Federal Art Project in San Francisco include Victor Arnautoff's *Life of Washington,* Lucien Labaudt's *Advancement of Learning,* Gordon Langden's *Modern and Ancient Science,* and Ralph Stackpole's *Contemporary Education,* all at George Washington High School; Bernard Zakheim's *Superstitious and Rational Medicine* at the University of California at San Francisco's Cole Hall. Murals produced under the PWAP include Nelson Pool's *Harvest and Land* and George Walker's *Education* at Roosevelt Middle School and Glenn Wessels's *Four Elements* at Laguna Honda. And those produced under the State Emergency Relief Administration (SERA) include Victor Arnautoff's *History of California Religion and Army.* I discuss many of them in my "Public Painting in San Francisco: Diego Rivera and His Contemporaries," Ph.D. diss., University of California at Berkeley, 1995.

18. The chalet has had a remarkable existence, as much because of its site as because of the businesses that have occupied it. It has been home to a short-lived restaurant, to the Army Corps of Engineers, to the Veterans of Foreign Wars, to a seedy bar, and again to a restaurant, its current occupant. Left in disrepair several times, it has recently undergone a restoration that includes Labaudt's murals. Materials on the chalet can be found in files in the California Room, SFPL.

19. Full identifications can be found in Masha Zakheim Jewett, "Scenes from Another Time," *San Francisco Chronicle,* September 12, 1976.

20. Danysh, "Federal Art" (as in note 2), chapter 1, n.p.

21. H. L. Dungan, "Coit Tower Frescoes Near Completion," unidentified clipping (possibly from the *Oakland Tribune*) in "Victor Arnautoff" folder, OAK.

22. Lucien Labaudt, untitled manuscript (May 1938), 2–3, AAA.

23. Edgar Walter, quoted in "Labaudt Wins San Francisco Purchase Award," *Art Digest* 11, no. 17 (1937), 17.

24. Jehanne Bietry Salinger, quoted in Gene Hailey, "Lucien Labaudt," *California Art Research* 19 (San Francisco, 1937), 14.

25. "San Francisco ought to be informed of the hold of the Red element on the situation. A strong radical element within the ranks of the longshoremen's union seems to want no settlement of this strike." Assistant Secretary of Labor Edward McGrady, quoted in Bruce Nelson, *Workers on the Waterfront: Seamen, Longshoremen, and Unionism in the 1930s* (Urbana, Ill., 1990), 144; and Mike Quin, *The Big Strike* (Olema, Calif., 1949), 52–53.

26. Nelson, ibid., 189–266; Charles Larrowe, *Harry Bridges: The Rise and Fall of Radical Labor in the United States* (New York, 1972), 176.

27. Edward Vandeleur, *San Francisco Chronicle,* October 27, 1935, 1.

28. On the left's perception of Culbert Olson and the revived Democratic Party, see Dorothy Healey and Maurice Isserman, *Dorothy Healey Remembers: A Life in the American Communist Party* (Oxford, 1990), 59–79; and Eric Homberger, *American Writers and Radical Politics, 1900–1939* (London, 1986).

29. Phyllis Ayer, interview by author, San Francisco, June 11, 1994.

30. Shirley Triest (as in note 2).

31. See Leake's assessment of Zakheim in his pamphlet *The Opportunity for Pictorial Art in Modern Medicine* (San Francisco, 1936), CHS.

32. In mid-project, however, when the original funding ran out, Zakheim was forced to turn to Danysh for support, much to his chagrin. On his reluctant contact with Danysh, see Zakheim, interview by Ferbrache (as in note 2), 31–35.

33. Alma Reed, *Orozco* (New York, 1956), 241.

34. Laurance Hurlburt, *The Mexican Muralists in the United States* (Albuquerque, N.Mex., 1989), 69. See his general discussion of the Baker Library murals, 56–87.

35. Zakheim's shift from Rivera to Orozco as model was predicated on Rivera's distancing himself from the Stalinist line. On Rivera's activities between 1935 and 1940, see the chapter that follows.

36. Bernard Zakheim and Phyllis Wrightson, *California's Medical Story in Fresco* (San Francisco, 1939), 7.

37. Ibid., 9. A complete iconographic reading can be found in this text.

38. On Zakheim's handling of this case, see Masha Zakheim, "The Art of Medicine," unpublished manuscript, collection of Masha Zakheim.

39. Though I discuss Zakheim's use of dialectical materialism further, I ought to remark that one way to see how the national Communist Party line hardened after the Second International is to compare Stalin's theories of dialectical materialism with Lenin's and, ultimately, with Marx's historical materialism. Like Lenin, Stalin emphasized the idea of the "vanguard," which gave a structured (though problematic) form to what had once been a haphazard application of Marx's theories in America. On one level, it accounted for the problem of what Marx called the superexploited races; on another, it tried to exempt the Soviet Union from its own class conflicts. The point here is not to decide whether Zakheim represented "dialectical materialism" adequately but rather to note that he attempted it at all.

On the theoretical debates, see Paul Buhle, *Marxism in the United States* (London, 1987). On Zakheim's reading of Marxist theory, see Masha Zakheim, interview by author, San Francisco, 1994.

40. In these panels, the contrast of good and evil lies principally in the tension between the historical scenes and the mitigating circumstances around them. For example, King of Williams's surgery, which is the basis for the Sponge Case, was precipitated by a shooting; a newspaper editor and publisher who embarked on anticorruption crusades against the early robber barons, he was killed by vigilantes. Drake's autopsy (see Fig. 6.6) was reputedly a significant event because the body was that of Drake's brother, and the autopsy was used to disprove the exis-

tence of a wrathful God. It quieted the mutinous crew, led directly to the establishment of Fort Ross, and eventually brought about military rule in northern California. Often, the drama is less subtle. The Indians who offer herbs to Junipero Serra, for example, were in reality forced to do so as a sign of their obedience. In the adjoining scene, an Indian made drunk by conquistadores is baptized while a soldier binds an Indian woman as a prisoner-slave. The Spanish, having brutalized the Indian population, required them to share their knowledge of herbal medicines.

41. Zakheim, interview by Ferbrache (as in note 2), 29–30.

42. Ray Boynton, quoted in "Bernard Zakheim," *California Art Research*, vol. 20, part 2 (San Francisco, 1937), 103.

43. H. L. Dungan, *Oakland Tribune*, February 23, 1936. Dungan's remarks were aimed at Zakheim's related work for the University of California at San Francisco's Cole Hall.

44. Joseph Danysh, "The Federal Art Project," *San Francisco Art Association Bulletin* 3, no. 1 (1936), 2.

45. Meyer Schapiro, "The Public Uses of Art," *Artfront* 2 (1936).

CHAPTER 7

1. Rivera corresponded with Pflueger and Bender especially, and occasionally with Stackpole. See, for example, the letters collected in Bender's files at MILLS.

2. The best information on the GGIE is the fair's own publicity: *Pageant of the Pacific: A General Summary* (San Francisco, 1939); *Official Guidebook* (San Francisco, 1939); and Jack James and Earle Weller, *Treasure Island: "The Magic City," 1939–1940: The Story of the Golden Gate International Exposition* (San Francisco, 1941).

3. George Creel, "Talk by George Creel before Commonwealth Club," August 26, 1938, George Creel Papers, Library of Congress, box 5. See also Robert Rydell, *All the World's a Fair: Visions of Empire at America's International Expositions, 1876–1916* (Chicago, 1984), 85, and *World of Fairs* (Chicago, 1993), 95.

4. On the metropolitan ideology, see Mel Scott, *The San Francisco Bay Area: A Metropolis in Perspective* (Berkeley and Los Angeles, 1959), 224–43.

5. David Brody, "Reinterpreting the Labor History of the 1930s," in *Workers in Industrial America: Essays on the Twentieth Century Struggle* (Oxford, 1980), 120–72.

6. The neutralizing of militant labor in the city would seem to support Brody's general claim about the Wagner Act in his essay "The New Deal and the Labor Movement," in ibid., 138–46.

7. Not that the GGIE was strictly Pflueger's doing. I am summarizing a heated contest involving the city's elite factions. The names of the fair's major architects—Pflueger, Lewis Hobart, Arthur Brown, Jr., and William Merchant—suggest the competing interests and GGIE's accommodation of several kinds of ambition. Unlike the forces behind the development of the PPIE, those behind the GGIE have received much less scrutiny; the best materials can be found scattered in BANC. See, especially, the letters and pamphlets produced by the Yerba Buena Exposition Association, for example, *A Site for the 1938 Exposition* (San Francisco, n.d.). Roger Lotchin has pointed to the Reber Plan, launched prior to World War II and meant to transform the Bay Area into a military-industrial park, in which Treasure Island would have figured prominently. See his *Fortress California, 1910–1961* (Oxford, 1992), 62–63.

8. The phrase "Coloniale Moderne" is Rydell's (as in note 3), 61–91.

9. Peyton Boswell, "Eyes on Golden Gate," *Art Digest* 13, no. 12 (1939), 15.

10. I give the number of daily visitors estimated by Patricia French, "California Painting at the Golden Gate International Exposition," in *From Exposition to Exposition,* ed. Joseph Baird, Jr. (Sacramento, Calif., 1981), 61.

11. Elizabeth Bancroft, *Diego Rivera* (pamphlet, n.d., n.p.), available in the Diego Rivera Theater, City College of San Francisco.

12. Some of the best materials on the San Francisco Museum of Art (SFMA) can be found in files at SFAI, especially in the Minutes of the San Francisco Art Association (SFAA) and the *SFAA Bulletin.* I cite specifics below in the notes that follow.

13. The SFMA became another arena contested by the two longtime sets of patrons. In the late 1920s the SFAA, charged with establishing and directing the museum, fell under Gerstle's and then Pflueger's control when each served in turn as its president. The old guard found Pflueger's growing institutional power base unfortunate; subsequently, William H. Crocker and Charles Templeton Crocker reemerged to establish a separate museum board, along with Fleishhacker, that stripped the Pflueger-led SFAA of its charge ("SFAA Minutes," December 20, 1934, SFAI). In 1935, the Crocker-Fleishhacker board officially separated the SFMA from the SFAA and put the museum under the control of the conservatives ("SFAA Minutes," December 16, 1935, SFAI). As Wessels recalled, Fleishhacker "wanted the museum for his own purposes and he did not quite trust the artists" (Wessels, "Education of an Artist," an oral history conducted in 1967, Regional Oral History Office, University of California, Berkeley, 1967, 178 BANC). He meant "artists" satirically, since Pflueger and Gerstle hardly qualified. Prior to the separation, Pflueger, in installing Grace Morley as the director and curator, had produced a bizarre situation. The SFMA evolved into an important stronghold of the old guard but remained under the ostensible care of the new. Morley felt the pressure: she was eventually relieved of her full-time position at the museum, where she had been criticized from above for her poor management, had been lambasted by the Hearst dailies, and had endured years of abuse. But in the first years of her tenure, Morley's exhibitions revealed her allegiance: photographs by Stackpole, exhibits devoted to Beniamino Bufano and Joseph Raphael (two Pflueger favorites), and a solo show for Rivera. Under her care in the late 1930s the SFMA was the only museum that reliably devoted its wall space to local painters (see its stated intent in *SFAA Bulletin* 2, no. 3 [1935], 4). (For Morley's own assessment of events at the museum, see Grace L. McCann Morley, "Art, Artists, Museums, and the San Francisco Museum of Art," an oral history conducted in 1960, Regional Oral History Office, University of California, Berkeley, 1960, BANC.) Like the Mills College gallery a decade before, the SFMA became a storehouse for Bender's ever-growing collection. Indeed, from 1935, when the SFMA opened, to 1940, he stocked the museum with his continuous donations, his last great stake in the city's cultural politics.

14. Arnautoff took a temporary teaching position at Stanford University beginning in 1936; it became permanent in 1943. In addition, he found success outside the city with Edward Bruce's Treasury Section commissions: post office mural work at Pacific Grove, Richmond, and South San Francisco, California, and two sites in Texas. On these, see Barbara Melosh, *Engendering Culture: Manhood and Womanhood in New Deal Public Art and Culture* (Washington, D.C., 1991), 236, 257–58.

15. Vasily Arnautoff, interview by author, San Francisco, June 10, 1994.

16. On the particular iconography of Figure 7.2 and its significance, see Jacob Arnautoff, interview by Lewis Ferbrache, Oakland, Calif., March 23, 1970, 8, OAK.

17. The details of their appointment to Rivera's staff are unclear. It is likely that Lowe was assigned to mix paints and clean brushes; Okubo claims to have been responsible primarily for managing the onlookers ("Diego was high up there working on the scaffold, while I was down

below, near the bottom demonstrating and answering questions"); see Shirley Sun, *Mine Okubo: An American Experience* (Oakland, Calif., 1972), 18. Of the members of Rivera's staff, only Emmy Lou Packard was permitted to paint.

18. I do not mean to collapse ethnically Asian painters into the broad category "Asian-American," or ignore the obvious political and experiential differences within each group, or conflate immigrant, first- and second-generation attitudes. In fact a growing literature tries to uncover the absolute plurality of "Asian-American" cultural politics in California, though it says very little about the visual arts. For one aspect, see my "Another View of Chinatown: Yun Gee and the Chinese Revolutionary Artists' Club," in *Reclaiming San Francisco: History, Politics, Culture,* ed. James Brook, Nancy J. Peters, and Chris Carlsson (San Francisco, 1998), 163–82.

19. The best information on Gee during his San Francisco years is Joyce Brodsky, *The Paintings of Yun Gee* (Storrs, Conn., 1979); and David Teh-yu Wang, "The Art of Yun Gee before 1936," in *Yun Gee* (Taiwan, 1996). See also the materials collected in the folder "Yun Gee," JAB; Helen Gee, interview by author, New York, February 17, 1997; and my "Another View of Chinatown."

20. On Diamondism, see Brodsky, ibid., 17.

21. San Francisco's Chinatown had always been male dominated, mostly because of exclusion laws, local hiring strategies, and the financial reasons that brought most Chinese workers to California. Between 1924 and 1930 no Chinese women were permitted to enter the United States, the result of the 1924 Immigration Act. On the bachelor societies, see Victor Nee and Brett de Bary Nee, *Longtime Californ'* (Boston, 1974), 13–124.

22. Gee's statement, probably written in the early 1930s, is recorded in Brodsky (as in note 19), 13.

23. On these clubs, see Him Mark Lai, "A Historical Survey of the Chinese Left in America," in *Counterpoint: Perspectives on Asian America,* ed. Emma Gee (Los Angeles, 1976).

24. Helen Oldfield, "Otis Oldfield and the San Francisco Art Community, 1920s to 1960s," an oral history conducted in 1982, Regional Oral History Office, University of California, Berkeley, 1982, 144, BANC. Oldfield conflates two separate moments in her account, which incorrectly places Yun Gee in San Francisco at the time the club invited Rivera.

25. Kenneth Rexroth, *An Autobiographical Novel,* rev. ed. (New York, 1991), 434.

26. The club disbanded sometime in the early 1930s, but its members were still active. They lobbied for a solo show of Gee's work at the San Francisco Art Center in 1933 (heir to the Modern Gallery, where Gee first showed his work), even though Gee had not been in the city during the preceding six years; and they kept his legacy alive with shows at the Labaudt Gallery (begun by the painter and his wife) in the 1940s, even when it was clear that he would never return. See the two folders "Yun Gee" and "Lucien Labaudt," JAB.

27. Robert McChesney, interview by author, Petaluma, Calif., June 24, 1994.

28. For Okubo, see "Mine Okubo," JAB; "Mine Okubo," OAK; and Sun (as in note 17).

29. Her experience was fairly typical. See Ronald Takaki, *Strangers from a Different Shore* (New York, 1989), 218–20.

30. Cletus Daniel, *Bitter Harvest: A History of California Farmworkers, 1870–1941* (Berkeley and Los Angeles, 1982), 274–85.

31. Recorded in Sun (as in note 17), 12.

32. Rivera, *My Art, My Life* (New York, 1960), 217.

33. Bertram Wolfe, *The Fabulous Life of Diego Rivera* (New York, 1969), 349–52.

34. Rivera (as in note 32), 222.

35. On the Mexico City project, the Sindicato de los Talleres Graficos comprised Pablo O'Higgins, Leopoldo Mendez, Alfredo Zalce, and Fernando Gamboa.

36. The article appeared originally as "Manifesto: Towards a Free Revolutionary Art," *Partisan Review* 6, no. 1 (1938), 49–53.

37. But see also David Craven, *Diego Rivera as Epic Modernist* (New York, 1997), 98–99; Rivera's own claims, as recorded in *My Art, My Life* (as in note 32), 166; and the general tenor of Rivera's post-1940 essays, as collected in Raquel Tibol, *Diego Rivera: Arte y política* (Mexico City, 1978).

38. On Juan Almazán's diverse appeal and the 1940 presidential campaign, see Alan Knight, "The Rise and Fall of Cardenismo, c. 1930–c. 1946," in *Mexico since Independence,* ed. Leslie Bethell (Cambridge, England, 1991), esp. 292–302.

39. Alfred Miller, "Trotskyites Join Fascists in Mexico," unidentified clipping, Ralph Stackpole papers, BANC.

40. Knight (as in note 38), 301.

41. *Diego Rivera: A Retrospective,* exhibition catalogue (New York, 1986), 96.

42. Quoted in Hayden Herrera, *Frida: A Biography of Frida Kahlo* (New York, 1983), 248.

43. Wolfe (as in note 33), 360–61.

44. "Artists Protest: Plan Campaign to Combat Proposed Exploitation of Artists at Fair," unidentified clipping, Ralph Stackpole papers, BANC.

45. Ibid., n.p.

46. Ibid.

47. Meyer Schapiro, letter to Ralph Pearson, February 24, 1940, Earl Davis collection, AAA. See also Matthew Baigell and Julia Williams, eds., *Artists Against War and Fascism* (New Brunswick, N.J., 1986), 31–32.

48. *American Artists' Congress Bulletin* (March 1942), 1.

49. Rivera, quoted in Alfred Frankenstein, "Another Chapter in Rivera's Kampf," *San Francisco Chronicle,* September 8, 1940, 24.

50. Ibid.

51. Rivera, quoted in *Diego Rivera: A Retrospective* (as in note 41), 335 n. 4. The note refers to an "unidentified newspaper clipping" in SFPL.

52. Dorothy Cravath, "Conversation with Diego Rivera," in *Diego Rivera* (as in note 11), n.p.

53. I do not interrogate the simplicity of Rivera's reading, which collapses into a tidy whole "northern" and "southern" expression, construed monolithically, and multilevel production based on ethnicity and class. Much of his work is open to the critique of reductiveness; see Betty Ann Brown, "The Past Idealized: Diego Rivera's Use of Pre-Columbian Imagery," in *Diego Rivera: A Retrospective* (as in note 41), 139–56.

54. The connection to Chaplin had a biographical link, for Rivera had stayed with the actor immediately before beginning his Art-in-Action work. My thanks to Derrick Cartwright for reminding me of this.

55. Rivera, quoted in Cravath (as in note 52), n.p.

56. Rivera, quoted in Eileen O'Hara, "Marriage of the Artistic Expression of the North and South on This Continent," pamphlet (1992), Diego Rivera Theater, City College of San Francisco, n.p.

57. Kaja Silverman, *The Subject of Semiotics* (New York, 1983), 251. Silverman describes a "semic code," taken from Roland Barthes, *S/Z,* trans. Richard Miller (New York, 1974).

58. Michel de Certeau, "Walking in the City," in *The Practice of Everyday Life,* trans. Steven Rendall (Berkeley, Calif., 1984), 92.

59. De Certeau, "Spatial Stories," ibid., 119.

60. An inflection of Barthes's meditations on Eisenstein. See his "Third Meaning," in *Image, Music, Text,* trans. Stephen Heath (New York, 1977), 52–68.

61. O'Hara (as in note 56), n.p.

62. "10,000 Visit Island to See Rivera Mural," *San Francisco Chronicle,* December 2, 1940.

63. This destination was ordained from the beginning; hence the blueprint for the library in Pflueger's hands. The mural's dimensions accorded with the space available at this site: the south wall of the library measured 150 × 50 feet.

64. *Diego Rivera: A Retrospective* (as in note 41), 334 n. 3. See also O'Hara (as in note 56), n.p.

CHAPTER 8

1. The CSFA's abstract expressionist heyday is now receiving some of its best scholarly scrutiny. For a brief but useful summary, see Caroline Jones, *Bay Area Figurative Art, 1950–1965* (Berkeley and Los Angeles, 1990), 1–36; for an expanded account, see Susan Landauer, *The San Francisco School of Abstract Expressionism* (Berkeley and Los Angeles, 1996).

2. Not without debate, of course. See Jones, ibid., 5–11.

3. Anton Refregier had been prominent in the New York branch of the John Reed Club in the early 1930s and also worked at the JRC School between 1934 and 1936. He drew agitprop materials, most famous among them his 1932 work for the League of Struggle for Negro Rights. Prior to 1935 he remained devoted to the Trade Union Unity League, supported by the Communist Party, and a strict separatist agenda. After 1935 he embraced the Popular Front and was one of the original members of the 1936 Artists' Congress. He became a cartoonist for *New Masses* during the Popular Front's early years of optimism, even though the magazine had once been touted as too bourgeois by some hard-liners. During the period of the suspect Hitler-Stalin pact, he faithfully lobbied against American participation in the European war. After Hitler broke with Stalin, he abruptly shifted to the reoriented CP front organizations, including the new Congress of American-Soviet Friendship.

4. Normally Edward Bruce reviewed such documents. He died in January 1943, and the Section closed in June. Afterward, Refregier was answerable to the Public Buildings Administration. On the section's demise and reconfiguration, see Belisario Contreras, *Tradition and Innovation in New Deal Art* (Cranbury, N.J., 1983), 224–31.

5. Recorded in Anton Refregier, undated manuscript (roll D304), 4 (my pagination), AAA. Refregier names the sender only as "an official of the Public Buildings Administration in charge of my project." The placards had been approved in the original commission, but after seeing the walls, the local Chamber of Commerce and William Randolph Hearst challenged the original design; the censoring was accomplished, however, through the Treasury Section machinery. On the letter and its origins, see Robert McChesney, interview by author, Petaluma, Calif., June 24, 1994.

6. Refregier, ibid.

7. Here is the relevant passage from the WPA guidebook that gave Refregier his text: "A goodly portion of the 65,000-odd Chinese coolies whom Crocker and his associates had imported to build the Central Pacific's roadbed came drifting back into the city to compete with jobless whites. . . . The rising Workingmen's Party began holding great mass meetings where an Irish drayman, Dennis Kearney, delivered inflammatory harangues which soon made him the leader of a widespread movement to exclude the Chinese" (*San Francisco: The Bay and Its Cities* [San Francisco, 1940], 104–5). This description is itself rooted in contemporary revisions of California's past. Historians in the late 1930s had begun to make detailed connections between the nineteenth-century rise of unions and the promotion of an exclusionist, racist agenda. (See Elmer Sandmeyer, *The Anti-Chinese Movement in California* [Urbana, Ill., 1939]; the book spawned a number of others, including Gunther Barth, *Bitter Strength* [Cambridge, Mass.,

1964]; Stuart Miller, *The Unwelcome Immigrant* [Berkeley and Los Angeles, 1969]; and Alexander Saxton, *The Indispensable Enemy* [Berkeley and Los Angeles, 1971]. None have challenged any of Sandmeyer's basic assumptions, and the exclusionary model of unionism has, until recently, remained intact.) That history could only have seemed contaminating when, after 1938, the AFL and CIO struggled for supremacy, the CIO proclaiming racial expansiveness and condemning the AFL for its insularity.

8. Mike Quin's inclusion had considerable impact: when he died in 1947 a huge contingent of Bridges's rank and file turned out for the memorial service. See Bridges's eulogy in his introduction to the reissue of Quin's *Big Strike* (New York, 1979).

9. Refregier (as in note 5), 3 (my pagination).

10. Gale Cook, "Native Sons Accuse Rincon Murals' Painter of Plot to Distort History," *San Francisco Examiner,* October 26, 1948.

11. Matthew Josephson, "The Vandals Are Here—Art Is Not for Burning," *Nation,* September 26, 1953.

12. This is still the current "official" reading, as suggested by the Rincon Annex captions.

13. Refregier (as in note 5), 6 (my pagination). See also McChesney, interview by author (as in note 5).

14. "Vet Chiefs Score Mural in Rincon Post Office," *San Francisco Chronicle,* March 17, 1948.

15. See, for example, the contorted argument against the mural's "propaganda" in Gale Cook, "More Leftist Tailoring of Murals Cited," *San Francisco Examiner,* October 27, 1948.

16. The International Longshoremen's Association (ILA) became the ILWU in 1937 with John L. Lewis's founding of the CIO. It would have a difficult marriage with the CIO, because of the two organizations' different attitudes toward Communism as much as anything else. See Charles Larrowe, *Harry Bridges: The Rise and Fall of Radical Labor in the United States* (New York, 1972).

17. David Selvin, *Sky Full of Storm* (San Francisco, 1975), 81.

18. On the strike and its outcome, see Larrowe (as in note 16), 293–99.

19. McChesney, interview by author (as in note 5).

20. Robert McChesney, undated letter to Public Buildings Administration (most likely written in summer 1948), "Anton Refregier" folder, OAK.

21. McChesney, interview by author (as in note 5).

22. On Refregier's prolonged fight over censorship, see Gray Brechin, "Politics and Modernism: The Trial of the Rincon Annex Murals," in *On the Edge of America: California Modernist Art, 1900–1950,* ed. Paul Karlstrom (Berkeley and Los Angeles, 1996), 69–93.

23. Alfred Frankenstein, interview by Lewis Ferbrache, San Francisco, 1964–65, 22–24, BANC. This interview appears in an unpublished manuscript, "Interview with Bay Area Artists, 1964–1965."

24. Young Democrats of San Francisco, letter to the editor of the Argonaut Club of San Francisco, recorded in *Rincon Annex Murals, San Francisco: Hearing before the Subcommittee on Public Buildings and Grounds of the Committee on Public Works* (Washington, D.C., 1953), 5.

25. Resolution of California Society Daughters of the American Revolution, March 24, 1950, recorded in ibid., 7.

INDEX

Hearst, William Randolph: and controversy over Rivera's Pacific Stock Exchange commission, 61–62; and Palace of the Legion of Honor, 38

Heavenly Discourses (Wood), 123–24

Heil, Walter: and Coit Tower murals, 143; as director of de Young Museum, 132, 163, 164, 245n.72

Hendrickson, William, 236n.22

Hess, Rudolf, on Rivera's Mexican murals, 42–44, 49, 50, 53, 58

Hesthal, William, 193; *Railroad and Shipping,* 145–46, 145 (fig. 5.13)

Hetch Hetchy water project, 14, 77

Hill, Thomas, 79

History of California (Bancroft), 5

Hofmann, Hans, 163, 164

Holloway, Charles, 228n.31

Home Life (Berlandina), 144 (fig. 5.12)

Homer, Winslow, 30

Hope of the City (Dixon), 9–10, 10 (fig. 1.4), 228n.30

Hopkins, Harry, 128, 163

Houses along the Estuary (Clapp), 80–82, plate 5

Howard, Adaline Kent, 236n.23

Howard, Henry, 134

Howard, John Langley, 151, 157; *California Industrial Scenes,* 146–47, 148 (fig. 5.16), 197

Howard, Robert, 236n.23

Hunting in California (Hamlin), 143

Importation of Chinese Labor (Refregier), 129, 217–19, 218 (fig. 8.1), 253nn.5, 7

Impressionism, California, 21, 78–83, 105

Industrial Association, 154, 174, 217; on decline of union membership, 29–30, 39. *See also* Employers' Association

industrial capitalism, 29

Industrial Fire (Brangwyn), 17–18, 17 (fig. 1.7)

Industries of California (Stackpole), 149–51, 150 (fig. 5.18), 151 (fig. 5.19)

International Longshoremen's and Ware-housemen's Union (ILWU), 220, 221, 222, 254n.16

International Longshoremen's Association (ILA), 143, 149; and Big Strike of 1934,

139–40, 154; Communist Party linked to, 155, 174, 246n.87; revitalization of, 136, 137

Japanese-American painters. *See* Asian-American painters

Jewish Wedding (Zakheim), 125–28, 127 (fig. 5.6)

John Reed Club, 98, 175, 205

Kahlo, Frida, 51, 205, 210

Keith, William, 5, 70, 79

Kenneth Rexroth (Zakheim), 97, plate 7

Kent, Adaline, 242n.13

Kermode, Frank, 157

Labaudt, Lucien, 167–72, 247nn.17–18; *Beach Scenes,* 168, 169 (fig. 6.1); *Farm Commissar,* 60, 61 (fig. 3.1); *Fisherman's Wharf Scenes,* 172, plate 11; *Park Scenes,* 168, plate 10; *Powell Street,* 169–71, 170 (figs. 6.2, 6.3), 171 (fig. 6.4); *W2,* 172, 173 (fig. 6.5)

labor: connection between art and, 59–60, 94; in Rivera's *Allegory,* 62–63, 76; in Rivera's *Making a Fresco,* 109, 113–14; rural, and Darcy, 101–2, 134. *See also* labor unions; working class

Labor Clarion, 104

labor unions: in Chinatown, 197–98; and Communist Party, 134, 136–43, 155, 174–75, 205–6, 218, 246n.87; and controversy over Rivera's Pacific Stock Exchange com-mission, 62, 236n.17; decline in member-ship in, 29–30; Gerstle's hostility toward, 47; leftist artists working for, 103; and reconstruction of San Francisco, 227n.30; in support of Golden Gate International Exposition, 190. *See also* labor; working class; *specific unions*

landscape painting, 76, 78–86; and develop-ment of rural California, 78–83; as form of public art, 83–85

Laurens, Jean-Paul, 9, 32

Leake, Chauncey, 175

Lee, Russell, 124, 125, 242n.18

leftism: and Coit Tower murals, 134–36, 159; in easel painting, 192–95; end of link between murals and, 132–33; and San Francisco painting scene, 95–103,

167; as evidence of municipal culture, 34–35; as mediating between patrons and public, 25; prior to earthquake, 1; as sign of consent to centralized control, 39–41; vs. easel painting, 41, 165–66, 192–95. *See also* Coit Tower murals; Panama Pacific International Exposition (PPIE) murals; *specific murals*

Museum of Modern Art (New York), Rivera retrospective at, 115–17

museums, and municipal culture, 30–32, 38–39. *See also specific museums*

Nahl, Perham, Panama Pacific International Exposition poster, 7 (fig. 1.3), 8–9

Netzahualcoyotl, 209

Neuhaus, Eugen, on Brangwyn's murals, 18, 20

Neumeyer, Alfred, 164, 166

New Deal art programs, 117, 128–30, 190, 243nn.24, 27–28. *See also* Public Works of Art Project (PWAP); WPA Federal Art Project

Night of the Rich (Rivera), 53 (fig. 2.4), 62

1948 strike, 220–21

Noskowiak, Sonya, 162

Obstetrics (Arnautoff), 124–25, plate 8

Okubo, Mine: biography of, 198–99; magazine cover by, 199 (fig. 7.6), 200; as Rivera's staff member, 193, 200, 250n.17; *Two Fishermen*, 198 (fig. 7.5), 199

Oldfield, Otis, 169, 236n.23; *Figure*, 118–19, 118 (fig. 5.1); and Rivera, 242n.9; *San Francisco Bay*, 138–39, 139 (fig. 5.8), 144

Olson, Culbert, 175

On the Road of a Thousand Wonders (Mitchell), 10–11, 11 (fig. 1.5)

Organized Labor, 104

Orozco, José Clemente, 52, 56, 201; *The Epic of American Civilization*, 177, 178 (fig. 6.8); as influence on Zakheim, 176–77, 179, 181

Pacheco, Maximo, 54, 56

Pacific Gas and Electric, 14, 77, 175

Pacific Stock Exchange mural. *See Allegory of California* (Rivera)

Pack Train (Dixon), 67–69, 68 (fig. 3.2)

Paine, Frances Flynn, 115–16, 117

Palace of Fine Arts, 30–32, 37, 38, 39

Palace of the Legion of Honor, 38–39, 90, 104–6, 231n.31

Panama Pacific International Exposition (PPIE), 1–21; decoration theme at, 9–13; duration and purpose of, 4–5; organizers of, 14–15, 229n.44; photograph of, 2 (fig. 1.1); poster for, 7 (fig. 1.3), 8–9; and transformation of working-class values, 28–29. *See also* Panama Pacific International Exposition (PPIE) murals

Panama Pacific International Exposition (PPIE) murals, 1–24; critics on, 1–4, 12, 18–19, 20–21; as decoration, 1, 9–13, 15; guidebooks to, 3, 7, 226n.5; meanings in, 5–6; painters of, 11, 228n.31; post-exhibition disposition of, 15, 21, 33; as public art, 1, 3, 4; reality vs. city portrayed in, 6–7. *See also specific murals*

Pan American Unity (Rivera), 184, 185–90 (fig. 7.1), 208–15, plate 13; Chaplin in, 210, 212–13, 252n.54; public for, 214–15

Park, David, 216

Park Scenes (Labaudt), 168, plate 10

Patri, Giacomo, 103, 141, 240n.42, 242n.13

patrons: murals as mediating between public and, 25; of New Deal art, 130, 190, 243n.27; of Panama Pacific International Exposition, 3, 14–15; Rivera's San Francisco, 47–51. *See also names of specific patrons*

People's World, 133

Pflueger, Timothy, 210, 250n.13; biography of, 47, 216; as head of Golden Gate International Exposition, 190–91, 192, 198, 200; Labaudt's caricature of, 60, 61 (fig. 3.1); as New Deal art patron, 190, 243n.27; and Rivera's introduction to San Francisco, 51, 55, 99; and Rivera's *Making a Fresco*, 88, 89, 92, 93, 94, 239n.11; and Rivera's Pacific Stock Exchange mural, 57, 59, 60, 63–64, 73, 86, 236nn.22–23; and Rivera's *Pan American Unity*, 205, 207, 214

Phelan, James, 14

Piazzoni, Gottardo, 78–79, 87; *California Symphony*, 83–86, 85 (fig. 3.10)

Piłsudski, Marshal Jósef, 97

Designer:	Ina Clausen
Compositor:	G & S Typesetters, Inc.
Text:	Minion
Display:	Univers Light Condensed
Printer:	Malloy Lithographing, Inc.
Binder:	Lake Book Manufacturing, Inc.